Epic in American Culture

Epic in
American Culture
Settlement *to* Reconstruction

Christopher N. Phillips

The Johns Hopkins University Press
Baltimore

© 2012 The Johns Hopkins University Press
All rights reserved. Published 2012
Printed in the United States of America on acid-free paper
9 8 7 6 5 4 3 2 1

The Johns Hopkins University Press
2715 North Charles Street
Baltimore, Maryland 21218-4363
www.press.jhu.edu

Library of Congress Cataloging-in-Publication Data

Phillips, Christopher N.
 Epic in American culture : settlement to reconstruction / Christopher N.
Phillips.
 p. cm.
 Includes bibliographical references and index.
 ISBN-13: 978-1-4214-0489-9 (hdbk.: alk. paper)
 ISBN-13: 978-1-4214-0527-8 (electronic)
 ISBN-10: 1-4214-0489-3 (hdbk.: alk. paper)
 ISBN-10: 1-4214-0527-X (electronic)
 1. Epic literature, American—History and criticism. 2. Literature
and history—United States—History—18th century. 3. Literature and
history—United States—History—19th century. 4. National
characteristics, American, in literature. I. Title.
 PS169.E63P47 2011
 811'.03209—dc23 2011029762

A catalog record for this book is available from the British Library.

*Special discounts are available for bulk purchases of this book. For more
information, please contact Special Sales at 410-516-6936 or specialsales@
press.jhu.edu.*

The Johns Hopkins University Press uses environmentally friendly book
materials, including recycled text paper that is composed of at least 30
percent post-consumer waste, whenever possible.

In memoriam
Jay Fliegelman
(1949–2007)
ex uno, plures

Contents

Acknowledgments

The first thanks go, of course, to my wife, Emily. She has not yet read this book. This is because she has not needed to. She has heard and discussed every idea of every page, including the ones that didn't make it into the final version. She has mourned the deletions, nodded politely at the digressions, and taught me when enough was really enough. In addition to her patient listening, she has loved, encouraged, cooked, played, and done more than I can say to make this book a part of our lives *and* not the only (or most important) part of our lives. Together, we have welcomed two boys into the world since this project began, which means that for two people in our house, their father has always been at work on this book. I hope we all have a swift, smooth transition to the next stage of life— before we have Aliki's *How a Book Is Made* memorized.

My family has continually shown their support throughout this project. My father, Richard, is my most important imagined reader, and whatever is clear about this book is through the effort to do what he has taught me about writing over what is now decades. My sister, Britta, helped me see the importance of Milton to poetry many years ago and has kept asking brilliant questions about this work that helped me say what I needed to say. My mother, Elizabeth, may be the

most basic influence on my path as a scholar of literature, and her love of the word and of people has left its mark on this book.

Many friends and colleagues have helped to hone, elevate, and articulate this project. Luke Bullock has always asked the needed questions, leaving the easy skepticism of "What is an epic?" aside for more important matters, such as this scholar's duty to the texts he studies. He has nurtured this study's human character. Matt Garrett, Jolene Hubbs, Steffi Dippold, Patty Roylance, and Joe Shapiro gave invaluable criticism and encouragement in this study's early stages. Conversations with many colleagues have shaped the development of this work, too many to thank in this space; especially important have been those with Shelley Fishkin, Sam Otter, Max Cavitch, Ed Larkin, Marcy Dinius, Jason Shaffer, Paula Bennett, Lawrence Buell, and David Shields. Mark Thistlethwaite gave generously of his prodigious knowledge of American art criticism and helped energize my study of history painting.

Libraries and librarians have been central to this work, which has been supported by the generous funding of a Mellon Fellowship at the Library Company of Philadelphia and a Diana Korzenik Fellowship from the Friends of the Longfellow House in Cambridge, Massachusetts. My time at the Library Company was full of discovery and scholarly engagement, thanks in large part to their remarkable staff, particularly Connie King, who tirelessly helped me search out materials and connected me to scholars who helped me situate the epic more richly into American and other cultures. Anita Israel and the staff at the Longfellow National Historic Site were a delight to work with, and their making Longfellow's library available to me gave rare insight into the poet's prodigious reading (and furnishing) in the epic tradition. John Mustain, Polly Armstrong, Peter Whidden, and the rest of the staff at Stanford University's Special Collections Library have helped, cheered, and fed this project from its first stages to completion. The library staff at Lafayette College, especially college archivist Diane Shaw, frequently went beyond the call of duty, in particular in securing a crucial acquisition that I am honored to introduce to scholarship in this work (see chap. 2). The Academic Research Committee at Lafayette provided timely funds to support the later research and other expenses of this book, in particular allowing for Katie Thompson and Nicole Ceil to spend a summer poring through curatorial records and manuscript collections with me in New York and Philadelphia institutions; Katie and Nicole's work was invaluable in bringing together a wide range of materials on art, law, and poetry. Thanks to the staff at the National Academy in New York, the Pennsylvania Academy of Fine Arts, the Metropolitan Museum

of Art, the New-York Historical Society, and the New York Public Library for their accommodation and help during that summer.

Working with Matt McAdam and the rest of the staff at the Johns Hopkins University Press has been a joy and a privilege; everyone has demonstrated a level of enthusiasm and professionalism in producing this book that has continually impressed me and sustained my own efforts in seeing this project through to completion.

An earlier version of the introduction has been previously published as "Lighting Out for the Rough Ground: America's Epic Origins and the Richness of World Literature," *PMLA* 122.5 (2007), and is used with the permission of the Modern Language Association of America. Parts of chapter 1 have appeared in altered form as "Epic, Anti-Eloquence, and Abolitionism: Thomas Branagan's *Avenia* and *The Penitential Tyrant*," *Early American Literature* 44.3 (2009) and "Fragmenting the Bard: Sarah Wentworth Morton's Intertextual Epic," *Literature in the Early American Republic* 4 (2012); these are used with permission from the University of North Carolina Press and AMS Press, respectively. My thanks to the editors and readers of these journals for their insight and guidance.

Finally, two people stand apart as special guides to this project. Gavin Jones has been a treasured teacher, supporter, and critic in my life for over a decade, and his ability to be detailed and succinct in his praise, his critiques, and his advice continues to amaze me. I have learned much from Gavin about being a professor, a professional, and a lover of texts. And Jay Fliegelman, to whom this book is dedicated, poured himself into supporting and improving this study just as he has so many other works of American literary and historical scholarship, some of which appear in the bibliography of this book. Working with Jay made one quickly aware that strong scholarship must operate in a tradition, formed often from chosen relations, and the company I have enjoyed in my chosen tradition has been good indeed. An earlier version of this study was the last dissertation Jay signed, and though he did not live to see the volume you (dear reader) now hold, his faith that my story of the epic in America was a story worth telling has sustained the research and revision that became this book. Another career is launched, thanks to a man unreservedly committed to nurturing new professors.

Epic in American Culture

Epic Travels

The wisest definition of poetry the poet will instantly prove false by
setting aside its requisitions.
 —HENRY D. THOREAU, "Homer. Ossian. Chaucer."

They blunder who think tradition can be handed down unconflicted,
uncontested, monological.
 —DONALD G. MARSHALL, *The Force of Tradition*

"*Ocian in view*! O! the joy."[1] These words by Captain William Clark recorded the
Corps of Discovery's sighting of the Pacific Ocean from the Coastal Range west
of what is now Portland, Oregon, on November 7, 1805. From this most tangible
of Miltonic mounts of vision, Clark and his co-commander, Meriwether Lewis,
beheld with their party America's destiny in the latest rotation of the *translatio
imperii* that had moved the course of empire westward from Troy to Rome in Vir-
gil's *Aeneid*. Such an inspiring, pregnant moment may be described as epic, as
indeed it has. Frank Bergon has pointed to "epic" as "a word frequently and loosely
applied to the expedition itself—the historic act of exploration—with respect to
its magnitude, but the term might also characterize the journals as literary
texts."[2] Albert Furtwangler uses a similar observation of the word's frequent ap-
plication to Lewis and Clark's journey to distinguish between the adjectival sense
of epic—Bergon's "magnitude" sense, which Furtwangler says has been "beaten to
death in advertising blurbs"—and the nominal sense, which he claims "still has
some meaning left." After wrestling with the journals' lack of narrative unity, the
perpetual need for that unity on the part of readers, and the maelstrom of "themes
at the heart of American history" that have been isolated and recombined in

various editions and studies of the journals, he concedes that the sketchy note-
books "do not fit this genre at all," but still "in the story they tell, the achieve-
ments they record, and even the minute details of their composition they repeat
epic impulses toward grandeur and integrative comprehension."[3] This strange
dynamic, the impossibility of meeting the demands of form and the irresistible
gravitational pull of form, is the central drama presented by this study.

Lewis and Clark's journals are a fitting point of departure for a number of
reasons. First, few texts have received the description "epic" as frequently in
American letters as the journals. Elliott Coues in his 1893 edition declared, "The
story of this adventure stands easily first and alone. This is our national epic of
exploration, conceived by Thomas Jefferson, wrought out by Lewis and Clark,
and given to the world by Nicholas Biddle."[4] Coues's words would echo for the
next century, but not always in the way that he said them. The word "this" at the
start of the second sentence could mean the adventure, but grammatically it
seems to mean the story, the textual version of the Corps of Discovery's expedi-
tion. The actors Jefferson, Lewis, Clark, and Biddle (the editor of the journals'
first authorized edition in 1814) further complicate matters: did Jefferson con-
ceive the text, or merely what it represents? Could Biddle have given the expedi-
tion, rather than the text, to the world? Most authors have since cut this knot by
favoring the more striking interpretation, as one historian did in 1915 by identify-
ing the expedition itself as having been "well called 'our national epic of explora-
tion.'"[5] Bergon acknowledges this reading as the common usage, as he feels the
need to introduce his application of "epic" to the texts with a "but." This slippage
has fueled the powerful mythmaking associated with what now amounts to a
Lewis-and-Clark industry that Furtwangler archly says "has its own epic dimen-
sions."[6] And the territory of "epic" itself continually expands in the telling. This
expansiveness of the concept allowed Thomas Carlyle to call Emerson's episto-
lary description of Missouri epic, and Gettysburg veteran William McMichael to
do the same for Peter Rothermel's monumental painting of Pickett's Charge.
This slippage in its nineteenth-century context signals at once the apotheosis of
poetry and its departure from public life. If the West or a battle can be not just
poetic but epic, poets themselves are at best late to the scene and at worst will
need to find other employment. But what may seem to be a word's march toward
meaninglessness is in fact a linguistic evolution that reflects how widely and
deeply ideas about epic and national identity have worked into American cul-
ture. From the late seventeenth century, virtually all English dictionaries (in-
cluding Johnson's and Webster's) have defined epic largely as an adjective. To the

extent that the dictionaries recorded actual usage of the word, "epic" as a concept seems to have behaved more as a mode than as a genre; the expansiveness of the adjectival gave epic a penchant for acquiring new resonances and referents.

Epic *was* about origins. Epic *was* about higher principles. Epic *was* about history. Epic *was* about community. Epic has been the first term in narratives of modernity stretching from Schiller and the Schlegels to Lukács and Bakhtin (and, to a lesser extent, Benjamin). In a sense, the project of critical theory in its modern form arises from the sense of belatedness created by reading Homer and Virgil. The fact is that epic as a concept has weathered many previous death sentences. Herbert F. Tucker has recently reminded us, as he quotes Oscar Wilde reminding his contemporaries over a century earlier, that the demise of epic in modernity was an idea that troubled the Greek-speaking Alexandrian poets, a school that Virgil would learn from as he formed his own poetic project.[7] Epic is more talismanic now than it was for Aristotle, as writers' fears for the meaning of modernity have focused much more on the demise of epic than on tragedy, the form that Aristotle actually favored. German critics in the late eighteenth century argued that epic must necessarily give way to tragedy as the world of action was replaced by the world of thought in the modern age; Hamlet is more compelling to moderns than Achilles, as astonishing as the latter may be. Nevertheless, epic-as-adjective has still allowed us to name, organize, and choose between cultural values ever since: that Lewis and Clark's journey or journals can be called "epic" speaks to the importance and excellence ascribed to them by the callers. And those values never exist in a historical vacuum.

When Elliott Coues called the journals (or journey) an epic, he was adapting a discourse already some fifty years old. The first "epicizing" of Lewis and Clark was in an anonymous 1866 article on Oregon and the Washington territory in *Beadle's Monthly*. There the journey (not the journals) was declared "an epic of exploration—a modern Argonautic expedition in pursuit of the Golden Fleece of the future." The comparison with Jason and the Argonauts, one that Jefferson had used half-seriously to characterize his own generation in the eyes of his grandchildren, continued: "The little band were scouts of the grand army for the conquest of a hemisphere—the army of civilization and freedom." The rhetoric of Manifest Destiny is clear, but no less so in 1866 was the Unionism embodied in the reference to the "grand army," echoing the Grand Army of the Republic, the newly formed association of Union veterans. The vision of Lewis and Clark as epic served to legitimate the impossible vision of continental union after a bloody civil war. The article's closing paragraph recasts Clark's effusion at the sight of

the Pacific as the end of a grand political journey: "I never felt the magnitude of our Union until in Washington Territory, forty-four hundred miles from home, I found not only the same language, but the same currency, the same flag, the same hopes, and fears, and sympathies, and precious memories which are cherished at other extremities of the vast continent."[8] The curious blend at the end of this sentence strives to create a newly reimagined community of the United States, but it also connects back to projecting civilization and freedom onto a mission of "conquest" that Jefferson had carefully described in his official papers as a "literary pursuit," in order to avoid the political ramifications of conquest in the hotly contested territory of North America in the early 1800s.[9] Characterizing that literary pursuit as epic helped to make such useful conflations rhetorically viable.

Even the *Beadle's* instance had its own prehistory. After Meriwether Lewis's death in 1809, Jefferson appointed Nicholas Biddle to complete an authorized edition to combat the spurious editions that had already been appearing for years. Biddle worked at the project until 1814, when he suddenly delegated it to Paul Allen, the man whose name appears on the authorized edition. Though nothing in the organization of the journals themselves suggested the format, the 1814 edition was divided into twelve sections, the same number as the sections of Virgil's *Aeneid* and Milton's *Paradise Lost*. Though neither Biddle nor Allen (nor apparently anyone else) remarked on the association, the form set the precedent for later editions of the journals, until Frank Bergon in 1997 remarked that he had organized his Penguin edition "into the paradigmatic twelve-book epic scheme."[10] Whether or not Biddle or his contemporaries consciously considered the 1814 edition an epic, future readers—particularly post–Civil War readers searching for national origins untainted by the conflict—would find the suggestion irresistible.[11] Epic did not die with Milton; as this study will show, it developed new power and shape in the United States that continues to influence our literature and our culture today.

Toward a History of American Epic

Epic is traditionally held in modern thought as the most canonical of genres, and yet the paradox is that most (though not all) of the texts that I treat in this book have received little or no previous scholarly attention. This is then in one sense a recovery project, but it moves beyond recovery to aim for a new synthesis, a way of incorporating both the canon and the apocrypha of American literature through historicizing the very notion of canonicity within the context of epic.

In this, I follow the recent work of Edward Whitley, who in his *American Bards* brilliantly posits a quasi-Bakhtinian "abundance model for literary history," in which the object of study in literary history is not a canon (with or without supporting, "lesser" texts) but "a proliferation of texts and authors as succeeding generations of scholars and teachers redefine literary history with an expanding corpus of texts." The metaphors that Whitley uses of "layers of sediment" and "the traces of a palimpsest" for theorizing the place of authors in such a model are valuable for their ecological sensibility, reframing literary history as both phenomenon and environment.[12]

My own preferred metaphor (if I may call it such) of a tradition highlights the role of human choice and cultural influence, perhaps the reverse-angle version of Whitley's proposal. This interplay of natural given and human organization lies at the heart of one of the most influential nineteenth-century intellectual projects, Alexander von Humboldt's *Cosmos*, which Laura Dassow Walls has recently restored to the center of American literary discourse in her *Passage to Cosmos*. Such a project, as Humboldt's *Cosmos* would suggest, requires a focus beyond the range of the nation, and while this book emphasizes British America and the territory of the United States, I am indebted to the recent comparative work of scholars both prominent and little known in this country, from Kirsten Silva-Gruesz to Armin Paul Frank and Kurt Mueller-Vollmer.[13] Epic often ends up resisting the nation, as much as the form has been enlisted to celebrate the identity and history of many nations over the course of its history.[14] In writing what is in many respects a national history, then, I have repeatedly moved across the temporal and geographical boundaries of the United States in order to better understand how such an international form as the epic could be expected to make national meaning in a given historical moment. The structure of much of my argument is in fact philological, focusing on the changing meanings of "epic" as a term as it travels from poetry to law, to art criticism, and eventually into the realm of cultural work more generally, as definitions expand and anxieties about the place of the canon in modern life become more vexed throughout the timeline of this book.

While I make no claims to comprehensiveness in this volume, I do embrace a long chronology—roughly 1700 to 1876, with brief forays off either end of the timeline—as well as a wide sense of what counts as American, including not only Homer, Virgil, and Milton in discussions of works by American-born authors but also American translations, transatlantic correspondence, and works received more enthusiastically abroad than at home. Then there is the matter of what an epic is. I have lost count of the number of times someone has asked me

in recent years, "What is an epic?" That question usually strikes me as somehow reminiscent of Pontius Pilate asking Christ, "What is truth?" in St. John's Passion narrative. Yet rather than respond out of presumed omniscience, or with the silence that Christ returns in answer, I have looked for intelligent ways to paraphrase Augustine's reflection on time in his *Confessions*: "What is time then? If nobody asks me, I know: but if I were desirous to explain it to one that should ask me, plainly I know not."[15] But this does not amount to a default into literary agnosticism. Rather than work from a definition of what epic is, or was, I undertake to historicize it throughout my chronology in order to show the different work that epics have done in American history, the different forms that epics have taken, and the new insights into literary and cultural history that emerge once synchronic, monolithic definitions of form are abandoned—the surprises in the archive of American literary engagements with epic form are myriad.

But we can never abandon theory altogether. Franco Moretti expresses the paradox of literary history quite well: "We always pay a price for theoretical knowledge: reality is infinitely rich; concepts are abstract, are poor. But it's precisely this 'poverty' that makes it possible to handle them, to know."[16] But the creative tension between conceptual knowledge and archival richness must remain dynamic if literary history is to provide a meaningful basis for generating and supporting further scholarship. At their purest, concepts become so weak that they prove useless to us, and we thus find ourselves returning to what Wittgenstein called "the rough ground"—in literary studies, that means we return to the archive. But what are we looking for when we make that return? Do poems in cantos or books always qualify (as at least one bibliographer chooses to assume)?[17] Do we scour catalogs and databases for titles with words ending in "-iad"? Or look for specific conventions, such as single combats, invocations, or extended similes? All these have played a role in my research, as I suspect they have for previous scholars of the form such as John McWilliams and Herbert Tucker. But even once we find such works, what is to be included in a history of American *epic*? My working model has been that of a tradition, a term that I use interchangeably with *genre* throughout this study. While I discuss at length what I mean by *tradition* and how I see that concept at work in literary history in the next section, to explain the problems and the stakes of this study, I will say here that to write an epic, or to engage with epic via other genres, is to place oneself in a genealogy dominated by central ancestral figures, primarily Homer, Virgil, and Milton, in this case. With this set of parameters in mind, I look at a wide range of texts, in literature but also in other discursive arenas such as art and law, in order to

conduct a thought experiment: to place epic in the center of American literary and cultural history, and to consider how such a placement leads us to rethink key narratives of those histories.

One narrative that this study argues against is what Alfred Kazin called the "American procession" to modernism.[18] At one level, this argument has little novelty in it. Since around 1990, a growing body of scholarship in what is now referred to as the field of historical poetics has brought both historicist and formalist modes of analysis to bear on the huge amounts of poetry written prior to the twentieth century (primarily the two centuries prior) in an effort to recover practices and ideologies of reading, writing, performing, and consuming poetry in a range of social contexts and forms.[19] These studies have laid bare the tautologies of New Critical notions that "identify poetry as lyric," "the lyric as the literary," and "the literary as what they [professors] want to teach the student in turn to identify in poetry."[20] The idea that poetry is to be read as lyric poetry, and that poetry is in fact lyric, had rhetorical power in justifying the study of literature as an independent field of inquiry, but it also sequestered poetry to such an extent that by the time the likes of Richard Chase, R. W. B. Lewis, and F. O. Matthiessen were writing their monumental studies of American literature, American poetry was no longer American literature.[21] The elevation of Whitman and Dickinson—both innovators of lyric forms and self-identified as marginal to American society—as the two great pre-1900 poets only served to consolidate this ghettoization of genre. To describe things so politically is apt for historical poetics, as scholars have recovered discourses of sentimentalism, mourning, memorization, and imitation, ways of writing and thinking that dominated pre-1900 poetry but that had been excluded from modernist and New Critical notions of literary genius. Along these lines, the present study aims to correct the assumption that premodernist literature, at its best, had modernism unconsciously in mind by examining extended, narrative forms of poetry and looking at those forms in relationship to other kinds of writing in their historical moments.

The more important narrative that I seek to revise in this study follows from the first. The focus on both modernist aesthetics and prose literature was bolstered after the rise of theory by two influential studies: Georg Lukács's *The Theory of the Novel* and Mikhail M. Bakhtin's "Epic to Novel." Both theorists offered powerful new ways of thinking about the novel's relationship to modernity, but they also were taken by many scholars, especially Americanists, as useful narratives for understanding literary history, a purpose arguably distinct from what both Lukács and Bakhtin had aimed to do. This narrative is about the triumph of

modern prose over ancient poetry, often linked to pairings such as orality/literacy, script/print, and rural/urban. While historians of both European poetry and the novel have attacked this narrative repeatedly, even pointing to the reputation of Homer's *Odyssey* as the forerunner of romance or novel traditions, the epic-to-novel teleology still continues to appear uncontested in works ranging from Edward Mendelson's work on encyclopedic narrative to Wai Chee Dimock's recent reading of Henry James as a Lukácsian "pre-national."[22] For the period that this study covers, the only prior book on the subject, John McWilliams's 1989 *The American Epic*, includes an epigraph from Lukács, and while McWilliams highlights that theorist's rejection of verse as a necessary criterion for epic, he accepts the epic-to-novel *telos* as describing the development of American literature, pointing to the unpopularity and poor quality (from an updated New Critical standpoint) of early US epic poems as a sure sign that the form was dying out and to the success of mock-epic forms and large-scale novels such as Cooper's *Last of the Mohicans* as evidence that the novel did in fact inherit the epic's mantle in the New World as well as the Old.

Yet one of the great strengths of McWilliams's study is how he shows that through the eighteenth and well into the nineteenth centuries, Americans expected an epic poem to be the benchmark of national literary achievement, and no shortage of candidates were celebrated as reaching that benchmark, just as so many novels since the late nineteenth century have vied for that postbellum title, the Great American Novel.[23] The widespread production and consumption of mock-epic was not a sign that epic was dying out, for mock-epic only works among readers familiar with the conventions and claims of epic poetry. And in my research for this study, I have found, and am still finding, that Americans just would not stop writing epics—not out of nostalgia or from missing the memo that the epic was dead, but because the epic tradition continued to have relevance on a personal level, as well as in regional, national, and international contexts.

Nor was the novel necessarily the most important intergenre for the epic in America (if it indeed had been anywhere). As this study demonstrates, the generic acquisitiveness of epic brought it into contact with a wide range of intergenres, often several at once in a given text, resulting in mutually transformative interactions that indeed brought the epic and the novel into a line of descent together, as they did epic and closet drama, epic and elegy, epic and painting, and epic and constitution, to name a few of the more central pairings that appear in these pages. The language of painting appeared in works by men and women, in long forms and short, in poetry and prose, in order to convey what it was that the

author was doing by engaging with Homer and company; in turn, epic became a canon-making term in art criticism of the late eighteenth and nineteenth centuries, as part of the emerging discourse of the professional artist. The expansive sweep of the encyclopedia influenced the departure from narrative evidenced in works ranging from Joel Barlow's *Vision of Columbus* (1787) to Herman Melville's *Moby-Dick* (1851) and Walt Whitman's *Leaves of Grass* (1855), even as works such as *Encyclopaedia Americana* (1st ed., 1833) became key venues for theorizing the meaning of epic in modernity.

Most significantly, the preponderance of the elegiac in American epics helps to explain both the persistent relevance of epic poetry in the nineteenth-century United States and the epic poem's fall from critical grace after 1900. Max Cavitch's *American Elegy* convincingly presents the history of mourning poems in America as a dynamic interplay of popular culture, European poetics, and the psychological need to leave something behind in commemorating loss. Elegy was, as Cavitch argues, likely the most prevalent poetic form in American literature, practiced by parents, children, slaves, and professional writers alike. Epic, by far the more elite of the two genres, was historically reserved for learned men as authors, and only men and women of a certain level of cultural attainment as readers. While this cultural hierarchy continued to hold by and large in the American literary scene, writers such as the young slave Phillis Wheatley, the Quaker schoolteacher Richard Snowden, and the sanitarium inmate Richard Nesbit all wrote epic poems, and for such writers as well as others as elite as Daniel Webster and Henry David Thoreau, their entry into epic authorship was often through elegy. As will be shown in many of the chapters of this study, the language of mourning served to import the discourse of sentimentalism into epic beginning in the eighteenth century, a development that would make the classical form more accessible to modern readers and allow for writers including Lydia Huntley Sigourney and Henry Wadsworth Longfellow to reach their readers through ambitious poems meant to create a national mythology. The blending of epic and elegy is in fact endemic to the former genre; without mourning the fallen hero, there would be no *kleos*, no glory for Achilles or Hector or Odysseus. Sheila Murnaghan has argued that the particularity and occasionality of lament lead to reassessing epic, a "monumental" genre generally perceived as "a massive, univocal, and celebratory form of high art," as dependent "on the 'speech genres' of ordinary communal life," thus highlighting its "dialogic, polyvocal dimensions."[24] Distinguishing between male lament, which leads to *kleos* (Achilles mourns Patroklus), and female lament, which promises no redemption for the hero since his community

is doomed (Andromache mourns Hector), Murnaghan suggests that the source and extent of the elegiac infusion into epic may in fact undo the classical logic of heroism and monumentalizing that the form is expected to perform.

Something similar is going on in most, if not all, of the works studied in this volume, as Joshua and his men cannot cease mourning their fallen countrymen in Timothy Dwight's *The Conquest of Canäan* (1785); Hiawatha weeps over his dead wife, Minnehaha, at the start of his own exit from the story in Longfellow's *The Song of Hiawatha* (1855); and Richard Snowden's speaker breaks off his epic vision of American prosperity by calling for an elegist to retell his story at the end of *The Columbiad* (1795). This persistence of lament threatens the epideictic thrust of the Homeric form, and the result is that many of these texts have been branded in the twentieth century as sentimental failures—particularly Dwight's and Longfellow's poems. For better or for worse, the discourse of sentimentalism had associated most elegy by the mid-nineteenth century with the "graveyard school" poets, typified by Thomas Gray's "Elegy Written in a Country Church-Yard" and Edward Young's "Night-Thoughts," and later including what we might call the "cemetery school" poets, such as Sigourney, Longfellow, and Alice and Phoebe Cary, who performed personal mourning in ways generalized enough to translate to individual experiences of real loss. I would argue that this association, more than any other, led to the falling stock of the epic poem during the rise of New Criticism. The politics of academic taste have kept the course of epic in America from receiving due attention.

This has been the case even in previous scholarship on the topic. McWilliams performs the expected act of critical disdain for these cemetery poets in his summary of antebellum epic: "The disgrace of the imitative verse epic [in the early Republic] led authors to portray American heroic subjects in new literary forms more engaging to contemporary readers. If we mercifully except *Hiawatha*, Whitman's *Leaves of Grass* is still the one work commonly believed to have fulfilled this end."[25] While the problem of imitation was much more complicated, and perhaps less problematic, than McWilliams implies, my main point here is that his "merciful" exception of *Hiawatha* signals an anxiety that has haunted American studies since the early twentieth century. The idea that Longfellow, the most influential and commercially successful American poet of his own century, could have contributed to the development of American literature threatens the belief reiterated from F. O. Matthiessen's *American Renaissance* to John Carlos Rowe's *New American Studies*: that American literature is about democratic experimentation, liberal cosmopolitanism, and revolutionary iconoclasm (Longfellow

actually participated in all three of these, but in less Whitmanian modes). As Patricia Meyer Spacks has argued in *Boredom: A Literary History*, to find previously popular works (such as Richardson's novels or Longfellow's poetry) boring or tedious is not so much an aesthetic evaluation as it is an aggressive response to what the reader perceives to be a serious threat to his or her fundamental assumptions about the world. Rather than dismissing epics as boring, in the sense of inducing comas or suicidal thoughts, what if we came to see them as *boring* into the deepest, knottiest issues in American culture—of empire, of equality, of virtue, and of the place of the individual in a modern society?

The epic tradition resonated with American writers for several reasons. The ability to represent a nation both to itself and to the world made the epic a powerful diplomatic and cultural ally for writers such as Timothy Dwight and Joel Barlow, who were themselves institutionally involved in the new nation's intellectual and political development. The hope of these writers was that epic's (more or less) recognizable form and ideology would make the monumental task of civic reeducation more feasible, while the form's prestige would attract the greatest minds to step forward as the nation's literary Founders, as the prestige of chartering a new nation had seemed to produce heroes organically out of the colonies. Combining encyclopedic reach with rigorous narrative subordination offered a literary solution to the formal problem of extending a federal republic across a vast geography and a quickly diversifying economy. However, this last advantage in particular carried with it an increased danger. By foregrounding the nation's diversity for the purpose of subordinating that diversity to unity, America's epicists left open the possibility that such subordination could only be incomplete, if not altogether a failure. Alex Woloch describes two wars taking place in the *Iliad*: one between the Greek alliance and the armies of Troy, the other between the heroes who dominate the story and the masses without whom the story (and the heroes) would not exist.[26] Only through subordination, sometimes forcefully so, as in Odysseus's beating of an upstart commoner in *Iliad* II, can the story proceed. And a similar violence of subordination runs through the American epic as well, whether in verse or prose. Daniel Webster forces down the atrocities of Indian removal, slavery, and "free" labor exploitation in his Achillean history of the nation; Dwight's Joshua puts down a rebellion in order to complete his *Conquest of Canäan*; and Ishmael silences Starbuck's acuity in order to leave Ahab's monomania unimpeded to the end. The violence of the path to epic greatness led some American epicists, such as the pacifist Richard Snowden, to turn the form completely upside down, in an effort to produce a democratic epic—a subordinated

insubordination, a contradiction in terms and a description of a literary project that continued through Reconstruction and has continued to influence American literature down to the present, as with works as diverse as Thomas Pynchon's *Mason & Dixon* (1997), Leslie Marmon Silko's *Almanac of the Dead* (1991), and James Cameron's blockbuster film *Avatar* (2009). This history has been obscured by tenacious aesthetic filters, and yet it is still playing itself out in the twenty-first century.

On Terms and Methods

Much of the most influential criticism on epic has been done in the field of comparative literature, and a brief discussion of recent developments in that field will help contextualize my own approach to epics and to genre. Epic has become especially important in recent years to theorists of world literature, and American texts have been part of that new work. Franco Moretti has helped to redefine partially the critical debate over epic away from Bakhtin's and Lukács's epic-to-novel paradigm; in *Modern Epic*, Moretti treats epic from Goethe's *Faust* onward as a supergenre, specifically a phenomenon of what he calls a "world system" of encyclopedic literature in which a few great texts are written to both represent and create an entire world, while consciously seeking for themselves an international readership.[27] Melville's *Moby-Dick*, Whitman's *Leaves of Grass*, and Pound's *Cantos* appear in Moretti's supergenre, alongside Wagner's *Ring of the Nibelungs*, Joyce's *Ulysses*, and García Márquez's *A Hundred Years of Solitude*. Working from a more nation-based starting point, Wai Chee Dimock's *Through Other Continents* is a breakthrough in bringing American literature and world literature back into conversation, in considering genres as world systems and looking beyond the spatial and temporal boundaries of the nation-state to make sense of how literature is created and interpreted, but her heavy reliance on Lukács in dealing with epic makes it necessary to look for alternative theories of the form for us to understand what we find in the archive. In her essay "Genre as World-System," Dimock does indeed offer two such alternatives: laws of fractal geometry and those of Wittgenstein's "family resemblance" theory.[28] Both of these kinds of "laws" are designed for talking about categories and phenomena that defy classification, and Wittgenstein in particular emphasizes the need for maintaining "soft" boundaries around certain concepts, such as games, for which "hard," logically consistent boundaries are highly problematic. In this book I push Dimock's genealogical methodology even further, for one of the fascinating but understudied elements of intertextuality is the author's ability (at least to some extent) to

choose his or her own intertexts and intergenres—Virgil, for example, chooses to combine the *Iliad* and the *Odyssey* through the two halves of his *Aeneid*, while Camões focuses on the *Odyssey* alone in the *Lusiads*, his narrative of Vasco de Gama's voyage to India, with the addition of material from Iberian travel narratives. Particularly from Camões's era (the late 1500s) forward, Western writers of epic became increasingly choosy about the texts that would dominate the epic tradition in which they participated.[29] While unconscious, indirect connections certainly abound between texts, perhaps more in epics than in many other forms, the family resemblances that bind post-Renaissance epics together are to a considerable extent the result of chosen relations, or what I call a tradition.

Epic tradition has been a vehicle for anchored innovation from Virgil onward. With texts so prestigious and so complex, this is at one level a necessity. T. S. Eliot, in "Tradition and the Individual Talent," argues that tradition in fact creates the meaning of a single work or author: "No poet, no artist of any art, has his complete meaning alone. His significance, his appreciation is the appreciation of his relation to the dead poets and artists."[30] Given this necessity, then, Eliot advocates a willful response to those dead predecessors. His image of the bookshelf that each poet rearranges, moving this writer next to that one, removing and adding books, is his view of how canons are formed, but I find it especially apt for thinking of how the canons behind individual works are formed, the literary equivalent of what Kenneth Burke calls "the Constitution-behind-the-Constitution." Ralph Ellison has put this in even more striking terms in "The World and the Jug." Responding to Irving Howe's claim that Richard Wright had a crucial influence on Ellison's work, the novelist retorted that Wright saw him as a "potential rival," not as an apprentice. In a famous passage, Ellison explained how he understood his relationship to Wright among other writers he admired: "[W]hile one can do nothing about choosing one's relatives, one can, as artist, choose one's 'ancestors.' Wright was, in this sense, a 'relative,' Hemingway an 'ancestor.' Langston Hughes, whose work I knew in grade school and whom I knew before I knew Wright, was a 'relative'; Eliot, whom I was to meet only many years later, and Malraux and Dostoevsky and Faulkner, were 'ancestors'—if you please or don't please!"[31] Ellison mixes living and dead writers, countrymen and foreigners, in his notion of "ancestors." Those ancestors do not exist in a prior canon (though many, such as Hemingway and Dostoevsky, had moved beyond their national canons by the 1960s, when Ellison responded to Howe) but are created by and for Ellison as a group. These are the writers in whose tradition he wants to write and be evaluated. The writers that are most obvious to connect with him—other Af-

rican American writers of national or international stature—are important intertexts, but more for the cultural moment than for the author's own goals.

In adopting this line of literary genealogizing, as it were, I tend to foreground authorial intention, though not without the usual caveats of indeterminacy and the reader's role in making meaning. In a sense, my concept of how writers of epic choose their traditions—what I call *the epic impulse*—is a form of reading, with superlatively extensive annotation in the form of an "original" work. While Homer, Virgil, and Milton are the three consistent ancestors through this study, others stand alongside them, rise to their level, or fall away at various times. Tasso was considered more important than Milton by many eighteenth-century critics of epic, Dante was barely known in English-speaking countries before 1800, and *Beowulf* was not even available in print in Britain until the late 1820s. Thus, countenancing authorial intent is one way of keeping a historicized perspective on the canon; just because *Gilgamesh* or *Beowulf* came before Barlow's *Columbiad* does not mean that the tears of Columbus are part of a tradition with the laments of Beowulf's subjects. The *Kalevala*, while in one sense older than the many Renaissance epics Longfellow could have drawn on in choosing a model for *Hiawatha*, was attractive in the 1850s precisely because it was an ancient tradition that had only been available to outsiders for less than two decades. To speak of "the epic tradition" in this study is therefore valid, so long as the reader keeps in mind that it refers to specific traditions for specific writers and works—but is "the tradition" in that instance.

An example of how this kind of tradition-driven thinking manifests itself appears in Royalist poet William Davenant's 1650 preface to his *Gondibert: An Heroick Poem*:

> I will . . . begin with *Homer*, who though he seemes to me standing upon the
> Poets famous hill, like the eminent Sea-marke, by which they have in former
> ages steer'd; and though he ought not to be remov'd from that eminence, least
> Posterity should presumptuously mistake their course; yet some (sharply observing how his successors have proceeded no farther than a perfection of imitating him) say, that as Sea-markes are chiefly usefull to Coasters, and serve
> not those who have the ambition of Discoverers, that love to sayle in untry'd
> Seas; so he hath rather prov'd a Guide for those, whose satisfy'd witt will not
> venture beyond the track of others, then to them, who affect a new and remote
> way of thinking; who esteem it a deficiency and meanesse of minde, to stay and
> depend upon the authority of example.[32]

Davenant aimed to create a new heroic form of epic with his *Gondibert*, one free of the machinery and folklore that dominated Homer's works and those of his imitators. However, Davenant's choice of metaphor shows just how indebted his new concept is to a Homeric original. The "sea-marke," a point on land visible from the sea, is both a navigational point of reference and a boundary: one may adjust a course based on relationship to the sea-marke, one may adjust that relationship by sailing closer to or farther from the mark, but one can never come straight at the sea-marke after a certain point—total destruction would be the only result. Thus, Davenant archly comments that Homer's "successors have proceeded no farther" than the original; rather than accept the limitation, Davenant reverses the trajectory of his metaphor to make the sea-marke a point of departure, the edge of the known from which the "ambition of Discoverers" may set out in more flexible territory. But this kind of discovery is only that which is not-Homer; the new modern tradition that Davenant seeks to establish is possible precisely because Homer stands behind it. The English poet has chosen his genealogy for the purposes of declaring his independence from his forefather, but such a declaration only shows how closely the two are aligned.

Davenant's placing himself within a tradition defined by both critical consensus and individual choice is at the heart of the epic impulse; as a concept, it is no mere rehearsal of Harold Bloom's theory of weak and strong poets, but brings Bloom's weak and strong poets back together by acknowledging their shared starting point, while it also historicizes and thus troubles Bloom's distinction. What makes a strong poet, after all, if not the ambition of a discoverer ready to pass his predecessor's boundary? Yet Davenant's reputation as a poet is almost nonexistent today, and it is unclear whether that would have changed had he completed *Gondibert*. In the preface, Davenant announced his intention to finish the poem while serving as the new lieutenant governor of Maryland. This appointment was made by the exiled Charles II, however, and Davenant was captured by Cromwellians en route to America and held in the Tower of London. His reputation was such that Milton was one of several poets who personally petitioned Parliament for his release, but the poem was never finished, and it lay unpublished until after his death. Almost two centuries later, though, Davenant would become an ancestor when Herman Melville picked up a secondhand copy of his 1673 *Works* while on a trip to London and read it intently during the return voyage in 1850, when he began to write what would become *Moby-Dick*.

To put a finer point on *how* a prior work may be used in a tradition, let us turn to one more example, from Milton's *Paradise Lost*. The poem certainly redefined

the epic tradition in profound ways that would set some of the terms for Americans writing in that tradition, and much has been made of Milton as "an American poet"; the influence of *Paradise Lost* as a source text is well documented, both for American poetry and for political prose on both sides of the Revolutionary War. However, Milton's epic included a major formal innovation that, while virtually all American epicists felt compelled to either accept or openly reject it, has gone unnoticed by Milton scholars. The last two books of *Paradise Lost*, which contain Adam's vision of futurity with commentary by the archangel Michael, have sparked critical controversy for a century and more. The most famous of critical statements concerning these books is that by C. S. Lewis, who characterizes the books as "an untransmuted lump of futurity."[33] Milton's style in these books certainly does differ from that of the first ten books, in the relatively bare narration and relentless forward drive of the story. But what interests me is not so much the debate over the stylistic merit of Books XI and XII as what the debate has bracketed: Adam's vision continues not only up to Milton's time but all the way to "the world's great period," the Second Coming of Christ and the foundation of the New Heaven and New Earth. This marks the first time in the history of epic visions of futurity—a device that Milton would have traced back to Homer—that the vision moves temporally beyond the author's own era. If the great ekphrastic moment in an epic (such as Achilles's shield) is a hermeneutic for the work itself, as has often been argued,[34] then the vision of futurity provides an apology, or more precisely a teleology, for the work. In the *Odyssey*, this teleology belongs exclusively to the past, tied up in the life and death of Odysseus; in his prophecy at the edge of the underworld, Teiresias predicts only as far as the circumstances of the hero's death. Virgil shifted the tense of his teleology in the *Aeneid* by projecting Anchises's Elysian prophecy to Aeneas up to the death of Caesar Augustus's son, Marcellus—the poet's present. And in the poet's present the teleology rested, in Camões and Ariosto and Tasso. The uneasy alliance between Christian eschatology and epic teleology resulted in the shift from present to eternity in Dante's *Divine Comedy* and in the Redcrosse Knight's similarly extra-chronological glimpse of the heavenly city in Book I of Spenser's *The Faerie Queene*. Yet the move from present to eternity did not change the inflection of the works; Dante's and Spenser's respective presents still dominate their texts. In *Paradise Lost*, a work similarly a product of its time, Milton seeks to transcend that time by inflecting his narrative into the future tense. Epic was no longer about its own present, but about its own future, and the long-debated flattening of Milton's poetic voice in Books XI and XII would continue into *Paradise Regained*—and into American

epic poetry. The mount of vision, by virtue of its association with the imperialist gaze of prospect poetry and its newly fashioned futurist telos in Milton's epic, attracted American authors and critics alike. Milton had responded to his tradition, and Americans who took Milton as part of their tradition would offer dozens of responses to his mount of vision, from Barlow's *Vision of Columbus* to Cooper's mountain "The Vision" in *The Pioneers* to Mount Etna in Poe's *Eureka*. The mount of vision became an homage to Milton, a familiar gesture that could be used to make arguments about the meaning of landscape, the trajectory of the nation, or even the nature of knowledge.

I will here insert a brief word about my own choosiness. I say very little about the mock-epic in this study, despite dozens of texts available from the period covered in this study. One reason for this silence is the high quality of the existing scholarship, notably McWilliams's chapter on mock-epic in *The American Epic* and the work of Colin Wells, David S. Shields, and William C. Dowling on early American mock-epic.[35] Another reason is that mock-epic, like the literary historians with whom I take issue above, is centrally concerned with the failure of "high epic" in the face of modernity. From the quasi-Homeric "Battle of Frogs and Mice" onward, mock-epic as a form has assumed that epic takes a fundamental form (almost always based on the *Iliad*) and that the state of things today is so far removed from the high rhetoric and heroism of what the epic presents that the force of the new mock-epic is in pointing out that distance. While, as I show with authors such as Thoreau and Melville, mock-epic was a key element in the continual fluidity of epic as a tradition in the United States, the inherent conservatism of the form led me to de-emphasize it in my account. Another lacuna in this study is war poetry. Though poems about the Revolution and Indian wars are discussed here, many others are not, and poems dealing with the War of 1812, the Mexican War, and several other historical conflicts are largely bracketed. This is primarily because, as I argue in chapter 1, Milton's *Paradise Lost* and *Paradise Regained* are the paramount springboards for innovation in American epic poetry. While many American epic poems imitate the *Iliad*, versions of the *Odyssey* and Milton's epics tend to prevail not only in numbers but also in cultural influence and engagement. The phenomenon of the American war poem is itself a fascinating subject and is worthy of further scholarship; I here set it aside to allow for concentration on other, more surprising engagements with epic, which I hope will lead others to reassess the place of the *Iliad* tradition in American literature. As I have found in my research, there are many different kinds of epics in the archive, and they often blend into each other. I have tried to select a few

kinds that I have found most interesting to study and that I hope will be useful to others to read about as well.

In order to do so, I have faced the problem (a formal problem that any epic work must solve as well) of balancing the macro and the micro. New possibilities for studying the macro have made this end of the analysis especially attractive. Moretti's recent work, such as his *Atlas of the European Novel 1800–1900*, itself enacts a kind of epic, not unlike the Miltonic mount of vision in its attempt to make sense of global history through geographic distance: "[L]iterary history will quickly become very different from what it is now: it will become 'second hand': a patchwork of other people's research, *without a single direct textual reading*. Still ambitious, and actually even more so than before (world literature!); but the ambition is now directly proportional *to the distance from the text*: the more ambitious the project, the greater must the distance be."[36] Moretti's vision of distant reading owes something to the aesthetics of the Grand Manner, or what Sir Joshua Reynolds called "the epic style" in his *Discourses*, a work that is discussed in chapters 2 and 3. Yet this distance comes with a price, as David Damrosch has observed in his assessment of Moretti's vision; Damrosch advocates retaining close reading as a tool for constructing case studies out of the immense sweep of the Morettian project.[37] Dimock has also voiced a critique of "distant reading," in which she objects to Moretti's emphasis on universal laws in his methodology.[38]

Although I do provide some overview of the development of epic forms in English-speaking America, particularly in chapters 1 and 4, my primary mode of analysis is close reading, a commitment this study shares with works such as Virginia Jackson's *Dickinson's Misery* and Cavitch's *American Elegy*. While seeking to move away from treating all poetry as lyric poetry, I find that close attention to the language of key moments in epic works helps to highlight not only the presence of lyric qualities in epic writing (and in twentieth-century reading of epics) but also the value of holding the richness of poetic language and the extension of narrative in tension with each other. In taking on this challenge, I begin with a brief, admittedly idiosyncratic sampling of individual responses to epic; I then proceed with a thematic survey of major innovations in epic form in eighteenth-century writing, followed by an analysis of epic's expansion into other cultural arenas, particularly constitutional law and painting, before examining the changes in thinking about epic during the heyday of transcendentalism and the rise of German-influenced humanities study at Harvard. These studies lay the foundation for closer examination of individual authors, both for their own sake and for illuminating larger cultural functions of epic: the epic-novel relationship in Cooper, the persistence

and prestige of "Indian epic" poems in the career of Sigourney, Longfellow's commitment to translation and the Americanizing of *Weltliteratur*, and Melville's lifelong reflections on the meaning of authorial career in the age of professionalization. The study concludes with a brief look at the migration of epic from literary to broader aesthetic discourses, which pave the way for its inclusion in film and contemporary art.

IN HIS ESSAY "THE STORYTELLER," Walter Benjamin revises Lukács's epic-to-novel narrative with a third term; Benjamin sees both epic and novel as endangered by the rise of information.[39] As more events are pre-explained to people in the form of news media, the work of bringing meaning to events is displaced, and events therefore cannot be as resonantly meaningful in the modern present as they could when distances of place and time obviated the need for accuracy. What might be called the crisis of realism in epic form—the problem of making a larger-than-life story or persona widely believable—haunted American engagements with epic from its earliest stages. Lewis and Clark have not been immune to this problem. Clark's line that opens this introduction was not in the Biddle-Allen 1814 edition. It was not even in Frank Bergon's edition. Not until the publication of Gary E. Moulton's *The Lewis and Clark Journals: An American Epic of Discovery*, the 2003 abridgment (in twelve chapters, of course) of Moulton's monumental thirteen-volume complete edition of the journals, did an abridged collection include the line. The reason is that Clark did not write it in his journal, but in "a separate list" that Moulton had compiled as part of the supporting documentation. As many commentators have also pointed out, the Corps of Discovery did not in fact see the Pacific that day, but only the estuary bay of the Columbia River. The Miltonic mount of vision in the Coastal Range of Oregon fell prey to the epistemological limits of actual human eyes in history. Despite all this, though, Moulton closes his commentary by stating, "It remains for all time our American epic."[40] His "it" is the journey rather than the journals, which both justifies and diminishes his own great accomplishment as editor. More importantly, his phrase "for all time" signals a desire on the part of many (if not all) Americans who engage with the epic tradition: a desire to beat time, to transcend history in the name of something greater. A vital part of the fascination for me in undertaking this study has been how epic has made its home in history, and how important that truth is for understanding its place in American culture.

Reading Epic

All writing of epic begins with reading epic. One of the crucial reasons for the historical fluidity of epic's definition as a form is the variety of purposes and circumstances with which readers approach epic works—works that readers understand to be epic, or wish to be epic, or have heard are meant or reputed to be epic. This allows for a practice we may call *epic reading*, the making of a text into an epic work through the assumptions and intertextual workings of the reader. The next section focuses on two very distinct examples of this: George Sandys's translation of Ovid's *Metamorphoses* in colonial Jamestown and Elizabeth Graeme's translation of Fénelon's *Adventures of Telemachus*. Not all readers are concerned with fixing or shifting the genre of epic while they read, however; many read to learn a language, to experience an adventurous journey akin to novel reading, or to gain cultural capital as a student (and in so doing to retain or elevate one's class status). As will be shown throughout this study, epic has often been seen as essential equipment for living, providing both a fount of commonplaces and quotations for rhetorical deployment and a way (or several ways) of thinking about one's place in a class, a nation, or a world. Thus, before exploring more easily recognized acts of writing in the epic tradition, I begin with a brief

survey of ways that reading in that tradition became fleshed out in the British American colonies and their successors.

This survey begins with practices of translation both as ways of appropriating marginal texts into epic tradition and as strategies for dealing with personal loss, either of political support or of familial ties. As we will see, gender has much to do with the meaning of translation in epic tradition, a genre that has attracted more female translators and writers than is often recognized. The gendering of epic also has implications for the place of epic form in eighteenth-century pedagogy, whether in the informal setting of a group reading in a parlor, the intensive reading of a solitary youth, or the drilling of recitation-based college curricula. That *The Power of Sympathy*, America's self-proclaimed first novel, should include such a parlor scene speaks to the consciously shared world that both epic and novel inhabited in the late eighteenth century; the more strenuous pose of the devoted reader of epic is most dramatically taken on by Phillis Wheatley in "To Maecenas," and the college experiences of Timothy Dwight, the United States' first recognized epic poet, show some of the dark side of the devotion that Wheatley exhibits. The final section of this survey examines the interplay between illustration, children's literature, and epic form at the turn of the nineteenth century, as well as the often mysterious cultural uses to which epic was put in the early United States. Alexander Anderson's Homer illustrations, which became stock images for Philadelphia children's books in the 1810s, offer a curious parallel to Joel Barlow's *Columbiad*, the sumptuously visual book that overwhelmed the poem it contained, rendering the poem virtually unread even in its own time yet lending its name to objects that Barlow intended his poem to eradicate—heavy coastal artillery. These readings (or misreadings) of epic would set the terms for many contemporary and later writers and adapters of epic in the United States. They also help us to see that engaging with epic form continually catches both reader and writer between *in principium* and *in medias res*—between the quest for origins and the sense of belatedness, as if any beginning must necessarily find itself struggling to catch up to its own story. And so to Ovid.

Translating Loss: Two Approaches

George Sandys, the first known Anglophone reader of epic in America, was one of the early treasurers of Jamestown Colony, but his reading had preceded his appointment. By the time Sandys left for Virginia, he had completed the first five books of an "Englishing" of Ovid's *Metamorphoses*, and he used his own corporeal

translation to the New World as his inspiration for literary translation. Ac-
cording to his own account, Sandys translated another two books during the
voyage across the Atlantic and the remaining eight books while in residence in
Virginia. We will return to the Americanness of the translation itself in a mo-
ment,[1] but the first important point is that the *Metamorphoses* is not manifestly
an epic text, but Sandys read it as epic. He renders the opening line thus: "Of
Bodies chang'd to other shapes I sing."[2] Written within a generation of Virgil's
Aeneid, the *Metamorphoses* has long defied easy generic classification.[3] The
main reason for this difficulty is that while the length of the work and the use
of hexameters—a meter largely reserved for epic poetry in Latin—invite com-
parison to Virgil's masterpiece, the episodic structure resists subordination to
narrative unity that for Aristotle characterized the epic form. Furthermore,
Ovid adopts many of Virgil's and Homer's distinctive devices: invocations, ex-
tended similes, catalogs. However, he also slyly changes (metamorphoses?) many
of these conventions so that they are clearly his own, and not nearly as obvi-
ously in line with the developing epic tradition. For example, in the invocation,
which involves "singing" for Homer and Virgil, Ovid replaces the *Aeneid*'s *"cano"*
(I sing) with *"dicere"* (to tell). That Sandys should choose "I sing" to translate
Ovid's cagey phrase pushes his poet firmly into the epic tradition, and the trans-
lator thus associates himself with the tradition as well: the greatest of genres for
any Renaissance poet, but especially for a royally commissioned one, as Sandys
hoped to become.

 As James Ellison has argued, Sandys's own poetics are closer to Virgil's than
to Ovid's, emphasizing the regularity of line and expression rather than witty
agility; in fact, Sandys translated the first book of the *Aeneid* as well, probably
before his Ovid project. *Aeneid* I, with its explication of the Roman legacy of
colonialism and its account of Aeneas landing with his crew on the shores of
Carthage, the first "brave new world" of Virgil's epic, would have been an ideal
choice as a prolegomenon for an imperial project—such as the colonization of Vir-
ginia. Ellison speculates that Sandys translated Virgil as a form of political postur-
ing, hoping to win royal favor at a moment when Sir Edwin Sandys, George's older
brother, was part of a faction seeking to seize control of the Virginia Company
from within Parliament.[4] One need not look far to find Sandys's own politics
emerging from his reading of Ovid. *Metamorphoses* VI and VII, the books
Sandys said that he translated en route to Virginia, relate several famous voyages,
most notably that of Jason and the Argonauts, a story that includes Jason's civi-
lizing of and marriage to the barbarian sorceress Medea.

Ovid's treatment of the violence of the Trojan War as yet another cycle in the endless chain of metamorphoses would have served Sandys well during the aftermath of a 1622 massacre of over three hundred colonists by neighbors previously believed to be friendly. Like the Trojans, Sandys and his fellow administrators were under the impression during their first year in Virginia that the Powhatans wanted peace. The optimism surrounding renewed efforts toward education and evangelism in the Chesapeake region left Sandys and his cohorts vulnerable, despite intelligence reports and other warning signs. Having failed as a colonial administrator and eager to regain political favor from Charles, Sandys published his Ovid translation, which he titled the *Metamorphosis*, in 1626, a year after his return to England. In his dedication to the king, Sandys attempted his own metamorphosing of administrative disaster into cultural capital: "[H]ad it proved as fortunate as faithfull, in me, and others more worthy; we had hoped, ere many yeares had turned about, to have presented you with a rich and wel-peopled Kingdome; from whence now, with my selfe, I onely bring this Composure."[5]

Sandys in fact achieved considerable fame throughout the seventeenth and eighteenth centuries on the strength of his Ovid translation, the only lasting legacy from his work in Jamestown. Yet part of what made the translation so valuable was the extensive commentary that Sandys wrote later for the 1632 edition, which included engravings for each of the fifteen books, plus the *Aeneid* I translation, added as an appendix entitled "An Essay to the Translation of Virgil's Aeneis." The commentary distilled classical and medieval thought regarding Greco-Roman myths and their interpretation, but Sandys also provided examples from his experience in the New World as well as his extensive reading in the history of Spain's American empire, thus further adapting Ovid's text in light of his own reading of America. He likens centaurs to the initial appearance of Spaniards on horseback in Mexico; the Spanish lust for gold in South America is a modern antitype to Midas; and "*Columbus* by his glorious discoveries more iustly deserved a place for his ship among the Southerne Constellations, then ever the *Argonautes* did for their so celebrated *Argo*."[6] In many ways Sandys, like his translation, stood between two worlds, as he commented in his dedication: "It [the poem] needeth more then a single denization, being a double Stranger: Sprung from the Stock of the ancient Romanes; but bred in the New-World, of the rudenesse whereof it cannot but participate; especially having Warres and Tumults to bring it to light instead of the Muses."[7] Strange indeed, reading a text into the epic canon, and then reading it further into an American history made of imperial rivalries, anxieties of unlooked-for violence, and classical tropes

being strained from their original contexts to explain the unexplainable realities of America.

While Sandys found the translation of epic to be a useful form of political damage control, a century and a half later an even more ambitious translation project would serve the young Pennsylvanian Elizabeth Graeme as therapy. While traveling in Britain in 1764, Graeme learned that her mother had died of an illness that had begun slowly before the voyage's start. When she returned to Graeme Park, she found that not only her mother but her only remaining sister, Ann, had died. Graeme, alone with her aging father in a large, remote house, needed a way of expressing her grief, filling long solitary hours, and processing the loss that would mark the rest of her life. Already the author of hundreds of pages of prose and verse, she refocused her energies as a poet.

Her commonplace book known as *Poemata Juvenilia* provides a narrative of her 1760s experiences through poems and extracts. Following poems relating her travels and addressing new acquaintances, Graeme writes "Some lines upon my first being at *Graeme Park*," reflecting on the loss of her mother, then "Wrote on the Tomb Stone of Mrs Ann Graeme," and extracts from James Thomson "on the Death of a Friend." Some twenty-five pages later, she writes a series of biblical paraphrases, first dealing with guilt (the Prodigal Son, David's adultery condemned), and then with the presence of strong women in men's spaces (Judith's triumph over Holefernes, Moses and Miriam singing at the Red Sea). The very next item after the Moses and Miriam paraphrase is an "Invocation to Wisdom," identified as the introduction to her translation of Fénelon's *Adventures of Telemachus*. As Miriam is Moses's co-worshiper in the paraphrase, so Wisdom (or Minerva) becomes the handmaiden of God by guiding "the Modest Youth" through danger.[8]

Graeme realizes the difficulty of explaining Christian truth through classical mythology, even as she asks "Grave *Wisdom*" to "[i]nspire my *Muse* and Animate her Lays, / That She Mellifluous may chaunt forth thy praise" (345). She explains that Jesus taught in parables, and that Fénelon's allegory follows the same principle of "screen[ing] his purpose in the pleasing Tale," and as she seeks "a Spark of that Celestial Fire" that inspired Fénelon's work, Graeme claims to be following a source who follows *the* Source (347, 345). She further insists on her own personal faith as a Christian: "That sacred Name I awfully revere; / I humbly ho[p]e to reach the blest Abode / Prepard by *Christ* th' Eternal Son of God" (346). Graeme had spent the two years following her return to Graeme Park paraphrasing the Psalms, an act of piety as much as it was one of personal consolation. She

gave a copy of her paraphrase as a gift to her minister and family friend, Rev. Richard Peters, but her work on *Telemachus* seemed to be more private to herself, even if she did not keep the project a secret. Her turn from biblical imitation to classical epic-romance needed some explanation even to herself, but it becomes clear as her invocation continues that, as Susan Stabile has pointed out, she is translating the guidance of specifically female virtue rather than male: "*Passion* and *Wisdom* ever are at Strife . . . *Minerva* gives true Fortitude of Soul / That does the Rage of Passions Tyde controul" (348).[9] Using the metaphor of a flaming furnace to describe Wisdom's tempering of the "Puerile Mind," the Telemachus story also becomes suddenly autobiographical:

> This *Fire* is *disapointment*, *Grief*, and *Pain*,
> Which if the Soul with Fortitude Sustain:
> The Furnace of *Affliction* makes more Bright
> Still higher burnishd *Jehovahs* Sight:
> The rugged Path we joyful Shall survey
> Thro which our Passage to perfection lay;
> And Bless the Briars of Lifes Thorny Road
> Which Ends in *Peace* in *Happiness* and *God*. (348–49)

The date given for this poem in *Poemata* is June 14, 1768, three years after the loss of mother and sister, and these closing lines of the invocation point to both the hope of afterlife and the perspective of hardships receding into memory. Graeme dedicates her translation to Wisdom, a goddess disguised as a mortal man (Mentor) in Fénelon's work; her own identification with Telemachus, the son of a great hero in search of that heroic father, magnifies her own grief to heroic proportions.

Yet it is a heroism understood through the filiopiety of the child, and for all the claims that the invocation makes for her, the notes after her pseudonymous signature, "Laura," explain that the translation "much . . . amusd Her after the death of Her Mother And Sister: to amuse her was the aim" (349). Graeme spent three years, from 1767 to 1769, working on her translation, and the almost thirty thousand lines that she wrote suggest not so much a commitment to the original as a commitment to keep the project going. She returned to the translation in 1786, after her marriage to Hugh Fergusson had ended in separation, spending another year and more writing annotations and adding extracts from poets (Thomson and Milton were favorites) and critics (Johnson, Addison, and Beattie appeared frequently). Her project became in part a defense of her choice to translate

the work into verse, as *Telemachus* had been written in rhythmic prose, and no English translation to date had used verse; it also became an intervention in the masculine form of the learned edition. The sheer size of the project, over three thousand manuscript pages, is the usual reason given for her failure to publish her translation.[10] A labor of love that occupied almost three decades of Graeme's life would ultimately be buried like the departed loved ones for whom she undertook the work in the first place.

Graeme's decision to render *Telemachus* in heroic couplets would seem to corroborate the arguments of writers such as Hugh Blair that Fénelon's work was in fact epic, but it is worth considering what such an alignment of *Telemachus* with epic verse (rather than the novel) would have meant to her. Graeme's extensive reading in epic comes across even in her short works, such as her literary history of Britain and the new United States in her later "Litchfield Willow" odes, in which she celebrates Pope's Homer as well as American works such as Joel Barlow's *Vision of Columbus*.[11] Stabile describes Graeme as "fashioning herself as a female Odysseus," approaching the journal of her transatlantic voyage as a "heroic odyssey."[12] That Graeme boldly places herself as the center of the action in her journal, rather than a spectator of "greater" activities, is certainly remarkable, but her reading in Homer also gives her the occasion for a total experience of the sublime during her voyage: "I saw the Sun set clear, for the first Time, I was reading Priam's Petition to Achilles, for the Body of Hector, I think my Eyes were engaged in one of the finest Sights in the Universe, & my Passions, interested in one of the most pathetic that History or Poetry can paint."[13] The simultaneous reading of Homer and gazing at the horizon is a visual tour de force, as Graeme seems empowered by her reading to take in everything at once. This sumptuous view is the first American glimpse of epic as world literature, the literature of travel that transcends national and generic borders: the view, the text, and the voyage all participate in the overall effect, in a moment not unlike Thoreau's reading of Homer at Walden Pond or Longfellow's transcontinental nationalizing of the *Odyssey* in *Evangeline*. Significantly, Graeme compresses all this into the senses and emotions of an individual experience, her own. Almost a century before Whitman devised his legendary "I," Graeme was practicing an imperial gaze that emphasized the continuity of its vision rather than the hierarchies or categories that she might have invoked while steeping herself in the classics.

Graeme figures herself as a solitary figure in this passage, but she was far from alone in using epic as a gateway to the delights of scenery and leisured travel in her circle. Pennsylvania governor John Penn used Tasso's *Jerusalem Delivered* to

learn Italian while waiting to cross the Alps from Germany on a grand tour. Julia Rush Williams, the daughter of Philadelphia physician and Declaration signer Benjamin Rush, kept a commonplace book that included pages of excerpts from Homer, Virgil, and Tasso; however, her lists were organized as descriptions of sunrise, or of love. For the highly educated Julia, epic could serve the sentimental purposes of a girl's commonplace book as easily as the more traditional masculine virtues that another Declaration signer, John Dickinson, celebrated in his Lockean commonplace book, the hallmark of an educated gentleman of the eighteenth century.[14] Dickinson's gift to his 8-year-old daughter Maria of a copy of *Paradise Lost*—the only European epic printed in North America before 1790—suggests that the line between gentlemanly learning and female sentimental education may have been less rigid than has generally been assumed regarding the place of epic in eighteenth-century reading.[15] The interplay between these two modes of education, of virile virtue and pious sentiment, runs through the next section.

The Voice of the Student: Learning from Epic

Women were, in fact, rarely left to read epic by themselves in the eighteenth century. William Hill Brown's *The Power of Sympathy* (1789) provides a striking scene of the politics and aesthetics of a shared reading of epic in the eighteenth century. In Letter 30, Mrs. Holmes gives the young Myra her philosophy of education through narrating her domestic life:

> What books do you read, my dear? We are now finishing *Barlow*'s Vision of *Columbus*, and shall begin upon *Dwight*'s Conquest of *Canaan* in a few days. It is very agreeable to read with one, who points out the beauties of the author as we proceed. Such a one is [Mr.] *Worthy.*—Sometimes Mr. *Holmes* makes one of our party, and his notes and references to the ancient poets are very entertaining. . . . We have little concerts, we walk, we ride, we read, we have good company— this is *Belleview* in all its glory![16]

The reading of Barlow and Dwight makes this a scene of imagining the nation through literature, but the locality of reception is of equal importance. Reading Barlow's and Dwight's epics is rendered "agreeable" through on-the-spot critical assessment in a parlor scene of mutual performance; Mr. Worthy's notices of the authors' "beauties" properly direct the attention in an anthologizing act, while Mr. Holmes's "entertaining" notes on classical authors bring ancients and moderns

into dialogue in ways both *dolce* and *utilis*. The pleasures of the epistolary novel itself, the thrill of "listening in" on others' correspondence, makes voyeurism the originary moment of education, as it also blurs the lines between orality, script, and print. These blurred boundaries bring us to the heart of Mrs. Holmes's disguised instruction: not only must Myra read the right books, *"American"* books for the American lady, but she must also read in community, and with the right company. Reading is part of a larger communal activity that includes music, physical exercise, conversation, and the pleasure of knowing that one has chosen the right friends. All this constitutes the "glory" of Mrs. Holmes's aptly named Belleview, where seeing and being seen are just as important as reading and being read to—both for the men and for the women.

A distinct lack of visibility seems to have motivated Phillis Wheatley's own representation of herself as a reader of epic. In her case, she downplays the difference of gender by emphasizing her role as a solitary though mentored reader, a student of epic along much more male lines than either Mrs. Holmes or even the learned Elizabeth Graeme. Wheatley's status as a poet depended on her being able to convince white, educated men that she could read like them, and she aimed to do just that from the first poem in her collection, *Poems on Various Subjects, Religious and Moral* (1773). "To Maecenas" is an apostrophe presumably addressed to a patron, as Maecenas was the name of a Roman nobleman who supported both Virgil and Ovid at various times. While several candidates for Wheatley's actual "Maecenas" have been proposed, the fact that Wheatley opens her collection with an acknowledgment of the power of patronage in her own life is more important for this discussion than the identity of the actual patron (Wheatley had several, in fact).[17] And the opening description of Maecenas in the poem emphasizes his role as an ingenious reader, a kind of precursor to the "alert and heroic reader" that Thoreau posits in *Walden*[18] and a model for Wheatley herself:

> Maecenas, you, beneath the myrtle shade,
> Read o'er what poets sung, and shepherds play'd.
> What felt those poets but you feel the same?
> Does not your soul possess the sacred flame?
> Their noble strains your equal genius shares
> In softer language, and diviner airs.[19]

The next lines describe the power of Homer and Virgil as poets, and the addressee shifts from the patron to Homer, "Sire of verse" (10). Wheatley recreates a sense

of Homeric sublime (via Pope), as storms evoke "deep-felt horror"; slow, elegiac lines describe his "gentler verse," and the social contract of the sympathetic reader is fulfilled "when great *Patroclus* courts *Achilles*' aid, / The grateful tribute of my tears is paid" (10). Wheatley shows that she is a good enough reader to react properly at the right times to Homer, and a good enough poet to capture that reaction in the rhythm of her own lines, devices that John Shields has shown that she adapted from her mentor Mather Byles's poem, "Written in Milton's PARADISE LOST," itself a poem of youthful apprenticeship to a classical master.[20] Yet this last couplet makes a strange choice for a moment to weep. The couplet after it describes Patroclus's death and the mourning his death inspires in his great cousin, Achilles. Wheatley does not cry at the point of death, but at the point at which Patroclus begs Achilles to let him use the older warrior's armor as a disguise, that he might lead the Greeks to victory. It could be that the most moving thing about Patroclus's story for Wheatley is the moment when the young hero must seek patronage, even debasing himself to get it. Considering Wheatley's own youth in 1773 (she was around 19) and the obstacles she had faced in securing patronage as a young female slave, her tears suggest that she was a particularly sensitive reader, sensitive to both the pathos of the verse and the tragic politics of the story.

Wheatley's penchant for imitation, her playful revision of her sources, and her emphasis on reading and display of learning all show how seriously she took her own identity as a student—a mature one, yes, but hardly a graduate. When she laments that she has not equaled Homer and Virgil ("here I sit, and mourn a grov'ling mind" [11]), this need not be an act of race treason or yet one more apology for living too late for poetic fire. The lines just before this lament suggest an expectation of development: "O could I rival thine [Homer's] and *Virgil*'s page, . . . Soon the same beauties should my mind adorn, / And the same ardors in my soul should burn" (10). The word "soon" here assumes not that a muse's magic wand will suddenly change her writing, but that once the poet can find a way to "rival," a way that could very well exist, a growth in ability will follow in the course of further education. The subjunctive "should" further emphasizes the conditionality of poetic greatness and its unpredictability, rather than its impossibility. Even the "grov'ling mind" is one "[t]hat fain would mount and ride upon the wind" (11). She seeks not inspiration but indulgence and protection from her patron; she has her own plans for gaining inspiration, apparently. Though Maecenas's "breast" is "the *Muses* home," she aims only to "snatch a laurel" from his "head" and asks him to "defend my lays" (11–12). By claiming consanguinity with

the African playwright Terence but publicly desiring kinship with Homer and Virgil, Wheatley shows that even as a juvenile author she has a sense of her career and its political realities. Now that her patronage is secure, she subtly vies for her own space as an author.

Wheatley's youth is perhaps the most underemphasized element of her identity as an author, even as she foregrounds her role as student. And as her example shows, even committed student readers of epic can have unexpected and potentially severe reactions to their reading. In its way, Timothy Dwight's student reading of Homer was as radical as Wheatley's, though done as a Yale student rather than as a slave. Early in his college days in the 1760s, Dwight had developed a passion for Homer as well as an ambition for studying him in the original. Disappointed by the inefficacy of Yale's Greek teachers, he made a point of rising an hour before morning prayers to parse a hundred lines of Homer by candlelight, a discipline that made him one of New England's most accomplished Greek scholars in his day, but that also permanently damaged his eyesight.[21] Yet his passion for English letters was hardly less than that for the Greek bard. While a tutor at Yale, he started a campaign with fellow tutor John Trumbull for the inclusion of belletristic literature in the college's academic program; Dwight went so far as to offer lectures on English literature after regular class hours, based on Kames's *Elements*.[22] Such investment in literature, both classical and modern, helps to explain why Dwight wrote what is often credited as the first American epic poem published in the United States, *The Conquest of Canäan*. Yet when Dwight became president of Yale years later, he not only made the first major effort to introduce English into an American college's curriculum but also fought unsuccessfully to bar his beloved Homer from the sophomore curriculum, and when he lost his main point he insisted that the faculty not teach Homer on Mondays, as it would lead the students to study the heathen bard's works on Sundays.[23] Dwight's personal interest in Homer, however great it was, could not bring the venerable educator to advocate classical studies over the sublime (and pious) grandeur of Milton—or Milton's source. For Dwight, the classics had to be taught under very specific strictures, lest student reading lead to the wrong consequences—a position shaped by his own co-curricular reading of those same classics. He was, after all, teaching boys, or young men not much beyond boyhood, and by the start of Dwight's presidency at Yale in 1795, he had already seen the apprenticeship of epic reading give way to the self-assertion of epic writing in his own life and that of his classmates, and it was becoming increasingly clear that the childhood consumption of epic could have unpredictable consequences, especially

as images began to take over the text. The importance of the pedagogical origins of Dwight's and Barlow's epic poems will be discussed at length in chapter 1, but let us first examine some of the implications for the broader movement to package and consume epic poetry as fundamentally consumable boys' reading.

Guns, Ants, and Extravagance: Epic for Boys

As book illustration processes became more economical and widespread, the connection of image and word in the packaging of epic poetry made the form increasingly inviting for young readers. Alexander Anderson, by 1800 the preeminent wood engraver and book illustrator in the United States, considered his own reading as a child to have molded his thinking about the work of an illustrator. In his memoir, Anderson recounted few details of schooling years beyond his reading: "After devouring all the toy books of Newbury the first book of any consequence was Aesop's Fables and the next Dryden's Virgil, the engravings in which formed no small share of the entertainment."[24] By associating Aesop, the quintessential children's author, with Dryden, poet laureate of England and translator extraordinaire, Anderson showed how permeable the divide between high and low literature—and between adults' and children's literature—was in the English-speaking world. Later in the nineteenth century, British writers as diverse as Thomas Babington Macaulay, Thomas Arnold (Matthew's father), John Ruskin, A. W. Kinglake, and Compton Mackenzie all recorded memories of reading and play-acting from Pope's *Iliad* as boys,[25] which might help to explain that translation's loss of literary prestige in the nineteenth century: a translation that made Homer attractive to children could not be sufficiently serious for the likes of Matthew Arnold, Benjamin Jowett, or William Cullen Bryant (the latter made his own literal translation in blank verse, of both the *Iliad* and the *Odyssey*, in the early 1870s).

Anderson would in fact contribute to the recasting of Pope's Homer as a children's book with a series of woodcuts that he made for William Durell's firm in New York in 1808—the first American-designed illustrations of Homer, an event Durell highlighted on the title pages for both the *Iliad* and the *Odyssey*, which were "ORNAMENTED WITH WOOD CUTS,/Originally Designed and Engraved by Dr. A. ANDERSON, of New-York."[26] Rather than embrace the scope of European full-page illustrations of epic poems, Anderson composed tailpieces for each book of the *Iliad* and several books of the *Odyssey*, creating miniature vignettes within an already miniaturized text; virtually all American reprints of Pope's Homer were pocket-sized, including the duodecimo Durell imprints.

Even as Pope's Homer appeared in cheaper and cheaper reprints for an increasing range of readers, Anderson's illustrations were themselves recycled, but in a peculiar way. Philadelphia publishers Jacob Johnson and Benjamin Warner, Quakers specializing in children's literature who had published the first edition of Richard Snowden's *Columbiad* in 1795 (discussed in chap. 1), acquired the woodblocks to Anderson's *Iliad* illustrations, most likely from Durell, and used them in several children's books throughout the 1810s. Tracing one of these illustrations through Johnson and Warner's catalog is instructive. In *The Budget* and *The Friend of Youth* (both 1813) appears a woodcut of a man in classical armor, reclining on the seashore and gesturing toward the ocean, suggesting both the romantic adventure awaiting the young reader and the sobering messages the stories contain. This image originally appeared at the end of *Iliad* I, illustrating Achilles's mourning after the loss of his concubine Chryseis in his battle of words with Agamemnon. One of the most sentimental moments in *Iliad* I, Anderson's choice of scene translates easily into other venues for sentimentalism, which was a stock in trade for Johnson and Warner's child-friendly titles. The 1813 *A Present for Good Boys* is perhaps the most extreme example of this, as a story titled "The Travelled Ant," narrated in the voice of the eponymous character, closes with the ant bidding his young reader "Farewell!" (fig. 1). Directly below this last "Farewell!" is Anderson's Achilles in mourning, as if manifesting the narrator's confessed "vain race" of the ants in all-too-human form. What began as a sentimental depiction of an epic conflict transformed within five years into sentimentality stretched to the limits of imagination, a human fantastically standing in for an already fantastic ant-speaker. If Homer was not already a boy's book, the American visual response to Homer served to infantilize the epic even as history painters such as Benjamin West and John Trumbull sought to further fetishize it, as discussed in chapter 3. The inextricability of elevating epic and infantilizing it haunted even the most serious presentations of epic, and the prime example of this phenomenon may be Joel Barlow's *Columbiad* (1807).

A revision of Barlow's earlier *Vision of Columbus* (1787), his *Columbiad* was meant to celebrate Columbus's achievement and the spread of worldwide democracy that his discovery made possible. The title page included an untranslated epigraph from Tasso's *Jerusalem Delivered*, in which Fortune predicts that the mariner "will spread [his] sails so far toward an unknown pole that Fame . . . will scarcely follow with her eyes [his] flight." Fortune goes on to say that Fame may sing of "Alcides [i.e., Hercules] and Bacchus," but it is enough that "she only give some hint" of Columbus.[27] This excerpt from Tasso emphasizes two elements of

us, that every thing in this world was made for our use. Now, I have seen such vast tracts not at all fit for our residence, and peopled with creatures so much larger and stronger than ourselves, that I cannot help being convinced that the Creator had in view their accommodation as well as ours, in making this world.

I confess this seems probable enough; but you had better keep your opinion to yourself.

Why so?

You know we ants are a vain race, and make high pretensions to wisdom as well as antiquity. We shall be affronted with any attempts to lessen our importance in our own eyes.

But there is no wisdom in being deceived.

Well—do as you think proper. Meantime, farewell, and thanks for the entertainment you have given me.

Farewell!

Figure 1. Alexander Anderson, [illustration of Achilles], *A Present for Good Boys* (Philadelphia, 1813), p. 29.

Library Company of Philadelphia.

Columbus's legacy that serve Barlow's purposes particularly well: his immortal-
ity and his invisibility. While Fortune seems to elevate "the Mariner" above Her-
cules and Bacchus, superhuman champions and civilizers of mankind, she also
gives the earlier, more remote stories over to Fame to sing; Columbus is the topic
not of song but of some hint or sign (*"alquanto accenne"*). He is the indirect sub-
ject of fame, for Barlow as for Tasso, and the unity of Barlow's sprawling narra-
tive depends entirely on Columbus-as-spectator, not Columbus-as-heroic-actor.
Columbus is put before the reader's gaze only so that the character's gaze and the
reader's can merge; Columbus is nothing more or less than the vehicle for Bar-
low's literary enterprise.

And the *Columbiad* was certainly an enterprise. In its production values, it was
more a monument than a poem; in its cost ($10,000 to produce, of which Barlow
fronted $5,000), it was extravagant. It was printed in quarto at a time when even
ambitious American poems appeared in small octavo or duodecimo formats, and
it was meant to celebrate everything that America could produce involving books.
The paper was American-made, the type was designed and struck by an Ameri-
can foundry, and the illustrations were British in origin only because Barlow's
negotiations to employ the American John Vanderlyn fell through.[28] Attentive to
epic's importance to the language of its composition, Barlow also used his *Colum-
biad* to incorporate spelling reforms, most of them advocated by his Yale class-
mate Noah Webster, and the poet gives his explanation of his orthography in a
four-page postscript, in hopes that his poem would help Americanize English.
The sheer monumentality of the *Columbiad* presented a problem for Barlow, how-
ever. While his poem celebrated the universal spread of democracy (he had be-
come a radical after living in Paris in the 1790s), the *Columbiad*'s audience would
necessarily be an audience of wealthy consumers. While the book was published
on three different kinds of paper, including a "coarse" issue, this last version was
priced at $10 a copy in boards and was perhaps never even offered for sale; the fine
paper copies were to sell for $20 in boards or $25 bound, an extraordinary price
even for a fine book in England at the time.[29]

Such a sumptuous artifact ran so counter to Barlow's liberal principles that he
used his dedication to Fulton to shift the blame for the book's physical appear-
ance and suppress his own involvement in the book's production.[30] Barlow's
making Fulton out to be the agent that brought the *Columbiad* into being might
have been bad faith, but more importantly, it was the poet's admission that the
sheer materiality of his work had taken it out of his own control. When Barlow
gave copies of the book to such important Republican allies as Dolly Madison

and Thomas Jefferson and to institutions such as the American Philosophical Society, he seems to have made the presentation unbound, possibly out of embarrassment at the book's grandiosity as it was.[31] And yet the book seemed to only attract further luxury to itself. Later sellers inserted portrait pages of the presidents, and a two-page facsimile of the Declaration Signers' autographs transformed Barlow's anti-monarchical poem of the Enlightenment into a grand procession of *patri patriae*, with Barlow's own frontispiece portrait concluding the sequence.[32] Many buyers accentuated the luxury of the book through their choice of bindings; Joseph Brown Barry went so far as to have the leather boards of his Robert DeSilver–bound copy of the *Columbiad* painted with a pastoral landscape and a seascape—a pictorialization of Barlow's encyclopedic ambition.[33] This was a text not to be read, but to be dressed for displays of conspicuous consumption.

No less a tastemaker than the *Edinburgh Review*'s Francis Jeffrey recognized the *Columbiad*'s status as a luxury object in his review of the poem. After praising and damning various aspects of the writing, Jeffrey gave an effusive, though somewhat backhanded, tribute to the book's materiality: "There is one thing . . . which may give the original edition of Mr Barlow's poem some chance of selling [in Britain],—and that is, the extraordinary beauty of the paper, printing and embellishments. We do not know that we have ever seen a handsomer book issue from the press of England; and if this be really and truly the production of American artists, we must say, that the infant republic has already attained to the very summit of perfection in the mechanical part of bookmaking."[34] The very wondrousness of the book's physical quality raised doubts for Jeffrey, first of England's ability to compete with such fine publishing, next of the authenticity of the claim that the work was a wholly American production, and third of the place of technology in the cultural hierarchy that Jeffrey and his collaborators so tirelessly defended. The very desirability of such an object forces the issue as to whether sensual desire—for the "beauty" of the "handsome" book—should rival, or indeed supplant, the intellectual desire for good literature. That such beauty is a result of "mechanical" rather than artistic "perfection" foregrounds the class distinction that Barlow seems to have feared that his book would stand for; Jeffrey's compliment reversed the elitist pretensions of the artifact by drawing attention to its very status as an artifact. The poem was by this point already forgotten; like Joseph Brown Barry, Jeffrey had no need to read further, as the pleasures of looking at the book were a sufficient reason to table, as it were, the question of literary merit.

Yet if the physical attributes of the *Columbiad* carried both the book and the poem well beyond the author's control, the name "Columbiad" strayed even further.

In 1811, an American army engineer named George Bomford named a new smooth-bore cannon he had designed the "columbiad" in honor of Barlow's poem. By the start of the Civil War, the name "columbiad" applied to virtually any large defense artillery piece,[35] which had become icons of American military strength.[36] Barlow's vision of a millennial rise of reason had been translated into the terrible sublimity of modern warfare. Some two centuries after a failed colonial treasurer "misread" Ovid into the epic canon, Americans continued to take whatever they pleased from their reading of epic, be it power, freedom, a room of one's own, a prize for good behavior, or a clever name for a weapon. Even when Americans did not "read" the epics produced by their compatriots, epic would continue to define—and redefine—what Americans thought their nation and its culture meant.

Diffusions of Epic Form in Early America

The range of readings and readers of epic in colonial America testifies to the flu-idity of epic as a genre even as early as the seventeenth century. Many critics have assumed that epic was a fairly fixed idea in eighteenth-century England and Brit-ish America, partly from the proliferation of mock-epic poems and partly from the wide influence of French critics such as Voltaire and Bossu who sought to codify Aristotelian genre theory. These assumptions have prepared generations of critics to see early American epic as imitative, moribund, a literary dead end that would require the rise of the novel to overcome. Yet many of the later innovations in American epic writing—Cooper's *Leatherstocking* cycle, Cole's conflation of poetry and painting as epic arts, Whitman's gazes into the future of poetry—were anticipated in the years surrounding the Revolution. New experiments with epic form grew out of and fed a crucial shift in the usage of the term "epic" throughout the eighteenth century from a formal concept to a way of narrating and thinking about heroism. English dictionaries provide a helpful cross section of this shift; before about 1750, most English dictionaries defined "epic" in terms of verse structure. For example, Edward Phillips in his *A New World of Words* described "Epick" as "belonging to, or consisting of Heroick or Hexameter Verse;

as *An Epick Poem*." However, by the time Samuel Johnson defined "epic" in his *Dictionary*, the term had become popularly understood in terms of subject matter, to which Johnson added performance as a criterion: "Narrative; comprising narrations, not acted, but rehearsed. It is usually supposed to be heroick, or to contain one great action atchieved by a hero."[1] This shift saw its clearest theoretical expression in the writings of Scottish Enlightenment critics such as Hugh Blair and Henry Home, Lord Kames. By the time of the American Revolution, the frequent use of these writings in formal schooling and in educated families' libraries had prepared Americans such as Timothy Dwight (who read Kames's *Elements of Criticism* in Yale's library as a student in the 1760s) and Joel Barlow (who learned his Kames through Dwight) to treat epic as a malleable form ready to be updated by modern ideas, forms, and historical movements.

Both Blair and Kames rejected the rigid formalism of the French critics, but they struggled to establish viable criteria to take in the great range of texts ancient and modern that could be considered epic. Kames asserted that no one could draw a conclusive line between epic and all other forms:

> Much useless labour has been bestowed, to distinguish an epic poem. . . . It is not a little diverting, to see so many shallow critics hunting for what is not to be found. They always take for granted, without the least foundation, that there must be some precise criterion to distinguish epic poetry from every other species of writing. Literary compositions run into each other, precisely like colours: in their strong tints they are easily distinguished; but are susceptible of so much variety, and take on so many different forms, that we never can say where one species ends and another begins.[2]

Kames's analogy to colors suggests the affinity between epic literature and the visual arts, a relationship debated with increasing warmth after the publication of Gotthold Lessing's *Laocoön* in 1763. The choice of color—a favorite topic of controversy in the wake of Newton's experiments with light—as a category for comparison also suggests that epic form was in flux by the mid-eighteenth century, so much so that even the best critics could not systematically explain its development. A major reason for this instability was an increasingly complex web of European intertexts with which readers and writers of epic could, and often felt compelled to, engage. Two texts in particular, François Fénelon's *Telemachus* and James Macpherson's "translation" of Ossian's *Fingal*, played major roles in what amounted to the invention of epic as a national form in the eighteenth century. Both texts enjoyed numerous translations and reprintings

throughout Europe, and Ossian became a favorite figure for imitation among, for example, several American elegists of George Washington.[3] A vital element of *Telemachus*'s and *Fingal*'s influence on epic theory and composition was the fact that both were written in prose—metered in the former, highly figurative in the latter, but still prose.

The popularity of *Telemachus* led both Blair and Kames to gesture toward a more open epic canon. Blair anticipates Lukács's dismissal of verse form as a requisite for the epic, stating that to exclude Fénelon from the class of epic poets would be "unjust": "His work, though not composed in Verse, is justly entitled to be held a Poem. The measured poetical Prose . . . gives the Style nearly as much elevation as the French language is capable of supporting, even in regular Verse." His only objection to *Telemachus*'s status as an epic focused on content, specifi-cally the "minute details of virtuous policy" that the highly didactic Fénelon speaks through the mouth of Mentor to the young hero. According to Blair, the "object" of an epic is "to improve us by means of actions, characters, and senti-ments, rather than by delivering professed and formal instruction."[4] Kames also used *Telemachus* as his occasion for disagreeing with Voltaire's argument that verse is essential to epic. The Scottish jurist noted that the lack of verse form is the French critic's "single reason" for denying *Telemachus* epic status, while un-specified "others" who favor "substance" over form (such as Kames?) "hesitate not to pronounce that poem to be epic." Rather than turning to his own sense of critical judgment, as Blair did, Kames resorted to popular opinion as the gate-keeper of the epic canon: "As to the general taste, there is little reason to doubt, that a work where heroic actions are related in an elevated style, will, without further requisite, be deemed an epic poem."[5] The rise of substance over form as the prime criterion for epic was a popular movement, as Kames understood it, at least among the educated reading public. As the voice of common sense (in the sense of "public consensus"), Kames readily admitted that reading a work as an epic carried a great deal of weight in determining a work's status *as* an epic.

While the critical reception of *Telemachus* made the writing of modern epics more feasible, the publication of *Fingal* and the other Ossian poems spurred nationalist antiquarian projects in both Europe and America, as nations emerg-ing from the fallout of eighteenth-century empires sought to establish their own cultural independence through the "discovery" of their own Homeric pasts. J. G. Herder included Ossian in his discussions of poetry as expressing the *Geist* of a nation.[6] In English-speaking nations, Blair emerged as a champion for Os-sian, arguing that the poetry contained native energy now foreign to civilized

nations, even exhibiting "a remarkable resemblance to the style of Old Testament." Indeed, Blair made an almost Herderian statement on the power of "primitive" language in his often reprinted essay on Ossian: "An American chief, at this day, harangues at the head of his tribe, in a more bold metaphorical style, than a modern European would adventure to use in an Epic poem." The ancient vigor of *Fingal* trumped the refinement of Fénelon and Voltaire, and the American analogy would be significant for the acceptance of Native American materials as appropriate to epic form. The comparison to the "American chief" also posited a natural eloquence that permitted the critic to ignore neo-Aristotelian canons with relative impunity: "To refuse the title of an epic poem to Fingal, because it is not in every little particular, exactly conformable to the practice of Homer and Virgil, were the mere squeamishness and pedantry of criticism." Blair goes on to defend Ossian on Aristotelian grounds, however, stating that Homer and Ossian both wrote from nature, and that Aristotle used Homer to examine nature: "No wonder that among all the three, there should be such agreement and conformity."[7] And little wonder, too, that in the eighty years following the "Ossian revolution" numerous "primitive" European epics saw print for the first time, including the *Nibelungenlied, Beowulf, Sir Gawain and the Green Knight*, several of the Icelandic *Eddas*, and *The Kalevala*. Thanks to new paradigms for understanding epic, and to the new ambition to "discover" another *Iliad*, epic form changed from a structural sum of its parts to a vehicle for national and international self-assertion, paving the way for the Goethean project of world literature and the encyclopedic approach to genre mixing that it would entail. Such was the climate within which the first epic poems in America were written.

Epic writing in eighteenth-century America was a maelstrom of experimentation, cross-generic composition practices, and constant importations of other genres and modes, from elegy to prospect poetry to fragments and devotional writing. The four sections of this chapter trace the development and significance of four experiments that would prove especially influential in the nineteenth century. The first was the centrality of prospect to the narrative structure of epic; while I argued in the introduction that Milton had originated this new approach to epic narrative, the fact that it was most frequently adopted in eighteenth-century America by student writers, and usually as part of a prospect-laden commencement ceremony, points to the importance of occasion—even ephemerality—in American epic. The second experiment emerged not as a refocusing of epic to new purposes but as a critique of epic as a vehicle of memory and celebration; the dogged presence of elegy and lament in early American epics threatened to

"un-man" the epic, even as it opened new possibilities for sentimental discourse in epic form. A third experiment grew from an increasing interest in epic as a site for intertextual pluralism; as the language of sentiment began to make its way into the epic tradition, so did homiletic, ekphrastic, and hymnic discourses in ways not seen since the Renaissance—or, in the case of the poetic fragment, hardly seen before. As with the elegiac turn in American epic, women authors found intertextual experimentation as a way into the hypermasculine epic tradition, and less-educated writers found ways to make epic speak to their own discursive worlds. The fourth experiment, which I call Dissenting epic, amounted to the sharpest critique of all among writers who engaged the epic form: fueled by radical Protestant theology and a corresponding "plain-style" poetics, this approach emphasized biblical narratives while rejecting the learned style of *Paradise Lost* in order to create a more populist literature for a community of Christian readers that did not map easily onto the nation. More than perhaps any other strain of American epic (to borrow a biological term), Dissenting epic moved between the transnational world of Anglophone evangelicalism and the localities of the often isolated regions where this evangelicalism took root in the eighteenth century. To look at the history of American epic through these experiments gives us not only a much more dynamic and archivally grounded picture of epic traditions but also a clearer sense of how it interacted with the lives of individuals and communities in an often tumultuous period.

Commencing Epic: Prospects and Occasions

The Miltonic prospect was central to American engagements with epic from the early eighteenth century, but that prospect developed into a new convention in large part through a much more ephemeral genre, the college commencement poem. John Seelye has shown striking similarities between prospect poems and epics written by Timothy Dwight, Joel Barlow, Hugh Henry Brackenridge, and other early American poets,[8] but he ignores that most of those prospect poems were written not as gentlemanly works of art, as Pope's *Windsor Forest* was, but as student performances of learned skill and institutional aspiration. In fact, no scholar has ever before observed that the first versions of both Dwight's *Conquest of Canäan* (1785) and Barlow's *Vision of Columbus* (1787) were visions of futurity, presented at college commencement exercises. Dwight's and Barlow's epics were not a dead end of classical epic, but new attempts to use epic form as a vehicle for telling new kinds of stories about America and its future.

In addition to Miltonic prospects, American commencement poems tended to recycle the *translatio studii / translatio imperii* trope of George Berkeley's often reprinted "Verses on the Prospect of Planting the Arts and Learning in America." One element of this narrative that Berkeley created, and that young classical scholars were happy to repeat, was that epic would be a sign of America's cultural ascendency:

> There shall be sung another golden Age,
> The rise of Empire and of Arts,
> The Good and Great inspiring epic Rage,
> The wisest Heads and noblest Hearts.[9]

Berkeley's "epic Rage" saw development in the most famous of American commencement poems, Hugh Henry Brackenridge's 1771 *The Rising Glory of America*, at the College of New Jersey:[10]

> 'Tis but the morning of the world with us . . .
> I see a Homer and a Milton rise
> In all the pomp and majesty of song,
> Which gives immortal vigour to the deeds
> Atchiev'd by Heroes in the fields of fame.[11]

The combination of Homer and Milton served to conflate the ancient and the modern, the pagan and the sacred. But the idea that America was destined for not just epic fame but a distinctively modern epic fame had already been argued a year earlier at Yale's commencement exercises.

When John Trumbull gave his master's oration in 1770, he identified the pinnacle of British greatness not in the Hanoverian age of empire but in the career of Milton, who combined "the united charms of every Muse," "the greatest force of natural genius," "all the aids of art," and sources among "the inspired writers"; *Paradise Lost* was thus "almost as much superior to Homer's [*Iliad*], in sublimity of conception, as it is in the greatness of its subject."[12] As America inherits Milton's mantle in Trumbull's version of the *translatio*, it must find a new, modern poetry to challenge the reigning English champion. Trumbull offers four possible scenarios for the great American poem: first, the Harrowing of Hell trumps Milton's *Paradise Lost* by portraying Christ himself as the freedom fighter, following Milton's strategy of choosing a biblical moment nearly devoid of description or narrative; second is an inversion of *Paradise Lost* by portraying in full the cataclysmic end of history; third involves a poem on heaven itself, which takes Milton

head-on in seeking to surpass the heaven scenes in *Paradise Lost*; lastly, a more didactic piece, drawn from the classical store of "Nature's themes," might be more realistic than vying with Milton. In this last mode, a poet can settle for "shin[ing] with" the greatest eighteenth-century poets, in the vein of the *Essay on Man, The Seasons,* or *Night-Thoughts.* Rather than rising as a Homer *and* a Milton, Trumbull's American poet lives in a distinctly post-Miltonic literary world in which Homer has already been supplanted; the prestige of the original is no longer available to the American bard, but by a careful choice of subject the new poet might trump origins with endings—or else merely reach the top shelf of English letters.

If the rhetoric of commencement *translatio* narratives hailed the potential for Americans to repeat the feats of Homer and Milton, however, the actual intentions of Americans like Dwight who undertook epic poems did not necessarily share the same terms as their encouragers. George Sensabaugh describes Dwight as "fired with a sense of mission to advance the fine arts in the New World by writing a great poem," supporting his statement with a footnote citing Dwight's preface as his "statement of his ambition."[13] However, even in the initial printed proposal for subscription in 1775, Dwight admitted that most readers "will perceive that this [poem] is an attempt at Epic Poetry" and hoped that *Conquest,* "if not precluded by deficiency of merit, will be properly denominated an *Epic,* or *Heroic Poem.*"[14] In the preface to the published work, Dwight characterizes his accomplishment as having "thrown in his mite, for the advancement of the refined arts, on this side of the Atlantic."[15] Dwight is a participant in a "long American tradition . . . of trying to elevate the entire cultural enterprise, rather than a single individual, to heroic stature," a tradition John P. McWilliams, Jr., traces back to Cotton Mather's *Magnalia Christi Americana.*[16] John C. Shields has criticized McWilliams on this point for his "failure to examine the potential for viewing all efforts to compose the so-called 'great American Revolutionary era epic' collectively as a single American epic writ large,"[17] and in fact such seems to be Dwight's own view. Dwight goes further than either McWilliams or Shields: he refers to his own work as a "mite," however ironically, to depict the development of art and literature in the United States as a collective, democratic process rather than a tribute to the preeminence of a few Homers and Da Vincis. *Conquest* exists in American letters not as a monument for the ages but as a preface, a provisional work, an early brick in the edifice of the nation's "refined arts."

Dwight had in fact begun his poem without intending to write an epic. Though he began contemplating his epic project by 1771, that same year he wrote an initially

unrelated poem and shared it in manuscript with several of his friends at Yale.[18]
That manuscript, which no longer survives, served as a source for several subse-
quent poems, including *America*, a pamphlet poem signed in 1780 by "*a* Gentle-
man *educated at Yale-College.*"[19] Using the form of a commencement poem (rein-
forced by the collegiate connection in the signature), Dwight presents a history of
the colonies, culminating in the future glory of America as that of a larger, more
enlightened, richer, and more peaceful British empire:

> Hail Land of light and joy! Thy power shall grow
> Far as the seas, which round thy regions flow;
>
>
>
> No more shall War her fearful horrors sound.[20]

This last line signals a transition from America the end of the *translatio* narra-
tive to America the beginning of the millennium: "Then, then an heavenly king-
dom shall descend, / And Light and Glory through the world extend." More so
than any of the other *translatio* poems, *America* portrays the course of empire as
a horizontal counterpart to the vertical typology of America (or New England)
as the new Canaan. *America* grew out of a culture of collegiate verse emphasizing
the local, the occasional, and the topical within frameworks of universalized
topics such as empire and prosperity. It also became the core of *Conquest*'s vision
of futurity in Book X, a testimony to Dwight's effort to make the visionary pros-
pect central to the message of his Joshua narrative. Dwight's hesitancy to make
large claims for his text in its preface should be considered along with its compo-
sitional history; *Conquest*, both as a poem and as a literary event, is much more
about the future than its own present. Perhaps one of the reasons why so many
readers past and present have read Washington into Dwight's Joshua is because
the Israelite is a forward-oriented figure, looking ahead not only to the settle-
ment of the nation of Israel but also to the new Canaan of Dwight's America.[21]
This proleptic motive is likely in light of both the relationship between *America*
and *Conquest* and Dwight's influence on Joel Barlow's own ideas about epic.

Barlow's own epic ambitions grew out of the warm reception that greeted his
1778 commencement poem at Yale, "The Prospect of Peace." The poem proved to
be so popular that he gave another, very similar poem at the 1781 Yale commence-
ment, and both versions would appear as most of Barlow's contribution to Elihu
Hubbard Smith's influential anthology, *American Poems* (1793). By 1779, Barlow
had begun work on *The Vision of Columbus*, a poem that used the Miltonic vi-
sion of futurity as its central narrative frame. While Dwight's prospect poem

"America" had served as the core of his epic, Barlow's "Prospect of Peace" be-
came (at least formally) the entirety of the *Vision*—*Paradise Lost* XI–XII as an
epic unto themselves. However, this is not to say that Columbus's "vision" is only
one of futurity; he first sees the North and South American continents as sheer
geography, noting particularly the many rivers and mountain ranges (given in a
descriptive catalog in the poem), and begins his narrative vision in his own past
with the rise of the Incas. As Dwight had used Christian typology to move away
from the classical *translatio* narrative and the implied circularity of history, Bar-
low revises the *translatio* along geographical lines, moving from Incan South
America to British North America as a kind of *translatio republicae*. Barlow's
view of America is a hemispheric one, but the hemisphere serves rather as a way
to elide the violence against North American nations perpetrated by the "en-
lightened" colonists that Barlow celebrates in his work.[22] Barlow's epic does not
portray natives as new Latians, precisely because a repetition of the *Aeneid* nar-
rative would cast America as a conquering heir to the *translatio empirii* tradition
rather than sharing in the republican justice of the Incans. In fact, the millennial
prospect that appears at the end of Barlow's *Vision*, for all its debt to Dwight, is in
some sense a return to the golden age of the Incas, the great self-made American
culture. Commencement poetry was always about anchoring the past in the fu-
ture, and this dual-narrative momentum would continue to define American en-
gagements with epic from Thoreau's *Walden* to Melville's *Clarel*.

 Outside of collegiate circles, prospects often served similar roles in generating
and justifying epic poems. Sarah Wentworth Morton's *Beacon Hill*, the first
installment of a projected serial epic (discussed later in this chapter), began as a
prospect in a Boston newspaper. Richard Snowden, a Quaker schoolteacher in
New Jersey, wrote an epyllion on the Revolution that concluded with a vision of
futurity, but what he found was not a great future but his own reluctance in the
face of such sublimity:

> Then will Columbia o'er Europa shine,
> And the grand landscape swell in ev'ry line!
> E'en now I see the glowing picture rise,
> While distant nations hail our western skies!
> Yet as I sing, how great the task appears!
> Warn'd by the muse, I yield to prudent fears.[23]

The problem, according to Snowden, is not that America has not made room for
its Milton to step forward, but that the very roominess of America has rendered

the author insignificant against the vast landscape, like a wanderer in a Thomas Cole painting. In fact, Snowden admitted in the course of his poem that the American experience needed something besides epic to celebrate it—because the core of that experience for him, as for many American epicists, was mourning. And this would place the entire tradition of American epic in jeopardy.

The End of Epic: The Politics of Mourning

One key reason why lament was such a threat to American epic was because of its politics; the poems discussed in this chapter were largely written in a political climate in which lamenting wrongly or too much could be seen as an act of Toryism. Barlow seemed sensitive to this reality in his repeated cutting short of Columbus's often extravagant weeping, as when he witnesses the destruction of the Incas at the hands of the Spanish. And yet Barlow's continual choice to portray Columbus as both a great scientific mind and weeping visionary suggests the centrality of tears to American epic writing. Only once the tears dry can the male ideal of glory and fame be realized in epic narrative, as Sheila Murnaghan has argued; if the tears do not stop, male glory threatens to transform into female lament. Women such as Phillis Wheatley were well aware of this potentiality and exploited it to remake the epic to tell their stories; for many American men who had firsthand experience with the Revolutionary War, such rejection of epic as a celebration of masculinity would have been seen as unpatriotic—but in many of their epic poems, the mourning never seems to end, leaving the works feeling vulnerable, broken, even self-defeating at times. This breakdown of epic heroism is one of the most surprising and influential developments in American literature, one that would culminate in characters such as Longfellow's Evangeline and Hiawatha and Melville's Ahab and Starbuck.

Perhaps the most insistently elegiac American epic is Richard Snowden's little-known *Columbiad* (1795). At the level of narrative, what Snowden mourns is a hero. The first scene introduces Washington's "first glories," as he rallies the British forces after Braddock's defeat at Monongahela as "his country's champion in fair freedom's cause" (1–2), implying that he already fights as an American, even while serving Britain. Almost immediately upon his victory, Washington enters his first retirement as the American Cincinnatus, relinquishing his command for a farming life. Washington represents the ideal American farmer, living in a world of leisure and domesticity, with eyes and hands only for peace and cultivation. It may be that Snowden, who signed another work as the "New

Jersey farmer," conflates Washington with himself in this passage, seeking to place America in the peace of agricultural life rather than in the "dreadful" ferocity of military prowess.

McWilliams has pointed out that the *Columbiad* does not have a central organizing figure.[24] This is because once the war with Britain begins, Washington no longer is the Cincinnatus that Snowden wants him to be; he has left retirement to return to battle. In the Washington-shaped vacuum of the poem, many men on both sides of the war earn glory in battle, often in events unrelated to Washington's direct efforts. Majors and captains feature prominently at times in the *Columbiad*, while the epic catalog consists not of warriors but of members of the Continental Congress. Snowden's epic is a democratic one, a poem that honors a collective effort rather than focusing exclusively on Washington or a few of his compatriots. And so, when Washington returns as a conquering hero at the end of the poem, the effect is jarring. After the British surrender, the wings of peace spread across the nation, and Washington is depicted as sailing the "bark of freedom" safely into port. In one of the strangest moments in the text, Washington is immediately compared to a "rock deep rooted on the shore," which serves both as a metaphoric parallel and as a deadly foe to the firm-handed helmsman—as if Washington were his own worst enemy (45). The logic of the shift in metaphors lies in the narrative's move from the war to the establishment of the Constitution, over which "great *Washington* presides" as the helmsman; soon after, he must put down riots and dissensions as president of the new nation, a "rock deep rooted." However, this shift raises one of the fundamental questions of the 1790s: whether a revolutionary movement could successfully transition into an established form of government. The process of history that brings about Shays' Rebellion, the tensions of the ratification debates, and the emergence of party politics in the new government already calls into question the values of revolutionary freedom that the war supposedly brought about.

Snowden never expected his poem to be a success. In his preface, he says that he wrote it as an "epitome" to spur "some one more favoured of the Muses" to outdo his effort (iii–iv). The poet's impulse is to "resign, / To bards more favour'd of the muse divine" (46), but before he names his preferred heir, he looks back to Philip Sidney as his ideal, who "sung the fam'd Arcadian plains; / In verse like his, how would Columbia shine— / What glowing thoughts appear in every line" (46). Snowden wishes to transform Columbia into Arcadia, a topography outside of time, where the "rock deep rooted" will not be challenged or disrupted by the changes of history. The soothing dream of Sidney's utopian poetry, which

would "in sweet numbers grateful to the ear, / Sing the gay charms of each revolving year" and "the rising glories of our new-born day" (45), can only come about where each year and each day are the same. The regular measure of neoclassical verse can no longer contain history after the Revolutionary War. The war had changed Snowden's world so profoundly that he found himself unable to fit American history to existing forms—not so much from a lack of poetic skill as from a lack of new paradigms with which to see the new vistas of postrevolutionary America. At the end of the poem, Snowden expresses a wish that "Some future *Humphreys* . . . Shall soothe the soul amidst the pangs of death" (46). David Humphreys, an officer in the Continental Army and a Connecticut Wit, was considered by 1795 one of the most talented poets living in America, and Snowden considered Humphreys to possess the literary and military authority to produce a better *Columbiad*—but Humphreys's fame was as an elegist.

His choice of poet reemphasizes Snowden's conflicted attitude toward the war, loathing the violence while celebrating the heroism of America's military. Snowden and his family were Quakers who emigrated from Yorkshire in the 1760s and found themselves caught up in the political unrest of the 1770s. Snowden's father assisted in drafting reports against the revolutionaries to send to the London authorities and was imprisoned without a trial for seventeen months after the reports were intercepted; by the time Leonard was freed, he had gone insane, and he died a few years later.[25] According to one source, all of the Snowden brothers were arrested for Loyalist sympathies during the Revolution, while another source states that Richard was never arrested but had undergone a military search of his personal papers for seditious writings.[26] In another work, Snowden relates witnessing house-to-house guerilla warfare among erstwhile neighbors in western New Jersey.[27] In any case, the Revolution for Richard Snowden had meant threats of violence against himself and his family, both for his religion and for his politics. While celebrating the war may have violated Snowden's Quaker principles, celebrating the politics would have meant denying his family's traumatic experiences as neutrals and Loyalists, as well as his own ambivalence over the mission of the United States.

Snowden's text is one of the weirdest early American epics, but his fixation on lament does not make him an outlier; mourning haunts even the most famous of early epics. Laments for fallen loved ones fill the pages of Dwight's *Conquest*, whose source, Joshua, is notably hardened toward the realities of scorched-earth warfare. Dwight, though he supported the Americans, lost his supportive father, who was driven from his home in Northampton for his Loyalism and died in

1777 during the Lyman venture, an attempt by a group of displaced Loyalists to immigrate to western Florida; it is difficult not to see the son's grief for his lost father in the many laments of *Conquest*.[28] The poem's grief reaches its climax as Joshua, hearing his daughter's cries for her dead betrothed, demands why God has led him and Israel to this state, and he declares that he wishes for a quiet life in obscurity instead—the idyllic Northampton life before the Revolution, as it were. The angel of the Lord suddenly appears and tells Joshua, "O Chief of Israel! let no rebel thought / Accuse the wonders, God's right hand hath wrought." Having banished the lament as a traitorous intrusion rather than as the leitmotif it is, the angel then shows Joshua the vision of futurity reworked from the "America" poem. Joshua's vision of Israel's triumph and the rise of new Canaan in the New World serves as Dwight's theodicy, but even on the poem's last page, Israel's warriors weep for their fallen countrymen.[29] In a poem called *The Conquest of Canäan*, the true center of the work, its point of compositional origin and rhetorical conclusion, is the prospect of a world without war, yet its surroundings are little but war and its effects. Dwight refused to rebel openly from the cause of the war, either Joshua's or his own, but the loss his family suffered clearly weighed heavily on him.

Phillis Wheatley more openly turned mourning into rebellion in her epyllion "Niobe in Her Distress," an imitation of Ovid's account of a queen who loses her children to divine retribution after boasting of her motherhood. One of the most important interventions that Wheatley makes into Ovid's text is where she chooses to begin and end. She ignores the original bridge narrative between Arachne's punishment for outdoing Athena and Niobe's challenge to the gods, thus downplaying the moral point of the original story; she also leaves out the closing account of Niobe's metamorphosis into a weeping statue, leaving her instead as a grieving, flesh-and-blood mother. The message of the story, both in Ovid and in his several English translations, is that Niobe oversteps her bounds and is justly punished for it. However, Wheatley declares that she intends to use "lofty strains" to represent not a proud upstart but a "queen, all beautiful in woe" (101). This is the epic of Penelope, of Dido, of Eve, the forlorn woman whose greatness has been overshadowed by the masculine tendencies of epic narrative.

If Wheatley personally identifies with Niobe the stricken mother, she identifies at least as strongly with the weakest of the children, as he faces Apollo, the god of poetry and the agent of vengeance in the story. The prayer of the youngest son for mercy is heard by the god, but too late, as the arrow has already been released when Apollo relents. This futilely answered prayer of "*Ilioneus*, the last,"

echoes Wheatley's plea in her invocation: "Muse! lend thy aid, nor let me sue in vain, / Tho' last and meanest of the rhyming train!" (109, 101). While inspiration denied might not have as dire consequences as delayed clemency, Wheatley highlights her awareness of her own vulnerability as a writer in a subordinate social position, and she plays on her youth to make plain the potential cruelty of judgment by those with power over her. Her emphasis on the suffering of Niobe as a mother further humanizes her story, which closes with Niobe as both spectacle and spectator: "In her embrace she sees her daughter die" (112). The act of seeing the daughter's death is not in Ovid's account, nor in any of Wheatley's visual sources for her poem (which will be discussed at length in the next section). This is the last line of Wheatley's poem, and the word "sees" leaves the reader with a mother at the moment of witnessing the destruction of her children. A conclusion is added to the poem, though a note indicates that it is not by Wheatley; the unidentified poet goes on to narrate Niobe's transformation into a statue. While Wheatley may not have had much choice in including the added ending, the editorial choice to include it testifies to uneasiness at Wheatley's refusal to acknowledge the story's original moral. A mother's grief and the cruelty of the gods are the takeaways in her version, not messages about excessive pride. A poet best known in her lifetime through her elegies, Wheatley made the epic depiction of mourning a site of bitter moral struggle.

A different kind of moral struggle appeared in the writing of Thomas Branagan, an Irish American slaver-turned-abolitionist who published two epic poems about the evils of slavery. These poems were a weird blend of epic, tragedy, reportage, and a constellation of other genres Branagan saw fit to incorporate. His first poem, *Avenia* (1805), was subtitled "a tragical poem, written in imitation of Homer's Iliad," and the revised version of *The Penitential Tyrant* (1807) he called "a pathetic poem."[30] Branagan asserted in his preface to *Avenia* that he was writing an exposé of the evils of the slave trade, based on his firsthand witnessing of, and participation in, those atrocities. At several points in both poems, Branagan's own tears are offered as both expiation for his sins and a modeled response to the horrors of slavery, as he reimagines the horrors he helped to perpetrate:

> The poor unhappy slaves rose to my view,
> My former guilt, their wounds now bled anew;
> I heard their sighs, and saw their big round tears,
> Wept as they wept, and fear'd with all their fears[.][31]

Not all of Branagan's own tears are for slaves, however. After *Avenia*'s hero, the African prince Louverture, dies in a single combat with a slave trader, he ascends into heaven, where amid the nameless crowd of the blessed, one named member of the "vast concourse" brings private grief suddenly to the fore. Just before Louverture receives his saintly uniform and joins the multinational chorus, the narrator mentions that "[h]ere little BENJAMIN with rapture sings / Melodious anthems to the King of kings."[32] In a rare footnote, Branagan identifies this Benjamin as "[t]he author's infant son, who departed this life, the 22d of September, 1802, aged 21 months." This eruption of specificity, the shocking detail of personal loss in the midst of a Homeric epic, changes the nature of mourning from a collective, public experience to a deeply individual one. The author unexpectedly breaks into his own epic, not because convention allows it but because his loss of his son emerges at the moment of greatest mingled grief and relief in the text: Louverture's anticipated death has finally occurred, and the plot has nowhere to go now but down to its necessarily tragic conclusion.

While Timothy Dwight had struggled to contain his mourning, Branagan gives up the fight long before the end of either of his poems. While the opening couplet of *Avenia* had firmly placed the poem within the framework of epic narrative ("Awake my muse, the sweet Columbian strain, / Depict the wars on Afric's crimson plain" [*Avenia*, 15]), as the poem continues, the mournful tone takes over from the narrative drive of the African war. The opening of Book V connects the continuance of slavers' atrocities with the redefinition of Branagan's poetic identity: "Ah! melancholy muse, strike ev'ry string, / And teach your bard, your plaintive bard, to sing" (*Avenia*, 255). The epic bard has become an elegiac one, and part of the politics behind this change is a distancing of *Avenia* from the tradition it initially claimed for itself:

> No mortal eloquence can paint their [the slaves'] woes,
> Depict their wrongs, and malice of their foes:
> Not MILTON's pen, nor SHAKSPEARE's tragic lyre,
> Not HOMER's flame, nor POPE's poetic fire. (*Avenia*, 256)

Branagan had rejected classical languages in abolitionist writing before,[33] but he now rejects the English canon (including Homer via Pope) as a source for the discourse of abolitionism. The authors that he names are the apex of "mortal eloquence," but the Methodist Branagan argues that something more (that is, immortal help) is needed to describe the slave's experience, but also something less: the dark eloquence of silence.

Just before a scene in which Avenia is raped by her white master, a violation that drives the heroine to suicide, the poem almost shuts down, as several of its extreme moments converge in a single reflection: "Here cease my muse, nor further paint their woe, / Too horrid for the sons of men to know" (*Avenia*, 258). The scene is in fact so horrible, that Branagan must shut it down again a page later: "The violated maid now swoons with pain, / Here cease, my muse, the sad Columbian strain" (*Avenia*, 259).

Avenia herself is someone not to praise but to lament, as she does almost nothing but suffer and give voice (often plagiaristically so) to that suffering. When she is first abducted from Africa on her wedding day, most of her lament is an extended (and uncredited) quotation of the "eternal sunshine of the spotless mind" passage from Pope's "Eloisa to Abelard," interrupting the epic with a recognized elegy that serves to translate the suffering of blacks into white terms, as well as to question the notion of property as espoused both by the slave trade and by the literary trade. As will be shown in the next section, Branagan's cavalier attitude toward the use of others' texts leads him to push the imitative practices of the epic tradition to extremes. But the extreme sexual and physical violence with which Branagan at times aims to wound his readers gives a sharp edge to the politics of mourning: in moving his readers to tears and horror through his descriptions, Branagan hopes to win popular support for the abolition of slavery.

The spectacle of suffering is a trap, however; the sentimental pleasure of crying over the sufferings of slaves might end up as just that, an entertaining read that leads to no decisive action against slavery. Branagan himself seems to recognize this trap, and in *The Penitential Tyrant*, he applies to himself an extended simile from *Odyssey* VIII that describes a wife's frantic grief at seeing her husband die on the battlefield, feminizing himself as he mourns his own ineffectuality: "For them in vain I grieve, for them I sigh, / Yet still they [the slaves] groan, weep, languish, bleed, and die" (*Tyrant*, 60). While tears are the appropriate response to the plight of slaves, the calls to action that Branagan meant *Avenia* and *Tyrant* to be are derailed by his own admission that mourning, as W. H. Auden said of poetry, makes nothing happen. It would seem that more than mourning is necessary to make epic a viable form for abolitionist propaganda, and the range of genres on which Branagan draws moved his works farther away from the classical models he claimed to imitate and closer to a mode of encyclopedic literature of the kind Edward Mendelson has theorized: a narrative superstructure for the appropriation of whatever genres might give meaning to the multifarious world of the author.

Epic Fragments: New Intertextualities for an Ancient Tradition

Branagan was one of several early American epicists who experimented with new blends of intergenres, appendices, and recast conventions to exploit the rich intertextual range of epic writing, often from a starting point that paid homage to a conservative idea of a Homeric canon. Branagan was an inveterate anti-classicist, but even as he condemned classical languages and forms as elitist, he nevertheless chose to imitate the most prestigious of all classical texts in conveying the reality of the slave trade. He seeks to resolve this contradiction by warning his readers that such imitation is not to make his writing more pleasing: "Perspicuity instead of elegance, utility instead of method, the developement of truth instead of the flowers of rhetoric, have been my primary objects" (*Avenia*, ix). This stance is a badge of authenticity for Branagan, who often seems to equate elegant writing with artifice, but he nevertheless shows that he has paid close attention to his sources in his continuing efforts to push past them to his own form of truth telling.

One of the most remarkable ways that the abolitionist conveys the horrors of the slave trade in *Avenia* is in his careful following of epic conventions and set pieces, only to violate the expectations that those conventions evoke. Single combats abound between Africans and slavers, but they are nearly always decided by covert shots from outside the duel (by slavers, of course). When the hero Louverture's aged father reenacts Priam's visit to Achilles, the slavers' leader insults and summarily beheads his supplicant. The epic games, which the Africans hold in honor of Avenia's wedding, are violently interrupted by a raid of slavers on their village. A particularly striking example of this weird imitation appears as Louverture wounds an opponent, Willmore, who pleads for his life as the African prepares his death blow. Despite the numbers of friends and relatives of Louverture's who have fallen at Willmore's hand, the African warrior "hear[s] with philanthropic woe" and prepares to relent against his severely wounded enemy. Just at the point of decision, however, Louverture spots a "glittering belt" that Willmore had despoiled from the African warrior's youngest brother, Lango, after slaying him on the field. Enraged, Louverture spits out a final curse before dispatching his opponent:

> "Thou wretch accurs'd, canst thou to grace pretend,
> Clad in my brother's spoils, my murder'd friend?
>

Go then, a victim to his [the king's] son below,
'Tis LANGO, LANGO, gives the fatal blow.
Thus is my sire atton'd;" (the hero said)
And bury'd in his breast the reeking blade.
A groan that moment echo'd to the shore,
Another follow'd, and he groan'd no more;
The soul rush'd furious through the gaping wound,
The body beat, the fingers grasp'd the ground. (*Avenia*, 112)

I quote this passage at length to emphasize its likeness to the close of Dryden's translation of Virgil's *Aeneid*: Turnus's "Golden belt that glitter'd on his side," the repetition of the avenged Pallas's name, the cry "dost Thou to Grace pretend," and the final "the disdainful Soul came rushing thro' the Wound."[34] The close similarities serve to accentuate the striking reversal of roles in *Avenia*: the pious conqueror of Virgil's poem becomes the defender of the ancient homeland, so that empire and native switch places, and Turnus is now an invader as well as a pillager in a moment of classical epic gone horribly wrong—or at least played out to the postcolonial conclusion of its narrative logic. Such violations of Homeric and Virgilian narrative form exemplify the ideological payoff of Branagan's formal choice of ancient epic for the telling of modern, topical crimes: the revered form does not work, because slave traders refuse to play by even literary rules.

While such bizarre imitations threaten to undo epic form in Branagan's works, his willingness to appropriate and blend other genres amounted to an experimental redefinition of the form itself. His borrowing of Pope's "Eloisa to Abelard" has been noted in the previous section; Branagan also included Pope's "Messiah Eclogue" in the appendix to the 1810 revision of *Avenia* as a justification for his own commitment to imitation. Other intertexts point to a different source tradition, however. The title page of the 1807 *Tyrant* includes a couplet from the poem: "*Bold in the Lord, I know his grace is free— / Free for the vile, or it had pass'd by* me!!" This John Newton–esque effusion, by emphasizing the "me," individualizes Branagan more than Newton's "wretch" in "Amazing Grace," shifting from the archetypal "chief of sinners" everyman to the particular, identified confessant whose story is as much about himself as it is the "free grace" that saved him. And in the final book of the 1805 *Avenia*, which would also become the final book of the 1807 *Tyrant*, Branagan repudiates epic in favor of the didactic and hymnic:

No more of wars, of carnage, or of arms;
No more of virtue's worth or beauties charms;
No more I paint the flocks, the injur'd swain,
The beauties of the land, or terrors of the main;
But sing the mercies of the pow'rs above,
The tyrant's rage contrast with heav'nly love.
Celestial muse my ventrous flight sustain,
My plaintive muse, the sweet Columbian strain[.] (*Avenia*, 273)

Though the "ventrous flight" has Miltonic tones to it, this flight comes not from the bard but from the tradition of English hymnody associated with Isaac Watts and Charles Wesley. By contrasting "heav'nly love" with the "tyrant's *rage*," Branagan seeks to out-epic the epic, replacing the heathen virtues of classical epic with those of Christian morality. Returning to the rationale for his anti-eloquence, Branagan defends the inclusion of Book VI in a note: "I expect to be severely censured by the critics, for adding this book to the poem, as it should conclude with the death of AVENIA. But they must still remember, that as my object is the good, not the praise of man, I study utility more than method" (*Avenia*, 343). Here Branagan goes so far as to cordon off the rules of composition as strictly the realm of the epideictic; any more useful or beneficent purpose in writing must use a different set of rules.

If *Avenia* tested the limits of classical epic expression, *Tyrant* participated in the reconceptualization of epic as a psychological form in the early nineteenth century and applied it to new ways of forwarding the abolitionist, as well as the evangelical cause. This is evident in Canto III of *Tyrant*, where Branagan relates a nightmare that drove him to repentance: "One night, methought about the midnight hour, / A double darkness o'er me seem'd to lower" (*Tyrant*, 71). The phantasmagoria of the slaves' sufferings, as blood, sweat, and tears flow in torrents, eventually gives way to a vision of the torment in hell that awaits the perpetrators of those sufferings. The violence of Branagan's dream, the putative impetus for the poet's redemption, is projected as wounding the reader as well as the poet at the start of the third canto:

And now methinks, I hear the reader say,
"Your verses makes me tremble, make me pray;["]

.

And as the trembling child who long has laid
Mute in the dark, and of itself afraid;

When haply conscious of the pain it feels
The watchful mother to its pillow steals,
Springs to her breast, and shakes off all alarms,
Feeling its safety in her fostering arms:
With such quick joy, thus to your Saviour fly,
He stands with open arms, his grace is nigh. (*Tyrant*, 87)

Here the infantilized reader turns from phantasmagoria to salvation in what is one of Branagan's most eloquent passages. The repudiation of epic in *Avenia*'s Book VI here becomes a new kind of epic.

For *Tyrant* itself is a new kind of epic, drawing much more selectively on Homer and Milton to shape a poetics at once immense in scale and intensely personal in focus; the inner drama of gazing, realizing guilt, and repenting anticipates Jones Very's declaration (discussed in chap. 4) that epic had become a form of internal tragedy with Milton's *Paradise Lost*. Branagan's choice of "tragical" as a descriptor in the subtitle to *Avenia* and "pathetic" in the subtitle of the 1807 *Tyrant* evidences the shift that European romantics such as Schiller were positing at the time, and that Americans like Very would later reiterate. Branagan thus stands as a bridge figure between the advocates of classical emulation and imitation of Pope's time and the proponents of individualized poetic drama of Shelley and Byron's generation. And among American epicists, Branagan is not alone in that distinction.

Branagan's poetry sought to relocate the narrative force of epic in the individual soul rather than the public action, and a related development in American epic was the revival of *ekphrasis* as a way to blend visual and verbal effects in epic poetry. This revival was begun by Phillis Wheatley. The interplay between writing and painting had been a favorite topic in Renaissance poetry and would inform the work of many later epicists, from Cooper to Melville and Cole, but Wheatley's "Niobe" was the first serious revision of classical *ekphrasis* in American literature. John C. Shields has painstakingly traced the history of Richard Wilson's painting *The Death of the Children of Niobe* and its prints to determine how Wheatley would have had access to the work, but no critic has ever explored in much depth the significance of the full title Wheatley gives her poem: "Niobe in Distress for her Children slain by Apollo, from *Ovid*'s Metamorphoses, Book VI. and from a view of the Painting of Mr. *Richard Wilson*." Wheatley's inclusion of Wilson's interpretation of Ovid in the poem's title signals that she is taking on

a new kind of poetic project, one that bridges artistic media, as well as revising the old narratives on which epic storytelling is based.

Wheatley is unusually attentive to Apollo's place in the story, placing the blame for Niobe's "woes" solely on his shoulders in the invocation (she bids the muse to sing "Apollo's wrath" in the first line), and this is in part because of her interest in the Wilson picture. Wheatley describes her muse as

> Thou who did'st first th' ideal pencil give,
> And taught'st the painter in his works to live,
> Inspire with glowing energy of thought,
> What *Wilson* painted, and what *Ovid* wrote. (101)

The muse invoked here is one of the pencil, not the pen; Wheatley desires a visual muse for her poem and places Wilson before Ovid in the first of several moments where *ekphrasis* works backward in "Niobe." Wheatley asks the muse to "guide my pen in lofty strains to *show* [emphasis mine]" (101), keeping her identity as a writer but now attempting a different action in her wielding of the writer's instrument; she seeks to make the pen a pencil, to draw with words.

Wilson's *Niobe* features largest at the moment when Apollo and Diana attack Niobe's children. As Shields has pointed out, the pose that Apollo takes in preparation for his attack is not in the *Metamorphoses*, but in multiple versions of Wilson's picture (he painted *Niobe* three times): "With clouds incompass'd glorious *Phoebus* stands; / The feather'd vengeance quiv'ring in his hands." The sublimity of the thunderstorm in Wilson's painting was the kind of feature that helped to make landscape a prestigious form in British art, and that gained Wilson a following among both elite and bourgeois audiences. *Niobe* sold extremely well as a print in the 1760s, and it is likely that Wheatley knew Wilson's picture through William Woollett's engraving. The mythological content within the landscape was a major part of the appeal as well, and the thunderstorm provided a kind of stage for Apollo, arrow drawn back in his bow. Yet Wheatley's punning description of the quivering arrow is a visual effect impossible to depict in a painted image. As Apollo prepares the destruction of Niobe's sons, Wheatley rewrites both Ovid and Wilson by outdoing them; by taking the visual aspect of her poem to levels untried by Ovid and unavailable to Wilson, she further highlights the sublime (and terrible) power of Apollo the vengeful god.

Given Wheatley's intense interest in visuality, her famous frontispiece portrait can be a fruitful site for understanding how she understood herself as a

laboring writer. In her invocation in "Goliath of Gath," while it is up to the powers and muses to "remember" and "sing" the story, Wheatley "write[s]" them. Here a new verb enters the Virgilian *cano* formula; while Ovid chooses to tell rather than sing, Wheatley displaces the singing by pointing to the physical labor that she as a poet does, the labor signified in her portrait (fig. 2). Wheatley in this image works in two worlds simultaneously: the world of the mind or spirit, as she

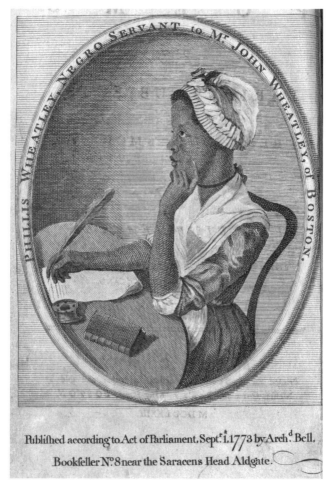

Figure 2. [attr. Scipio Moorhead], Portrait of Phillis Wheatley, frontispiece to *Poems on Various Subjects, Moral and Religious* (London, 1773).

Library Company of Philadelphia.

looks above for inspiration, and the world of textual materiality, where her quill touches the written-on page. Significantly, Wheatley's blank page is not blank; her right hand rests the quill at the top of several lines, suggesting that inspiration in this scene is not a matter of spontaneous composition but of considered revision—or even interpolation, a form of copying between the master's lines that Frederick Douglass describes as his route to literacy. By choosing to write rather than sing, and thus to willingly cede the most "original" action of composition, Wheatley actually creates space for herself to add and adapt her source, to *invent* in the older sense, and thus follow in the line of Pope's Homer, who has "the greatest Invention of any Writer whatever."[35]

The interplay between image and text, between imitation and invention, that pervades Wheatley's work has inspired some critics to claim that Wheatley's entire oeuvre constitutes an "intertextual epic," anchored by "To Maecenas" and her two epyllia, "Goliath" and "Niobe."[36] While this intertextual epic may be more an articulation of a will-to-canonicity desired for her by her champions, it suggests that conceiving of the epic in pieces may be a particularly useful entry into the tradition for marginalized writers like Wheatley (as well as others like Branagan and Snowden). One writer, in fact, conceived of an epic specifically as a loosely arrayed sequence of episodes and as such may be called the first writer of intentionally intertextual epic in American literature: Wheatley's fellow Bostonian, Sarah Wentworth Morton.

Morton's approach to epic convention was every bit as radical as Wheatley's. At the start of *Beacon Hill*, "Book I" of her projected intertextual epic, an invocation to Clio, the muse of history, prepares Morton's speaker to reject the entire epic tradition on grounds of historical inaccuracy while acknowledging the power of the versification associated with the form:

No more the *fabled action* claims our care,
The tales of *Ilion*, and the *Latian* war,
The length of realms by pious *Godfrey* trod,
To free the city of the Saviour-God,
For those their poets wrought the crown of fame,
And all was fiction, save an empty name;
Though the full blaze of epic numbers shed
Its dazzling luster round the storied dead,
From the bright Muse the peerless wonder grew,
Invention reign'd, while blushing *Truth* withdrew.[37]

The modern solution to the problem of rendering contemporary events epic, according to Morton, is to frame the telling of those events as more virtuous than the *Iliad* because they are more truthful. The speaker takes on the epic canon of Homer, Virgil, and Tasso (though, significantly, not Milton) not as a new kind of bard but as a "minstrel," a term primarily associated in the eighteenth century with folk poetry. While minstrels occasionally appear in translations of epic—Pope's Apollo is referred to as a "minstrel-god" in *Iliad* XXIV, for example—the main source for Morton's use of the term is from Scottish poet James Beattie's poem *The Minstrel* (1771).

Beattie's poem portrays the development of a young poet in the Middle Ages from childhood to the maturity of "appearing in the world as a MINSTREL, . . . a character which, according to the notions of our forefathers, was not only respectable, but sacred."[38] Hugely popular from its first publication, *The Minstrel* has been seen by recent critics as the beginning of the romantic trend of poets using poetry to fashion their authorial selves, as in Wordsworth's *Prelude* and Byron's *Childe Harold's Pilgrimage*.[39] For Morton, Beattie's envisioning of the minstrel as a youthful ingénue but also a burgeoning genius served well as a model for deferring to the great bards of the past while in a sense growing out of them. *Beacon Hill* was Morton's most ambitious work of her career, and if, as she claims in the apology, she was "terrified at [her] own temerity" (*Beacon*, viii), the stance she develops from Beattie's Scottish Opposition poetics of self-creation represents a bold stroke—particularly since Morton's "minstrel" always genders herself as female, a reproach to the lying, male bards of antiquity.

In the preface to her poem, Morton assumes a female audience for her project, as she mentions that her plans beyond *Beacon Hill* include the histories of the Marquis de Lafayette, Lady Harriet Acland, Jane McCrea, and Charles Asgill, and that these episodes "will occasionally diversify the scene, and awaken, at least in the female breast, sympathy and condolence" (*Beacon*, ix). The descriptions of these episodes as recounting "noble enthusiasm," "heroic and impassioned adventures," "tragic fate," and "pathetic perils" place Morton's work in the tradition of romance, both verse and prose, in which language designed to evoke sympathy predominates over the appeal to awe and admiration traditionally associated with epic poetry.

Beacon Hill itself began as a prospect poem[40] and was published in its final form in 1797 as "a local poem, historical and descriptive," with the phrase "Book I" appearing beneath the title. The title page thus enacts its own federal tension between part and whole—is *Beacon Hill* a whole "local poem," or merely a part of

something else as "Book I"? Morton addresses this difficulty in her "Apology for the Poem," which she begins by answering the charge that "twenty other names would equally apply" to the subject she takes up in the poem (*Beacon*, vii). The author at first acknowledges the arbitrariness of her choice and then retrenches by pointing to chronology as her justification: "[W]hen it is remembered, that the great events, which form the subject of the piece, originated within the view of this interesting eminence, the mind, by the natural association of ideas, will be easily led to contemplate every succeeding occurrence of the Revolution" (*Beacon*, vii). Viewing the entire Revolutionary War from a point in the city of Boston is allowed, in other words, because of the fact of the war's beginning at Beacon Hill, or rather Bunker Hill, where residents of Beacon Hill witnessed the battle.

Morton had no unifying title for her project, and likely not even so much a unified project as an accumulative series of associations built from the initial vantage point of Beacon Hill; she begins, rather than ends, with the prospect, placing the variety of view not in an imagined future but in the composition of episodes to "diversify the scene." *Beacon Hill* is thus not an installment but a fragment, composed within a planned network of fragments. Sandro Jung has recently shown that eighteenth-century British writers engaged intensively with the fragment well before the romantic era,[41] and contrary to traditional narratives of American cultural development, Morton and her print world show that there was virtually no lag in the importing of fragmentary literature or the more romantic ideas about what that mode involved. In the 1790 volume of the *Massachusetts Magazine* alone (where several of Morton's shorter poems appeared), at least six different poems and several prose pieces include the word "fragment" in the title. Morton was a writer of fragments in a textual world of fragments, and her choices as well as those of her compatriots demonstrate that Americans were not slow to embrace what we see as romantic modes, but were instead selective in importing elements of romanticism, a tendency that continued even among the transcendentalists, and certainly for writers like Whitman and Melville.

Morton never received enough public support to complete her episodic project, if she had ever intended to finish it at all, but the one later episode she did publish, the story of "Lady Harriot Ackland," emphasized both the fragmentation of Morton's long narrative poems and their intertextual connectedness; the poem appeared in 1799 under the title *The Virtues of Society*, signed by "The Author of the Virtues of Nature," which had been the subtitle of her first major narrative poem, *Ouâbi* (1790). The poem thus connected *Beacon Hill*, *The Virtues of Society*, and (retrospectively) *Ouâbi* together as a series of fragments, constituting

not a whole but a set of texts that mutually informed each other. No longer solici-
tous to earn the public's favor, she now seeks to present "a patient, persevering,
fortitude, which, in displaying the individual, ennobles the whole species";[42]
though taking the public pose of the republican authoress, withholding her own
name but upholding that of the first lady (the poem was dedicated to Abigail Ad-
ams), Morton takes a more Miltonic tack in *Virtues*, assuming less an identifica-
tion with a public sphere than with a "fit audience" of sympathetic reciprocity.

While *Virtues* works at one level as a diptych with the meditations on marital
constancy in *Ouâbi*, it is also clearly a continuation of *Beacon Hill*. The opening
lines renew the challenge at the beginning of *Beacon Hill*, while reintroducing
the same narrator:

> Let the proud Bard of ancient virtue tell,
> How *Arria* lived, and *Laodonia* fell;
>
>
>
> The humble minstrel will a tale impart,
> Drawn from the *living* efforts of the heart,
> Adventurous beauty, love's inspiring flame,
> Beyond the storied page of fabling fame. (*Virtues*, 5)

Here again the ancient chauvinistic "Bard" is set against the new "minstrel," and
extreme stories of women losing their lives out of devotion to their husbands
contrast with the "*living*" story of a woman who risked, but did not lose, her life,
and by so doing achieved her own conquest. The story of Lady Ackland is one of
female heroism, but without military glory: the young, talented wife of a British
officer penetrates enemy lines during the Revolution to reach her husband, whom
she has learned was wounded at Saratoga. Morton turns Ackland into a kind of
Odysseus seeking not a homeland but a wayward love; she even adds a detail of
Ackland being wounded by an American sentry while crossing a river to heighten
her heroism. When Lady Ackland reaches her husband, Morton uses an epic
simile to recreate a moment of rescue from the *Aeneid*:

> —Thus, when in war's red arms *Æneas* lay,
> And seem'd to breathe his heaving soul away,
> Before his view the sea-sprung *Venus* stood,
> And swathed with heavenly hand the clotted blood[.] (*Virtues*, 36)

Morton here gives her heroine divine status, and when Major Ackland promises to
retire from military life and follow his wife's desires, Lady Ackland accomplishes

what only goddesses seem to be able to do in epic. She makes the hero stop fighting. *Virtues* was Morton's last long poem, and it was also her final answer to the *Iliad*: the hero cannot survive without the love of his woman. The romance ultimately overcomes the epic, provisionally concluding a project that seemed to take on epic tradition only to take it in directions unthinkable to most writers and readers of the time.

Though readers likely found Morton's fragments confusing in the 1790s, many were accustomed to encountering epic poems in fragments, both in anthologies and in schoolchildren's textbooks. In fact, that was precisely the form in which Dwight's *Conquest* and Barlow's *Vision* first saw print, in Part 3 of Noah Webster's *Grammatical Institutes*, published in 1785. Webster, a Yale classmate of the Connecticut Wits, designed the third and last part of the *Institutes* as a reader to supplement his first textbook. In order to teach students reading—meaning public declamation—Webster excerpted passages of speeches from classical sources in translation, as well as selections from Pope, Milton, Shakespeare, Dwight, Barlow, and Trumbull, among others. Webster admitted in his preface to have "borrowed from British writers of eminence," "fugitive American publications," and "the manuscripts of my friends," as well as interspersing some of his own work. Webster saw epic as highly useful in a pedagogy focused on public speaking and civic education, and he wryly remarks in his preface that in choosing selections from works such as *Conquest* and *Vision*, he was "not . . . inattentive to the political interests of America."[43] Epic had been a crucial element of the Connecticut Wits' education, and that Webster would see the performed reading of epic poetry as part of a young American's primary education indicates how deeply connected elements of canonicity, nation-making, and pedagogy were at the time.

Webster's *Institutes* also highlighted how mutually indebted his circle of Yale alumni were to each other, as well as the wide range of intertexts that informed their work. The textbook's publisher was the firm Babcock and Barlow, a partnership that Joel Barlow had formed with a printer from central Massachusetts. The printing of Webster's work, as well as other volumes the partnership underwrote, was financed by subscriptions to their periodical, the *American Mercury*. Barlow edited the periodical and wrote political commentary for it, but the main reason for the high number of subscriptions was Barlow's decision to serialize the journal of James Cook's last voyage in the Pacific, a work under royal copyright in London and difficult for American readers to acquire without great expense. American readers' fascination with the Pacific, in other words, funded the first publication of Dwight's and Barlow's epic works, and indeed Barlow arranged

for his firm to print the first full edition of *The Conquest of Canäan*, also in 1785, though by the time the book appeared, Barlow had dissolved the partnership, and Babcock's name appeared as the sole printer. Epic existed in a sea of texts for eighteenth-century Americans, and the cross-influence of those texts was as potentially generative as it was unpredictable. No intertext, however, had as much influence on American epics as the Bible, and the final section of this chapter posits an alternative tradition of epic writing predicated on specific ways of reading the Bible's implications for poetics and politics.

Dissenting Epic: Clash of the Canons

One of the unexplored mysteries of early American epic poetry is the considerable resistance that authors of ostensibly epic poems mustered against the epic as a genre. Joel Barlow decried the influence of Homer in the preface to his *Columbiad* (1807); distinguishing between the "*poetical* object" and "the *moral* object" of a poem, Barlow asserts that the "high degree of interest" that the Trojan War gives the *Iliad* as its poetical object, for instance, gives the poet the responsibility to make the moral or "real design" of the poem "beneficial" to social improvement. However, Homer's poem tends "to inflame the minds of young readers with an enthusiastic ardor for military fame," and Virgil's *Aeneid* similarly is designed to "increase the veneration of the people for a master, whoever he might be, and to encourage like Homer the great system of military depredation."[44] For the moral needs of the modern era, something radically different was necessary. Barlow chose not to include the word "epic" on the title page of either *Vision* or the *Columbiad*. In fact, only one poem discussed in this chapter, which has never received modern critical treatment, includes "epic" in the title. This reticence to name the genre could be traced back to Milton, who subtitled *Paradise Lost* "A Poem," yet during Barlow's lifetime, Robert Southey, John Henry Pye, James Lovell Moore, Percy Bysshe Shelley, and Lord Byron were among the many British epicists who applied that subtitle to their own works. The resistance to epic convention and style was often most marked in poems on biblical subjects, and I would describe these works as defining a tradition of Dissenting epic.

To speak of Dissenting epic immediately conflates religious and literary categories. For readers of Milton, this merging may have seemed inevitable. The Puritan poet's striving to outdo the classical giants by writing into the white spaces of the Bible certainly invited the blending of faith and poetics. However, the Miltonic critique of aesthetic affect as idolatry came to be used by others to reject the

high poetics of *Paradise Lost* itself. In fact, the hallmarks of Dissenting epic—low-church religion matched by a stripped-down poetic style and, frequently, a devotional or polemical style rather than the high literary tone of *Paradise Lost*—trace their lineage to *Paradise Regained*, through a Quaker friend of Milton's. Thomas Ellwood was involved not only with the Foxes and the Penns but also with many Dissenters of other persuasions during the time of the Civil War. He famously became the blind Milton's reader in 1662, and according to Ellwood's own memoirs, Milton composed *Paradise Regained* after Ellwood had asked him, upon reading the manuscript of *Paradise Lost*, where the other half of the story was.[45] The plain style and focus on argumentation in *Paradise Regained* might indeed be a nod to Ellwood's plain style, an aesthetic shared both by early Quakers and by Cromwellian Puritans. However, even stripped-down Miltonic verse was too ornamental for Ellwood, who in 1712 published a sacred poem in three books titled *Davideis*, a life of King David versified from 1 Samuel. His goal was to exhort and to teach, not to gain critical attention; in his address "To the Reader," he states, "*I am not so* vain to seek *Applause: I don't expect to be commended. . . . I don't affect the* Title *of* Poet."[46]

While following David's life from his anointing by Samuel to his death and burial as king, Ellwood chose to intersperse his narrative with moral and political commentary rather than the literary devices exploited by Milton and his predecessor, Abraham Cowley, whose own *Davideis*, an incomplete epic in four of a projected twelve books, is often credited as the first biblical epic in English.[47] Cowley's work, published in 1656, predates both Milton's epics and Ellwood's, but the latter claimed not to have read the earlier *Davideis* until he had substantially completed his own poem, though he knew of it. Rather than express embarrassment or regret at this oversight, however, he confessed after having read it to being "*very well pleas'd, that I had not read it before: lest* [Cowley's] *great* Name, *high* Stile, *and lofty* Fancy *should have led me, though unawares, into an* apish Imitation *of them; which doubtless would have look'd very* odly, *and* ill *in me, how* admirable *soever in him*" (12). Rejecting the creative imitation that Milton so valued in what Harold Bloom has called his "misreading" of earlier writers, Ellwood prefers an originality produced out of ignorance, or at least a refusal to allow influence. The Quaker poet realized that literary influence could unintentionally distort or even supplant heavenly leanings. Part of this avoidance of influence also has to do with intended audience; in Ellwood's view, his ideal reader and Cowley's are so different that their poetic styles should never even mix: "*He wrote for the Learned; and those too of the Upper Form: and his Flights are*

*answerable. I write for common Readers: in a Stile familiar, and easie to be under-
stood by such.*" He also points out that Cowley's heavily annotated work required
such annotations, but that part of his own plain style necessitates a dearth of
citations (12).

Ellwood's plain style is an act of willful originality, despite his close adherence
to the biblical text. Reducing the number of layers of remove between his *Dav-
ideis* and its inspired source actually allows him to posit a new kind of narrative
poetry, emphasizing immediacy, accuracy, and right teaching over genius and
literary prowess. Such writing dissented not only from the trappings and politics
of the Anglican Church but from the traps and dangerous dances around heresy
exemplified in both the Puritan Milton and the Royalist Cowley, and this dissent
also entails a rejection of the classical canon in favor of more prosaic forms of
storytelling: "*I am not so wholly a* Stranger *to the* Writings *of the most* Celebrated
Poets, *as well* Antient *as* Modern, *as not to know, that the great* Embellishments
of their Poems *consist mostly in their* extravagant, *and almost boundless* Fancies;
Amazing, *and even* Dazeling Flights; Luxurious Inventions; Wild Hyperble's; Lofty
Language: *with an* Introduction *of* Angels, Spirits, Dæmons, *and their respective*
Deities, *&c. Which, as not suitable to my Purpose, I industriously abstain from*"
(12). By characterizing his abstention from literary "Embellishments" as industri-
ous, Ellwood anticipates critical objections to his much simpler poetics as a lazy
or dumbed-down form of writing. For Ellwood, telling the story of David in sim-
ple form requires as much work, and as much grace, as writing *Paradise Lost*. And
the power of this writing, he argues in his invocation (one of the very few epic
conventions to appear in this text), comes from a different kind of flight, aiming
higher than the muse, however heavenly, for inspiration:

> *I Sing the Life of David,* Israel's *King.*
> *Assist, thou sacred Pow'r, who did'st him bring*
> *From the Sheepfold, and set him on the Throne;*
> *Thee I invoke, on Thee Rely alone.*
> *Breath on my Muse; and fill her slender Quill*
> *With thy refreshing Dews from* Hermon-Hill:
> *That what she Sings may turn unto thy Praise,*
> *And to thy Name may lasting Trophies raise.* (14)

In a Christian epic of Ellwood's Dissenting variety, God trumps the muse, who
becomes only another of his servants, in need of grace to fulfill her task to his
glory.

But is this really an epic? The title, based on Virgil's Latin *Aeneis*, certainly gestures in that direction, and Ellwood's preface shows him to be in dialogue (or pointed silence) with the epic tradition. Yet to ask whether this work is an epic ignores the work that such engagement with epic does for shaping literary history. More useful for this study is to ask how Ellwood's *Davideis* interacted with the epic tradition in colonial America. This question leads us into issues of reading and publication. While the first canonical European epic printed in North America, *Paradise Lost*, first appeared only in 1777, and reprints of Homer and Virgil began only in the 1790s, Ellwood's poem went through no fewer than four American editions before the Revolution, and a total of six before the first reprinting of Homer.[48] Today's readers may find Ellwood's *Davideis* dull; John Greenleaf Whittier mentioned in *Snow-Bound: A Winter Idyl* (1866) that his family's only book of poetry was "Ellwood . . . A stranger to the heathen Nine."[49] Yet the idea that the Whittiers, a New England Quaker family with limited resources, owned a copy of the *Davideis* before Milton, Homer, Virgil, or Shakespeare tells the same story that the poem's publication history does: no one read the *Davideis* as a literary monument, but almost everyone with an interest in religious literature seems to have read it. Works like the *Davideis* opened up the possibility that epic writing could be designed for purposes that trumped the kinds of aesthetic pleasure that Pope, Dryden, and Milton had led privileged readers of poetry to expect. Epic could be written not just for the elites but for the lower classes—and perhaps not written *by* the elites, either.

Over time, Dissenting epic behaved as an alternative tradition, one with its own genealogies and shared ideologies. Yet the connections between texts were not as direct as the kinds of borrowing that characterized the Homeric line. A case in point is Phillis Wheatley's longest poem, "Goliath of Gath," a verse imitation of the battle between David and Goliath, the very scene with which Ellwood began composing his *Davideis*. It is unclear whether Wheatley knew of Ellwood's poem, though her movements in evangelical circles might have given her opportunity, even if the Wheatleys or her poetic mentor, Mather Byles, did not own copies. Yet the attraction of the ultimate underdog combat would have been powerful for Wheatley, both from her interest in George Whitefield's much-maligned Methodism and her identity as a young slave on the margins of genteel Boston society. Whether or not Ellwood was a direct influence, both the Quaker author and Wheatley may have had motivations in common when they chose the David-Goliath battle to imitate. However, rather than expanding the narrative as Ellwood had done, Wheatley chose to stay within the confines of the epyllion, or

miniature epic. At a mere 222 lines, "Goliath" follows virtually every verse of 1 Samuel 17 and parts of 18 in order, plus an invocation that pushes the limits of Miltonic synchronicity between divine inspiration and the classical muses. Milton opens his brief epic *Paradise Regained* by asking "Thou Spirit," the Holy Spirit that had sent Jesus into the wilderness to face the temptations that form the setting of Milton's poem, similarly to inspire the telling of an inspired event. Wheatley uses the dual-inspiration device but addresses an entire army, and more: "Ye martial powers, and all ye tuneful nine,/Inspire my song, and aid my high design" (31). Not only all nine muses but unspecified "martial powers" appear in this invocation, and according to Wheatley they are the same "powers" that inspired the prophet Samuel in his account of David's battle with Goliath—a bold doctrinal revision, to say the least. If Wheatley's notion of writing is largely a matter of interpolation and imitation, as her portrait would suggest, she wants to do her work in the best possible company.

Part of the power of Wheatley's "Goliath" for eighteenth-century readers was its instant recognizability, both as a scripture imitation and as an epyllion or miniature epic. Thomas Brockway's *The Gospel Tragedy: An Epic Poem in Four Books*, on the other hand, escaped notice partly because it defied definition.[50] Brockway attended Yale with Trumbull and Dwight, but he absorbed Milton's influence in ways sharply distinct from the Connecticut Wits' project of writing poetry for enlightened citizens. Like Dwight and Barlow, Brockway had briefly served as an army chaplain during the Revolution, but he quickly settled into the quiet life of a country pastor in Lebanon Crank (now Columbia), some twenty-five miles east of Hartford, and stayed there until his death thirty years later. Unlike his classmates, Brockway seems to have had little public contact with either the intellectual currents of the day or the political events of the early national era. Yet out of this seemingly marginal life came the first American heroic poem to claim the term "epic" in its title, and the only blank verse poem treated in this chapter.

The first (and almost the only) indication of how Brockway's poem may have been received appears in printer James R. Hutchins's advertising for subscriptions in *The Massachusetts Spy*, starting in March 1795.[51] Hutchins declared Brockway's poem a kind of poetic theological treatise, in which "*good sense* and *solidity* of *argument*, breathe in every line." Brockway had apparently found his own manuscript networks outside of the Connecticut Wits' sphere of influence, as Hutchins cited endorsements from "the Clerical Associations in Connecticut," as well as John Wheelock, president of Dartmouth, and "several literary characters

in Newhampshire [*sic*]." But Hutchins's own appraisal helped to place Brockway's work on the shelf: "In one word, we see the force and energy of *Milton*, blended in a happy union, with all the floridity and luxuriance of *Thompson* [*sic*]."[52] If Brockway had not read much recent poetry (Dexter records that fewer than twenty books were found in his estate after his death),[53] his publishers at least recognized echoes of two of Britain's quasi-classical poets—and the two most prominent practitioners of nondramatic blank verse. What Brockway was doing was eminently recognizable, and its poetic merit was that of a steady seller, not a revolutionary writer.

The poem was not a steady seller, however; it does not seem to have sold very well, or very widely. And such may have been the author's intention. His preface begins with almost aggressive indifference: "The Author has no apologies to make: He would wish to avoid those self-compliments, that often introduce publications to the world. . . . Should he in many instances, fail of affording the entertainment, that might be wished; it will be kind in the reader to remember, that his pain has been light, compared to that of the writer."[54] He defends his choice to publish anonymously, declaring that "[s]hould any merit be discovered in the work, he is content without the honor" (iv). His invocation also seems somewhat daring in its humility, chiding previous poets for ignoring the life of Christ:

Ye Bards sublime, whose strength has borne the Muse,
Through unknown worlds, and fame immortal gain'd,
Pardon my bold attempt, with feebler wings
To soar, on subject great that's left by you. (7)

Brockway's approach to the invocation is strangely modern, placing the agency of the poetry not on the muse but on the great poets' ability to carry her "through unknown worlds," challenging conventions of fictive story while recognizing what those conventions have done for the "Bards sublime." While Milton had carefully chosen the interstices of biblical narrative for his own works, Brockway chooses the Passion narrative, the most extensively and redundantly recounted event in the entire Bible. Brockway clearly takes Milton as his point of departure, but his imitation is a radical one, one that uses Miltonic technique to aim for the devotional, the conventional, and the popular. *The Gospel Tragedy* is a kind of everyman's Milton.

The opening scene, a council of Satan and his devils in Hell, revisits *Paradise Regained* as the demonic powers scheme to destroy the plan implied in the promise to crush the serpent's heel at the Expulsion. Book II of *The Gospel Tragedy* in

effect retells *Paradise Regained*, the story of Jesus's temptation in the wilderness. Rather than the battle of wits that Milton presents, in which Christ out-argues Satan, Brockway's version of the scene is explicitly a matter of single combat, which lasts through the forty days of fasting. And Brockway's high Christology directs him to move away from Miltonic debate to a battle of identities: as Satan takes on different personae to lead Christ into the final temptations, Christ defeats the temptations simply by declaring that he discerns the tempter's true demonic character. Moral and epistemic superiority negates the need for any further struggle. Following the last temptation, when Satan takes Christ to a mount of vision where "optick charms" (54) combine pastoral beauty and the four-dimensional sweep of empires ("Great Babylon, with Nineveh, and Rome" [53]), the combat concludes in another Miltonic importation, as Christ ends his speech by removing the veil of his humanity to show Satan the same face he saw in the war in Heaven. To remove any doubt that Brockway had *Paradise Lost* VI on his mind while writing this section of his poem, an epic simile comparing Satan's flight to hell with a mortar shell ends the passage, a witty reversal of the Satanic origins of gunpowder that Milton posits in his work.

Brockway's response to Milton is fundamentally more like Ellwood's than Dwight's or Barlow's. Whereas Dwight sought to Americanize *Paradise Lost* and Barlow to secularize it, Brockway follows Ellwood in conceptualizing biblical history in verse as a matter of devotion and pedagogy. The beginning of Book III presents Brockway's fullest challenge to the Homeric tradition. He explains that the muse used to see only as far as the beauties of nature, which he describes at length, "till Jesus rose to view/ And bade her sing" (63). The muse has more important business to do after the coming of Christ, and so the fascination with the external world that dominated the pre-Christian epics no longer suffices. Even the place of the sublime in such poetry seems to change, as the Sermon on the Mount is typologically linked to the "smoky pillars" of Mount Sinai, but only to emphasize the difference: Jesus preaches the law "not . . . with terror," but "mix'd with grace in gentler accents" (65). Before he presents the Sermon in a comprehensive paraphrase, Brockway pits content against form in determining the greatest poetry:

> The ancient bards, have mighty heroes sung,
> And worthy deeds have grac'd the epic page,
> Where lines harmonick read, have charm'd the world
> To think the man a God. 'Tis fiction all,

The muse has done the deeds, and not the man.
Not so the one I sing . . .
Greatest my hero then though less my song. (63–64)

For Brockway, epic is a terrible way to relate the history of heroes, because the glory comes from the poetry rather than from the events. His choice of a "less[er] song" then serves to elevate his own "greatest" hero, because his poetry is less likely to distort the truth. Brockway's reaction against eloquence arguably results in more forceful poetry, but it also shows how versatile a vehicle epic could be for varying aesthetic as well as theological and ideological positions.

The Gospel Tragedy may be the most theologically earnest epic poem in American history, offering not a replacement of scripture as Lawrence Buell's "literary scripturism" entails[55] but an authoritative explication of it, one that from a self-consciously inferior position can vie against the greatest poems ever written. The epicizing of the Bible in America was often not so much a supplanting of the Bible as it was a supplanting of epic. Dwight had argued in his 1771 master's thesis, *A Dissertation on the History, Eloquence, and Poetry of the Bible*, that the Bible should be read not only for its theological and historical merits, but for its rhetorical and poetic accomplishments as well. Declaring that Scripture is excellent in style as well as in content, Dwight challenges the very canon that defined his studies: "Whilst we are enraptured with the fire and sublimity of *Homer*, and the correctness, tenderness, and majesty of *Virgil*, the grandeur of *Demosthenes*, the art and elegance of *Cicero*; Shall we be blind to Eloquence more elegant than Cicero, more grand than *Demosthenes*; or to Poetry more correct and tender than *Virgil*, and infinitely more sublime than him who has long been honoured, not unjustly, with that magnificent appellation 'The Father of Poetry?'"[56] Lawrence Buell points to Dwight's work as marking the rise of literary scripturism; it was certainly the case that in the years before higher criticism traveled to the United States, Dwight's name remained associated with the literary interpretation of the Bible,[57] but it would be more accurate to say that Dwight laid the groundwork for the kinds of literary scripturism in which Emerson's generation engaged than that Dwight was taking on such a bold project himself. The question as to whose tradition would ultimately crown American literature—Homer's or the Bible's—remained open throughout the chronology of this study. Other foundational texts occasionally came into contact with the epic tradition as well, and the following chapter focuses on just such a point of contact: that between epic and the United States Constitution.

Constitutional Epic

While American poets were experimenting with epic form, the concept of epic itself became increasingly influential in cultural spheres beyond that of poetry, and indeed beyond that of literature, as the term was coming to be defined in the early nineteenth century. Perhaps the most significant one, though previously unrecognized by scholars, is the influence of ideas about epic on the ratification and early interpretation of the United States Constitution. As the first written constitution for a national polity, the proposed document that emerged from a secretive convention in 1787 introduced difficult hermeneutic problems for its early interpreters. One of the most intriguing of these problems was the capacity of a written text to create a nation as well as a state; although the putative purpose of the Constitution was to establish a legal basis for national government, from very early in the ratification process it was clear that the cultural values that stood behind those laws—what Kenneth Burke calls "the Constitution-behind-the-Constitution"[1]—evinced a developing but contested national culture that the new government and its plan would help instantiate. The Constitution had to be suited to the people, but what was the best way for laws to be thus adapted? At the same time that the new document had to address what Arthur Lee called "the

genius of the people,"[2] meaning the unique, collective quality of the nation, it was also very quickly wrapped in celebrations of the genius of its Framers, in the sense of extraordinary ability to produce something great. In engaging with both senses of "genius" at the same time, epic entered the discourse as an analogy as well as a source.

Even before the new Constitution was drafted, John Adams had considered the question of the relationship between the genius required to compose a great epic and that required to produce a great constitution. In the first installment of his *Defence of the Constitutions of the United States* (1787), Adams championed the theory of mixed government that informed many of the American state constitutions and would inform both the new federal constitution and Madison and Hamilton's defense of it in the *Federalist*. Part of Adams's strategy in making his case was to take on modern political philosophers one by one, showing how weak their own systems were compared with those developed by the hard-won wisdom of Americans in the wake of the Revolution. His usual structure was to point out how impressive an individual's intellectual accomplishments were, in order to cast into stark relief the errors of that person's constitutional thinking, thus countering opponents' citations of European luminaries by pointing out that "[c]himerical systems of legislation are neither new nor uncommon, even among men of the most resplendent genius and extensive learning." One of Adams's cases in point was Milton: "A man may be a greater poet than Homer, and one of the most learned men in the world; he may spend his life in defence of liberty, and be at the same time one of the most irreproachable moral characters; and yet, when called upon to frame a constitution of government, he may demonstrate to the world, that he has reflected very little on the subject. There is a great hazard in saying all this of John Milton; but truth, and the rights of mankind, demand it."[3] Adams not only hails Milton's work on behalf of the English Parliamentarians, his morality, and his prodigious learning but also places Milton above Homer as the greatest of poets, as the Connecticut Wits had done in their collegiate writings. Adams lifts Milton up to the top of the canon in order to show how much more a great constitution requires compared to a great epic. For Adams, constitutions take more than genius and labor.

Adams's main objection to Milton's plan for a constitution—that a unicameral legislature made up of life-term members invited either oligarchy or mob rule—presents Milton as an aristocrat more so than most critics would, but Adams's own reading of *Paradise Lost* may have influenced his reading of Milton's constitutionalism. As a Harvard graduate in 1756, Adams noted in his diary

after reading *Paradise Lost*, "[Milton's] Soul, it seems to me, was distended as wide as Creation. His Powr over the human mind was absolute and unlimited. His Genius was great beyond Conception, and his Learning without Bounds."[4] As Lydia Dittler Schulman has pointed out, while Jefferson scoured Milton's epic for philosophical truths that led him toward an interest in the Miltonic Satan, Adams understood the poem as a sheer act of sublimity and self-assertion: the hero for Adams was indisputably Milton.[5] Another way of putting Adams's comments in *Defence* is that while the power of the individual's own confidence makes for remarkable poetry, it was a poor substitute for the proper kind of reflection that works like *Defence* and the *Federalist* sought to show had generated the US Constitution and its state-level counterparts. Adams's elevating and deconstructing of Milton's genius also enacted a version of the ancients-moderns debate that in many ways defined Adams's generation, and in which Adams himself often favored the ancients—partly out of his middle-class awareness that access to the classics meant upward mobility in eighteenth-century America.[6] If Adams had found power in Milton as a young country schoolmaster, he carefully respected the power in classical learning that had helped him to become a famous politician. While Adams revered Milton's political prose as well as his epic, he would grow old with Homer, even debating with Jefferson the Greek poet's metrics in their extensive correspondence.[7] Like Jefferson, Adams throughout his life sought to balance his admiration for modern genius (like Milton's) and the wisdom of the classics, which his education had taught him to use as "equipment for living."[8]

At one level, it seemed natural that Adams would discuss the writing of epic and constitutional theory on the same page. Gentlemen of his day were raised on Homer and Virgil. Other key epic works in a gentleman's education of the time included not only *Paradise Lost* but also the Roman republican Lucan's *Civil War*, both poems written by defeated republicans whose prophetic anger against tyranny and commitment to republican government provided powerful rhetorical ammunition for eighteenth-century Federalists and Republicans alike.[9] In the eighteenth century, such study was a matter not only of learning stories and language but also of understanding the moral and rhetorical power that such stories and language wielded, and so to find James Madison, Adams, and other members of the founding generation talking about epic when they talk about constitutions should not come as a surprise. In the face of an unprecedented genre, and one of such importance to national identity, epic was a useful analogy for developing new interpretive canons. More surprising is the fact that

early interpreters of the Constitution actually articulated an epic genealogy for the document, tracing its generic and philosophical origins to Homer and Virgil.

The groundbreaking work of Eric Slauter has opened up new avenues of inquiry into the sources of the Constitution, especially the metaphors that dominated constitutional theory and polemical debate in the eighteenth century.[10] While Carl Richard has helpfully illuminated how the Framers used the classics as models for writing and thinking, Slauter's work goes beyond typical source criticism to trace the rise of thinking of a state as an art object produced by legislators, a departure from earlier, anatomical notions of constitution, such as Hobbes's Leviathan, made possible in part by the increasing importance of written documents produced by identifiable (if still collective) authors. Something like the US Constitution could be treated as a work of art because its creators (Madison, Franklin, Washington, etc.) could be identified, even as those creators aimed to produce, as Jefferson said of the Declaration, "an expression of the American mind."[11] The concept of taste was vitally important for the discussion of politics in the late eighteenth century, as it was based on exclusion—only those privileged and experienced enough could be said to have it—and at the same time allowed for the assumption of common consent that claimed immunity from factional wrangling.[12] If the classics served as a "calculus of motives"[13] for the Framers, taste was the language of consent by which they accepted the classics. To understand the pleasures and power of Homer, then, was a political act couched in the language of aesthetics. This chapter presents two veins of this aesthetic discourse, versions of what I term *constitutional epic*, the use of canonical epic narratives and devices to substantiate the Constitution as a text and a cultural talisman. The first vein involves the tracing of the Constitution's genealogy back to Homer, a strategy employed in the *Federalist* and in early Supreme Court case law. The second vein emphasizes the visual discourse of constitutional epic, particularly the importance of Achilles's shield as a national symbol and the borrowing of Joshua Reynolds's notions of Grand Manner and epic style in the visual arts by the Marshall Court and its later commentators. Together, these two traditions highlight just how far beyond poetry epic was absorbed into American culture; they also show that the deployment of creative works, often in moments of crisis, has always made the Constitution a text among texts, dependent not only on legal intertexts but on a vast network of cultural discourses for its legitimacy and efficacy.

From Homer to Columbia: Epic's Legal Genealogies

As a gentleman's son in colonial Virginia, Madison received an education concentrated on the study of Latin and Greek. According to biographer Ralph Ketcham, by the time Madison entered Princeton as an undergraduate he had a considerable command of both languages and probably had committed large portions of Virgil and Cicero to memory, perhaps even before he had read many of the English classics.[14] Madison put that deep knowledge of the classics to good use in his writings during the ratification debates; as George Kennedy has observed, the presence of classical allusion and convention in the *Federalist* was in great part a rhetorical device for "making the papers acceptable to educated men of the age as the effort of reasonable, literate, and humane men of manners and learning."[15] For Publius and "his" audience, classical literature was a way of life, not only as a lens for understanding the world, but as a cultural code by which members of the educated class could recognize and communicate with each other.

Well over a third of the essays contain references to classical figures and works; from the legislative feats of Lycurgus and Solon to the legal researches of Polybius, the authors of the *Federalist* drew both their ideas of good government and their evidence in the comparative study of constitutions from the ancients, supplementing with moderns such as Hume, Blackstone, and Montesquieu. Madison's knowledge of classical history and letters has been well documented, as has that of his *Federalist* coauthors, Alexander Hamilton and John Jay.[16] However, very little has been written on the peculiar classicism of *Federalist* 47, in which Madison, in the process of defending a doctrine of the separation of powers, departs from the canon of history and biography to an epic canon with profound implications for the nationalist thrust of Publius's argument.

Madison frames *Federalist* 47 as the beginning of his analysis of the "particular structure" of the proposed government, and the first objection that he faces is the charge that the Constitution does not maintain a proper separation of powers between the three branches of government.[17] Madison's ventriloquism of his opponents' argument bears the neoclassical hallmark of conflating the interests of liberty and government with the aesthetics of beauty and balance: "In the structure of the federal government, no regard, it is said, seems to have been paid to this essential precaution [separation of powers] in favor of liberty. The several departments of power are distributed and blended in such a manner, as at once to destroy all symmetry and beauty of form; and to expose some of the essential

parts of the edifice to the danger of being crushed by the disproportionate weight of other parts" (323–24). And rather than dismiss aesthetics as a red herring, Madison embraces it: "No political truth is certainly of greater intrinsic value or is stamped with the authority of more enlightened patrons of liberty than that on which the objection is founded" (324). Aesthetics was certainly of great concern to and had rich political implications for Madison's generation; Robert A. Ferguson has shown the centrality of aesthetics to John Jay's contributions as "the forgotten Publius" and to the *Federalist* as a whole, and Slauter has demonstrated how prevalent the state-as-architecture motif had become by the time Madison wrote his essay.[18] The idea of the aesthetic model or canon as an authoritative standard in constitutional theory is indeed at the core of Madison's argument in *Federalist* 47. As the essay develops, it reiterates the canonical model several times, using politics, aesthetics, and literature together in forming a new canon for constitutional interpretation.

To answer his opponents' argument, Madison asserts that "the sense, in which the preservation of liberty requires" the separation of powers be ascertained. He then pursues this sense in one of his favorite authorities: "The oracle who is always consulted and cited on this subject, is the celebrated Montesquieu." (324). Madison's use of "oracle" here highlights the historical range from classical to modern that figures like Montesquieu, Pufendorf, and Blackstone represented to eighteenth-century legal scholars. Montesquieu rhetorically absorbed classical legal thought as the foundation for his *Spirit of the Laws*, a work that brought the comparative study of constitutions into the Enlightenment and established the concept of positive law as an extension of national identity.[19] The encyclopedic form of Montesquieu's *Spirit of the Laws*, like Blackstone's *Commentaries on the Laws of England*—which served as the core of legal education in the United States and in Britain at least through the 1860s—provided a hierarchical system for understanding the relationship between natural and positive law and among various elements of positive law. This form also established its authors as unquestionable experts on their subjects, invaluable references to be "always consulted and cited," to use Madison's phrase. In describing Montesquieu as an "oracle," the American author uses the eighteenth-century sense of the word, a revered and reliable authority on a particular topic. However, the classical sense of a prophetic or divinely inspired voice hovers in the background, as the actions of consulting and citing apply not only to modern reference works but to the ancient appeal to the oracle for wisdom and the possession-by-quotation of the oracle's words as uncontestable truth.

The question as to whether an oracle is an authorial or a scribal voice also emerges in Madison's praise of Montesquieu. He says of the French scholar, "If he be not the author of this invaluable precept in the science of politics, he has the merit at least of displaying, and recommending it most effectually to the attention of mankind" (324). Montesquieu is the source of wisdom on the doctrine of separation of powers, at least for Madison, but even such a devoted reader of *Spirit of the Laws* concedes that this wisdom is not an author's genius but what Alexander Pope might term a critic's wit. Madison's praise of Montesquieu's "displaying" and "recommending . . . most effectually" echoes the famous lines from Pope's *Essay on Criticism*:

> *True Wit* is *Nature* to Advantage drest,
> What oft was *Thought*, but ne'er so well *Exprest*,
> *Something*, whose Truth convinc'd at Sight we find,
> That gives us back the Image of our Mind.[20]

Montesquieu provides a model for understanding constitutional theory, but that model is belated, merely casting in an Enlightenment idiom the wisdom of the ages. As Madison's remark on the number of "enlightened patrons of liberty" suggests, the appeal to Montesquieu is not a matter of choosing the right answer out of a cacophony of political views but an affirmation of the rational consensus that *Spirit of the Laws* rhetorically represents, a consensus momentarily forgotten in the heat of passionate debate over ratification.

Montesquieu's own views do point to an origin, however, in the example of Britain's constitution, which enjoys the status in *Spirit of the Laws* of the most perfect legal expression of a nation. The legal genre of the constitution in Montesquieu's thought takes shape, according to Madison, through an inductive logic similar to that of Aristotle's *Poetics*:

> The British constitution was to Montesquieu, what Homer has been to the didactic writers on epic poetry. As the latter have considered the work of the immortal Bard, as the perfect model from which the principles and rules of the epic art were to be drawn, and by which all similar works were to be judged; so this great political critic appears to have viewed the constitution of England, as the standard, or to use his own expression, as the mirrour of political liberty; and to have delivered in the form of elementary truths, the several characteristic principles of that particular system. (324–25)

The language of this remarkable passage requires careful attention. Here Montesquieu, the "great political critic," more fully takes on that role as he displays not only wit and judgment but also the didactic impulse shared by Pope's ideal critic and Enlightenment legal commentators alike. Blackstone and Lord Kames were standard reading for students of law in the English-speaking world of Madison's time, and the fact that Kames authored not only *Historical Law Tracts* and *Principles of Equity* but also the equally influential *Elements of Criticism* likely surprised few of Madison's contemporaries. But to compare Montesquieu directly with "the didactic writers on epic poetry" put him in the company of Kames, Dryden, Addison, and Blair, as well as the celebrated French critics Voltaire and René Le Bossu—as one of a class of writers who argued for a genre's definition based on a single model, and who could use such a model to educate the thinkers of an entire century on his subject. For Madison, Montesquieu's power, as well as the power that he bestowed on his revered British constitution, was the translation of the "several characteristic principles of a particular system" into "elementary truths." In Kenneth Burke's terms, the god-terms that held the British constitution together as a national calculus of motives transcended, in Montesquieu's hands, the boundaries of national difference, just as the calculus of motives within Homer's epics was apotheosized into the gold standard for Western narrative literature by Renaissance readers of Aristotle and by later Enlightenment critics.

Yet Montesquieu's achievement, like those of Kames and Voltaire, did not solve the problem of difference between species for Madison, in either literary or constitutional discourse. Homer's works constituted "the perfect model from which the principles and rules of the epic art were to be drawn, and by which all similar works were to be judged." Or did they? Most critics followed Aristotle in basing their rules for epic poetry on Homer's *Iliad*, but from the Athenian Lyceum down to Madison's day, the amorphous structure and uneven pacing of Homer's *Odyssey* created difficulties for the argument for epic symmetry. And yet Virgil based the first half of his *Aeneid* on the structure of the *Odyssey*, and Milton packed the *Iliad* into a single melodramatic book of *Paradise Lost*, while giving over the rest of the poem to scenes of domesticity, legality, scholarship, and several iterations of the *Odyssey* narrative. Further, the *Iliad* (possibly paired with the *Odyssey*) was the model by which to judge "all similar works." As has been shown earlier in this book, the question as to what was similar enough to merit the term "epic" was a matter of contention by the mid-eighteenth century—as was the question of whether works such as Fénelon's *Telemachus* or Ossian's

Fingal could be judged in light of Homer's work(s), whether they were "actually" epics or not.

The implications for Madison's analogy were profound: the proposed constitution was a constitution, indeed one based in large part on the British constitution, but was it close enough in content and form to the British constitution to merit comparison? Could the US Constitution be held to the "mirrour" of its British counterpart? The oracle of Montesquieu, while "always consulted and cited," might not always have the answer to fit the unprecedented events surrounding the United States' creation. In *Federalist* 14, Madison praised Americans' pragmatic attitudes toward precedent: "Is it not the glory of the people of America, that whilst they have paid a decent regard to the opinions of former times and other nations, they have not suffered a blind veneration for antiquity, for custom, or for names, to overrule the suggestions of their own good sense, the knowledge of their own situation, and the lessons of their own experience?" (88). Despite Madison's own veneration for Montesquieu, his resistance to the transcendence of political ideals advocated in *The Spirit of the Laws* lies in his understanding that analogies can at best only approximate the American situation. The young nation's new constitution, while born out of a long tradition of constitutionalism, must make at least a few choice radical breaks from that tradition in order to work effectively.[21]

Yet Madison was careful to use tradition as his means for breaking with it. In comparing Homer with the British constitution, he set up a remarkable analogy that reflects the confluence of historical trends in shaping the United States' proposed constitution; this analogy is nothing short of claiming epic status for the American constitution, not in the line of Homer but in the line of Virgil, the literary epicist who refashions his ancestor's poem into a more civilized, literate, and politically useful work—and who combines multiple models (*Iliad* and *Odyssey*) in doing so. If Britain's constitution, based in the orality of common law and centuries of tradition, was the gold standard for Enlightenment constitutionalism (as was Homer's *Iliad* for neoclassical critics), the new American constitution even more fully realized Enlightenment ideals by incorporating the best of British constitutional wisdom into a documentary body, one capable of rapid reproduction through printing and distribution technologies unavailable in the early years of Britain's constitution. This embodiment, this self-consciously textual constitution, further heralded the culmination of the Enlightenment because the "barbaric" errors of the British constitution, shaped as the latter was by feudalism and monarchy, had been written out of the United States' text, even as

such classic doctrines as the separation of powers were *re*written into the American document—cited, not copied.

It is worth noting here that Madison's focus on Homer, like Adams's focus on Milton, reflected a highly exclusive canon of epics with which the Constitution could actually be compared in public discourse. As experimental and genre bending as the Constitution may have been, it was essential for its early supporters to put it in a relationship to the traditional canon that had formed their schooling and gentlemanly reading. Jefferson's approach to this canon is typical. In 1773, Jefferson had praised Ossian as "the greatest Poet that has ever existed," and he collected epic poems by his countrymen throughout his life (many of them unsolicited gifts, but he kept them).[22] Nevertheless, by the time he was serving as an ambassador in Paris, Jefferson had settled his canon into the top three—or two— worth reading more than once, his ultimate criterion of literary excellence. By way of celebrating in his "Thoughts on English Prosody" the English language as "the only one which has dignity enough to support blank verse," the diplomat extolled the form's ability to leave the poet "at liberty," "unfettered by rhyme," as if exacting forms and political oppression were related. They were, at least in the case of Jefferson's prime example of "the most precious part of our poetry," John Milton. The opening passage from *Paradise Lost* is quoted at length as an instance of extreme poetic liberty, for Milton here "even throws off the restraint of the regular pause." Yet for Jefferson, the ultimate measure of literary art is not the author's daring but the effect the poem has on the reader. Specifically, he looks to effects over time, as personal development establishes the canon diachronically: "What proves the excellence of blank verse is that the taste lasts longer than that for rhyme. . . . When young any composition pleases which unites a little sense, some imagination, and some rhythm, in doses however small. But as we advance in life these things fall off one by one, and I suspect we are left at last with only Homer and Virgil, perhaps with Homer alone."[23] Jay Fliegelman has argued that Jefferson saw in Homer the paragon of natural language, as well as natural genius; that Homer seemed to speak with the voice of the people only underscored his importance as a poet for a new nation, or the politicians that would guide that nation.[24] So Milton represented the pinnacle of English poetry, Homer that of all poetry, and Jefferson the sage that pored over them both again and again, reducing his canon, like his political philosophy, to the core values of liberty and populism. While not everyone of his generation held Jefferson's political views, few members of the new nation's government would have quibbled with the exclusivity (not to say the elitism) of his canon.

Not least of the ideological goals that Madison and his pro-Philadelphia constitution contemporaries faced was an attempt (resembling that of the Bloomian strong poet) to "misread," and thereby usurp, the authority of a predecessor. Milton's legacy as a combiner of classical epic and biblical narrative was seminal in American letters, as we have seen in chapter 1; however, his example as an ambitious rewriter of both traditions held particular significance for members of the Constitutional Convention and for those who, like Madison, defended and expounded the convention's proposals in the ratification debates. Madison himself, as Publius, was already rewriting the constitution that he helped draft, itself a rewriting of the British constitution. The name "Publius," which Hamilton chose as the pseudonym for the *Federalist* authors, has often been read as an allusion to Publius Valerius Poplicola, the Roman consul that Plutarch celebrated as one of the republic's saviors during the fallout at the end of Tarquin's tyranny. The historical events, together with Hamilton's known penchant for adopting pseudonyms from Plutarch's *Lives*, lend support for this reading,[25] but the nature of what both the convention and Publius were doing, as Madison describes it in *Federalist* 47, suggests that a more famous Publius might be implied: Publius Vergilius Maro, or Virgil.

After the passage comparing the British constitution to Homer, Madison spends the balance of his essay outlining the specific applications of the separation of powers doctrine in the British constitution, as well as in the state constitutions then in effect in the United States. While pointing out the strengths and weaknesses of each, Madison's central goal is to build a case for the flexibility of legitimate methods for establishing the separation of powers. As he says at the end of the essay, "What I have wished to evince is, that the charge brought against the proposed constitution, of violating a sacred maxim of free government, is warranted neither by the real meaning annexed to that maxim by its author; nor by the sense in which it has hitherto been understood in America" (331). Madison opened his essay with an aesthetic argument; he then moved into literary criticism. He now concludes with a philological argument for the Constitution, in order to avoid a constitutional version of the "pedantry" of epic criticism that Hugh Blair had bemoaned.[26] This combination would prove essential not only for American epic composition for the next generation; it would help define the idiom of American constitutional law for at least one generation more.

Madison's own association with Homer would continue into his presidency through an unusual gift. On the occasion of his inauguration as president in 1809, Madison received a folio edition of Homer's *Iliad* as a gift from the publishers

Bossange, Masson, and Besson of Paris. The imprint consisted of only twenty-five copies, and the publishers did not put them up for commercial sale but chose rather to give them as gifts to elite patrons or prospective patrons. The book was a sumptuous presentation of Charles LeBrun's 1776 French prose translation of the poem, though it was clearly meant to be looked at, not read: along with a complete set of Henry Flaxman's thirty-four illustrations for the *Iliad* in full-size plates, the book boasted separate title pages that were printed respectively in black ink and gold leaf, the latter adorned with a bust portrait of Homer drawn and signed by Adéle Masson (presumably a daughter of one of the publishers).[27] In the copy given to Madison, the black-ink title page has a further hand-drawn illustration, a ship under full sail facing the viewer; the mainsail is monogrammed "JM" and an inscription to "Maddison" from the publishers is written beneath it (fig. 3). The book testified to Homer as a source of elite cultural capital, and in this case of conspicuous consumption as well. As a gift to a head of state by private citizens of another country, the book also made clear the international and public importance of Homer and his works as universally recognized signifiers in the realms of power and privilege at the turn of the nineteenth century. Madison, who twenty years earlier had argued that Homer could be used to understand the significance and international standing of the Constitution, became graced with Homer as a token of his accomplishment and status as the newly sworn defender of that Constitution.

Epic was part of the language of power in the late eighteenth century, and it would receive its greatest elevation into American legal discourse by James Wilson. One of the most talented—and most overlooked—of the Founders, Wilson was a Scottish immigrant trained at the University of St. Andrews and considered the greatest legal mind of the early republic. Having signed both the Declaration of Independence and the Constitution, and having played a central role in orchestrating the 1789–90 Pennsylvania state constitutional convention, he undertook a series of law lectures as the College of Philadelphia's first law professor in 1790—the same year he sat on the first US Supreme Court as an associate justice. Planning his lectures not as a technical exercise but as "a rational and useful entertainment to gentlemen of all professions," Wilson clearly had literary ambitions for his series.[28] Indeed, because of his public standing, luminaries including Washington and Adams attended the inaugural lecture, many bringing their wives.[29] And Wilson played to his audience, using wit, humor, and rhetorical flourishes to show the intellectual excitement of law for him. In discussing the Constitution's age requirements for public service, he

Figure 3. Hand-illustrated title page and inscription to James
Madison in Homer, *L'Iliade d'Homère*. Paris: Messange, Masson et
Besson, 1809.

reflected on the oddly arbitrary nature of such requirements, not just in the Constitution but throughout known history:

> How differently is the same object viewed at different times and in different countries! In New York, a man is deemed unfit for the first offices of the state *after* he is sixty: in Sparta, a man was deemed unfit for the first offices of the state *till* he was sixty. Till that age, no one was entitled to a seat in the senate, the highest honour of the chiefs. How convenient it would be, if a politician possessed the power, so finely exercised by the most beautiful of poets! Virgil could, with the greatest ease imaginable, bring Æneas and Dido together; though, in fact, some centuries elapsed between the times, in which they lived. Why cannot some politician, by the same or some similar enchanting art, produce an ancient and a modern government as cotemporaries? The effect would be admirable. The moment that a gentleman of sixty would be disqualified from retaining his seat as a judge of New York, he would be qualified for taking his seat as a senator of Sparta.[30]

The power of poets in this passage is the ability to select and combine from reality, to behave (to paraphrase Jefferson) unfettered by history. The result, Wilson points out, is "convenient," and the blending of ancient and modern, a practice he traces back to Virgil, becomes the vehicle of political ambition—an ironic move, considering the number of classical genealogies that had been traced by Publius and other supporters of the Constitution during the ratification debates that had only concluded the year before.

The irony is almost certainly intentional, leaving Wilson's position on the relationship between law and literature ambiguous. *Should* the power of poets enter the political or legal realms? Earlier in the same lecture, Wilson suggests that such a blend not only should be but in fact *was* the case. As he considers the legal definition of "the people," as the Constitution's preamble identified them, Wilson turns to Athens, but rather than quote from an Athenian orator, which he does elsewhere in his writings, he turns to an epic account of the pan-Hellenic armies aligned against Troy: "When Homer, one of the most correct, as well as the oldest and one of the most respectable, of human authorities, enumerates the other nations of Greece, whose forces acted in the siege of Troy; he arranges them under the names of their different kings: but when he comes to the Athenians, he distinguishes them by the peculiar appellation of 'the people.'" For Wilson, Homer's use of a different term (identified in a footnote as *demos*) to refer to Athens's contingent signified not only a different political structure but a different attitude about

the nature of humans in society. The collective mattered more than the metonymic head of the group. Wilson expects this sudden foray into literary criticism to surprise his audience, and he immediately defends his chosen source:

> Let it not surprise you, that I cite Homer as a very respectable authority. That celebrated writer was not more remarkable for the elegance and sublimity, than he was for the truth and precision, of his compositions. . . . From one of the orations of Æschines it appears highly probable, that in the Athenian courts of justice, the poems of Homer, as well as the laws of Athens, were always laid upon the table before the judges; and that the clerk was frequently applied to, by the orator, to read passages from the former, as well as from the latter. On the authority of two lines from Homer's catalogue of the Grecian fleet, was determined a controversy between the Athenians and the inhabitants of Salamis.

Homer's utility, as it turns out, traces back to ancient Athens, where literature served as a legal precedent on a par with the city's laws, much as John Marshall would use the *Federalist* on a par with the Constitution itself for interpretive assistance. But this is not merely a historical curiosity; Wilson concludes his discussion of Homer by praising him as a harbinger of enlightenment in a dark age, and thus eminently useful to progressive moderns: "His immortal poems, like a meteor in the gloom of night, brighten the obscure antiquities of his country."[31] The immortality of the poems, their canonicity, illuminates the modern era as well, as Jefferson had suggested in "Thoughts on English Prosody." For Wilson, however, this illumination is not about personal edification but sound political judgment.

Wilson was so convinced of this last point that he recycled his philological gloss of Homer's use of "the people" in his opinion in *Chisholm v. Georgia* (1793), often considered the first major constitutional law case before the US Supreme Court, and the most important case before *Marbury v. Madison* in 1803. While the case itself made its greatest mark on history by being overturned by the Eleventh Amendment, Wilson used the occasion to more succinctly, and more forcefully, explain Homer's relevance to American law. Using the example of toasts to the United States, rather than to the people of the United States, Wilson argued that cultural conventions and common language usage were the root cause of the "confusion and perplexity" over the source of national sovereignty. The Constitution, in its preamble, decides the question in its opening phrase, pointing to what Wilson calls "the first great object in the Union," since while "A State . . . is the noblest work of Man . . . Man himself, free and honest, is, I speak as to this world, the noblest work of GOD." The language of great objects brings Wilson's

opinion into the discourse of aesthetics, and his theological justification for view-ing the people as the preeminent object is, he argues, "not only politically, but also (for between true liberty and true taste there is a close alliance) classically more correct."[32] Here Wilson's use of the word "classically" suggests that he is us-ing a preeminent authority in Homer, and one distinctly aesthetic. Like Jefferson, who explains the merits of blank verse in terms of "liberty," and Madison, who as-sumes aesthetic analogies to governmental organization, Wilson nearly equates taste and political freedom. To my knowledge, no Supreme Court justice ever again would turn to Homer as a precedent, but Wilson's practice on the first Court was indicative of a generational trend. Epic was a model for law, a prop to law, an analogy to law. Though the personal pleasures of reading epic were not lost on Wilson, Madison, or their contemporaries, that pleasure always had a larger, more public purpose: the shaping of citizens and of a nation. One of the most remark-able examples of the dictum that literature is "equipment for living" was in the use of literature to define and deploy the Constitution as a document of immense cultural power and generic authority.

Visualizing Constitutional Epic

Direct comparisons between the Constitution and epic form faded in American legal discourse after 1800, but the concept of the Constitution as an art object had considerable longevity, and throughout the nineteenth century commenta-tors would continue to use epic conventions to create images of the Constitution-as-art, often at moments of tremendous tension. One of the most striking of these moments came at the end of Daniel Webster's "Constitution and Union" speech, which the Massachusetts senator gave as his entry into the debate over the 1850 Compromise; thanks in part to Webster's support, that legislative package rein-stated the Fugitive Slave Law in what Northern supporters saw as a desperate ef-fort to preserve the Union. Twenty years before, Webster had famously exchanged a series of speeches with Senator Robert Hayne on the question of constitutional nullification, and on the strength of his victory for pro-Unionist Whigs, Webster believed the nation and its constitution to be at last unshakable. For reasons still unclear, Webster changed his mind in early 1850, as the Senate debated Henry Clay's compromise proposal. On March 7, Webster gave what is perhaps still his most fa-mous peroration, in which he argued that dissolving the Union was impossible—despite the fact that he was then speaking precisely because he no longer believed in the impossibility of secession. Webster's argument for the impossibility was

grounded in the tautology of national identity; the Union was the Union, and thus it could not be dissolved and still be the Union. This matter of identity extended to Webster's own self-image as a citizen: "Peaceable secession! . . . Why, what would be the result? . . . What States are to secede? What is to remain American? What am I to be? An American no longer? Am I to become a sectional man, a local man, a separatist, with no country in common with the gentlemen who sit around me here, or who fill the other house of Congress? Heaven forbid!"[33] At the same time, Webster's tautology extended to fill the whole cosmos: "[H]e who sees these States, now revolving in harmony around a moon centre, and expects to see them quit their places and fly off without convulsion, may look the next hour to see the heavenly bodies rush from their spheres, and jostle against each other in the realms of space, without causing the wreck of the universe. There can be no such thing as a peaceable secession" (546–47). Yet while Webster argued for peaceable compromise, for "forbearance and moderation" (548), at the close of his speech he prepared for the worst.

Horrified by the spectacle of imagined secession, Webster constructs his final paragraph as a series of denials: "And now, . . . instead of speaking of the possibility or utility of secession," which was only too obvious by this point, "let us come out into the light of day; let us enjoy the fresh air of Liberty and Union" (550), the famous paradoxical pair from the senator's "Second Reply to Hayne."[34] Such freedom comes at the price of constant security measures: "We have a great, popular, constitutional government, *guarded* by law and by judicature, and *defended* by the affections of the whole people" (550; emphasis mine). Webster's closing flourish depicts the government (disguised as the nation with an ambiguous "it") as a colossal Greek hero strutting on the world's stage:

Its daily respiration is liberty and patriotism; its yet youthful veins are full of enterprise, courage, and honorable love of glory and renown. Large before, the country has now, by recent events, become vastly larger. This republic now extends, with a vast breadth, across the whole continent. The two great seas of the world wash the one and the other shore. We realize, on a mighty scale, the beautiful description of the ornamental border of the buckler of Achilles:—
 "Now, the broad shield complete, the artist crowned
 With his last hand, and poured the ocean round;
 In living silver seemed the waves to roll,
 And beat the buckler's verge, and bound the whole." (551)

Webster makes the closing lines, taken from Alexander Pope's translation of Homer's *Iliad*, do enormous rhetorical work, though filled with contradictions and ambiguities. Moving from the youthful hero to the "mighty scale" of the continent on the globe, Webster declares that the fulfillment of Manifest Destiny in acquiring land across the continent brings the country (or the government? or the people?) to "realize"—to make real—the "beautiful description" of Achilles's shield. But even as Webster proleptically creates the shield of Union to fend off the threat of "impossible" secession, he attempts the truly impossible: rendering Homer's legendary *ekphrasis* real.[35]

The account of Achilles's shield in *Iliad* XVIII is one of artistic creation; the narrator follows Haephestus's own composition process as he exquisitely crafts the scenes on the wondrous shield. Yet as critics have often pointed out, the narration of the shield cannot be visually represented, though many artists have tried.[36] Even Pope tried; in his confusion over visualizing what Homer was actually describing, he drew his own visual interpretation of the shield in the manuscript of his *Iliad* translation, thus making his own translation an *ekphrasis* based on a reverse *ekphrasis* of Homer's *ekphrasis*.[37] In a similar rhetorical sleight of hand, Webster "realizes" the shield by speaking that reality into being, rather than drawing, painting, or sculpting it. And *ekphrasis*'s claim to supersede language—to give a picture in words—is what makes Webster's rhetoric so powerful and so problematic. Like the concept of Manifest Destiny, which uses history to bring about a millennial end to history (what happens when we reach the Pacific?), Webster's meta-*ekphrasis* tries to freeze America's youthful vigor into an aesthetic unity of coherent vastness. But Homer's *ekphrasis* refuses such aesthetic unity. The ocean that covers the rim of the shield is the only located image in all of Homer's account; the other scenes of fields, herds, trials, weddings, wars, and feasts all flow into and around each other, such that the scenes are narrative, not the tableaus that visual artists must take them for. For instance, in one of the agricultural scenes,

> The artisan made next a herd of longhorns,
> fashioned in gold and tin: away they shambled,
> lowing, from byre to pasture by a stream
> that sang in ripples, and by reeds a-sway.
> Four cowherds all of gold were plodding after
> with nine lithe dogs beside them.
> > On the assault,

in two tremendous bounds, a pair of lions
caught in the van a bellowing bull, and off
they dragged him, followed by the dogs and men.
Rending the belly of the bull, the two
gulped down his blood and guts, even as the herdsmen
tried to set on their hunting dogs, but failed:
no trading bites with lions for those dogs,
who halted close up, barking, then ran back.[38]

Is this one scene, or two, or more? Is it a magically animated picture, like the photographs in the *Harry Potter* novels? Such representational problems fill *Iliad* XVIII, even before Haephestus begins his task.[39] The dichotomy that Gotthold Lessing set up in his *Laokoon* between the spatial silence of the visual arts and the temporal voice of language breaks down in Achilles's shield, as Homer's language precludes spatial representation. Webster's claim for realization, like "the buckler" he cites, exists only in language.

Yet the United States' dependence as a state entity upon language is one of the great truisms in American Studies. The rhetorical sleight of hand that Webster's speech attempts follows in the tradition of the Constitution's "We the People," the linguistically constructed collective that utters the nation and its founding document into being (with Homeric origins, as James Wilson argued). The Constitution itself embodies a kind of *ekphrasis*, as it claims to linguistically *represent* as well as *constitute* the state—to stand in for and to stand as at the same time. The linguistic construct of the state, which points to itself as a construct par excellence, distracts from the prior construct of the nation naturalized by the process of ratification; since the Constitution has been constructed by specific, intentional citizens within the nation, the argument goes, we no longer need worry about the identity of that nation. And yet the dissonance of the ratification process, the party wars in the 1790s, the increasing tensions between North and South and the rising frustrations of those living in the West, slave rebellions, suffrage and abolition movements, riots, and mutinies all suggest that the Constitution's ekphrastic argument does not quite work. The nation must still be explained by some extraconstitutional means. In the case of Webster's speech, he borrowed a shield from the most famous of the ancient epics, in an attempt to save the Union by placing it into a narrative grander and more complete than itself.

Webster's connecting the nation to the shield of Achilles as a way of naturalizing the Constitution was not mere idiosyncrasy but has literally been cast into

the very architecture of the United States Supreme Court. On the bronze doors of the Supreme Court Building in Washington, D.C., eight scenes of "the evolution of justice" appear, chosen by Cass Gilbert, the building's architect, and sculptor John Donnelly. The very first scene is labeled "Shield of Achilles" and depicts a trial over the blood price in a manslaughter case, a vignette from the description of the wondrous shield in *Iliad* XVIII that the artists considered "the most famous representation of primitive law."[40] The drama of the scene has been altered from Homer's description, however; whereas in the poem a crowd watches the debate between adversaries, and a ring of judges listen as well, the only figures in the door scene are the two adversaries, pacing around a pedestal as if stalking each other (fig. 4). A backdrop of classical architectural facades sets off the two

Figure 4. Detail of "Shield of Achilles" from John Donnelly, doors of United States Supreme Court, Washington, D.C. Cast bronze.
Collection of the Supreme Court of the United States.

figures, and on the pedestal they circle are two gold coins, which in the poem are to go to the judge that gives the most just decision. In the scene, the absence of the judges leaves open the question of who the coins are for—is it the blood price? The legal fees due to the victorious adversary? Is this scene in fact a competition for a monetary prize? Ambiguous though it is, the *Iliad* scene sets the tone for the depictions of Roman antiquity and early modern England, the scenes culminating in Joseph Story and John Marshall discussing *Marbury v. Madison* in front of the Capitol. The structural connection between the *Iliad* and the *Marbury* scene is clear: two figures balanced by classical architecture. Yet while the conflict between the Greek figures and the amity between the Americans come through in the pictures, the gold coins from the *Iliad* leave in question what the meaning of the Constitution's epic origins actually is. As a story about a stolen wife that opens with quarrels over booty, is the *Iliad* the best choice for a literary ancestor to the Constitution? In seeking to connect the Constitution to the grandest of origins and the most illustrious of cultural artifacts, the rewriting of the Homeric original threatens to rewrite the story of America as well. And all of these rewritings played into the redefinition of epic itself across the Constitution's history. The closing example in this chapter is that of John Marshall, perhaps the most famous rewriter of the Constitution next to the *Federalist* authors (partly thanks to his liberal use of *Federalist* quotations to gloss the document in his opinions).

Part of Marshall's mystique as a jurist was his ability to strike grand poses, both on paper and in person. And that is precisely how William Wetmore Story, the son of Marshall's colleague and first biographer, Joseph Story, chose to depict him in a government-commissioned statue placed in front of the US Capitol in 1884. The statue's original base included a relief celebrating the divine origins of the Constitution (the Constitution-as-Scripture trope was soon to take hold in public discourse), but it deployed an oddly syncretic notion of authorship. The relief depicted "Minerva Dictating the Constitution to Young America" (fig. 5). The Constitution was an inspired text according to Story, but it was inspired by the goddess of wisdom, the same guide that had informed Elizabeth Graeme Fergusson's translation of *Telemachus* over a century earlier. The scene shows America in a pose not unlike that of Phillis Wheatley in her frontispiece, blending the icon of the poetess with an image of youthful malleability. Surrounded by conversing philosophers and a pastoral group of women and children gathering a harvest, America's scribal pose settles between economics and academics. And all this supports the seated statue of Marshall, draped in judicial robes that, in their bronze medium, suggest the draped folds of the philosophers' togas (fig. 6). Story's

Figure 5. William Wetmore Story, *Minerva Dictating the Constitution to Young America*, 1884. Plaster relief. Collection of the Supreme Court of the United States.

Figure 6. William Wetmore Story, *John Marshall*. 1884. Cast bronze.
Collection of the Supreme Court of the United States.

friend and biographer, Henry James, wrote a characteristic reflection on the effect of the statue in situ: "[Marshall's statue] has, in a high degree, the mass and dignity prescribed by its subject, and the great legal worthy, seated aloft, in the mild Washington air, before the scene of his enacted wisdom, bends his high brow and extends his benevolently demonstrative hand in the exemplary manner of the recognised sage and with all the serenity of the grand style."[41] James reads the statue as an expression of gesture, praising Marshall's raised hand as "benevolently demonstrative" while being "exemplary": Marshall exhibits interiority, but in

an archetypal manner that obviates the need for such interiority. He is the ultimate public man, and the "serenity" of that publicity is a matter of pose, of style—the "grand style." As will be explained in the next chapter, the "grand style," or the Grand Manner, was an aesthetic tradition in the visual arts that theorists such as Joshua Reynolds held up as the epitome of art in a climate dominated by both elite patrons and increasingly broadening middle-class markets for spectacular exhibitions and affordable prints. That Marshall's statue should embody such a style—one that Reynolds had termed "epic"—places both the man and the memorial to him in a tradition of epic heroism that, like the justice's gesture, holds history still. And such might in fact be the drive behind Jefferson's fixation on Homer, Adams's criticism of Milton, and Madison's analogy of generic preeminence: a transcendent point of reference that will hold firm in the onslaught of history, a telling metaphor of what the producers of constitutional epic wished the Constitution itself to become—for this kind of epic has always been proleptic in its aims.

James's associating Marshall with the "grand style" likely would have made aesthetic sense to the judge himself. In *McCulloch v. Maryland* (1819), Marshall's most famous opinion during his own lifetime, the chief justice opened his opinion with a grand gesture suggesting the intended canonicity of the decision: "The constitution of our country, in its most interesting and vital parts, is to be considered . . . and an opinion given, which may essentially influence the great operations of the government." And this canonical opinion would be the legacy of a necessarily heroic court: "No tribunal can approach such a question without a deep sense of its importance, and of the awful responsibility involved in its decision. But it must be decided peacefully . . . and if it is to be so decided, by this tribunal alone can the decision be made." The court's supremacy is bound up with the supremacy of the Constitution itself, as well as with the document's totality. Marshall's description of the Constitution's totalizing power points up his sense of the ultimate importance of his work: "It is the government of all; its powers are delegated by all; it represents all, and acts for all."[42]

And yet this totality does not suggest encyclopedic comprehensiveness. The Constitution addresses the nation as a whole, but it does not address every minute detail of that whole—it is not a legal code, but a founding text that gives the shape of the government. For Marshall, it would be beneath a Constitution to provide its own commentary:

> A constitution, to contain an accurate detail of all the subdivisions of which its great powers will admit, and of all the means by which they may be carried

into execution, would partake of the prolixity of a legal code, and could scarcely be embraced by the human mind. It would, probably, never be understood by the public. Its nature, therefore, requires, that only its great outlines should be marked, its important objects designated, and the minor ingredients which compose those objects, be deducted from the nature of the objects themselves. That this idea was entertained by the framers of the American constitution, is not only to be inferred from the nature of the instrument, but from the language. . . . In considering this question, then, we must never forget that it is a *constitution* we are expounding.[43]

The nature of a constitution, according to Marshall, is to deal explicitly only with "grand outlines" and "important objects," leaving the "minor ingredients" to be sorted out by politicians. This language echoes that used by Joshua Reynolds in his explication of grand style in his *Discourses*: "[I]t is not the eye, it is the mind which the painter of genius desires to address; nor will he waste a moment upon those smaller objects which only serve to catch the sense, to divide the attention, and to counteract his great design of speaking to the heart."[44] As chief justice of the nation's high court, Marshall claimed authority to pass judgment on what the "grand outlines" were, thus placing himself in the role of Madison's "didactic critic," explaining what the narrative of America's Constitution is, and in the role of Reynolds's "painter of genius" in "speaking to the heart" in focusing on the grandeur and wisdom of the Constitution. L. H. LaRue argues convincingly that the reason why Marshall's opinions are so powerful is because they narrativize the Constitution as they theorize it, and the Constitution's own lack of narrative (aside from the Preamble, which Marshall quotes incessantly) necessitates this—according to LaRue, Marshall "showed us how to combine story and theory and thus re-create the Constitution. As a result, lawyers read Marshall, not the original. His voice is so powerful that it has replaced the voice of the original."[45] Marshall writes himself into the Constitution by transforming law into story and image. Henry James rightly pursued the secret of Marshall's character through gesture, as the visuality of expounding the Constitution enabled the judge's authority and connected it to new ways of thinking about the relationship between narrative, authority, and art. This network of relationships is the subject of the next chapter, a history of the "epic style" that Reynolds had espoused in Britain and that would shape the development of American art as a profession and a cultural institution.

Epic on Canvas

Despite the seeming ubiquity of "epic" in the literature of art history—including its popular manifestations, such as Robert Hughes's 1999 *American Visions: The Epic History of Art in America*—virtually no study has ever analyzed the historical meanings, uses, and evolutions of the term in art and art criticism. Only one historical investigation of the term seems to have been published, *Notes and Memoranda Respecting the Liber Studiorum of J. M. W. Turner, R.A.* (1879). This slim volume was a posthumous edition of fragmentary notes made by John Pye, a mid-nineteenth-century engraver and an early admirer of Turner's *Liber Studiorum*, a collection of prints (partly engraved by Turner himself) meant to show the range and scope of Turner's work. Turner had marked each of his plates using a generic classification system that he mostly explained: "H." for Historical, "A." for Architectural, and so on. Pye's interest in epic stemmed from the controversy over "E.P.," a designation that Turner evidently used as a subgenre of Pastoral ("P.") inspired by Claude Lorrain, but that he never defined. In the absence of an explanation from the artist, critics continually disputed whether "E.P." might mean Elegant, Elevated, or Epic Pastoral; Pye favored the latter. Pye's editor, John Lewis Roget, considered the merits of other candidates before commencing a series of

glosses of known uses of epic as an art term (Roget was the son of Peter Mark Roget, the compiler of *Roget's Thesaurus*). Roget concluded that Pye's interpretation is likely the correct one, and most Turner scholars have since agreed with Roget and Pye.[1] But why did Turner choose "epic" as a way of alluding to Claudian landscapes? And how did that idea compare to how other artists and art critics understood the term?

The stakes of Pye's interest in Epic Pastoral are in some ways representative for users of the term in art. As an engraver, Pye was excluded from membership in the Royal Academy, a fact he spent his career protesting. Turner was almost unique as an elite painter who unabashedly did his own engraving and who worked closely and knowledgably with Pye and other engravers. He was something of a hero for Pye, and explaining what heights of art could be achieved in engraving—even epic art!—could give the engraver just the ammunition he needed to convince the Royal Academy that his was not a mere trade but a legitimate art profession. Indeed, from the earliest appearances of epic as a British art term in the eighteenth century, most who used the term used it as a way of legitimizing the view that visual art was just as much a profession as authorship, an institution newly legitimated by the legal invention of copyright. At the same time, epic in art tended to attach to works that were in danger of not being recognized as elite, and the rapid decline of the posthumous reputations of "epic artists" such as Benjamin West and Thomas Cole highlights the pitfalls of blending popular and elite academic forms in the often uncertain process of art's professionalization. John Ruskin, one of Turner's greatest champions and a venerable tastemaker in mid-nineteenth-century art, despised Claude's idealism, and Roget points out that half of the few Turner prints that Ruskin considers worthless were designated "E.P." Roget in fact jokes that Ruskin's candidates for the "E." might have been "'Exploded,' or 'Effete,' or perhaps 'Engravers' Pastoral,'" emphasizing the sharp cross-media politics that shaped aesthetic debate at the time.[2]

Perhaps even more so than in literature, epic in art was a term that policed boundaries. When Thomas Cole, having been dubbed a producer of "epic" after his 1836 *The Course of Empire*, wrote an open letter to art critics in the *Knickerbocker* in 1840, he stated that the judicious critic "will not condemn this or that kind of picture, despising the landscape to prefer the historical painting"—a line that Cole was already famous for blurring. Yet Cole's critic would also "not fail, however, to acknowledge that some departments of art are more lofty than others: the epic, for instance, . . . may not be compared with the mere portrait of the human face."[3] Even for a genre bender like Cole, epic was a gold standard, perhaps

more a mode than a genre, but nevertheless the trump card in any art discussion. Cole's example of epic art was Michelangelo's ability to convey "one sublime idea," reflecting the canon established by Sir Joshua Reynolds as justification for the professional status of the Royal Academy. This chapter examines the uses of epic in art, particularly within the careers of artists like Cole, whose "epic" works have received more and earlier attention from literary critics than from art historians.[4] In the hope of opening further dialogue between these two disciplines, let us begin by straddling the Atlantic.

The Anglo-American Origins of Epic Painting

Benjamin West was the point of origin for the concept of epic art in America, largely because of his identity as a Pennsylvania-born artist. Despite spending most of his adult life in London and remaining a British subject his entire life, West sympathized with the American Revolution (carefully, because he was serving as George III's court history painter at the time) and stayed connected to Pennsylvania through patronage and a series of unsuccessful attempts to sell his works to institutions such as the Pennsylvania Academy of Fine Arts. Having trained in Rome with Anton Mengs, West began his career by focusing on classical subjects and a style associated with Italian depictions of antiquity. After attracting the king's attention with works such as *The Death of Regulus* (1768) and *The Death of Wolfe* (1770), West became not only the royal history painter but also the recipient of the commission of a lifetime. In 1773, George requested West to plan dozens of pictures representing the entirety of biblical history from Eden to the Apocalypse, to be displayed in a new royal chapel the king planned to build at Windsor as the English answer to the Sistine Chapel.[5] By the 1790s, West had risen to the pinnacle of the British art world, becoming the Royal Academy's second president in 1792 after the death of Sir Joshua Reynolds. However, by that time, West's style had begun to age as landscapists such as Turner and more emotive history painters such as Swiss émigré Henry Fuseli challenged the primacy of classical history painting, and West as its representative. West's art had always been known for its grandeur, but it was only at the first moment of serious challenge to West's reputation soon after his installment as President of the Royal Academy (P.R.A.) that anyone would speak of his art, at least in print, as being epic.

Fuseli and the American-born John Singleton Copley led a protest within the Royal Academy after one of West's admirers, a clergyman named Robert Anthony

Bromley, published the first volume of a treatise entitled *A Philosophical and Critical History of the Fine Arts, Painting, Sculpture, and Architecture* in 1793. In a chapter on historical and poetic painting, Bromley chose West's *Death of General Wolfe* (see fig. 7), his most famous work to date, as the most representative contemporary work in that genre, exhibiting "genuine historic spirit," "dignity of sentiment," and ability to "enlarge[] the compass of our feelings." After Fuseli and Copley accused the author of being partisan and ignorant and demanded that the Academy censure the book, Bromley launched biting counterattacks on both artists in a pair of open letters at the start of his second volume in 1795. After taunting Fuseli that his plans for opening a Milton Gallery would succeed because he knew so well *"that industrious crew"* that inhabited Pandemonium in *Paradise Lost*, Bromley singled out Copley as "the first, and if possible the most vehement" critic of the *Philosophical and Critical History*. He then followed by raising the stakes of his own critical principles, declaring that anyone who studied the ideas in the chapter on historical and poetic painting would conclude "that an historic painting, in that superior character which becomes epic, does not depend for the legitimacy or the sublimity of it's [*sic*] composition on matters of fact."[6] By choosing West's work as an exemplification of this point, Bromley now claimed more for *Wolfe* than he had before: the painting was not only an exemplar of the genre but of "superior character," indeed akin to epic.

But epic as a critical term was not only a defensive weapon in Bromley's hands. He went on to explain why Copley's own work was not proper for representing "epic principles." Beginning with Copley's painting of the *"squirrel,"* which initially established the painter's reputation in Britain, Bromley objected to so low a subject as an example of epic. The next example was more damning: Bromley cast Copley's historical painting *The Siege of Gibraltar* as an exercise in "celebrity," citing the series of high-profile exhibitions, the sale price, and the admissions fees that Copley's painting had brought to the artist, concluding, "[W]hy should we urge that picture as an illustration of *epic* principles? Surely it was not *those* principles for which the author contended, or which would at all come up to his contemplation." In fact, Copley's evident will to produce epic led Bromley to sarcastically classify *Watson and the Shark* as an example of a "new sort of epic," defined by *"bathos"* rather than sublimity, from the *"epic* boat" to the *"epic* shark."[7] Copley's work was not epic because Copley had given himself too much to self-promotion and financial gain to be capable of achieving epic. Bromley's concept of epic was tied to ideals of enlightened patronage rather than success on the open market, so that the fact that West's *Death of Wolfe* resulted in a court

appointment valued at £1,000 per annum did not disqualify either the painting or the painter (conveniently, West's defender failed to mention the huge profits that the sale of prints after *The Death of Wolfe* had raised). This sense of epic is just as forceful for what it excludes as what it includes; if West is to be defended and elevated, his rivals must be denigrated. West had become for Bromley, partly through negation, the embodiment of epic, in himself as well as in his art, and the conflation of art and artist would be a key element of West's developing reputation as a maker of epics.

When Bromley used the term "epic," he was operating within a still nascent usage of the term in British art criticism. While history painting had been established as a prestigious form with Alberti's seminal 1436 treatise *On Painting* and bolstered by André Felibien's work in the seventeenth century,[8] Jonathan Richardson, Britain's first major art theorist, was among the first to develop an analogy between this high form of painting and the most prestigious literary forms, the epic and dramatic, starting with his *Essay on the Theory of Painting* (1715). He described the painter's labor as requiring the same kinds of effort as those of the poet: "the painter must imagine his figures to think, speak, and act, as a poet should do in a tragedy, or epick poem." For Richardson, this analogy did not make the painter subservient to literary art but superior, as a result of his ability to produce multiple masterworks, "as his business is not to compose one Iliad, or one Æneid only, but perhaps many." Opposing his painter to the severe limits of poetic canons, Richardson argued that quantity and quality were not mutually exclusive, in part because a great painter's education was necessarily so extensive that "to be an accomplished painter, a man must possess more than one liberal art, which puts him upon the level with those that do so, and makes him superior to those that possess but one in an equal degree. . . . A Raphael therefore is not only equal, but superior to a Virgil, or a Livy, a Thucydides, or a Homer."[9] Even more so than for the poet, epic was a matter of accumulation for Richardson's painter.

The counter-canon that Richardson offers, with Raphael as the best of the great artists vying (successfully) with the best of the epic poets and historians, would be revised by the late eighteenth century when Joshua Reynolds placed Michelangelo atop the pantheon in his *Discourses* given before the Royal Academy.[10] Nevertheless, the core of Richardson's ideas about the relationship between painting and literature, including the hierarchies he both contested and created, would govern the thinking of Reynolds and the academy of which he was the first president.[11] Reynolds asserted in his fourth *Discourse* that the

"Roman, the Florentine, [and] the Bolognese schools . . . have deservedly obtained the highest praise. These are the three great schools of the world in the epic style." Reynolds did not feel the need to define what he meant by epic, using the term rather as a talisman to legitimate the principles of painting that he most admired, using the "great purposes of painting" to stand in relief from the "inferior qualities" of Venetian, Dutch, and other traditions.[12] By the time West's work began to be recognized as epic, the term held little specific meaning in art but had considerable rhetorical weight, particularly within the Royal Academy. West himself would contribute to forming clearer definitions of the term, even as those definitions would influence the succession of rises and falls that West's work would suffer in the years ahead.

Despite Bromley's efforts to defend West, the P.R.A.'s status did not improve over the next decade. At aesthetic odds with an increasing number of Royal Academy fellows, West also found that his political leanings aroused suspicions, even in the king. West not only supported the French Revolution but took advantage of a brief peace with France to exhibit an early version of *Death on the Pale Horse* in Paris in 1802, gaining a personal audience with Napoleon during his visit. At the same time, he continually admitted American art students into his studio, including John Trumbull (cousin of the Connecticut Wit of the same name, he had served on Washington's staff during the Revolution) and Charles Willson Peale, an inveterate Jeffersonian democrat with whom West maintained a lifelong correspondence. He was even known to associate with the radicals Thomas Paine and Joel Barlow when they were in Britain.[13] The man who had become known in 1760s London as "the American Raphael"[14] did not seem British enough for the Royal Academy or for its royal patron. West was forced to resign as P.R.A. in 1805, but world events would quickly give him a chance to redeem himself. Lord Nelson's death at the Battle of Trafalgar in October 1805 set off an unprecedented wave of mourning, memorializing, and capitalizing on the need for public memory in Britain. Or almost unprecedented: of the dozens of engravings produced of Nelson's finest moment, many took their visual cues from *Wolfe*, even as Nelson's eulogists compared his sacrifice for the nation's salvation to General Wolfe's.[15] Josiah Boydell, the nephew and successor of the publisher John Boydell that had produced William Woollett's lucrative engraving of *Wolfe* thirty years before, announced a competition for the best painting of Nelson's death, which would be engraved in "the size and manner of the Death of General Wolfe."[16] James Heath, a London engraver, was clearly thinking along the same lines as Boydell when he approached West personally to arrange for a painting that

would be engraved for mass consumption; West would retain the painting, pay Heath for the engraving, and share the profits. Short on income and stinging from his ouster, West agreed. And he would now take on the title of epic as his own.

West's *Death of Lord Nelson* (1806) was indeed a monumental work that sold thousands of prints and created a sensation in West's studio, where he exhibited it alongside a copy of *Wolfe*. In the only year that West did not exhibit at the Royal Academy since its opening in 1768, the artist estimated that thirty thousand people came to see the painting in just over a month, and the royal family requested a private viewing soon after.[17] West won back his elite audience by turning to his larger public, the public that had grown up with prints of *Wolfe* hanging in their homes and recognized West's work as a kind of brand-name celebration of heroism. But the success of *Nelson* (see fig. 8) was also a jab at the Academy for its betrayal. Academy member Joseph Farington recorded in his diary that West had said that "it had been a great motive to induce Him to paint that picture 'the Death of Lord Nelson,' to shew the Academy what they had done in causing the author of it to withdraw himself."[18] The Academy's new president, architect James Wyatt, was proving to be an administrative failure, and the sudden rise in West's popularity among London audiences led to his reinstatement as P.R.A. the same year that *Nelson* appeared. And when West exhibited *Nelson* at the Academy's 1811 exhibition, he included in the exhibition catalog a statement touting his ability to paint in the greatest of forms: "Mr. West, conceiving that such an event demanded a composition every way appropriate to its dignity and high importance, formed it into an Epic Composition. This enabled him to give it that character and interest which the subject demanded."[19] *Nelson*'s epic nature was both the product of and the answer to West's bitterness at his treatment by his contemporaries, as well as the beginning of his refashioning himself as a painter of the nation, not for the crown but for the crowds—at least the bourgeois crowds.

A frequently reprinted London newspaper item announcing the completion of West's *Nelson* in 1806 effused, "The picture is truly epic, for it combines a perfect history of the battle with such a burst of passion as to arouse every generous emotion of the soul."[20] The combination of "perfect history" and "passion" here contributes to a new, more popular style of history painting, one that moves away from the sculptural aesthetic of Richard Wilson's *Niobe* or Reynolds's history paintings to an emotionally evocative piece, in keeping not only with the work of academic artists like Turner but also popular painters like the controversial John Martin. Epic indeed became the standard for West's own comparison of his work with that of his competition, just as it had been for Bromley over ten years earlier.

West's response to seeing Arthur William Devis's *Death of Nelson*, the painting that won Boydell's competition, revealed both West's own ideas about epic and the term's potential as a weapon in art criticism. While he admitted that the work had "much merit," his viewing Devis's more realistic portrayal of Nelson's death in the cockpit of the *Victory* rather than on its deck "convinced him that there was no other way of representing the death of a Hero but by an *Epic* representation of it. It must exhibit the event in a way to excite awe and veneration." In order to explicate his meaning of epic and Devis's failure on that count, West read his concept of epic back into his early work: "Wolfe must not die like a common soldier under a bush; neither should Nelson be represented dying in the gloomy hold of a ship." According to West, realism must give way to "spectacle" to "raise and warm the mind," a spectacle with a pointedly pedagogical quality: "No boy . . . would be animated by a representation of Nelson dying like an ordinary man. His feelings must be roused and his mind inflamed by a scene great and extraordinary. A mere matter of fact will never produce this effect."[21] West's version of epic was not for adult consumption only, but was to have at least as much of an influence on the young.

But this kind of education trades a certain level of cultural awareness—every middle-class boy in England could learn how to understand British history through West's paintings—for academic prestige, leaving open the question of how West's own memorial making would be remembered. Even as West made a bid for universal, cross-generational appeal, he anticipated the fate of works such as John Trumbull's *Declaration of Independence*, Leutze's *Washington Crossing the Delaware*, and even West's *Penn's Treaty*. Each of these works would be reproduced endlessly through the nineteenth and twentieth centuries in the United States, often as showcases for new technologies in industrial reproduction and almost always marketed to families or their younger members. These pictures have become iconic, but at the price of celebrating their cultural importance and instant recognizability far above their artistic merit. If West intended his notion of epic to establish his own preeminence as well as that of history painting in modern culture, his own work and those of his students and admirers served to make the genre both ubiquitous and trite: epic could go anywhere, thanks to popular demand and inexpensive means of meeting that demand through engraved reproductions, but those endless travels also bred critical contempt through familiarity. The slippery boundary between prestige and popularity, a common dilemma for authors from Cooper to Longfellow, was perhaps manifested most dramatically in the career of Benjamin West.

West's Panoramic Turn: The Late Paintings

Despite its resounding reception during the Napoleonic era, West's *Death of Nelson* has faded into near oblivion among art historians studying his late works, partly owing to a new direction his work took after 1810, when George III retracted the Windsor Chapel commission, leaving West with no steady income and almost four decades' worth of religious paintings on his hands.[22] West again turned to his public for support, and the three works that dominate West's late period were designed to amaze massive audiences: *Christ Healing the Sick* (1811, 1817), *Christ Rejected by the Jews* (1814), and *Death on the Pale Horse* (1817).

By this point in West's career, epic was becoming a standard term for describing his work in the press. A frequently reprinted review of *Christ Healing* highlights one of these contradictions: "Boldly conceived and appropriate in all its parts, it appears strictly conformable to the invariable truths of Epic composition, which the greatest painters have received from the most celebrated poets."[23] Even before *Christ Rejected* was completed, several magazines and newspapers on both sides of the Atlantic reprinted a gossip item indicating that "Mr. West has for some months been engaged on a grand epic painting." The item asserted, "It certainly has not, as a grand epic picture, any superior in England," comparing the work to famous works by Reynolds, James Barry, and even West's own earlier pictures. The ultimate proof of the work's success as an epic, however, was its price; the cost of *Christ Healing the Sick* (see fig. 9) was well known in Britain, and the article compares *Christ Rejected* to its predecessor in mentioning that "in this age of speculation, . . . we are not surprised that the painter has already been offered by some dealers ten thousand guineas for this *chef d'oeuvres*, or seven thousand guineas and the profits of the first season"; to gauge the likely value of the second offer, the article repeats the rumored figure of 13,000 guineas in admission fees and print subscriptions the British Institution received for the earlier work.[24] West had in fact sold the first version of *Christ Healing the Sick*, a picture intended as a gift to the Pennsylvania Hospital in Philadelphia, as the first acquisition of the British Institution. The forerunner of the National Gallery, the British Institution paid a well-publicized 3,000 guineas for the first *Christ Healing*, a record for a new work.[25] The second version was a commercial success in the United States as well, attracting such huge crowds that admission fees paid for the "picture house" the hospital had constructed for viewing the painting, as well as providing $25,000 toward the hospital's general funds by 1843.[26] And fame and sales had become mutually reinforcing, as around the time

that the record sale of *Christ Healing the Sick* was made public, one contemporary recalled that "the usual address about the weather was forgotten, and 'have you seen the picture?' became its substitute."[27] Bromley had defined West as epic in opposition to the money-attracting work of his rivals in the 1790s (despite West's own commercial success by that time), but by the end of West's career, epic had become for his admirers a matter of money as much as anything else—if it could draw the crowds and open their purses, it was epic.

Still set against the monetary success of the Christ paintings, however, was their unique effect on their viewers. As thousands processed through West's studio to view *Christ Rejected* (see fig. 10), viewers would spontaneously remove their hats before the sight of the Savior in chains, giving himself over in the ultimate sacrifice.[28] This had happened once before in West's career, with *Nelson*, when the "awe and veneration" that West had argued was the core of his epic style led people to uncover their heads in the artist's studio as they saw their nation's hero in a *pieta* pose related both to the familiar *Wolfe* and to the Italian Masters' iconography of Christ that West had popularized in his death paintings.[29] Jane Austen wrote that the figure of Jesus in *Christ Rejected* was "the first representation of our Saviour which ever at all contented me."[30] Viewing the Philadelphia version of *Christ Healing*, Richard Nisbet, a scrivener plagued by schizophrenia and one of Benjamin Rush's favorite mental patients, wrote his own phantasmagoric interpretation of the painting (he also wrote an unpublished epic poem, *The Notioniad*, during his twenty years' confinement in the hospital).[31] The kind of absorption that viewers reported experiencing in front of West's religious works was precisely the kind of effect he had described hoping for in his earlier comments about *Nelson*'s epic quality.[32]

At the same time, West's own ideas about epic evolved as he worked on his depictions of Christ. The original exhibition catalogue to *Christ Rejected* emphasizes the multi-narrative sense of West's epic: "For such a subject an Epic composition was demanded; for it seemed every way proper, that the principal characters in the history, as well as the Divine Chief himself, should be brought together on the canvass." However, those narratives had been carefully selected not for historical accuracy but to evoke the most powerful emotional reaction possible: "There are introduced into the Picture incidents which the Epic demands, such as the sorrow of St. Peter, the attachment of Joseph of Arimathea, &c." Part of the power of this selection, however, is its presentation precisely as an academic rather than a sentimental choice; the catalog explains that the subplots were chosen "so that the spectator has before him every object necessary to the explanation and

Figure 7. Benjamin West, *The Death of General Wolfe.* 1770. Oil on canvas. 152.6 × 214.5 cm. Transfer from the Canadian War Memorials, 1921 (Gift of the 2nd Duke of Westminster, England, 1918). National Gallery of Canada, Ottawa (no. 8007).

Figure 8. Benjamin West, *The Death of Lord Nelson.* 1806. Oil on canvas. 182.5 × 247.5 cm. Accession no. WAG3132. Courtesy of National Museums Liverpool [The Walker Art Gallery].

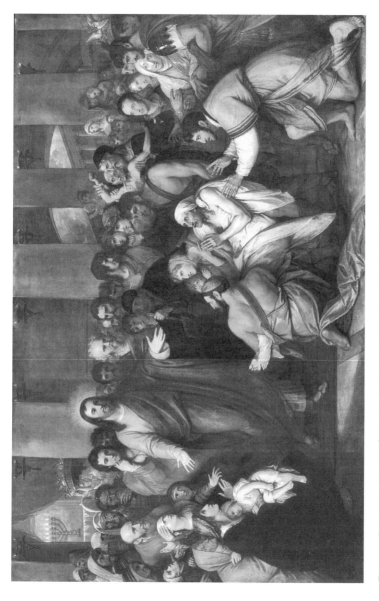

Figure 9. Benjamin West, *Christ Healing the Sick in the Temple.* 1817. Oil on canvas. Courtesy Pennsylvania Hospital Historic Collections, Philadelphia.

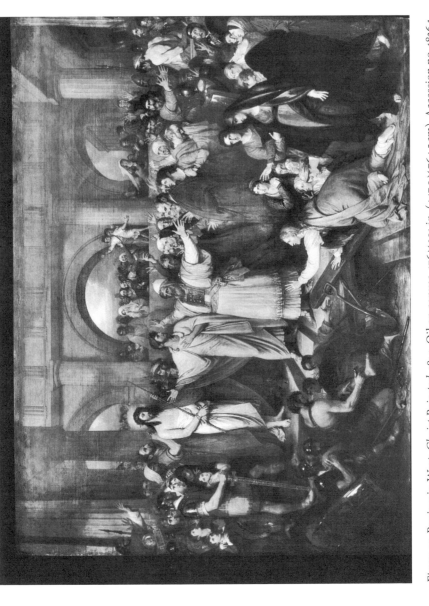

Figure 10. Benjamin West, *Christ Rejected*, 1814. Oil on canvas. 176 × 301 in. (447.0 × 764.5 cm). Accession no. 1836.1. Courtesy of the Pennsylvania Academy of Fine Arts, Philadelphia. Gift of Mrs. Sarah Harrison (The Joseph Harrison Jr. Collection).

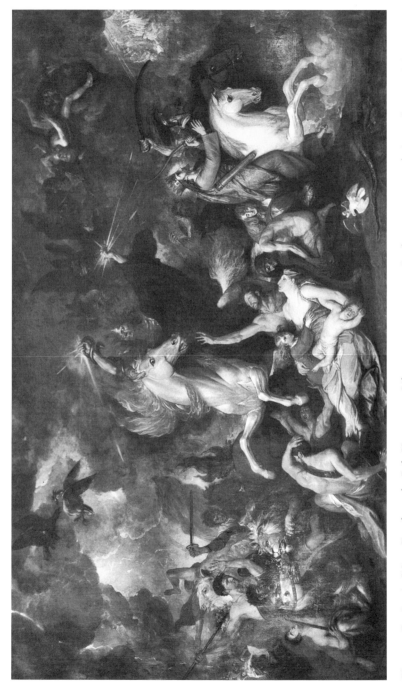

Figure 11. Benjamin West, *Death on the Pale Horse*, 1817. Oil on canvas. 200 × 260 in. (508.0 × 660.4 cm). Accession no. 1878.1.9. Courtesy of the Pennsylvania Academy of Fine Arts, Philadelphia. Pennsylvania Academy purchase.

unity of the story."[33] In *Christ Healing the Sick* and *Christ Rejected*, the telescoping of multiple narratives into a single canvas allowed for a display of technical mastery, but it also condensed the emotional effect of the increasingly popular panorama form, West's competition on the other end of the artistic spectrum from his Academy rivals. For West, epic was becoming the form that challenged the stillness of painting, telling an entire story through one carefully orchestrated moment.

Such a multi-narrative strategy was nowhere more evident than in West's last major work, *Death on the Pale Horse* (see fig. 11). The painting actually depicted all four horsemen, in addition to other scenes and images from St. John's Apocalypse. However, by the time West undertook the final version, his health was failing, and he had to enlist his sons to help him finish some of the figures as his hands were wracked with gout. The picture is much more sketched out and raw than any of West's other major works; one horseman's arm even reveals the outline of the original scimitar that West had used in earlier versions, but in this case it had been abandoned for a straight sword. Critics marveled at the complexity and the sublimity of the painting, but no one called it an epic in West's lifetime. William Carey, an aspiring British art critic, undertook to write his own catalogue of the painting, and he used epic as an analogy to defend West's picture, arguing that monumental works were not intended to be as carefully finished as miniatures, as epic poems were not crafted like lyrics. In fact, Carey pointed out that whatever defects there were in such an ambitious work put West in illustrious company: "The greatest Poets and Painters of past ages have, in their most admirable performances, showed an inequality. If HOMER, VIRGIL, MILTON, MICHAEL ANGELO and RAPHAEL, have had their less happy moments, and been negligent or feeble in particular instances, who can hope to produce a faultless performance."[34] As usual, West is compared only to epic poets and artists associated with epic form.

In his biography of West, published in the year of the artist's death in 1820, the Scottish novelist John Galt gave the following peroration: "As an artist, he will stand in the first rank. His name will be classed with those of Michael Angelo and Raphael; but he possessed little in common with either. As the former has been compared to Homer, and the latter to Virgil, in Shakespeare we shall perhaps find the best likeness to the genius of Mr. West."[35] The praise Galt lavishes on his subject has become infamous among art historians, and one later West biographer has referred to the quotation above as "the often-quoted, embarrassing passage."[36] If Galt exaggerates in his praise, though, there is a pointed politics

in his exaggeration. Galt might have been thinking of Henry Fuseli's Royal Academy lectures in his choices of comparison; Fuseli, then professor of painting at the Academy, had lauded Michelangelo as a practitioner of the "Epic," pointing to the Sistine Chapel as evidence of Michelangelo's astonishing powers of invention. Fuseli, however, saw Raphael as an artist of the "Dramatic," thus aligning him with Shakespeare.[37] Most important, by shifting Shakespeare from Raphael's counterpart to West's, Galt made to nationalize his subject, so that he could stand for Britain's cultural accomplishments, but also so that political questions of West's status as an Englishman might be laid to rest. West was the "American Raphael," not the British Raphael. While West had spent almost all his adult life on the island of Britain, his civic identity was still a puzzle to his British critics. Shakespeare was thus a crucial choice for Galt: West could be epic without being Michelangelo, and he could be English without being Sir Joshua Reynolds.

Ultimately, the use of epic as a concept in West's work was driven by ideas of economics, affect, and popularity more than elite aesthetic concerns. Epic was about making, remaking, and preserving a career for West, and the claim in the above item for West's discursive quality speaks as much to the domination of narrative forms such as the book and the panorama in the marketplace as it does to West's own interests in composing his canvases. These contradictions between epic's cultural capital and its marketplace realities would hold true for American artists for the half century following West's death.

Inheriting Epic: Allston, Morse, and the Import(ation) of Epic

While West's views on epic were largely confined to table talk and London exhibition catalogs during the nineteenth century, critical notices of West in British periodicals were eagerly reprinted and read by American audiences who longed to see international recognition of national artists; in fact, I have cited all of the above periodical quotations about West's paintings in American reprints, which usually (though vaguely) gave credit to their British sources. In addition to learning from the British to equate West with epic, Americans were also eager to exhibit West's work in the United States, and the Pennsylvania Academy and West spent almost twenty years courting each other—though West wanted a sale while the Academy's board wanted a gift. West's sons offered to sell the artist's entire remaining collection after his death to the United States government to serve as the core of a version of the British Institution, but Congress declined the offer.

Where West's influence appeared most strongly in the antebellum United States (aside from prints of *Wolfe*, *Penn's Treaty*, and other popular works) was in the cadre of students that he had mentored in his London studio: Trumbull, Peale, Gilbert Stuart, Mather Brown, Robert Leslie, and Washington Allston all spent formative years under West's guidance.

Trumbull had used the prestige of his association with West to form and lead the American Academy of Art in New York, founded in 1802; his later commissions for the US Capitol's rotunda were likely due to the prestige both of his training and of his own works, such as the 1784 *Battle of Bunker Hill*. Peale translated the prestige of his West connection into his museum of American portraits and natural history in Philadelphia. But the only one of West's students whose work critics called epic was Allston. In a letter presenting his catalog of *Death on the Pale Horse* to the Pennsylvania Academy, William Carey declared Allston's Milton-inspired *Uriel Standing in the Sun*, which had just won first prize in the British Institution's 1818 exhibition, to be "an epic composition, breathing the spirit of Milton."[38] Such praise would have gratified the Academy's board, which two years before had mortgaged its building to pay for its first large-scale canvas, Allston's *The Dead Man Restored to Life by Touching the Bones of the Prophet Elisha* (1814); the only other work that the Academy would ever go to such lengths to acquire would be West's *Death on the Pale Horse*, almost twenty years later.[39]

Allston's rise to prominence coincided with Congress's announcement of its intent to commission large history paintings for the dome of the new capitol building in Washington.[40] The politics around the commissioning committee were fierce, and among favorites such as Trumbull and Allston arose younger, ambitious artists, perhaps none as ambitious as one of Allston's few students, Samuel F. B. Morse. As one of the few college-educated artists of his generation in the United States (Morse had attended Yale), the young American initially pursued epic as his goal as an artist with intellectually challenging works such as *The House of Representatives* (1823) and *The Gallery at the Louvre* (1833), and when his career as a painter faltered, he became one of the most learned and articulate apologists for the fine arts as a profession in America. Morse would finally stop painting altogether after he failed to gain one of the last Capitol rotunda commissions in 1837.[41] Morse's own work would never attain the epic status he dreamed of—at least not until his work on the telegraph was lauded in William C. Richards's poem *The Electron; or the Adventures of the Modern Puck: A Telegraphic Epic of the Times* in 1858. Morse had failed in his ambition of adorning the

Capitol with his art, but his larger vision for sharing information would be realized on a global scale.

Rather than following West's example and offering the public a more accessible and commercially viable kind of art, Morse focused his efforts in the 1820s on building the standing of art as a cultural institution within New York's professional worlds. Together with figures such as Asher B. Durand, Thomas Cole, and William Cullen Bryant, Morse organized the National Academy of Design in 1826 and served as its first president on the strength of one of the most prestigious portrait commissions of the decade: a portrait of the Marquis de Lafayette, funded by City Hall in honor of the war hero's return visit to the United States in 1824. Morse cast himself as a patriotic artist at the helm of the National Academy, which faced fierce opposition from Trumbull and his merchant-dominated American Academy.[42] After a vaguely accusatory speech by Morse set off a fiery exchange between him and Trumbull in the press, Morse chose to take the intellectual high ground by offering a series of lectures on the arts at another new institution, the New York Athenaeum (Trumbull had earlier declined an invitation to deliver a similar series there).[43] Aware that he was the first artist to give such a series in the United States, Morse sought to absorb and condense all the most influential theories of painting and the sister arts, drawing on Reynolds's *Discourses* and the works of Fuseli, Opie, Barry, West, and other important British critics, in addition to older European authorities such as Da Vinci and Algarotti. His extensive research notes, preserved in the archives of the National Academy, show that he was familiar with many theories of epic in art, such as Fuseli's three forms of Epic, Dramatic, and Historic composition, and that he used epic as a concept to flesh out his comparisons between painting and art.

In one example, he copies a passage from Kames's *Elements in Criticism* in which Kames argues that "fable operates on our passions, by representing its events as passing in our sight, and by deluding us into a conviction of reality."[44] Kames wrote this in a discussion of the unique traits of epic and dramatic compositions, and Morse reads the context into a narrower meaning of Kames's remark: he replaces "Fable" with "Poetry" and inserts the word "epic" before "Poetry" later. He follows Kames's sentence in his notes with the statement "so in painting." Morse next synthesizes Kames's ideas for a proper epic subject ("a noted event taken from History") with those of other critics, insistently repeating below the paragraph "So in Painting." Some of his notes on epic are of a more explicitly literary cast, as when he records evaluations of heroic meters and Kames's

analogy of an epic composition to a complete sentence; to the latter, Morse added in brackets, "has this a parallel?"[45] Morse even offered his own take on the debate over the level of detail in epic painting by offering his own definition: "In the epic, which is the highest class of Painting, the effect is produced by a more severe selection and rejection of objects, and parts of objects, but having made the selection, down to the minutest fold of the drapery, I can perceive no reason why all that is adopted should not be mechanically imitated with exactness."[46] Morse makes a dialectic move in advocating a democracy of mimetic detail, but predicated on a "severe selection and rejection" in the composition process. Morse's epic is that of an enlightened republic, supportive of democracy but wary of lost control and declining standards. This definition of epic stands between two worlds: the elitism of Reynolds and the populism of the panorama. While few of Morse's ideas in his lectures were new, he synthesized a remarkable array of sources and presented them for an educated lay audience in a country where few academic treatments of art had been offered with the public in mind. As biographer Paul J. Staiti has pointed out, Morse's lectures were designed both to elevate painting to equal status with poetry, architecture, and arts valued in the new nation and to present a less antagonizing case for public support of the visual arts than in his earlier lecture that had drawn Trumbull's ire.[47]

Given in the spring of 1826, Morse's lectures became a staging point for American artists to make bold intellectual claims for their own works. Morse himself was not averse to using the Royal Academy's own critical principles to endorse his academy's artists. In an anonymous review of the 1827 National Academy exhibition, he went so far as to arrange Fuseli's scheme for the hierarchy of forms into a table for his readers' reference (see fig. 12), citing Fuseli for the definitions of forms such as epic and historical landscape. Morse would not have been unique in presenting Fuseli's notion of epic as "the loftiest species of human conception" to an American public; British reviews of the artist's Royal Academy lectures, including summaries of key points, were reprinted in American magazines well into the nineteenth century, as later British lecturers such as Henry Howard would be reprinted in the 1840s and onward.[48] The significance of Morse's review is his willingness to map Fuseli's concepts onto individual American works. Working through the hierarchy, Morse writes, "In the highest class of epic, we find no attempts [in the exhibition], nor did we expect them. In the dramatic we find Dunlap, Marsiglia, and Durand."[49] Little did Morse realize that the artist who would achieve American epic art was already in the National Academy and

had in fact been "discovered" by two of Morse's dramatic artists in company with his archrival, Trumbull.

Characterizing Thomas Cole

That Cole would become the first American resident to receive the epithet "epic" is hardly surprising given the place in the narrative of American art he had been given in the mid-1820s. The story of Cole's discovery is the stuff of art-historical legend: after a member of the American Academy bought a picture in 1825 for $25 and arranged for other works to be displayed at a New York art dealer's shop, the 24-year-old Cole was discovered—simultaneously, in some versions—by Trumbull, Dunlap, and Durand.[50] The discovery, by Dunlap's early newspaper account in November of that year, amounted to a generational shift. In that version, Trumbull told the art dealer, "I am delighted, and at the same time mortified. This youth has done at once, and without instruction, what I cannot do after 50 years' practice."[51] Later versions of the story would leave those words virtually unchanged.[52] They proved to be prophetic, as Cole's choice to exhibit his works at the National Academy instead of Trumbull's American Academy contributed to the latter organization's demise, but even in 1825 the notion that a new artist had been announced by none other than West's famous student had a messianic ring to it, and the narrators of the discovery story were careful to point out or even invent similarities between Cole and West. Dunlap held up Cole as an "American boy" (he miscalculated Cole's age as 22) in competition with "the first European masters," hailing his "untutored and unknown" background from "the interior of Pennsylvania."[53] All these details paralleled John Galt's account of West's early life in the 1820 biography, and not by coincidence. The heir to West had been found, and he had appeared as a landscape artist, representing the most distinctively American subjects in a distinctively American manner.

Or at least that is how the story has run. The first pictures encountered by Cole's New York enthusiasts were indeed landscapes of the Hudson River area, but his admirers Americanized both the artist and his subject matter (in West's image) beyond either the facts or Cole's likely intentions. Cole was in fact a relatively recent immigrant, having arrived in Philadelphia with his family from Lancashire, England, in 1818, when Cole was already 17 years old. Having grown up at the epicenter of Britain's Industrial Revolution and left his homeland owing to his family's financial hardship, Cole worked as an itinerant artist in Ohio before

relocating to Philadelphia in 1823 to launch a professional art career in an urban market.[54] While little is known of Cole's years in England, biographers often point to his voracious reading of English poetry (especially Milton on through the Lake Poets) and his own poetic compositions, which he started before the age of 20.[55] Cole's literary bent would translate well into the style of landscape that he developed through the influence of Claude Lorrain, J. M. W. Turner, John Martin, and contemporary theorists of the sublime, beautiful, and picturesque.

Although his literary interests have been well documented—thanks in part to Durand's influential memorialization of Cole as painter-poet alongside William Cullen Bryant in *Kindred Spirits* (1849)—Cole's time in Philadelphia has been overlooked as an influence on his later career. While developing his abilities as a landscape artist and exhibiting a landscape at the Pennsylvania Academy in 1824, he also spent time copying casts in the Academy's teaching collection and would have been exposed to large-scale works such as Allston's *Dead Man Restored*.[56] Cole would continue to exhibit at the Pennsylvania Academy for most of his life, both landscape and historical works, and his development during the two years before his arrival in New York City shows that he rarely separated landscape work and more ambitious figural compositions from the beginning of his career. In fact, while his *Kaaterskill Falls* and *Lake with Dead Trees* impressed New York art critics in 1825, he was simultaneously exhibiting a now-unlocated work at the Pennsylvania Academy's annual exhibition, with the title *Christ Crowned with Thorns and Mocked*.[57] William H. Truettner has described the history of Cole scholarship as "the problem of the two Coles,"[58] in which celebrating Cole as a pure, American landscape artist fails to account for his repeated forays into history painting, often in mixed genres and produced simultaneously with notable landscape works. Cole's time in Philadelphia shows that this dichotomy between Cole's landscape work and his historical works existed much more for Cole's contemporaries than for the artist himself.

Cole in fact seems to have had an idea of blending the two traditions of painting early in his career, when he wrote his patron Robert Gilmor in 1826 that he desired to execute "a higher style of landscape," soon after he completed work on both a historical landscape for Gilmor depicting a scene from Cooper's *Last of the Mohicans* (one of several Cole would paint in the 1820s, for a variety of patrons) and a daring pair of biblical scenes, *Eden* and *The Expulsion from Eden*, produced on speculation and displayed at the 1828 National Academy exhibition.[59] Both the *Mohicans* landscapes and *The Expulsion from Eden* (see fig. 13) portrayed human figures dwarfed by an imposing landscape. While the Cooper

scenes drew from scenery Cole had viewed in the White Mountains, he used exotic elements for his *Expulsion*, including a tropical garden and an erupting volcano. In both scenes, high and low come together in a panoramic construction that seems both to follow academic conventions of historical landscape and to abandon the traditional decorum of Claude's scenes.

One source of Cole's rebellion from previous canons can be traced to the kinds of influences he chose—not only in terms of genre, but in terms of medium. Recent critics have noted Cole's debt in his *Expulsion* to John Martin's *Paradise Lost* illustrations (see fig. 14), which first appeared in 1825, using extreme chiaroscuro effects and almost shockingly deep perspectives in a series of twenty-four illustrations available both as mezzotint prints and in illustrated book form alongside the text of the poem.[60] The same gallery that had introduced Cole's work to Trumbull and his colleagues also carried Martin's prints, and the similarity between the *Paradise Lost* engravings and Cole's *Expulsion* led one New York critic to accuse Cole of plagiarism.[61] However, the influence of "*Pandemonium Martin*," as Cole's detractor called him, on the younger artist is a complicated one that has never been appreciated by art historians. Like Durand in the United States, Martin was trained both as a painter and as an engraver, and he executed his *Paradise Lost* pictures exclusively in mezzotint, bypassing the usual canvas-to-engraving practice to make an epic cycle of pictures for a middle-class audience, in small scale but made to look like reproductions of much larger works. Cole was not a product of the academic genealogies of Trumbull and Morse, and his haphazard apprenticeship in art had familiarized him with a number of media that would have been considered below the dignity of a professional painter (though still usually considered professional artwork). His first recorded commission in America had been a set of woodcuts for an 1818 Philadelphia edition of John Bunyan's *The Holy War*, and he might have learned to depict the volcano in the *Expulsion* while painting transparencies for public spectacles in Philadelphia.[62] At the same time, he absorbed the vocabulary and aesthetic values of academic composition both from examples such as Allston's work and from the major art theorists of the day. As recent critics have pointed out, the core of Cole's self-understanding as an artist, like the image of Cole in the rose-tinted biography by his friend Louis Legrand Noble, is based on the ideal of a poet-painter, an artist who has available to him every possible device, be it high or low, that allows him to capture the quintessence of his thought.[63] While Cole's association with landscape made it difficult for critics to classify many of his works, the critical narrative of Cole following in the line of West allowed for a solution to the classification

problem. While his pursuit of "higher style" that led to his epic status was in fact a form of rebellion from professional classifications, critics' use of the word "epic" to describe Cole's work may have been as much an attempt to categorize the artist as it was to valorize him.

The first of Cole's works that critics dubbed epic was *The Course of Empire* (see fig. 15), his most famous work today. The set of five canvases relates a cyclical narrative of rise and fall of human civilization, syncretically incorporating Native American tipis, Greek and Roman architecture, a Stonehenge construction, and other "ancient" traditions against a backdrop of picturesque landscape that stays remarkably fixed. Though the perspective changes in each

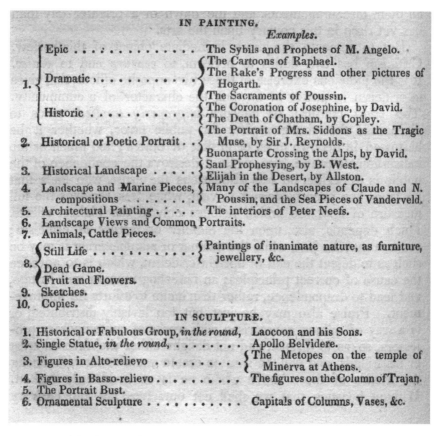

Figure 12. Table of genres from Samuel F. B. Morse, "The Exhibition of the National Academy of Design, 1827." *United States Review and Literary Gazette* 2.4 (July 1827): 1–23, 4.

Skillman Library, Lafayette College.

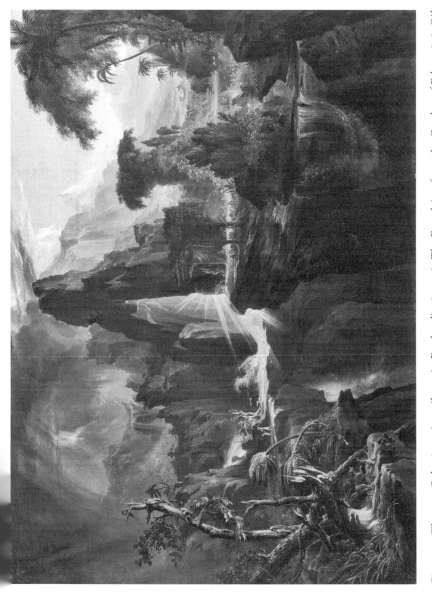

Figure 13. Thomas Cole, American (born in England), 1801–48, *The Expulsion from the Garden of Eden*, 1828. Oil on canvas. 100.96 × 138.43 cm (39 ¾ × 54 ½ in.). Museum of Fine Arts, Boston. Gift of Martha C. Karolik for the M. and M. Karolik Collection of American Paintings, 1815–65. 47.1188. Photograph © 2012 Museum of Fine Arts, Boston.

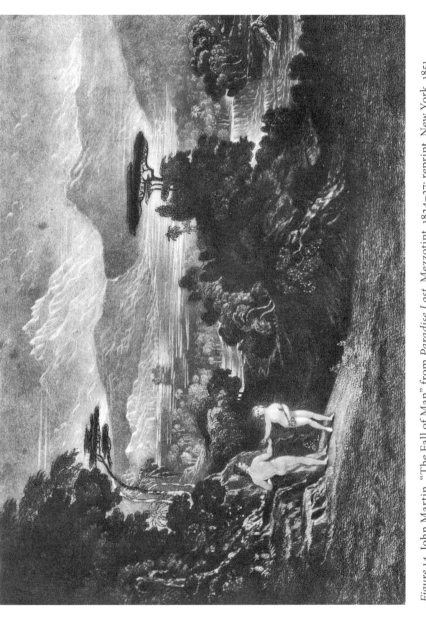

Figure 14. John Martin, "The Fall of Man" from *Paradise Lost*. Mezzotint. 1824–27; reprint, New York, 1851. Following p. 334. Author's copy.

Figure 15. Thomas Cole, *The Course of Empire*, 1836. Oil on canvas. Accession no. 1858.1-5. Collection of the New-York Historical Society.

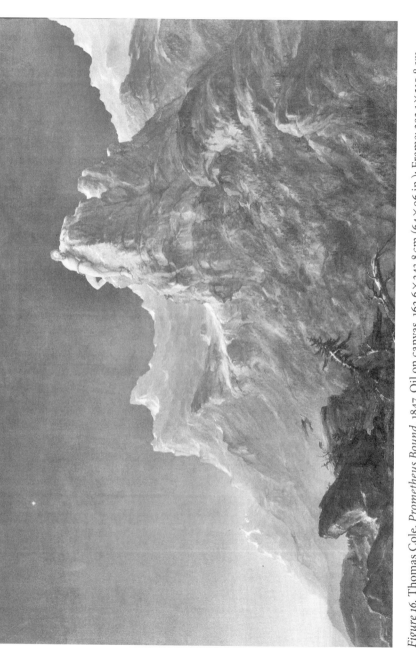

Figure 16. Thomas Cole, *Prometheus Bound*, 1847. Oil on canvas. 162.6 × 243.8 cm (64 × 96 in.); Frame: 292.1 × 210.8 cm (115.0 × 83 in.).

Fine Arts Museums of San Francisco, Museum purchase, gift of Mr. and Mrs. Steven MacGregor Read and Joyce I. Swader Bequest Fund, 1997.28.

picture, landmarks such as the bay and the distinctive mountain peak show that each stage of civilization is unfolding in the same landscape as before—the landscape remains intact in the final image, *Desolation*, as a critique of the narrative of human progress and its related justification of the erasure of nature. Newspaper items announcing the exhibition of *Course of Empire* referred to the series as a "beautiful epic," a "grand moral epic," and each canvas "as perfect in itself as a single book of a finished poem."[64] While the work did not produce as much income as Cole had hoped—Luman Reed, the patron who commissioned the cycle, had died while Cole was still at work on the series—the public reaction to the *Course of Empire* encouraged the artist that such ambitious works could find a popular audience.

One of the reasons why so many critics found *Course of Empire* to be "epic," and also book-like, was its intense engagement with literature; Cole took his title from Berkeley's famous poem and drew on extensive reading in the history of world empires, publishing the series with a motto adapted from Byron's *Childe Harold's Pilgrimage*: "First freedom, and then glory; when that fails, / Wealth, vice, corruption."[65] Cole adds the end of empire to Byron's narrative, which in the original concludes with "barbarism." Cole's *Course* clearly follows as its central idea what Byron says by way of summarizing his universal narrative: "History, with all her volumes vast, / Hath but *one* page."[66] Working in a medium in which any narrative was confined to one page, or canvas, Cole took West's multinarrative practice closer to the logic of the moving panorama, which would dominate American visual entertainment by the late 1840s:[67] a series of "pages," by closing in on itself, enacts the narrative it describes while reducing that narrative back to the single idea, the single image, so that the diversity of Cole's cycle actually leads to greater unity of impression. For all its critique of martial prowess and the building of monuments to human glory, *The Course of Empire* amounted to a work that celebrated its creator's heroism while rejecting the ultimate significance of heroic action in history.

The Voyage of Life: Epic in the 1840s

If critics celebrated the mixed genres of *The Course of Empire*, they had more trouble deciding what to make of Cole's next major series, *The Voyage of Life*. Cole's growing interest in religion in the late 1830s prepared him for a new turn in his career when Samuel Ward, a prominent New York banker and an evangelical ascetic, commissioned an allegorical series in 1839. Cole's four-canvas *Voyage*

proved to be even more popular than *The Course of Empire*, and although Ward's family refused to allow Cole to exhibit the series for profit, a second set that Cole painted in 1842 toured Boston, New York, and Philadelphia and was reproduced in myriad engravings, including subscriber's prints for organizations such as the Pennsylvania Academy and the American Art-Union. One of the reasons for such a wide interest in the series was that Cole used a more accessible set of intertexts for the *Voyage* images. While *Voyage* has often been dismissed as an exercise in Victorian sentiment and piety, Cole's most important source for the series' vocabulary was the emblematic geography of John Bunyan's imaginary landscape in works such as *Pilgrim's Progress*. The Edenic verdure of the first canvas, *Childhood*, is unusual in Cole's later works, but it resonates with his earlier depictions of Eden in the *Expulsion*. The connection of childhood with beauty and faith (represented by the angel) would have been a commonplace in Cole's time and might partly help to explain the popularity of this work as a print. The cave behind the child, however, suggests the mysterious nature of the soul and the unknowability of life before birth. The blending of the emblematic and panoramic—the life-as-ship motif, the angel holding the hourglass in the boat's prow, the supernatural beings that at times blend with natural phenomena (as in the demonic clouds of *Manhood*)—split critics over the question of originality. Had Cole achieved a new conception of life-as-journey through landscape imagery, or was he merely rehearsing material from didactic poetry and emblem books? The very question may suggest what gave *Voyage of Life* such a popular following: accessible allegory, grounded in the tradition of low-church iconography, was recast in the rhetoric of sublime (though not necessarily American) landscape. Alan Wallach has argued that the importance of Cole's *Voyage* and his later *The Cross and the World* series is precisely this unique blend of "the formal techniques of high art with the themes and imagery of a popular tradition."[68] Despite critical attacks in Britain, prints of *Voyage* also did well overseas, bringing Cole's next epic to the masses in a way that *The Course of Empire*, which was never copied in engravings, had never done. Cole, like West before him, had become a brand, leading one critic to raise the rhetorical question, "[W]ho can paint an Epic Poem the way [Cole] has and can?"[69]

Cole's reputation as a painter-poet climaxed in the wake of his *Voyage of Life*, but the rest of the 1840s saw enthusiasm for his new works wane, even as he had become the canonical standard for poetic painting. His works had "an epic sublimity and grace . . . which, without imitation reminds us of Claude Lorraine's and Salvator Rosa's best manners, united"; throughout his career, Cole had been

called both "the American Salvator" and "Our American Claude," but by this 1839 review he had synthesized and transcended both artists, escaping the bar to originality that the adjectival phrase "the American" had created for West, Cooper, Sigourney, and others.[70] An 1845 review held up Cole as an inimitable paragon, "the most imaginative of our painters—or perhaps it were better to say that his imagination is of a more epic cast."[71] Cole had become a benchmark for critics, and other artists were sized up accordingly. An 1843 review of a Durand landscape declared that Durand "would succeed, triumphantly succeed, should he endeavor to paint an Epic Poem or two, as Cole has done,"[72] while an 1840 article condemned the young Daniel Huntington as "not yet old enough to paint an *epic poem*."[73] As the 1840s progressed, in fact, even Cole himself found it difficult to compete with the critics' epic Cole. The reviewer who asserted the "epic cast" required a clear commitment to the sublime, to "grandeur and wildness"; Cole's forays into medieval narrative painting, *Past* and *Present* and *Departure* and *Return*, were "romantic trifles" that represented the "inanities in which he seems like a Sampson in the toils of some bewitching Delilah."[74] Cole was still epic, but his more religious works somehow were not. In fact, I have found no references to *Voyage* as an epic before Cole's death, as it seemed difficult for critics to find epic art outside of the classically inflected sublime of *The Course of Empire*.

Cole's work was never deemed more epic than in the wake of his sudden death on February 11, 1848. A week after Cole died, The *Literary World* declared, "His place will long, we fear, remain unfilled among us. We look about in vain for the poet who shall present us with other epics like *The Voyage of Life* and *The Course of Empire*."[75] Many experienced the loss of Cole as the end of an era, and the *Literary World*'s obituary conveys a sense of the artist's irreplaceable genius. Yet that genius seemed irreplaceable partly because it was directed into forms that were becoming untenable in American art; as nationalist projects in the work of Frederic Church, William Sidney Mount, and other prominent artists took shape in the 1840s, Cole's extranational epics—displaying classical or medieval European architecture, emphasizing religious truth over national greatness, drawing clear patrimonies from British writers ranging from Bunyan to Milton to Byron— both announced American art to the world and seemed to ignore their own Americanness. While critics have often pointed to connections between *The Course of Empire* and the politics of the Jacksonian era, the topicality of Mount's or even Morse's work is largely absent from Cole's.[76] The man hailed as an American successor to Benjamin West used his affinities with English art and letters, and with Italian scenery and European masterworks, to craft an art so unallied

with national academic traditions that its grand sweep seemed ready for appropriation by the first audience to come along. No one else could produce Cole's "epics" because no American artist could so slight his own Americanness by 1848, nor could such an artist place his religion above his patriotism. Those artists who did reject American art ideologies, or found themselves too attracted to European traditions, generally chose to emigrate, like genre painter Richard Caton Woodville in London or sculptor William Wetmore Story in Rome. Cole was strangely transnational, and perhaps that more than anything led to the creation of the "two Coles": the landscape artist whose American scenes could be embraced by Young America, and the epic painter-poet, whose allegories traveled well but never settled into national narratives of cultural development in the nineteenth century—and indeed most of the twentieth.

Early biographer Louis Legrand Noble quotes Cole as saying in his last year, "O, that I had the Course of Empire yet to paint!" He goes on to explain that Cole's last ambition was to undertake a "crowning work" that would make *Voyage* and *Cross* "stand to it somewhat in the relation of episodes"; if *Voyage* had "evinc[ed] less plenitude of his poetic faculty" than *Course* did, the compensation for admirers of the secular epic would be a project tentatively titled "the Kingdom of Christ, or the Course of Sacred Empire," which Noble described as "a grand, divine epic, generalizing, and truthfully relating religious facts with regard to 'many nations,' as his great, profane epic does with regard to one."[77] In other words, Cole's career as he envisioned it would have recapitulated the development from Homer to Milton in expressing the grandest ideas of humanity, using the writer's own history (his late growth into Christianity, his "untutored" genius at the start of his career) as an epitome of universal history. In lieu of the great Christian epic on canvas, Cole's life would have to suffice as a vision of futurity at the end of an incomplete poem.

Cole had in fact been at work on a major multi-canvas project at the time of his death, *The Cross and the World*, projected to relate in five pictures the journeys of two pilgrims, one pursuing the cross through a howling wilderness, the other chasing pleasure in the metropolis. The new work included elements from both *Course* and *Voyage*—fantastic cityscapes, dramatic rises and falls in both landscape and fortunes—and they shared in the literary sensibilities of the earlier series as well. Cole's completed canvases and sketches for *The Cross and the World* were included in the memorial exhibition, and the *New York Journal of Commerce*'s reviewer called the work "a magnificent Christian poem."[78] The *Literary World* had used almost exactly the same phrase in its obituary for Cole. But

what kind of poem was it precisely? More than any of his works, *The Cross and the World* emphasized Cole's attachment to Bunyan, and it exposed the cultural divide between his religious identity and the artistic image that his friends held of him. William H. Gerdts has shown that Cole's work in the 1840s was part of the initial wave of a trend that amounted to "Bunyan . . . becom[ing] the new evangelist of mid-nineteenth-century America." Bunyan's *Pilgrim's Progress* had been a boon to publishers in America through the War of 1812, and the text experienced a major revival around 1840, the year that Cole completed *Voyage*.[79] The 1840s were the decade in which Bunyan became accepted in some circles as an epic writer, but Cole's eulogists were not willing to see Cole's engagement with Bunyan when they celebrated his reading or his influences. William Cullen Bryant spoke of the last series in his funeral oration on Cole, but he chose to locate its source in a higher register: "The idea is Miltonic, said a friend when he first beheld it. It *is* Miltonic; it is worthy to be ranked with the noblest conceptions of the great religious epic poet of the world."[80] Charles Lanman made a similar claim for Cole's corpus: "The productions of Cole appeal to the intellect more than to the heart, and we should imagine that Milton was his favorite poet."[81] Though Cole had brought Bunyan into his art from the first to the last of his artistic career, his enthusiasm for the Bedford preacher met only with silence, or misreading, among his own cultured admirers.

Misreading did not only plague Cole's religious canvases, however. In his 1848 retrospective "The Epic Paintings of Thomas Cole," Lanman collected his various reviews of *The Course of Empire*, *The Voyage of Life*, and Cole's other mixed-genre works (some of which Lanman had not before described as epic) in presenting the artist's corpus as that of a highly imaginative painter-poet. He concluded his survey with a treatment of a work that was in England at the time of Cole's death and had been seen by few Americans before its transatlantic voyage in 1847: *Prometheus Bound* (see fig. 16). Lanman praised the work as "one of the wildest and most splendid efforts of the painter's pencil . . . one of the most truly sublime pictures we have ever seen," which "possesses all the qualities which constitute an epic production." For Lanman, *Prometheus* was a genre-defining work. He pointed to the "unity of design," the "atmosphere," and the excellent "execution," as well as Cole's unsurpassable ability to "illustrate . . . the idea of the poet."[82] Epic for Lanman was not only derived from literary rules such as the Aristotelian unities, but was in fact a product of effective translation between literary and visual art. The stark simplicity of *Prometheus*'s composition allowed one central idea, Fuseli's mark of an epic painting, to emerge, even as Cole had used not only

Aeschylus but Elizabeth Barrett's adaptation of the Greek tragedy for his inspiration.[83]

Prometheus was not a mere poetic effusion, however. Having missed his chance for a Capitol commission in 1837 (one of the reasons he chose *The Course of Empire* as the subject for his Reed commission was to attract Congress's attention),[84] Cole set aside his uncommissioned *Cross and the World* project in late 1846 to paint *Prometheus* as an entry in the Royal Commission's competition for works to decorate the new Houses of Parliament in Westminster. Having had great difficulties in securing patronage for his epic works in the United States, Cole turned back to his home country, where patronage was more secure. His *Prometheus* would be classified as literary, one of the three categories allowed in the competition. However, Cole's painting was "skied," placed so high on the exhibition wall that the judges probably saw it as a landscape piece, as the narrative elements of Jupiter (a star on the left), the raptor, and Prometheus are very small against the towering mountains and the treeline. At any rate, Cole did not win a prize or a patron, and he had not managed to bring his painting back home before his death in 1848.[85] Cole's inability to escape being pigeonholed as a landscape artist in Britain anticipated his legacy in America.

Prometheus was something of a family favorite among the Coles, and the artist's son kept careful records of it.[86] An entry in a Cole family scrapbook describes an astounding turning point in the painting's history: "The Figure of Prometheus and the Bird were painted out by Mr. Storey [*sic*]—Curator of the Metropolitan Art Museum, New York in 1909, and renamed 'Dawn.'"[87] George H. Story, one of the first curators at the Met and famous in his own right as an artist, had stepped down from his curatorial position in 1906, but he continued to live in New York and could very well have altered the painting.[88] Such a radical act on a Cole canvas, however, is difficult to imagine, even after his reputation declined in the second half of the nineteenth century. And yet the concept of converting a Cole "epic" into a landscape painting, from making a moral statement to showing a light effect, epitomizes in some ways the critical response to Cole's epic works since the Civil War. A note in the De Young Museum's curatorial files reports that infrared examination of the canvas shows evidence of abrasion on the figure of Prometheus, which might support the account of the altered picture.[89] Whatever might be the case, that the story of Prometheus could also be considered as the story of a sunrise suggests how complicated, and how tenuous, the concept of epic in American art actually was.

The Course of Epic Art after Cole: Expansion or Oblivion?

The early years of the 1850s saw several Hudson River artists emerge as potential neo-Coles, but Jasper Cropsey was the only Hudson River painter to receive the epithet "epic" from critics. Certainly, he went to greater lengths than almost anyone else to follow in Cole's footsteps, even going so far as to rent Cole's former studio in Rome during his European studies in 1847–49.[90] In 1851, after Cropsey's return to the United States, the *Bulletin of the American Art-Union* announced that "Mr. Cropsey, who in many respects resembles Mr. Cole, has lately been carrying the resemblance still farther, by painting two pictures in that epico-allegorical style, if we may so call it, in which our great landscape painter delighted."[91] The works, *The Spirit of War* and *The Spirit of Peace*, depicted an army of mounted knights deploying from a medieval castle, shrouded in sublime gloom, and the ruins of a very similar castle, now the site of pastoral celebrations by peasants. The similarity to Cole's *Past and Present* hampered Cropsey's attempt at achieving epic status, however; once the paintings were completed, critics chided him for being too imitative, and the trap that Cole had fallen into with Martin's works in his early *Eden* pictures would convince Cropsey that taking on a great American predecessor was to jeopardize his academically impressive landscape art.[92] Indeed, by 1855 almost all landscapists who had attempted to take on Cole's epic works had returned to "pure" landscape. The paradox of making painting poetic while seeking to remove its idealism was most effectively resolved by Frederic Church, in works such as *Heart of the Andes* (1855) and *Niagara Falls* (1857), pictures that were designed to compete not only with National Academy oils but with touring exhibitions, and the monetary success of Church's massive works made him the new target for emulation and critique. Two institutional changes had also seemed to seal the door between Cole's poetic approach and the ascendant naturalism of Durand, Cropsey, and Church. The American Art-Union, which had popularized history painting in the United States through its subscription prints and had achieved massive success with offering Cole's entire *Voyage of Life* series as a lottery prize in 1848, was disbanded in 1851 after a court ruling that such lottery practices violated New York state law.[93] Four years later, Durand's son John began the first independent art periodical in the country, the *Crayon*, which based its aesthetic stance on two main principles: that painting was poetry, and that good painting was naturalistic. Though the equation of poetry and painting showed the *Crayon*'s debt to Cole, the late painter's work

quickly became a glorious moment in a history irrelevant to artists within a decade of his death.

The distance between Cole and the rest of the Hudson River tradition grew even greater during the Civil War, as Church's and Albert Bierstadt's expansive approaches to landscape came under increasing attack by forerunners of the Luminist movement such as George Inness, who favored detailed attention to light effects and small, intimate canvases that invited close scrutiny. In 1863 Inness exhibited an uncharacteristic large-scale landscape, *The Sign of Promise*, and to make sure that viewers did not miss his critique of the Church/Bierstadt style, he declared in the exhibition catalogue that he "does not offer this picture as a perfect illustration of the epic in landscapes, but only as the visible expression of a strongly-felt emotion of Hope and Promise."[94] Inness's picture was destroyed, but he painted a new version in 1865 as if to keep his challenge to the "epic in landscapes" visible forever. The growing interest in the aesthetics of light, the distrust of landscape as ideological art, and the depression of the art market during the war all seemed to make the decline of epic inevitable to those artists who had seen its rise in the 1830s and 1840s.

The career of Emanuel Leutze, most famous today as the painter of *Washington Crossing the Delaware*, perhaps best illustrates the vicissitudes of epic as a critical term in the mid-nineteenth-century United States. A Philadelphia-born history painter, Leutze spent most of the 1840s abroad as one of the leaders of a group of American artists in Düsseldorf, though he continuously exhibited work in the United States and had gained early fame for a series of scenes from the life of Columbus starting in 1842. However, whether because he had chosen academic history painting rather than Cole's "higher landscape," or (more important) because he was a Philadelphian artist in an art world overseen by New York–based art critics, Leutze's work was flatly denied epic status in the press. A review of his *The Iconoclasts* in 1847 declared that although the work was a "noble picture," it also demonstrated that "[t]his walk is not the highest. It is not the epic style or the allegorical. Leutze cannot paint a Last Judgment, or the Prophets, or a Holy Family—His strength lies in representing the passions, the struggles, the loves and hates of humanity."[95] In other words, he was a particularly pretentious dramatic painter, according to Fuseli's and Morse's scheme. A few years later, *Washington Crossing* was acclaimed as "a grand national painting,"[96] but not as an epic until the end of the Civil War, when James Jackson Jarves, an influential American critic who had fallen in love with European art and immigrated to France, commented in his *The Art-Idea* (1865) that *Washington* was a "striking exam-

ple[]" of Leutzes's "epic style." Jarves classed Leutze's most famous work along-side *Westward the Star of Empire Takes Its Way*, a fresco Luetze had just com-pleted in the Capitol, as well as a portrait of General Ambrose Burnside and *The Storming of the Teocalli*, the latter inspired by Prescott's *History of Mexico*, as "*Tours de force*," but this was not meant as unequivocal praise. The critic described Leutze as "the Forrest of our painters. Both men are popular from their bias to the exaggerated and sensational, cultivating the forcible, common, and striking, at the expense of the higher qualities of art."[97] Jarves, who preferred Raphael's de-corum to the works of Martin, saw Leutze like the Shakespearean actor Edwin Forrest as crude, overly forceful, and most appealing to the lower classes. Leu-tze's fame was doomed to be popular, epic without the name. And by the time he died in 1868, only *Washington*'s fame lived on, leaving the artist forgotten.

If New York had denied Leutze entry into the epic canon, the Philadelphia elite's support of history painting (fueled by veneration for West) provided one last opportunity for a history painter to produce an epic painting. That opportu-nity came for Peter Rothermel, who was a classmate of Leutze's at the Pennsylva-nia Academy in the 1830s. In the same year that *Washington* made its American debut, Rothermel exhibited *Patrick Henry before the Virginia House of Burgesses*, which critics hailed as "the best history painting ever executed in America."[98] Engravings of *Patrick Henry* made their way into all the major art societies in the United States, becoming such a popular success that by the time of the Civil War Rothermel was considered one of the most famous artists in America. In 1866, the Pennsylvania legislature commissioned Rothermel to depict the Battle of Get-tysburg for display in the state capitol building. Rothermel quickly became bogged down, however, as he sought to reconcile contradictory reports of the battle in order to meet what he knew would be exacting standards of historical accuracy; he also planned a massive scale, beyond the works even of West and Church, in an attempt to depict as much of the ground and figures involved as possible. The final painting was over 32 feet long, and the state declined delivery in 1870, as there was no space large enough in Harrisburg to display it. As compensation, the legislature permitted Rothermel to exhibit the painting for his own profit. The unveiling at the Philadelphia Academy of Music was a gala event, and both Generals Meade and Sherman were among the dignitaries in attendance; history painting collector Joseph Harrison was one of the organizers and was attempting to establish a new art museum in Fairmount Park with Rothermel's *Gettysburg* as the centerpiece.[99] In the course of the unveiling ceremony, which included a full drum corps accompanying the drawing of the curtain, Gettysburg veteran

William McMichael gave his pronouncement on the painting and its source: "This is not a mere battle . . . it is an epoch. This is not a picture only—it is an epic—a national struggle, a national record."[100] For McMichael, an army officer–turned–politician, the cultural power of Rothermel's work took it beyond the realm of the pictorial—for the first time, outside of the genealogies of West and Cole, an American artist had achieved an epic. However, it was not an art critic who said so, but a veteran of the battle depicted in the painting; epic was a category that no longer belonged only to the cultural elite, and it was being taken up by figures like McMichael just as quickly as tastemakers such as Jarves and Inness abandoned it.

The Rothermel painting generally known as *Gettysburg* was in fact only a representation of Pickett's Charge, the last major event on the third and last day of the battle. Rothermel had painted four other Gettysburg scenes on smaller canvases to contextualize his massive work (possibly as a nod to Cole's *Course of Empire*?), and the five hung as a group at the pavilion in Philadelphia built to exhibit them. When the Centennial Exhibition opened in Philadelphia in 1876, Rothermel's work created a great deal of controversy when it occupied a prominent place in the American section of the art exhibit, a place personally chosen by the art exhibit's director, John Sartain, who was engraving a print of the main Gettysburg canvas for sale at the Centennial, and who broke two of his own rules: no Civil War subjects were to be displayed, and only the Placement Committee could decide where to display works.[101] Other paintings in the exhibition, including Cole's *Voyage of Life* and part of the *Cross and the World* series, represented one final burst of interest in American "epic" painting, but the cold reception that Rothermel's *Gettysburg* received from critics signaled that Cole's triumph with *The Course of Empire* was not to be repeated.[102] As impressive as Rothermel's approach to the problem of painting the Civil War was, audiences would soon flock instead to the French painter-entrepreneur Paul Philippoteaux's *Battle of Gettysburg* cyclorama upon its unveiling in 1883 in Boston. Engulfing the audience in a 360-degree representation of Pickett's Charge, complete with objects placed in diorama fashion to heighten the three-dimensional illusion, proved more popular than inculcating moral values through the style of academic history painting to which Leutze and Rothermel adhered. In fact, the fragility of a work's or artist's status as epic seems to be a mark of that epic quality. In recent years, Elizabeth Johns has said of Thomas Eakins's iconic *The Gross Clinic* (1875) that the painting was both "imposing in scale" and "truly epic in theme."[103] That epic work, however, appeared at the wrong time in art history for

initial recognition; Eakins had painted the work with the intention of placing it in the Centennial Exhibition, but Sartain's judges rejected it as inappropriate as a portrait and would not consider it as a history painting. Eakins eventually placed the picture at the Exhibition, but in the medicine section alongside displays of new surgical tools and techniques.[104] As Johns's statement shows, epic has never died in American art history, but it has always needed very specific (and unpredictable) historical conditions to allow for the recognition and the acceptance of the form in what even the elitist Eakins often presented as a democratic art.

Transcendentalism and the "New" Epic Traditions

The work of artists such as West, Cole, and Leutze inhabited an uneasy space between the national and the transnational. American art, for all its wealth of material for landscape painting, relied on methods and styles imported from Europe—and often made in or sent to Europe as well. Similar practices of import and export also defined the literature of the early nineteenth century. As has been shown in previous chapters, the classics had played a central role in colonial and early national experiments with American epic, but the classics themselves began to be transformed in the wake of new American interactions with modern Europe. Caroline Winterer describes a shift in the place of the classics in the American academy and the belletristic world after about 1820, a move she characterizes as one "from words to worlds."[1] While Timothy Dwight's generation had revered the discipline of recitation drills and the authority of the ancient authors they studied, the generation of Ralph Waldo Emerson and Edward Everett looked to the classics as sources of transcendent truth to be mined through philological inquiry. Responding to the rapid changes in German scholarship after the systematizing of classical philology and of hermeneutics at the end of the eighteenth century (Everett had earned a PhD from the University of Göttingen),

many of the new generation of American teachers and critics saw their purpose focused not as much on creating an ordered society through classical education as on finding truth that each individual student could grasp and explore. At the same time that poets like Homer came to stand for timeless genius, however, new scholarship called into question the very existence of a Homer at all. The lessons of history became a tug-of-war between first principles and the mess of historical information that was rapidly accumulating. A new generation of American writers would have to come to terms with epic in the wake of this maelstrom, and the search for American epic's place in the world became increasingly exciting and uncertain as the nineteenth century continued.

The debate over "the Homeric question" swept through classical scholarship across Europe and the United States, remaining a major controversy in the field throughout the nineteenth century. The touchstone that started this debate was the philologist Friedrich August Wolf's *Prolegomena ad Homerum* (1795), which argued that the composition of Homer's epics was actually the work of several anonymous bards and editors stretching across centuries. The furor over Wolf's ideas spread from the universities into Atlantic intellectual culture, as the debate entangled ancient Greek philology, biblical scholarship, and religious skepticism: if Homer was not the author of the *Iliad* and the *Odyssey*, perhaps God was not the author of the Bible, either. The Homeric question entered American intellectual culture by the 1820s and served as a litmus test for religious and political liberalism.[2] Suddenly, the act of reading Homer became not just a matter of genteel education but a dramatization of one's place amid the ideological tensions of the post-1812 United States.

This shift in thinking about the classics paralleled a startling expansion of the available epic canon in Europe and the United States following the Napoleonic Wars. The wide, rapid dissemination of print associated with the pre-1800 "age of the pamphlet" reached unprecedented volume as machine printing became available in the 1820s, making true mass production possible at the same time that railroads and post roads finally made rapid national distribution a reality for publishers and booksellers. This new age of mass publishing, while it primarily benefited the growth of periodical and popular literature, also made the classics more widely available than ever before. At the same time, new texts from inside and outside the United States entered American literary markets. *Beowulf* appeared in print, and soon thereafter in a modern English translation, for the first time in the 1820s; the Finnish epic *Kalevala* appeared just a few years later; and Hindu texts such as the *Mahabharata* appeared in English and French translations by

1840. Dante's *Divina Commedia* had first appeared in English at the turn of the nineteenth century and moved into Anglo-American consciousness after Coleridge lectured on the Tuscan poet twenty years later. And the American answer to James Macpherson's Ossianic poems came in the 1836 publication of what the Franco-American linguist C. S. Rafinesque claimed was a Lenape epic, the *Walam Olum* or *Red Score* (discussed further in chap. 6). Poems such as Byron's *Don Juan* and Wordsworth's *The Excursion* enjoyed both popular success and critical influence in American literary circles through the mid-1800s. The first professors of modern languages began teaching at colleges such as Harvard and the University of Virginia, reflecting the gradual widening of American academic and commercial interests based on a growing awareness of the importance of international relations in the economy and culture of the nineteenth century. The epic canon in the 1830s was both much larger and more diverse than the already growing pantheon treated in the mid-eighteenth century by Blair and Kames.

At the same time, texts not previously considered epics were reevaluated through a blend of classical poetics and modern attention to a book's cultural influence. For example, *Pilgrim's Progress* had long been seen as literature for the pious and the young owing to its strong didacticism, emotional spectacle, and heavy allegory. However, few books had as much of a cultural impact on nineteenth-century America as *Pilgrim's Progress*, and that cultural influence set off a minor culture war within intellectual circles,[3] even as critics increasingly found Bunyan's work to be commensurate with epic—even epic outright. In the *United States Magazine and Democratic Review* in 1847, a survey of popular classics offered high, if somewhat bemused, praise of Bunyan: "Modern criticism, indeed, has ventured to assign to [*Pilgrim's Progress*] a rank even equal with that of Homer, the sublime epic of Milton, and the mighty genius of the world's great poet!"[4] The final exclamation point suggests surprise at *Pilgrim*'s elevation alongside works like the *Iliad*, revealing the critic's preference that some sort of demarcation could stand between Bunyan's "low" work and the "mighty genius" of more sophisticated writers. A less squeamish critic in the *New York Observer* took on more traditional senses of epic in defending Bunyan's fame: "The Pilgrim's Progress is in fact an exalted epic even according to the most philosophical definition of that term." The *Observer* critic went on to consider "matter," "form," and "end" as criteria for *Pilgrim*'s epic status, even noting that "the law of the epic in its threefold distribution was unconsciously observed by this profound student of the human heart," ultimately discounting the importance of academic principles

of epic in favor of the sheer emotional power of the book's "profound" author.[5] One of the most pointed celebrations of *Pilgrim* appeared in a notice of a new American edition of the book in 1848 in the *Ladies Repository, and Gatherings of the West*: "What more can be said, of this great epic poem in prose, that has long since secured an immortality of renown? It will be read as long as the Iliad, or Paradise Lost, or any other work in any language."[6] In the face of Bunyan's cultural power, distinctions between high and low—or between poetry and prose— had little significance for many of his readers. New philological paradigms and a new array of "epic" texts had joined with common usage to further destabilize what an epic was. This chapter traces the efforts by members of the transcendentalist movement, as well as those they corresponded with and influenced, to gain new understanding of what epic could mean for their time, and for the ever-belated project of American literature.

The New Classicism: Jones Very, Francis Lieber, and Modern Epic Criticism

If Dwight's and Barlow's generation had been haunted by the question of whether epic was possible after Milton, the question facing Emerson's and Longfellow's generation was whether epic was possible after modernity. This shift from an author-based literary history to a culture- or worldview-based one reflected the increasing interest in universal history among Anglo-American intellectuals, as well as an increased awareness of the intellectual and economic systems that manipulated the work and reception of authors, even those of the rank of Homer and Milton. In his lecture on "The Hero as Poet" in *On Heroes, Hero-Worship and the Heroic in History* (1841), Thomas Carlyle lamented the presence of conventionality even in Shakespeare's finest works: "Alas, Shakspeare had to write for the Globe Playhouse: his great soul had to crush itself, as it could, into that and no other mould. . . . No man works save under conditions. The sculptor cannot set his own free Thought before us; but his Thought as he could translate it into the stone that was given, with the tools that were given." No perfect works emerge from authors or artists, says Carlyle, only "*Disjecta membra*," disjointed limbs of a complete constitution, evidence of the individual artist's struggle against the systems that both enable and defeat him.[7] Could even Milton produce a great poem under such "conditions?" Did Milton rather defeat modernity through his classical learning and his financial independence from the literary marketplace? The example of Milton as the great critical touchstone for epic extended well into

the 1830s, but by then the ways that Milton was read and could be rhetorically deployed had changed drastically since the 1770s.

Perhaps the American essay that best encapsulated current European thought regarding the viability of modern epic in the 1830s United States was Jones Very's "Influence of Christianity and of the Progress of Civilization on Epic Poetry," published in 1838 in the *Christian Examiner* and again the next year as "Epic Poetry" in Emerson's edition of Very's *Essays and Poems*.[8] Very had continually reworked his essay from 1835, when he submitted it as his senior dissertation at Bowdoin, through the following two years, in which time he gave a related lecture on "Heroic Character" at Harvard and two respective versions of the "Epic Poetry" essay at the Salem and Concord Lyceums, with further personal feedback from Elizabeth Peabody and Emerson.[9] Rejecting the terms of Kames's and Blair's earlier discussions of the relative merits of epic machinery, catalogs, and other traditional conventions of epic poetry, Very began his own essay with a bold denial of the very notion of continuing epic poetry as Homer's age defined it: "The poets of the present day who would raise the epic song cry out, like Archimedes of old, 'give us a place to stand on and we will move the world.' This is, as we conceive, the true difficulty" (1). Drawing silently from German writers such as Schiller and the Schlegels, Very argued that modern failures to equal Homer's poetry are not so much a matter of diminished genius as of the changing culture and psychology of European civilization.

As Very saw the history of epic composition and reception unfold, he found that Homer's poetry had more influence over his own time than Virgil's had over the Roman empire; Very traced the source of this inequality to the fact that while Virgil had followed Homer's model admirably, the "advance, which the human mind had made towards civilization" (2), made Virgil's anachronisms too obvious to move his readers as Homer had done. The Greeks lived in a world dominated by externals, such that everything about the *Iliad* was conceived in terms of the physical world. As the rise of philosophy and artistic self-awareness rendered the physical world less important relative to the immortal world of intellect and spirit, what constituted Homer's "*epic* interest" would come less from external events than from internal "*dramatic*" (4) interest. Very moves forward to Tasso and Dante, the former as the last great example of attempts to create an epic on a truly Homeric plan, the latter as the first author to successfully engage the poetic power of the spiritual—and to show how much at odds the spirit of Christianity was with the form of the classical epic. The cataclysmic battle no longer could capture an audience's complete attention, since the power of the

individual wills that brought that battle into being were more infinite, more god-like, than any physical action on the field. For Homer, nothing greater than fame throughout history could be imagined, much less attained; for Dante, Milton, and the poets who followed them, infinity itself became an object of ambition. Only by the representation of a mind in terms as objective as those Homer used in his epics could a poet truly surpass, or even equal, the *"epic* interest" of the *Iliad*.

The case of *Paradise Lost* was particularly demonstrative for Very of the new world that epicists faced in Christian modernity. As with Dante, Milton wisely chose an infinite subject, the spiritual struggles leading up to and implications of the Fall. Very's Milton works only in biblical and spiritual terms, abandoning the temporality and materiality that bound Dante to his historical Tuscany in popu-lating the spiritual realms with actual Italians. However, by going further into the immortal than Dante, Milton in *Paradise Lost* "confirms more strongly the conclusion that we drew from Dante's [poem], that *dramatic* is supplying the place of epic interest" (25–26). Citing Milton's original intention to write *Paradise Lost* as a tragedy (26), as well as the structure of the poem itself, Very finds that the narration of motivations for action, rather than the actions themselves, has blended the epic and the dramatic. This causes serious rhetorical problems for Milton, as Very points out that if Adam's exercise of free will is what makes him a hero, Satan's use of free will is even more heroic: "*There* is seen a conflict of 'those thoughts that wander through eternity,' at the sight of which we lose all sense of the material terrors of that fiery hell around him, and compared with which the physical conflict of the archangels is a mockery" (28). If the spiritual side of humanity could be heroic, the purer spirituality of Satanic consciousness would be even more compelling. Epic had moved from sculptural description to cosmological portraiture.

As Perry Miller noted, Very's reading of Milton's Satan as a Byronic hero, though common enough among European romantic critics, was new in the United States at the time.[10] The implications that Very saw for his reading were even more astonishing: "Adam is not so much the Achilles as the Troy of the poem. . . . Though he [Milton] has not made the Fall of Man a tragedy in *form*, as he first designed, he has yet made it tragic in *spirit*; and the epic form it has taken seems but the drapery of another interest" (29–30). But the impossibility of writing epic in the current age was actually cause for celebration; continuing his metaphorics of human development, Very quipped that "to sigh that we cannot have another Homeric poem, is like weeping for the feeble days of childhood," and such nos-talgia fails to acknowledge "those powers of soul which result from . . . progress,

which enable it, while enjoying the present, to add to that joy by the remembrance of the past, and to grasp at a higher from the anticipations of the future" (31). To paraphrase Stanley Fish, Very argued that there's no such thing as a modern epic, and it's a good thing, too.

And yet Very refused to relinquish the aura of the term "epic" to ancient works; in a rapid survey of modern literature, he asked, "What, indeed, are the writings of the great poets of our own times but epics; the descriptions of those internal conflicts, the interest in which has so far superseded those of the outward world" (34). While Very had taken what seemed to be a much more traditional stance toward epopee than, say, Dwight and Barlow, both of whom had denied Homer preeminent status as the model for all epics, Very's reading of Homer emphasized not so much form as poetic purpose. He posited that Homer's decision to write an epic poem "originated, doubtless, in that desire, which every great poet must especially feel, of revealing to his age forms of nobler beauty and heroism than dwell in the minds of those around him" (5). Rather than denying Homer's place as the father of all epic poetry, Very rejected Aristotle's formulation of the rules for epic, arguing that the original of those rules, the *Iliad*, should take critical precedence; as a sort of Aristotelian new covenant, Very declared that "we would only say that according to the spirit of those rules every true epic must be formed" (13). And this "spirit," tied to Homer's original poetic motives, could infuse texts that were not even formally recognizable as epics: "The Sartor Resartus, Lamartine's Pilgrimage, Wordsworth's poem on the growth of an individual mind, all obey the same law,—which is, that as Christianity influences us, we shall lay open to the world what has been long hidden, what has before been done in the secret corners of our own bosoms; the knowledge of which can alone make our intercourse with those about us different from what it is too fast becoming, an intercourse of the eye and the ear and the hand and the tongue" (21). The spirit of Homer, channeled across the centuries from the age of epic interest to that of dramatic interest, could ensure a connection to the greatest of all poets, even as modern poets sought to escape the limitations of classical form. As Very declared at the end of his article, the inability to celebrate the past in epic form was itself something to celebrate, a sure sign of cultural progress: "We rejoice at this inability [to write an epic]; it is the high privilege of our age, the greatest proof of the progress of the soul, and of its approach to that state of being where its thought is action, its word power" (37).

Like his poetry, Very's criticism was motivated by his own personal pursuit of moral and intellectual authenticity; Edwin Gittleman gives the most comprehensive

reading to date of Very's "Epic Poetry" in *Jones Very: The Effective Years*, in which he argues that the essay is actually a projection of the essayist's own personal growth, with the classical and the modern mind-sets separated by what Very himself described as a "change of heart," an identity crisis he suffered in late 1835.[11] However personal Very's essay was, and however striking it seemed to its early audience (especially Peabody and Emerson), it was by no means unique—at least among European thinkers and their American readers.[12] In fact, Very's essay might be read as a response to the essay on "Epic" in Francis Lieber's *Encyclopaedia Americana* (1829–33), which summarized German romantic theories of epic. While Very's transcendentalist connections and reputation for mental instability marked him as a fringe intellectual with an influence that barely expanded beyond Boston, Lieber enjoyed widespread respect among American cultural elites. Lieber was a legal scholar who emigrated from Germany to the United States after being banned from teaching in Prussia during the Metternich regime as a result of his radical democratic ideals; ironically, however, his thorough scholarship and his enthusiastic nationalism and Unionism made him a favorite among Whigs and elite scholars in his adopted country. Sympathetic New England intellectuals, including Göttingen alumni George Ticknor and Everett, assisted Lieber in his *Encyclopaedia* project, which was based not on the *Encyclopaedia Britannica* but on Hermann Brockhaus's *Konversations-Lexikon*, as Lieber indicated on his title page.

The actual wording of Lieber's title page emphasizes the meaning he assigned to the use of a German model for an American encyclopedia. An opponent of what he called the "Germanizing of United States," Lieber advocated the adoption of German academic methods within a nationalistic American culture, not a direct importation of German culture; his vision was for a blended national identity instead of American culture as a variation of an existing European culture.[13] Nevertheless, Lieber maintained his pride in his identity as a German even as he embraced his new homeland. Thus, on his title page, rather than naming Brockhaus, Lieber cites "the German Conversations-Lexicon." The anglicized spelling, together with the addition of the word "German"—which did not appear in Brockhaus's title—argues for a unique cultural relationship between the Anglophone United States and German print culture, in fact a hybridized culture that could be simultaneously nationalistic and transatlantic.[14]

The *Encyclopaedia Americana* exhibits throughout a similar tension between the national and the international, particularly in articles on literature such as "Epic." Much of the article builds on the critical theory of the genre as developed

by August Schlegel and Jean-Paul Richter, but it starts out with a broad, etymologically based definition similar to Noah Webster's: "Epic; a poem of the narrative kind. This is all that is properly signified by the word, although we generally understand by it a poem of an elevated character, describing the exploits of heroes."[15] By moving from etymology to usage to arrive at a more relevant definition, the article follows the methodology of J. G. Herder, whose *The Spirit of Hebrew Poetry* shaped romantic conceptions of national literature and culture in Germany as well as England and the United States.[16] However, in this case the "we" who "generally understand" the definition applies not just to Germans or to Americans but to all who adopt a broadly Western poetics; Herder's nation dissolves into the larger semantic republic of Goethe's *Weltliteratur* (world literature). The article next offers a comparison between epic and drama, which resolves into a metaphor of extended travel, perhaps even of tourism: "The epic is not a hasty journey, in which we hurry towards a certain end, but an excursion, on which we take time to view many objects on the road, which the art of the poet presents to amuse us" (4:538). Throughout this article, epic is represented not as a form to promote national pride so much as a way of projecting national character out into the world of letters.

After discussing the variety of forms within epic, pointing to examples of romance epics (e.g., *Orlando Furioso*) and mock-epics (e.g., *The Rape of the Lock*) among others, the article provides a nation-by-nation overview of world-worthy epics. The role of epic in displaying a nation's language, and thus providing evidence for philologists, is established at the very outset of this survey: "Who can calculate the great influence which Homer probably had on the Greek language? Whilst, on the other hand, it is partly owing to the plastic trait in the two ancient languages, that this characteristic was imparted to their epic poetry" (4:538). Among modern languages, English is the best for epic, owing to its capacity for "description," the article argues. "Spenser, Milton, Glover, Butler, Pope, Scott, Byron, Moore, Campbell, Southey, and many other distinguished names" further speak to the language's affinity for epic. By contrast, the French language is poorly adapted to epos, while the Italian language (in lieu of an Italian nation) has produced three great epics: Ariosto's *Orlando*, Tasso's *Jerusalem Delivered*, and Dante's *Divine Comedy*—the last still relatively unknown to American readers at the time (4:539). The Germans have produced only one world-class epic, the *Nibelungenlied*, which had been only recently published and about which Lieber had personally written an article for the *Encyclopaedia*. Modern German writers, while prolific in the epic form, have fallen short of their ancient heritage: Goethe's

Hermann und Dorothea, Voss's *Luise*, and Klopstock's *Messiade* are all criticized for obvious flaws of structure and conception. Spanish and Portuguese epics are quickly touched on (although Camões's nationality is not identified), and a rapid summary of classical epic in Latin and Greek abruptly closes the article.

In a work claiming preeminence in providing the most important knowledge for Americans to have, the essay "Epic" contains a glaring absence. While the entry on Timothy Dwight noted that Dwight had written a "regular epic poem" in the 1770s in the *Encyclopaedia*'s entry on the Yale president (4:352), there is no mention of American authors—or even the existence of epic literature in the New World—in the article on epic. The closest to the United States the essay comes, despite its international range, is Ercilla's *La Aurucana*, an account of one of the wars of conquest that the article excuses as a product of idiosyncratic Spanish taste, "a poem, which, to foreigners, generally appears like a dull chronicle, defective in poetical conciseness of language and originality of ideas" (4:539). Like Very, Lieber remains silent on the state of the epic art in the United States, which speaks to the sea change in American and European literary taste since the War of 1812 but also might involve a more insidious issue. Epics produced in the United States before 1830 had been distributed on a local or, at best, on a national scale, as in the case of Barlow's *Vision of Columbus*. Even the London imprints of Barlow's and Dwight's works were made in small print runs, and rarely with the intention or actuality of continuing with later print runs. And only Barlow's diplomatic career carried his works as far into Europe as France, and then more as a flash of revolutionary consanguinity than as a vote of critical confidence. If Europeans refused to talk about American epics, a very likely explanation was that Europeans had not even seen, much less read, American epics since the 1780s. Without effective transatlantic publishing networks, such as those from which Washington Irving and James Fenimore Cooper had benefited in the 1820s, American epics could not secure an international market and thus international critical attention. One exemplary network began developing in the mid-1830s, the friendship between Ralph Waldo Emerson and Thomas Carlyle, which paved the way for writers such as Henry Wadsworth Longfellow to secure European business connections—and which produced a remarkably rich dialogue surrounding the changing meaning of epic in the midst of a rapidly modernizing literary market.

A Philology of Epic: The Emerson-Carlyle Connection

Ralph Waldo Emerson had first crossed the Atlantic in 1833 in search of new pur-
pose after the loss of his first wife, Ellen Tucker Emerson. As part of his *Wander-
jahre* Emerson visited his literary heroes, including Wordsworth, Coleridge, and
Carlyle. The Concord minister made a remarkable impression on Carlyle and his
wife, the latter particularly suffering from the isolation of western Scotland; the
three maintained a lifelong friendship thereafter, primarily through correspon-
dence. And Emerson, already fascinated by the charismatic power of great men,
told Carlyle in his first letter after their meeting that he believed that the Scots-
man was an era-defining poet whose moment had arrived:

> No poet is sent into the world before his time . . . all the departed thinkers &
> actors have paved your way . . . nations & ages do guide your pen . . . Believe
> then that harp & ear are formed by one revolution of the wheel; that men are
> waiting to hear your Epical Song; and so be pleased to skip those excursive
> involved glees, and give us the simple air, without the volley of variations.[17]

Emerson's use of "Epical Song" has a surprisingly broad sense for its time; Noah
Webster's definition in his 1828 *Dictionary* discussed "epic" as implying narrative
and "epic poem" as denoting a work with conventions and aims similar to that of
Homer's *Iliad*. Carlyle had published only essays and portions of *Sartor Resartus*
by the time Emerson met him—Emerson would in fact oversee the first complete
printing of *Sartor*, which appeared in Boston in 1835—and had not yet launched
his career as a historian, so we might ask how Emerson thought the "Epical Song"
might appear. The Concord lecturer-to-be might have envisioned an intertextual
epic, one that would emerge through Carlyle's entire oeuvre, as it arguably had
for Goethe. However, Emerson's comment on his friend's style, with its "volley of
variations" rather than a "simple air," suggests that the Epical Song might simply
be the poetic truth that Carlyle expresses in his notoriously meandering *Sartor
Resartus*, if he could just get to the point. The "[p]ure genuine Saxon" sentences
that Carlyle would later praise in Emerson's *Essays*, "strong and simple; of a
clearness, of a beauty" (371), the powerful yet masterfully crafted directness of
the English prose essay, not only could but should, Emerson seems to say, serve
as the form for the latest epic creation. In fact, Emerson conceived of the essay, as
related to the lecture, as a form-*sans*-form that could absorb even the all-
absorbing genre of the epic; in the wake of the publication of his first series of
Essays in 1841, Emerson commented to Carlyle that "I am always haunted with

brave dreams of what might be accomplished in the lecture room—so free & so unpretending a platform,—a Delos not yet made fast—I imagine an eloquence of infinite variety—rich as conversation can be, with anecdote, joke, tragedy, epics & Pindarics, argument & confession" (308). The new formal possibilities for epic (via the essay) were virtually limitless for Emerson.

For Carlyle the timing of Emerson's phrase was remarkable. The two had met in the summer of 1833, not long before Emerson's return voyage to Massachusetts; the "Epical Song" letter is dated May 14, 1834, which puts it at the very end of Carlyle's pivotal foray through Homer's *Iliad* in the Greek.[18] After failing to find a publisher for *Sartor Resartus* and searching for a suitable artistic model for his planned history writing, Carlyle had begun in January 1834 a slow, intensive study of Homer in the original Greek, alongside Johann Heinrich Voss's translation of the *Iliad* into German hexameters. Carlyle, who had done serious translating work before and had despised Pope's and Chapman's translations of Homer, found his encounter with the *Iliad* in Greek and German together to be the revelation he had been seeking. Also instrumental to Carlyle's Homeric study was Wolf's *Prolegomena ad Homerum*. While he was astonished at the power of the *Iliad*, Carlyle found encouragement in the idea that the book was merely a masterful compilation of songs, a world made by editorial assembly. Carlyle now had his model; soon after his study of Homer, he began work on *The French Revolution*, which reviewers such as John Stuart Mill and Francis Espinasse called an "epic"; Thoreau referred to it as an "Iliad."[19] Carlyle's own ambitions for the work were clear to his readers, and in a letter thanking Emerson in 1838 for overseeing an American printing of the book, his apologetic tone still rang with the epic impulse: "I would only the Book were an Epic, a *Dante* or undying thing, that New England might boast in aftertimes of this feat of hers, and put stupid poundless and penniless Old England to the blush about it" (193). Carlyle's reference to Dante rather than to Homer suggested the avant-garde nature of the Scotsman's epic ambition. Dante only began receiving critical attention in Britain after Coleridge's lectures in 1820, and George Ticknor had offered the first American college course on the *Divina Commedia* at Harvard in 1831. Until Longfellow's and James Russell Lowell's public advocacy of Dante studies, especially after the Civil War, Emerson's and Carlyle's reverence for Dante put them in a minority at the time of Carlyle's letter. Although the *Encyclopaedia Americana* testified to Dante's reputation in Europe and aided the growth of his reputation in America, epic was not yet so big a category in the United States as Emerson and Carlyle perceived it during the 1830s.

Carlyle would in fact become famous for expanding the definition of "epic." The *Oxford English Dictionary* cites Carlyle's comment on Shakespeare as the first instance in English of "epic" used in the sense of "a composition comparable to an epic"—a work that does epic work even if it does not exhibit a traditional epic structure.[20] In the *OED*'s quotation, Carlyle is citing August Wilhelm Schlegel's statement that Shakespeare's history plays constitute "a national epic." Here is the quote in context, the *OED* quotation appearing in italics: "August Wilhelm *Schlegel has a remark on his Historical Plays,* Henry Fifth *and the others, which is worth remembering. He calls them a kind of National Epic.* Marlborough, you recollect, said, he knew no English History but what he had learned from Shakspeare. There are really, if we look to it, few as memorable Histories. The great salient points are admirably seized; all rounds itself off, into a kind of rhythmic coherence; it is, as Schlegel says, *epic*;—as indeed all delineation by a great thinker will be."[21] Schlegel's actual term in his *Über dramatische Kunst und Literatur* (1809–11) is "*Heldengedicht,*" literally "hero-poem" and translatable as either "epic poem" or "heroic poem." In a move similar to Lieber's in the title page of his *Encyclopaedia,* Carlyle inserts the nation into his source, rendering Schlegel's *Heldengedicht* as "National Epic." Carlyle is careful to capitalize both the adjective and the noun, for in his discussion of Shakespeare they carry equal and interdependent importance. The work of Shakespeare explodes the definition of "epic" to include "all delineation by a great thinker," going beyond even Jones Very's claim for modern poetry. And the cultural capital involved in the term "epic" is exactly what makes Shakespeare not only great but useful.

Carlyle's discussion of Shakespeare appears in the second half of his lecture "The Hero as Poet," the first half of which focuses on Dante. In his tribute to the Florentine poet, Carlyle refuses to countenance the question of his utility: "The uses of this Dante? We will not say much about his 'uses.' A human soul who has once got into that primal element of *Song,* and sung forth fitly somewhat therefrom, has worked in the *depths* of our existence . . . in a way that 'utilities' will not succeed well in calculating! We will not estimate the Sun by the quantity of gas-light it saves us; Dante shall be invaluable, or of no value." Dante thus stands for the ultimate romantic poet, one whose song can survive the absence of a market precisely because he will always find a fit audience though few; his transcendent genius "speaks to the noble, the pure and great, in all times and places." In summarizing the greatness of Shakespeare, however, he considers the English bard "a real, marketable, tangibly useful possession." Here the international power of epic, the cultural capital that the Schlegels saw in the form and that the

Encyclopaedia article had touched on, is realized in Shakespeare as intellectual property—particularly as a nation's intellectual property. The need for such property, Carlyle states, barely needs an argument: "England, before long, this Island of ours, will hold but a small fraction of the English: in America, in New Holland, east and west to the very Antipodes, there will be a Saxondom covering great spaces of the Globe. And now, what is it that can keep all these together into virtually one Nation, so that they do not fall out and fight, but live at peace, in brotherlike intercourse, helping one another? This justly regarded as the greatest practical problem, the thing all manner of sovereignties and government are here to accomplish." The obstacles to Germany's unification seem minute here in comparison with the sublimity of global space that separates the English-speaking parts of the world. Carlyle includes the United States in his Anglophone empire, which gives greater weight to his assertion that "Acts of Parliament" and "prime-ministers" cannot hold this virtual nation together. It is rather the heroic figure of "an English King, whom no time or chance, parliament or combination of Parliaments, can dethrone! This King Shakspeare, does not he shine, in crowned sovereignty, over us all, as the noblest, gentlest, yet strongest of rallying-signs; *in*destructible; really more valuable in that point of view, than any other means or appliance whatsoever?"[22] Only an international readership of Shakespeare can defeat politics, national boundaries, and transoceanic distances in uniting Carlyle's "Saxondom," and thus Shakespeare the epic poet and Shakespeare the presiding genius of global Englishness are one and the same for Carlyle.

Emerson joined Carlyle in touting Shakespeare as the world's greatest poet, passing over Homer and Dante in his choice of the playwright as his "representative man" for the figure of the poet. However, Emerson's attitude as an American toward Shakespeare was more conflicted than Carlyle had anticipated in his vision of a transnational Bardophilia. In "The American Scholar," Emerson famously declared that Shakespeare was actually an enemy of modern American innovation: "Genius is always sufficiently the enemy of genius by over influence. The literature of every nation bear me witness. The English dramatic poets have Shakspearized now for two hundred years."[23] This impatience with British influence on American culture extended even to Emerson's relationship with Carlyle.

As the Concord lecturer pointed to increasingly cosmopolitan themes for his American audiences—all six of his subjects in *Representative Men* are European—he emphasized his American nationality abroad, both in public and in private. In one of his most sweeping epistolary passages, Emerson described to Carlyle his impressions of the Mississippi following his 1853 lecture tour:

The powers of the river, the insatiate craving for nations of men to reap & cure its harvests, the conditions it imposes, for it yields to no engineering,—are interesting enough. The Prairie exists to yield the greatest possible quantity of adipocere. For corn makes pig, pig is the export of all the land, & you shall see the distant dependence of aristocracy & civility on the fat fourlegs. Workingmen, ability to do the work of the River, abounded, nothing higher was to be thought of. America is incomplete. Room for us all, since it has not ended, nor given sign of ending, in bard or hero. Tis a wild democracy, the riot of mediocrities, & none of your selfish Italies and Englands, where an age sublimates into a genius, and the whole population is made into paddies to feed his porcelain veins, by transfusion from their brick arteries. (486)

Carlyle's reply was all admiration, but it was now his turn to explain to Emerson what "Epical Song" he saw emerging in his work: "Your glimpses of the huge unmanageable Mississippi, of the huge dᵒ Model Republic, have here and there something of the *epic* in them,—*ganz nach meinem Sinne*" (489).[24] Carlyle locates epic in the text, as *he* reads it—not as Emerson wrote it. By this time, epic has entirely moved for Carlyle into the eye of the beholder. And yet years later, Carlyle could relocate epic into Emerson's authorial persona, as he found it in *Society and Solitude* (1870): "It seems to me you are all yʳ old self here, and something *more*. A calm insight, piercing to the very centre, a beautiful sympathy, a beautiful *epic* humour" (566–67). Epic was no longer in the eye of the beholder; it was in the soul of the author, if the beholder could perceive it. This kind of "indwelling epic," we may say, was the product of a lifelong engagement with German Idealist philosophy, but also with an interlocutor who repeatedly refused to let Carlyle define him. At last this definition becomes a compliment, but the edge of power is still present. In the next section, we explore a different kind of definitional power, this time directed at anything within sensory range: the tyranny of Thoreau's epic gaze at Walden Pond.

Thoreau's Homeric Eyeball

If we might call Carlyle's and Emerson's approaches to epic "indwelling," at least in the late correspondence, we might call Thoreau's "internal epic." For Thoreau, epic has little to do with external features or constitutional *Geist* in an object; rather, it is the gaze and reading of the subject that creates epic experience, and thus epic form. This gaze breaks down distinctions between parody, imitation, and originality, as Homeric echoes such as the "Battle of the Ants" passage in

Walden show. The reading of "The Battle of the Ants" as mock-epic, accepted and developed by generations of Thoreau scholars, originated with an essay by philologist Raymond Adams in 1955, entitled "Thoreau's Mock-Heroics and the American Natural History Writers." In arguing that Thoreau's introduction of mock-heroic descriptions into nature writing created an American literary tradition, he glosses an extended quotation from the ant battle with the following sentence: "When one talks about the hills and vales of a woodyard, a sunny valley and an eminent chip, the battle cry of an ant, the shield of an emmet whose Spartan mother sent him into battle, and the wrath of a pismire Achilles, one is using the method of the mock-epic."[25] Adams is correct that the materials of mock-epic are very present in this passage. However, the way in which Thoreau uses these devices amounts to something very different from what Adams suggests. McWilliams gives a much fuller assessment of this passage when he argues that Thoreau successfully combines the registers of high epic and mock-epic to create a humor-based American brand of heroism.[26] Yet Thoreau's understanding of epic and the traditions in which it participated encompassed ancient Asian as well as European texts, and his sense of genre was much more fluid than his critics have acknowledged. This sense opened new possibilities for authorial manipulation of earlier sources, even some of the most venerable of all.

As we have seen throughout this study, definitions of epic had become increasingly fluid following the Renaissance, and the decisive shift in definition from generic convention to cultural work was fairly complete by the mid-nineteenth century. At the same time, poets such as Byron and Shelley were experimenting with a new poetic subgenre, the dramatic poem. Unlike the closet drama, which was written for the page but possible to stage, the dramatic poem required the indefinite space of the reader's imagination to make the scenes work: in poems such as *Manfred*, *Prometheus Unbound*, and Longfellow's *The Golden Legend*, the casts were too big, the locations and special effects too cinematic, for theatrical presentation. In a dramatic poem, what is unstageable in the world can be present to the mind, combining the interiority of the novel and the narrative poem with the visual and interpersonal conventions of the play. The dramatic poem is the ultimate reader's drama. And an examination of Thoreau's reading of epic in *Walden* suggests that his goal is to construct the ultimate reader's epic, an epic that moves out of the limitations of traditional form to transform the known world into the inspired vision of the romantic author.

The first mention of an epic text appears in the chapter "Economy," in which Thoreau comments on his scanty and haphazard reading during the weeks he

builds his cabin: "In those days, when my hands were much employed, I read but little, but the least scraps of paper which lay on the ground, my holder, or table-cloth, afforded me as much entertainment, in fact answered the same purpose as the Iliad."[27] Yet epic is already present before this point, as an Irish neighbor of the Collins family, whose hut Thoreau has just purchased, watches the dismantling, and that watching transforms the mundane, though vaguely tragic, scene: "He was there to represent spectatordom, and help make this seemingly insignificant event one with the removal of the gods of Troy" (44). In the next chapter, the experience of nature after sunrise trumps the most sublime literary experiences: "Morning brings back the heroic ages. I was as much affected by the faint hum of a mosquito making its invisible and unimaginable tour through my apartment at earliest dawn, when I was sitting with door and windows open, as I could be by any trumpet that ever sang of fame. It was Homer's requiem; itself an Iliad and Odyssey in the air, singing its own wrath and wanderings. There was something cosmical in it" (88–89). Here hearing the hum of a mosquito condenses Homer's epics and their referents into a single "cosmical" moment. The mosquito passage is more earnest, more evocative; it is the observer side of Thoreau's statement at the beginning of the chapter "Reading" that all men have the capacity to be both students and observers (99)—as with Emerson, study and attentive experience go together.

And by the time he reaches the chapter on reading, after quoting Latin and alluding to Chinese poetry, Thoreau's student side emerges anew. We learn that he kept Homer's *Iliad* on his table during the summer, though he read it very little (99–100). The very presence of Homer, it seems, is enough to inspire the man who was probably the most adept classicist in the transcendentalist circle; as Thoreau goes on to say, "A written word is the choicest of relics" (102). The purpose of reading the classics, of holding them, of keeping them, of owning them, is to learn to read them well, to imbibe their heroism. Thoreau declares, "To read well, that is, to read true books in a true spirit, is a noble exercise, and one that will task the reader more than any exercise which the customs of the day esteem" (101–2). And this ability to read well is reserved only for the Miltonic fit audience, though few. This concept of the select audience that "gets" it, a vital part of the invention of romantic authorship and reinvented by the modernists, is what makes Chanticleer's song intelligible, the cockcrow that Thoreau sets up as his epigraph "if only to wake my neighbors up."[28] Only the "*uncommon* school," the "few scholars," the "great poets," can understand Homer as Thoreau does—and thus only they can understand the great poet-scholar Thoreau. The sage of

Walden rejects translations of the classics and despises the popular literature that distracted the Greeks from Homer and that distracts Americans from the great books; only Homer is good enough for *his* mosquitoes.

But even as Thoreau takes pains to translate Homer from the Greek for his illiterate wood-chopper friend, he elsewhere quotes from Pope's Homer. In fact, the only object that Thoreau ever mentions being stolen from his cabin is "one small book, a volume of Homer, which perhaps was improperly gilded." The smallness of the book suggests a reprint from the "cheap and fertile press," and it was probably a translation, as Thoreau implies when he speculates that if everyone lived a life of simplicity, theft would disappear, and "the Pope's Homers would soon get properly distributed" (100, 107). We may start to wonder how many copies of Homer Thoreau kept in that cabin. And the wood-chopper who needs the translation has learned only to parse the Greek and not to understand its meaning: "To him Homer was a great writer, though what his writing was about he did not know" (144–45). How does one read well without reading? This wood-chopper Thoreau declares to be a "true Homeric or Paphlagonian man" (144)—can one be truly Homeric and not be able to read Homer? This conflation of innocence, ignorance, and genius not only endangers the power of the reader that Thoreau has supposedly just bestowed but also makes insects—some of the least grand of creatures—into the most Homeric, and the most epic, of all the characters in *Walden*: both the mosquito and the aforementioned ants.

The "Battle of the Ants" passage is based partly on a secondhand account of an ant battle recorded in Kirby and Spence's *Introduction to Entemology*. The strange merger of science and art in Thoreau's passage, of the epic and the encyclopedic, echoes that of his source. On pismerean warfare, Kirby and Spence bemoan their lack of epic rage:

[In the woods] you will sometimes behold populous and rival cities, like Rome and Carthage, as if they had vowed each other's destruction, pouring forth their myriads by the various roads that, like rays, diverge on all sides from their respective metropolises, to decide by an appeal to arms the fate of their little world. As the exploits of frogs and mice were the theme of Homer's muse, so, were I gifted like him, might I celebrate on this occasion the exhibition of Myrmidonian valour; but, alas! I am Davus, not Oedipus; you must, therefore, rest contented, if I do my best in plain prose; and I trust you will not complain if, being unable to ascertain the name of any one of my heroes, my *Myrmidonomachia* be perfectly anonymous.[29]

The celebration of ant battles, if too lofty a task for these entomologists, becomes an opportunity for a Concord squatter to demonstrate how well—and how poetically—he has read his Homer.

As Patrick O'Connell has pointed out, Thoreau's repeated characterization of the ants as Myrmidons highlights not only the Homeric allusion to Achilles's great warriors but the story of the Myrmidons' origin in Ovid's *Metamorphoses*.[30] The Myrmidons were once ants (the Greek for ant is *myrmex*) and were transformed into humans by the gods in order to repopulate the kingdom of Ancaeus, Achilles's grandfather. The Myrmidons, according to Ovid, had superhuman, or rather antian, capacities for strength, endurance, and prowess in battle. As Thoreau watches his own ant battle, he comments that "I was myself excited somewhat even as if they [the ants] had been men. The more you think of it, the less the difference" (230). It is worth noting that the battle in the "Brute Neighbors" chapter is not the first appearance of ants in *Walden*. Just a few paragraphs after the mosquito sings Homer's requiem, Thoreau bemoans the haste of modern social life: "Still we live meanly, like ants; though the fable tells us that we were long ago changed into men" (91). This is a direct allusion to the Ancaeus story in Ovid, but it universalizes the myth such that, to paraphrase Thomas Jefferson, we are all humans, we are all Myrmidons. The problem with modern society, according to Thoreau, is that we have not shed enough of our brute ant-ness to fully realize our humanity—we are trapped in a Myrmidonian existence, not completely belonging to one sphere of life or the other. And it is this tension of placelessness that makes the "Battle of the Ants" passage so powerful and so difficult to categorize.

Thoreau begins the passage by describing two ants, a red one and a much larger black one, in mortal combat. After watching them transfixed for a few moments, he realizes that they are not alone; that he is witnessing "not a *duellum*, but a *bellum*," an apocalyptic war between what he calls "red republicans" and "black imperialists" (228–29). The metonymy between the single combat (the *duellum*) and the war (the *bellum*) is patently epic, focusing the attention and the fate of the armies onto a representative pair, like Achilles and Hector or David and Goliath. However, the armies seem not to notice the duel, at least not as much as Thoreau does. After a second red ant joins the duel, Thoreau removes the wood chip that the three combatants stand on, and places it literally under a microscope, viewed through a tumbler with which he encases the ants on his window sill (230–31). Here Thoreau literalizes the mock-epic trope of placing the tiny subject under a microscope in order to magnify it (artificially) to epic stature.

However, his emphasis on his own sight throughout this passage, as his emphasis on his own translation of Homer elsewhere in *Walden*, argues that epic is only in the eye of the poetic beholder. The power of Thoreau's vision can transform anything into an epic subject, whether the mosquito's buzz or the spectacle of the ant battle. The scale of the subject, the traditional determinant of a text's epic stature, gives way to the scale of emotion, of affect, for Thoreau. As the mosquito affects him at least as much as "any trumpet that ever sang of fame," so in watching the ants Thoreau confesses that "I felt for the rest of that day as if I had had my feelings excited and harrowed by witnessing the struggle, the ferocity and carnage, of a human battle before my door" (231). Nor is Thoreau alone among ant-gazers in drawing conscious and specific political parallels to his subjects' warfare. He quotes Kirby and Spence's accounts of earlier ant battles, themselves recorded by earlier naturalists, which are described as occurring "in the pontificate of Eugenius the Fourth" and "previous to the expulsion of the tyrant Christiern the Second from Sweden" (231–32). Thoreau, ever loyal to his sources even as he blatantly parodies them, offers his own historical frame: "The battle which I witnessed took place in the Presidency of Polk, five years before the passage of Webster's Fugitive-Slave Bill" (232).

To say that Thoreau is invoking mock-epic here only seems to make sense, but to continue on to say that the passage is in fact mock-epic claims more (or less) than I think the passage actually accomplishes. There is something universal, something "cosmical" about the ant battle, and for such a habitual punster as Thoreau, there is certainly also something comical about it. And yet the earnestness of his reactions, his need to find the Homeric in the environs of Walden Pond, pushes Thoreau to a solution to the problem of epic that faced contemporaries such as Whitman and Melville. In *Moby-Dick*, Ishmael defends his choice of the whale as his subject: "Applied to any other creature than the Leviathan—to an ant or a flea—such portly terms might justly be deemed unwarrantably grandiloquent. But when Leviathan is the text, the case is altered. . . . To produce a mighty book, you must choose a mighty theme. No great and enduring volume can ever be written on the flea, though many there be who have tried it."[31] And in the preface to the 1855 *Leaves of Grass*, in which Whitman declares that "the United States themselves are essentially the greatest poem," American poetic expression is to have a quality that "goes through" the epic "to much more."[32] Admittedly, Thoreau's book is not about the flea (or the ant), but, like Wordsworth's *Prelude*, about the possibilities of individual experience artistically remembered. But he can reach those sublime possibilities *through* the ant, *through* the epic, so

that (according to Thoreau) the old form gains new life through the power of Thoreau's imagination rather than falling by the wayside, as Whitman hoped epic would do. What Thoreau's "Battle of the Ants" does is relocate epic within the mind of the poet, thus trumping the Western literary tradition while extending the empire of European romanticism into what would become the cosmical heart of the American canon.

Walt Whitman's Epic Pursuits

Sharing that cosmical heart today is Walt Whitman, who called himself "a kosmos" and once observed that "[f]rom anything like a cosmical point of view, the entirety of imaginative literature's themes and results as we get them to-day seems painfully narrow."[33] Whitman was the poet of the unsung, and especially later in his life his theme became the unsung-ness of the unsung. When he announced "I celebrate myself" to the world in 1855, he stressed in the first preface to *Leaves of Grass* and in newspaper puffs that he was taking up material never before celebrated in poetry: "Let the age and wars of other nations be chanted and their eras and characters be illustrated and that finish the verse. Not so the great psalm of the republic. Here the theme is creative and has vista" (*L*, 619). The vista, Whitman's rendition of the mount of vision, tied him to prior traditions even as it allowed him, like Barlow, to look across continents and centuries to find and reveal the new. And this new material called for a new kind of poetry, "indirect and not direct or descriptive or epic" (*L*, 619). This line has often been quoted to emphasize Whitman's break from the past, but the poet reveals a fascinating tension in his relationship with his ancestors: the new work is not epic, but must go *through* it. Epic is the gateway to the new poetry, even if the new poet cannot remain in that form. According to Whitman's own account, his engagement with poetry began with reading Walter Scott's verse as a teenager, then the Bible, then "Shakespere [*sic*], Ossian, the best translated versions I could get of Homer, Eschylus, Sophocles, the old German Nibelungen, the ancient Hindoo poems, and one or two other masterpieces, Dante's among them" (*L*, 479). This reading, which Whitman did outdoors, was in effect his apprenticeship as a poet, one that had an almost religious quality for him: "If I had not stood before those poems with uncover'd head, fully aware of their colossal grandeur and beauty of form and spirit, I could not have written 'Leaves of Grass'" (*L*, 478).

Yet Whitman did not acknowledge this debt until very late in his career; the above syllabus appeared in the 1888 essay "A Backward Glance O'er Travel'd

Roads," and by then, Whitman's ideas about what he was doing as a poet had changed considerably. Even as he includes tales of war and national myth (such as the Alamo and John Paul Jones episodes) in his original *Leaves of Grass*, he seems determined in 1855 to leave epic behind him, to find a vista beyond traditional form. As that form continued to expand, however, and as Whitman's own understanding of his relationship to other authors became less stark, he found that epic had somehow been pursuing him. By 1872, as he prepared the small volume *As a Strong Bird on Pinions Free*, Whitman described the fervor of the 1850s as "[t]he impetus and ideas urging me, for some years past, to an utterance, or attempt at utterance, of New World songs, and an epic of Democracy" (*L*, 647). While moving through epic, Whitman discovered after the fact that he had in fact settled there—or that it had settled on him. In the process, he also realized that his attempt to sing the great national poem had morphed into a celebration of "the great composite *Democratic Individual*," of himself and/as the cosmos. The purpose of *As a Strong Bird* was to announce that while the "epic of Democracy," *Leaves of Grass*, was now complete (in its fifth edition in 1872), he still intended to write the other half of his original project, "*Democratic Nationality*" (*L*, 651). In writing of himself as a representative and a comrade of all, Whitman decided that he had lost sight of the nation somewhere along the line.

Whitman had early on imbibed Herder's idea that poetry represents the *Geist* of a nation, but his own emphasis on the centrality of the individual poet led him to sidestep the problem of Homeric authorship for modern writers; he refused to consider that it might not be possible for a single poet, a single Homer, to embody or represent a nation's *Geist*. For Whitman, the new poetry was often not simply new but also in a way self-sufficient. In a notebook entry on the *Nibelungenlied* from around 1856, Whitman confronts the authorship issue as he summarizes many of the points from an essay on the poem he had recently read in Thomas Carlyle's *Critical Miscellanies*, a piece that argued against the poem's originating from an individual, original poet: "Probably dates back to about the 6th or 7th Century but the date when it was written as now, is the *13th century*"; "Carlyle supposes it to be about the third redaction (digestion) from its primitive form"; "In their present shape these poems Heldenbuch, and Neibelungen, cannot be older than the twelfth century." Finally, in an emphasis seemingly borne out of frustration with Carlyle's denial of the poet's individual genius, Whitman concluded his entry thus: "The poet himself is unknown—he probably *made up* the poem in the thirteenth century."[34] Rejecting Carlyle's insistence that the poem is a mere digest of earlier myths and legends, Whitman insists that the poem is

"*made up*," composed anew by an individual poet. Through his view of the *Nibelungenlied* poet, Whitman imagines a bard who can work with prior materials without the anxiety of influence that he saw in American literature and feared in his own work. In an entry in *Specimen Days* titled "The Prairies and Great Plains in Poetry," Whitman expressed his wish to see "all those inimitable American areas fused in the alembic of a perfect poem, or other esthetic work, entirely western, fresh and limitless—altogether our own, without a trace or taste of Europe's soil, reminiscence, technical letter or spirit" (*P*, 887). Here Whitman calls for a "perfect poem" that represents (though does not imitate) a landscape so unlike those in Europe that nothing European must remain in the poem; the perfect poem's originality must encapsulate everything, yet also resist contamination and refuse to imitate—or more accurately, not try to imitate that which is "inimitable."

By the time Whitman published this latest version of his nationalist manifesto in 1882, however, he had made his signature poem, titled "Song of Myself" by 1881, more epic than ever. This edition of *Leaves* was the first to change the opening line of "Song of Myself" from "I celebrate myself" to "I celebrate myself, and sing myself" (*L*, 662, 26). The 1872 edition, published the year of *As a Strong Bird*, had been the first to open the first poem with the words, "One's-Self I sing." The Virgilian *cano* had been a Whitmanian commonplace since the 1855 *Leaves*, but in the years following the Civil War it became more and more dominant in his poetry. At the same time, his confidence that the nation could be turned into a national literature waned. In 1891, responding to *North American Review* editor Lloyd Bryce's request for an essay on America's national literature, Whitman composed his response with the title: "American National Literature: Is there any such thing—or can there ever be?" Whitman concluded his essay with the same question, to drive the point home that the question was itself unanswerable (*P*, 1282–86). For a man who had set up his own standard in 1855 that "[t]he proof of the poet is that his country absorbs him as affectionately as he has absorbed it," the aged iconoclast found his country without a poet just as he had found himself without the benefit of his country's absorption.

Yet there was always the future, the horizon, for Whitman. He wrote in the late 1880s that the nation's "myriad noblest Homeric and Biblic elements are all untouch'd" (*P*, 1280), just as the future readers of "Song of Myself," "Crossing Brooklyn Ferry," and "Starting from Paumonok" would find Whitman waiting for them. This connection from the past was not without its risks: "Even in the Iliad and Shakspere [*sic*] there is (is there not?) a certain humiliation produced to

us by the absorption of them, unless we sound in equality, or above them, the songs due our own democratic era and surroundings, and the full assertion of ourselves" (*P*, 1280). Epic was an oppressive force, but because of that it was also a challenge. But would that cycle ever end? Would not the next generation have to overcome and answer the great national poem, were it ever to come to be? The vision of futurity at the end of Whitman's "Children of Adam" section of *Leaves of Grass* has him "[f]acing west from California's shores . . . seeking what is yet unfound" (*L*, 95). He is full of both potential and experience, "a child, very old," trying to close the circle of the globe back around to "the house of maternity, the land of migrations," Asia. He wanders in imagination through all the continents and all the seas but is left not with vista but with a pair of parenthetical questions: "(But where is what I started for so long ago? / And why is it yet unfound?)" (*L*, 95). Epic was by turns a champion to be defeated, a gateway to the new poetry, and a return to origins for Whitman. Perhaps no other writer of his time wrestled so deeply with the fitness of epic for his time, but as the following chapters will show, a range of writers—in novels, lyrics, drama, and the long poem—returned to those same questions. If epic was questionable as a goal at times, it effectively paved the road for American literature.

Tracking Epic through
The Leatherstocking Tales

While other American novelists have been more celebrated in the past century of criticism, few have been hailed as his country's bridge between epic and novel as often as James Fenimore Cooper. Lukács found "truly epic grandeur" and "almost epic-like magnificence" in Cooper's portrayal of the Mohicans in the *Leatherstocking Tales*, as the five novels following the career of Natty Bumppo came to be called even during Cooper's lifetime. Indeed, Lukács refers to Cooper's "immortal novel cycle" as "*The Leather Stocking Saga*," a title never attributed by Cooper or his contemporaries to the series, but which effectively highlights how much the five thick novels had come to approximate epic literature.[1] D. H. Lawrence, perhaps the most influential critic of Cooper's *Leatherstocking Tales*, collapses the categories of epic and novel into reading the stories as one epic novel: "They form a sort of American Odyssey, with Natty Bumppo for Odysseus."[2] McWilliams sees *The Last of the Mohicans* (1826) as a dual turning point in American literature, when the American novel absorbs the epic and when the imaginative treatment of the Native American moves from poetry to prose.[3] I take up the latter claim in chapter 6, but a discussion of Cooper's place in the epic-novel trajectory

is a useful entry into the often bewildering changes involved in American thinking about epic between 1820 and the Civil War.

The Problem with the Great American Novel

Cooper's status as a bridge figure in the Lukács/Bakhtin trajectory is partly by association with his cultural moment. In a famous passage from his preface to *The Yemassee* (1835), which he subtitled "A Romance," William Gilmore Simms asserted that "[t]he modern Romance is the substitute which the people of the present day offer for the ancient epic."[4] Simms's romance seems to have been a direct response to Cooper's *Mohicans*, and Simms, who had previously attempted treating Native Americans in poetry in his *Vision of Cortes* (1828), used the heroic lineage he traced for prose romance to emphasize a break from the domestic realism of the English novel, a break often connected to the romance/novel distinction Hawthorne insists on in the preface to *The House of the Seven Gables* (1851). Romance for Simms "substitute[s]" for epic, a form somehow unavailable, either by the form's outdatedness or by the inability of moderns to properly wield it. A generation later, epic would become a silent ancestor to the new concept of the Great American Novel, a term coined by John W. De Forest in 1868, and whose first major candidate was Harriet Beecher Stowe's *Uncle Tom's Cabin* (1852). Having been celebrated soon after its release (and by a British reviewer) as the "Iliad of the Blacks," *Uncle Tom's Cabin* was for De Forest better celebrated for its nationalism than for its racial politics, and the Great American Novel became a way of approximating epic without the danger of dragging the *Iliad* into literary discussions so soon after the Civil War.[5] While Cooper's texts have rarely been offered as candidates for the Great American Novel, Lawrence Buell's assertion that one of the twentieth century's top candidates was John Dos Passos's *U.S.A.*, a trilogy of three novels,[6] suggests that the collective sweep of the *Leatherstocking Tales* had an indirect but important influence on the development of the later concept.

Simms was far from alone in his day in reading the epic into the novel, and vice versa. The same year that *The Yemassee* was published, the *Literary Gazette* reprinted an anonymous story titled "Aunt Tabitha Timpson; The Novel-Reader." A parody of women's sentimental reading of novels, the story gives an account of an old maid who read novels for almost seventy years and cried nearly the entire time. While Tabitha certainly read *Clarissa* and many lesser imitators, the narra-

tor speaks of a particular binge period in her reading life, when she "read every-
thing in the way of fiction, from Homer's Odyssey to Lewis's Monk, [and then] she
began and read them over again," especially identifying with the plights of Penel-
ope and Dido.[7] Far more earnest writers made similar connections. A writer for
the *Western Monthly Review* in 1828 argued against the "crusade" against novels
as a class, asserting that "Homer's Illiad [*sic*] and Odyssey, Virgil's Eneid, Milton's
Paradise Lost, and Tasso's Jerusalem Delivered, are novels—that is to say, fictions
to create interest."[8] Another writer made a bolder statement than even Simms had
for modern fiction in the *Southern Literary Messenger*: "The modern novel is the
lineal descendant of the epic poem,—for what are the Odyssey and Aneid [*sic*] but
novels in verse?"[9] If current literature was not itself of a heroic age, it could at least
trace its parentage along aristocratic lines. The epic could be a means of elevating
the novel, though it could also be a way of explaining sublime but confusing works
such as Cooper's sweeping *The Two Admirals* (1842), which William Cullen Bry-
ant (in words that echo bemused reviewers of *Moby-Dick*) called "a sort of naval
epic in prose."[10]

Cooper himself saw the novel as a rival to the epic, at least in the hands of Sir
Walter Scott, whom the American novelist declared had "raised the novel, as
near as might be, to the dignity of the epic."[11] The modifying phrase is important
here, however, both in corroborating Simms's sense of the romance as a "substi-
tute" for epic and in highlighting Cooper's suspicion that modern society was
simply not amenable to epic. In the preface to his projected thirteen-volume
"Legends of the Thirteen Republics," a lightly fictionalized history of the original
states, Cooper assured his readers that he "has made no impious attempt to rob
Joe Miller of his jokes; the sentimentalists of their pathos; nor the newspaper
Homers of their lofty inspirations."[12] This was both a disavowal of the use of pop-
ular (and thus questionable) sources and a refusal to participate in the discourses
of what Cooper clearly saw as lower-class literature. His reference to "newspaper
Homers" may be seen as a version of journalists' reputation for self-aggrandizing
prose, exemplified in British literature by Mr. Puff in Richard B. Sheridan's *The
Critic* (1779), but this comment is a criticism not of Homer as much as of the uses
to which Cooper saw him and his classical peers put. In *The Pioneers*, a recita-
tion of Virgil by the most advanced student in the frontier town of Templeton is
so embarrassing as to convince the trustees of the boy's academy to drop clas-
sics from the curriculum.[13] Cooper, a ready Latinist as a boy who nevertheless
admitted to a professor at his alma mater that he "never studied but *one* regular
lesson in Homer,"[14] would have appreciated the indifference toward the classics

that remote towns like Templeton (based on his own hometown of Cooperstown, New York) found necessary.

Yet Homer was also an authority of last resort for Cooper and his supporters. In defending his portrayal of Native characters such as Chingachgook and Uncas as idealized and dignified, Cooper concluded his 1850 preface to the collected *Leatherstocking Tales* thus: "It is the privilege of all writers of fiction, more particularly when their works aspire to the elevation of romances, to present the *beau-idéal* of their characters to the reader. This it is which constitutes poetry, and to suppose that the red man is to be represented only in the squalid misery or in the degraded moral state that certainly more or less belongs to his condition, is, we apprehend, taking a very narrow view of an author's privileges. Such criticism would have deprived the world of even Homer" (2:492). Literature itself would have stopped *in ovo*, Cooper argued, if critics held the same standards in Homer's day that they did in his own. The continuation of literature after Homer was in just as much danger, according to one writer rising in answer to the claim that Cooper was a mere imitator of Scott: "[I]s every writer of an epic an imitator of Homer?"[15] To share a form with a prior writer might not amount to imitation, but the proximity was at times for Cooper too close for comfort. In his efforts to forge his own name, Cooper wrote not only novels of Indian adventure but some of the first American sea novels, utopia and dystopia narratives, the first history of the US Navy, and the first American novels written as series, among other forms.[16] Like Natty Bumppo leaving what he sees as the crowding of civilization into Templeton, heading "towards the setting sun,—the foremost in that band of Pioneers, who are opening the way for the march of the nation across the continent" (1:465), Cooper's continuous need to create new kinds of novels was in fact widening Scott's influence into more and more subgenres of the novel. As with his most famous character, Cooper was part of the very problem that he was trying to escape in his quest for originality.

Epic-to-Novel: A Five-Way Street?

If Cooper did not achieve his highest goals, what he did accomplish was considerable, as is evident in his comments about the epic-novel relationship in the prefaces to *The Leatherstocking Tales*, where the series finds connections to epic in company with history, high drama, painting, and poetry, among other forms. The preface to the first edition of *The Deerslayer* (1841), the last novel to be written but the one set earliest in Bumppo's life, was the first moment when Cooper

wrote publicly of his view of the series as a whole; there he says that the *Tales* "form now something like a drama in five acts; complete as to material in design, though quite probably very incomplete as to execution" (2:485). Concerned that the wide range of time between the novels—*Deerslayer* was published eighteen years after *Pioneers*—affected not only the continuity of style but also the continuity of readers, Cooper was already referring to his latest novel as "the last in execution, though the first in order of perusal" (2:485), indicating that he thought readers should proceed according to Bumppo's chronology through the works. Such would be consistent with his sense of what he had achieved as related in the first preface to *The Prairie* (1827), which was written immediately after *Mohicans* and which, because it depicts Bumppo's death, Cooper believed was the last he would write of his character. Knowing that it was already unusual to focus on the same character in three separate novels, Cooper presented himself as a "faithful chronicler" of a life in his Leatherstocking works. While he found "something sufficiently instructive or touching" in tracing a life from birth near the Atlantic to death on the western plain, he also considered such an imaginative conception to bear a curious relationship with historical fact: "That the changes, which might have driven a man so constituted to such an expedient [as to migrate to the Prairie], have actually occurred within a single life, is a matter of undeniable history;—that they did produce such an effect on the Scout of the Mohicans, the Leatherstocking of the Pioneers and the Trapper of the Prairie, rests on an authority no less imposing than these veritable pages" (1:882). The power of the series for Cooper is the commentary on American history that it provides. Natty Bumppo is witness to the wild, colonial era of northern New York, both in peace and in war; he lives through the Revolution (though that era is never depicted in the *Tales*), the era of nation-building, and finally the era of exploration and westward migration, as he journeys through the Prairie at the same time that Lewis and Clark make their voyage to the Pacific. If this is a five-act drama, it is high drama indeed; the central hero acquires interest not only for himself but for what the reader/viewer might see around him. The fact that so many of the chapter epigraphs in these novels (especially the first three) are from Shakespeare is no coincidence. At nearly the same time that Thomas Carlyle made the argument that Shakespeare's British history plays constituted a national epic (as discussed in chap. 4), Cooper claimed to have done something similar for America.

Unlike Carlyle, however, Cooper does not make the connection between sweeping historical drama and the cultural work of epic. He invoked Homer in his 1850 preface to the *Tales* as a series, but only in reference to his technique. In

the *Deerslayer* preface where the figure of the five-act drama appears, that metaphor immediately follows another taken from an extranovelistic art. Claiming that his readers' enthusiasm for the first three books induced him to write more (the 1840 preface to *Pathfinder* would claim it was his publisher's fault for proposing it), Cooper found that "the pictures [i.e., the earlier novels], of [Bumppo's] life, such as they are, were already so complete as to excite some little desire to see the 'study,' from which they have all been drawn" (2:485). This sentence plays on an element of Cooper's style that was perhaps his most celebrated quality during his lifetime: his talent for landscape description made his "chief praise" to be "a painter with words."[17] Cooper paid close attention to what people said about his works. The "latent regard" for Bumppo that Cooper would claim in 1850 had induced him to write *Pathfinder* was likely at least partly induced by his readers (2:489); he averred that receiving a fan letter from a woman in Britain who asked him for a book remarkably like *Deerslayer* while he was working on that book had convinced him not to destroy the manuscript (2:485). He certainly would have known his reputation for painterly effects when he adopted that language to explain his own thinking. The grammar of his pictorial statement is also intriguing, as the "desire to see the 'study'" comes not from the readers but from him as the author. Where would an author find the study that provided his own work? Perhaps Cooper here alludes to the delving into earlier American history, which he certainly would have been pleased to do after his rude awakening to the realities of Jacksonian democracy upon his return to the United States in 1832. In any case, it suggests that the *Leatherstocking Tales*, or Leatherstocking himself, enjoys a firmer reality than that of most fictions. And a key part of that reality involves how Natty Bumppo responds aesthetically to landscape.

Cooper was himself an art enthusiast who considered himself a connoisseur; he easily befriended artists including Cole, Horatio Greenough, William Dunlap, and especially Samuel F. B. Morse. Cooper was one of the most famous commentators on Thomas Cole's work and contributed an eight-page review of *The Course of Empire* to Louis Legrand's hagiographic biography of Cole. There Cooper "pronounced" Cole's five-canvas series "a grand epic poem, with a nation for its hero, and a series of national actions and events for its achievements," expressing great satisfaction in Cole's raising landscape "to a level with the heroic in historical composition."[18] He was conversant in the critical language of the contemporary art world, and he had an eye for both painted and real scenery. And while filling his *Tales* with richly descriptive scenes, Cooper showed the moral valences of such views as well.

Early in *Deerslayer*, Bumppo (known at this point by the title of the novel) and his companion, Hurry Harry, exit the forest for the young Deerslayer's first view of Lake Otsego; the description moves from the total view ("the most striking peculiarities of this scene, were its solemn solitude, and sweet repose"), to the major elements ("the mirror-like surface of the lake, the placid void of the heavens, and the dense setting of the wood"), and down to the details of individual species, including "dark, Rembrandt-looking hem-locks," "'quivering aspens'" (set off in quotation marks by Cooper to highlight the allusion to Scott's *Waverly*), and "melancholy pines" (2:514). The grand vista is delightful, but it is also a veiled critique of the inroads into the landscape made by the people of Templeton in *Pioneers*. More immediately, it is also a test for the two witnesses of the pristine scene. Deerslayer gasps audibly at his first glance, and after taking in the above description, he exclaims, "This is grand!—'Tis solemn!—'Tis an edication of itself to look upon! . . . every thing left in the ordering of the Lord, to live and die according to his own designs and laws!" (2:513–14). As the pair of adventurers boat across the lake, Deerslayer's assumed reaction is elevated further, but in stark contrast to Harry's thoughts: "The placid water swept round in a graceful curve, the rushes bent gently towards its surface, and the trees over-hung it as usual, but all lay in the soothing and sublime solitude of a wilderness. The scene was such as a poet, or an artist would have delighted in, but it had no charm for Hurry Harry, who was burning with impatience to get a sight of his light-minded beauty" (2:533–34). The beauty alluded to, Judith Hutter, is the central love interest of the novel, and the greed with which Harry anticipates seeing her face, a kind of portrait contemplation, suffers alongside the poet- or artist-pleasure that Deerslayer enjoys in the present moment, a pleasure in the more prestigious genre of landscape.

While the interest of Leatherstocking for Cooper involves the passage of time, it no less involves the freezing of it in poetic landscapes such as this one. That Cooper intimates rather than asserts that Deerslayer is a poet in the above scene suggests that he expects his earlier readers to understand that such was a characteristic and lifelong part of Bumppo's relationship to nature. In describing a waterfall above the Hudson to his young protégé Oliver Effingham in *Pioneers*, Bumppo paints such a vivid word picture that the educated Oliver exclaims that his mentor is "eloquent," though Bumppo reveals his ignorance of the word's meaning (1:297). Cooper portrays his hunter as a natural poet, one proudly ignorant of books but deeply sensitive to the lessons of the vista. And that sense of natural poetry was crucial to Cooper, who stated in the 1831 preface to *Mohicans*,

"the business of a writer of fiction is to approach, as near as his powers will allow, to poetry," and that his intention in writing the first three *Tales* was to "poetically . . . furnish a witness to the truth of those wonderful alterations which distinguish the progress of the American nation, to a degree that has been hitherto unknown, and to which hundreds of living men might equally speak" (1:476, 475). Bumppo's poetry is a poetry of witness, and it makes him what Emerson called a "representative man," not only an example of a type but the fullest expression of that type, one that Cooper understood as existing in an actual generation of American life, but that found its "*beau-idéal*" in Natty Bumppo. The next section seeks to trace Cooper's development of his character and his place in epic tradition across the nearly twenty years of the series' composition.

There and Back Again: The Place of Convention and the Convention of Place

Reading Cooper's *Tales* often has a cyclical feeling to it, partly because of the overlapping chronologies of the books. On the one hand, Cooper began suggesting with *The Prairie* that the reading order should follow the progression of Natty's life. However, the order of composition gave Cooper's initial audience much more of a back-and-forth experience, both spatially and temporally. In this section I examine the major epic conventions that Cooper incorporates into his novels, by title and in order of composition, in order to reconstruct what it meant to Cooper to engage the epic tradition at various stages in his own life and in his work with the life of his most famous character. While I generally refer to that character by his birth name (Nathaniel or Natty Bumppo) in this chapter, this section will use the various names that are bestowed on him in each volume. Bumppo is a self-made man, in that his deeds rather than his birth dictate his name, but as a sign of the dependence of a hero on the celebration of his deeds, he does not choose those names but rather receives them. In this way, Bumppo the self-made man is in fact made by his ever-changing milieux, and by the vicissitudes of his own life. He is a lone, mythic figure, but he is far from self-sufficient.

The Pioneers (1823)

In debates over which of the *Tales* is most epic (*Mohicans* is the usual but disputed winner in this debate), *The Pioneers* is probably the only one of the five never offered as a candidate. The story revolves around domestic drama, mysteries

of Oliver's background and the interior of Natty's cabin, and the rapidly chang-
ing scenery of Lake Otsego as Templeton moves from frontier outpost to western
boomtown. Much of the initial action follows the perspective of Elizabeth Tem-
ple (the daughter of Templeton's founder, Judge Marmaduke Temple), who has
returned after receiving an elite education in New York City. She is charmed by
the sublime landscape and amazed at the growth of the town, but her early im-
pressions of the aged Leatherstocking and John Mohegan, while intriguing, in-
volve no pretensions to heroism or unusual importance. When Elizabeth chooses
Leatherstocking as "my knight" in representing her in the Christmas turkey-shoot,
she says it playfully, and as much to slight the overly proud Oliver as to honor the
old hunter (1:187). When his rifle hangs fire in his first attempt, it seems that both
hunter and weapon are showing their age, though his second attempt succeeds at
winning the prize turkey (1:195). And while Leatherstocking has clearly been a
long-term resident of the Otsego region and his companion, John Mohegan,
shows signs of dignity and grace, the pair are marginal figures, not left in the
wilderness or integrated into the town; John is a Christian convert, but only su-
perficially, and his most powerful conversion, to alcoholism, has destroyed his
constitution. They are relics of the New York wilderness that is about to disap-
pear in the wake of Templeton's progress.

 And yet glimmers of a heroic past appear in rare moments. In the midst of
loud conversation and singing among various groups in the tavern, the drunken
John Mohegan draws unwanted attention as he ominously recollects what he has
been:

> Mohegan was uttering dull, monotonous tones, keeping time by a gentle
> motion of his head and body. He made use of but few words, and such as he did
> utter were in his native language, and consequently, only understood by him-
> self and Natty. Without heeding Richard, he continued to sing a kind of wild,
> melancholy air, that rose, at times, in sudden and quite elevated notes, and
> then fell again into the low, quavering sounds, that seemed to compose the
> character of his music. . . . Mohegan continued to sing, while his countenance
> was becoming vacant, though, coupled with his thick bushy hair, it was assum-
> ing an expression very much like brutal ferocity. His notes were gradually
> growing louder, and soon rose to a height that caused a general cessation in the
> discourse. (1:165)

The Indian's lament stops the townspeople's festivities cold. Natty rebukes his
friend, not for interrupting, but for singing out of season: "Why do you sing of

your battles, Chingachgook, and of the warriors you have slain, when the worst enemy of all is near you, and keeps the Young Eagle from his rights? I have fought in as many battles as any warrior in your tribe, but cannot boast of my deeds at such a time as this" (1:165). Mohegan's fury does not subside however, and he attempts to untie his tomahawk from his belt, but Natty takes him out the door, muttering, "This is the way with all the savages; give them liquor, and they make dogs of themselves" (1:166). The others in the tavern laugh off the interruption and continue their festivities.

In the eyes of the townspeople, Mohegan's mourning of his heroism seems more of a set piece than anything else. While the noise and threat of violence break into civil society for a brief moment, it has no permanent effect. Mohegan had once been a hero, but his mourning, like Natty's morose silence, is an ignored rebuke of the violence of urban development—it is a lament with no hope of redemption into glory. The greatest enemy that Natty alludes to is Judge Temple, who Natty and Oliver believe is withholding legal title to land that belonged to Oliver's family; the new foe wields weapons of law and writing, rather than tomahawks and firearms. While the perceived villainy turns out to be an illusion at the end of the novel, the violence of the law is held up as an insidious evil, though a necessary one, throughout the story. Natty's two great acts of heroism in the middle of the book, the killing of a deer in the lake and the killing of a panther about to attack Elizabeth and her friend, are defined not by a code of honor, as Natty would understand it, but by law. The panther earns Natty a bounty from the county; the deer killed out of season warrants a fine and imprisonment. When Natty defends the privacy of his home from the official who comes to seize the deer (though merely as a pretense to search the cabin for rumored treasure), his fate is sealed, and he stands trial for defying the law. All the while, Natty continually upholds a higher law, condemning the "wasty ways" of the townspeople in felling ancient trees and slaughtering thousands of migrating pigeons and fish, more for sport than out of any physical need. Natty, like Mohegan, takes the long view, longer than that which Judge Temple continually tries to support above the short-term plans of his townspeople. While Temple's goal is to develop a sustainable community—and thus restrain the consumption of natural resources—Natty sees the very appearance of Temple and his enterprise as condemning the landscape and the lifestyle it supported to extinction despite the best civilized efforts at preservation.

The long view takes its most physical form in the book in "Mount Vision," the highest point on Lake Otesgo, which Judge Temple named in honor of his first view

from the summit, which "seemed to me as the deceptions of a dream," consisting of "boundless forest, except where the lake lay, like a mirror of glass" (1:236). The landscape was beautiful to Temple, but he also saw the potential for development, seeing a pine tree as the future site for his house, places for roads and buildings. In contrast, Leatherstocking's views are of nature itself and the rhythm of seasons and migrations that accentuate its scene—despite his own, little-suspected impact on the landscape in his hunting practices and his "smoke curling from under the mountain," the sight of which attracts Temple during his first visit. The Vision, as the mountain is usually called in the book, is the site of futurity and of vista, but it is frequently a place of danger as well. Elizabeth's first visit is a treacherous one, as she negotiates steep, slippery paths choked with mud and barely escapes a falling tree on the return trip. Her second visit leads to her encounter with the panther, which again almost proves fatal. Her third and final visit, during which she plans to meet Leatherstocking with supplies to aid his escape after his jailbreak, finds her, John Mohegan, and Oliver all trapped on the mountain as a forest fire sweeps up the far side and engulfs the entire summit. Leatherstocking's last-minute rescue saves the young people's lives, but Mohegan is mortally burned after stoically re-signing himself to the flames. The approach of death is centered on eyes, as Natty tells Oliver, "His time has come lad; I see it in his eyes;—when an Indian fixes his eye, he means to go but to one place" (1:424). When a minister tries to speak to Mohegan, the Indian "fastened his dark eyes on him, steadily, but vacantly. No sign of recognition was made; and in a moment he moved his head again slowly towards the vale, and begun to sing, using his own language, in those low, guttural tones that have been so often mentioned, his notes rising with his theme, till they swelled so loud as to be distinct" (1:425–26). The song is one of futurity, but rather than envisioning the growth of a city or the decline of heroes, Mohegan sings of death, a death of "the just" that will reward him for his heroic past, which he looks forward to in the posture of looking out across the valley from the Vision. He dies "with his glassy eyes open, and fixed on the distant hills, as if the deserted shell were tracing the flight of the spirit to its new abode" (1:429). The vision of futurity becomes a vision of death and the hereafter, as the man who is known in the story as the last of a great nation dies facing west, seeking a new point of origin at the end of all things. This most manifest vestige of epic in a book about laws, inheritance, and marriage makes the American landscape a place of both promise and destruction, even as the landscape's destruction can be witnessed—in the rapidity of the forest fire or the gradual increase of Templeton—and that vision is carried west by Natty in the closing pages of the book.

The Last of the Mohicans (1826)

To understand Cooper's goals in the *Tales*, it is important to note that Natty Bumppo is not the central character in either of the first two books. In *Pioneers*, he had been an aging hunter caught on the edge of civilization; in *Mohicans*, he is the heroic scout Hawk-eye who leads fair maidens through the forest and aids the military efforts of both British and Mohican forces with natural but subordinate leadership. The title of *Mohicans* refers to Uncas, the son of Chingachgook, who had met his end in *Pioneers* after surviving his son, the last of the line. Uncas has been held up as an Achilles figure in Cooper's writing, a beautiful young warrior whose prowess is defeated only by treachery, not by being out-mastered by an opponent. *Mohicans* is certainly the most Iliadic of the *Tales*, between the two large-scale battle scenes and the only epigraphs from Homer that appear in any of the novels. However, the ways in which Cooper deploys Homer in his text do not readily admit of the simple mapping of characters and conventions. The first epigraph, to chapter 24, quotes the reaction to Nestor's speech encouraging the Greeks to resume the war with Troy, alluding to Magua's oratorical mastery of the Hurons in spurring them to war. The other epigraph, from the same council in *Iliad* II, describes Achilles rising to address the king and his assembly; however, the key speaker in this chapter is "La Longue Carabine," the Canada name for Natty Bumppo meaning "the long rifle," and that role winds up being contested, as Duncan Heyward, whose ideas of chivalry are strongly tinted by romances of medieval knights-errant, pretends to be Hawk-eye in order to protect the scout. The real Hawk-eye, not understanding his friend's intention, counters. The other orator in the chapter besides Tamenund, a century-old avatar of the famous historical chief and the clear king figure of the scene, is Magua. The ambiguity of which character is being alluded to is typical of Cooper's epigraphic practice, but this sole mention of Achilles in the book suggests that there is no one Achilles; the Greek warrior's prowess and narrative importance are shared by several characters (including Uncas), yet owned by none. Homer is more important for lending atmosphere than for providing direct sources for convention or character, and this use of tone as a traditional convention may be Cooper's greatest innovation in bringing epic into *Mohicans*.

Other epic works lend themselves to the tone as well, generally those with powerful emphases on loss and survival, such as Scott's *Lay of the Last Minstrel* and Gray's "The Bard," the latter providing the epigraph for the battle scene outside Fort William Henry. These more modern ancestors share indirectly in

commentary that Cooper makes on the modern iterations of epic poetry. One site of overlooked commentary is the character most often criticized by early reviewers of *Mohicans*: David Gamut, the gangly singing master from New England, the "bore" or comic-relief character who seems like a benevolent, though no less single-minded, Ichabod Crane. He carries a copy of the *Bay Psalm Book*, as much a part of him as the rifle Kill-deer is part of Hawk-eye, and sings from the book at every opportunity. His relentless moralizing and psalm singing drove many readers distracted, and in this light Cooper's characterization of Gamut after the fight at Glenn's Falls sheds light on his understanding of Christian modernity's roots:

> He was, in truth, a minstrel of the western continent, of a much later day, certainly, than those gifted bards, who formerly sung the profane renown of baron and prince, but after the spirit of his own age and country; and he was now prepared to exercise the cunning of his craft, in celebration of, or rather in thanksgiving for, the recent victory. . . . Never minstrel, or by whatever more suitable name David should be known, drew upon his talents in the presence of more insensible auditors; though considering the singleness and sincerity of his motive, it is probable that no bard of profane song ever uttered notes that ascended so near to that throne, where all homage and praise is due. (1:605–6)

The bardic material of the Western world is not a new set of ballads or lays but the psalms of the Hebrew Bible, some of the first poetry to reach British America and that, though it had become dated even as liturgical content after the rise of hymnody in the eighteenth century, had remarkable longevity—even a sense of connecting to America's distant past as well as Israel's. Gamut is a "bard" who performs for an Audience of one, and who cannot convince other people to engage with his songs but sings for his patron nonetheless. The blend of mocking tone and admiration for David's commitment to his art makes this a difficult passage to parse, but the comparison to ancient bards stresses both the overseriousness of Gamut's self-image and his participation in a tradition that predates the psalms themselves. The Christianity that he professes becomes important to some of the other white characters at critical moments in the narrative, but by and large his sheer devotion is his greatest power, as when the Iroquois leave him unharmed as he sings at top volume across the battlefield at Fort William Henry—at first believing that he is lustily singing his "death song" and then leaving him as sacred because they judge him insane (1:674). Epic rage has become the farcical madness of religious devotion.

This parody of the bard-as-convention emphasizes a recurring practice in the book. Much of the moral commentary in *Mohicans*, as in Branagan's *Avenia*, comes across in the failure of epic conventions. Even when moments more seriously approach Homeric stature, things tend to fall apart in *Mohicans*. The single combat between Chingachgook and Magua, famously depicted by N. C. Wyeth in his *Mohicans* series, is thrilling but inconclusive, as Hawk-eye's idle commentating after Chingachgook subdues his enemy allows Magua to escape after faking death. The single combat that should happen at the end of the book, that between Uncas and Magua, turns into a melee, as Magua's supporter stabs the captive Cora in a fit of rage, and then Magua stabs his supporter in revenge and stabs Uncas in the back before the warrior can recover from a flying leap; Hawk-eye can only witness the carnage from a distance, and he kills Magua with a rifle shot. After a brilliantly executed battle that has decimated the Hurons, Uncas finds himself dying not as Achilles, or even as Hector, but in a horrible breach of the Indian code of war. The mourning scene that follows is much more decorous and symmetrical than the final struggle, though the lament for the beautiful Cora and the love she shared with Uncas across racial lines changes the nature of the lament. The death of Uncas means certain doom for the Delawares, as it did for Troy at Hector's funeral, but celebrating the tragedy of faithful lovers separated forever, culminating in a burial of the two victims as husband and wife, mixes the tears of those immortalizing the hero and those immortalizing the lovers. As Hawk-eye and Chingachgook shed tears, their bond is sealed even more fully, though they are now heroic survivors, not conquering heroes.

The Prairie (1827)

The third *Tale* is set ten years past the end of *Pioneers*, but thematically it is very much a sequel to *Mohicans*. While Hawk-eye's sadness in the first novel is tempered by his love for his friends and for the wilderness, Leatherstocking's loss through his exile from his native ground (this is the only *Tale* not set in New York) has no check. The wilderness is all-encompassing and extends spiritually as well as physically, a scene of alienation reminiscent of Adam and Eve's expulsion from Eden. Deprived of his homeland, his friend Chingachgook, and his characteristic eyesight (he is known in this book simply as "the trapper," finding himself unable to live anymore by hunting), Natty Bumppo is a desolate man in a desolate place. At the same time, that place is one of infinite possibility, as unknown travelers approach from all directions, requiring if anything more

vigilance than in the forest. The historical sweep of the pioneers in the first novel and of the Indians' disappearance in the second continues with waves of westward migration in the third. However, that wave is only in the distance in *Prairie*, as the trapper inhabits the Great Plains west of the Mississippi during the voyage of Lewis and Clark. The book is all expectation, and anything can happen (and almost does). Indian wars, wagon trains, prairie fires, and bison stampedes all anticipate conventions that would define the western adventure genre in the later nineteenth century, but as usual in the *Tales*, the landscape dominates the atmosphere and drives the plot.

Unlike the picturesque vistas of New York's lakes, the rolling prairie offers endless prospects, but little hope: "From the summits of the swells, the eye became fatigued with the sameness and chilling dreariness of the landscape. The earth was not unlike the ocean, when its restless waters are heaving heavily, after the agitation and fury of the tempest have begun to lessen. There was the same waving and regular surface, the same absence of foreign objects, and the same boundless extent to the view" (1:892). The endless prospects in *Prairie* are sites for scouting game and enemies, particularly the avaricious bands of Sioux and the stubborn, amoral pioneers represented by the gigantic Ishmael Bush and his family. If the Indians possess a similar grace to those of their eastern counterparts, the Bushes are almost monstrous, powerful yet uninterested, autochthonous yet not native to their surroundings. The civilized future of Templeton has been reversed into the uncertain future of the frontier, where both the Sioux and the more noble Pawnee sense their impending doom in the rise of white migration, while most of the whites who have thus far penetrated the Plains are lawless, uncaring souls who leave as little mark on those they encounter as their wheels do on the ground almost too hard to cultivate.

Yet all this surfeit of scarcity serves to clear space for Natty Bumppo–as–trapper to emerge as the undisputed hero for the first time. He is both the sage, able to read the landscape and the faces of people, and the tactician, skilled in anticipating and devising "sarcumventions." Natty's sole companion besides the stragglers who attach themselves to him is his faithful dog, Hector. The name is a curious one for the dog of a man proud of his lack of book knowledge, but in the wake of Hawk-eye's terrible loss at the end of *Mohicans*, the dog is a beloved though inadequate substitute for the Mohican companions. Indeed, though Natty alludes to owning dogs in other novels such as *Pathfinder*, the only dogs to appear in the *Tales* are in the novels of old age, after either Uncas or Chingachgook have been lost. Hector had also appeared in *Pioneers*, but here his name

carries greater poignancy, particularly as he suffers old age and death along with his master; though it turns out that pups descended from Hector's family live on, he is the last companion of a man whose own line is ending. In the course of the narrative, the trapper encounters an Indian, Hard-Heart, who fulfills the promise of Uncas, a young warrior who is nevertheless a wise, respected chief who leads his Pawnee nation into battle, defeating his opponent in the satisfying single combat—mounted on horses, no less—that was denied the young Delaware in *Mohicans*. Natty continually likens the Pawnee to the Delawares, as if he hoped to create a new version of his life in a foreign wilderness; this is, in fact, his motive for leaving Templeton in the first place. The trapper is a consummate wanderer by now, not only having walked all the way to the Plains from upstate New York but also having been over the Rockies to the Pacific and back by the opening of the *Prairie*'s narrative. As a witness to American history, he has literally seen it all.

The trapper ends his life not on the shores of the Pacific to complete the continental sweep but in the center of the continent (though the far west of the nation at the time), at the line where beginnings and endings meet. Among the characters he encounters is Captain Middleton, the grandson of Duncan and Alice Heyward from *Mohicans* who actually knows the trapper's history—his exploits, his friends, his previous names. Even as the trapper reaches the point where his name fades to an epithet and he finds himself unable to do deeds like those in *Mohicans*, his story lives on in the families that knew him. His death is peaceful and easy, in honor among the Pawnees and next to his new white friends; he is buried with Hector, who the Pawnees have stuffed to soften the blow of his prior death, and Kill-deer returns to Oliver Effingham in New York. His grave lies by oak trees in the midst of the prairie, and a gravestone makes him a permanent fixture in one of the few fixed points in a weirdly blank landscape. Where the man physically fails, his story achieves transcendent permanence both in the land and in the minds of his friends.

The poignancy of this good death heightens through contrast with another death two chapters earlier. Ishmael Bush's brother-in-law, Abiram, a counterfeiter and kidnapper on the run, is found to have murdered Ishmael's oldest son, Asa, and in a case of frontier justice the family's leader decides to execute his brother-in-law. Ishmael's wife, Esther, finds herself torn between outrage over the loss of her son and pity for her brother, but Ishmael insists that Abiram execute himself by hanging from a ghastly, dead willow tree, "a noble and solemn monument of former fertility," with "ragged and fantastick branches"—as if

taken from a Samuel Becket set (1:1283). The night following, as wind howls across the prairie, the wanderer Ishmael feels "a keen sense of solitude" (1:1291) for the first time in his life. In this moment, he hears screams on the wind, and his wife insists that they return to the tree to bury her brother. They find "a human form swinging, in the wind, beneath the ragged and shining arm of the willow," with pages from a fragment of Esther's disintegrating Bible scattered from the dead man's hands on the ground. As the husband and wife approach the body once it is on the ground, the heartbreak of the scene becomes a Christian version of Priam's petition to Achilles for the body of his son:

> The grave was soon dug. It was instantly made to receive its miserable tenant. As the lifeless form descended, Esther, who sustained the head, looked up into the face of her husband, with an expression of anguish, and said—
>
> "Ishmael, my man, it is very terrible. I cannot kiss the corpse of my father's child!"
>
> The squatter laid his broad hand on the bosom of the dead and said,
>
> "Abiram White, we all have need of mercy, from my soul, do I forgive you. May God in Heaven have pity on your sins."
>
> The woman bowed her face, and imprinted her lips long and fervently on the pallid forehead of her brother. After this came the falling clods and all the solemn sounds of filling a grave. Esther lingered on her knees, and Ishmael stood uncovered while the woman muttered a prayer. All was then finished. (1:1293)

Buried in an unmarked grave at the foot of a dead tree, condemned for committing a horrendous murder, Abiram White is not so much mourned as the occasion for mourning—for the murdered Asa, for the heartbroken Esther, for the profoundly isolated Ishmael. The husband and wife come together at the grave, her grief partially healed by her husband's act of forgiveness. After the work is done, no trace of Abiram, or of the Bushes, remains in the prairie, as the family begins the march back east the next day and eventually fades into oblivion in the western towns. The trapper has been the nexus for the changing lives of many in *Prairie*: the downfall of the band of Sioux that harass him, the annihilation of the Bush clan by the force of their own family's sin, and the upward mobility of the young pioneers he meets. The Homeric close to their story marks a race that leaves no trace; unlike Troy, no one is left to remember Abiram or the Bushes. In contrast, Middleton adds a line to Natty's requested epitaph, the closing line of the novel, *"May no wanton hand ever disturb his remains"*

(1:1317), as a means of ensuring the permanence of his memory, even if his life had been marked by impermanence and often bewildering change. At the point that Natty Bumppo ends, his influence on the country turns full circle—that is, back to the east, back to the point of origin, even as he finds peace in some of the last wilderness available to him.

The Pathfinder (1840)

Cooper was certain that he had left Natty Bumppo behind with the last line of *Prairie*; the hero's "chronicler" was surely the last person to disturb his remains. Yet he returned, for reasons still unclear, to the character thirteen years later, after several years' residence in Europe, an extended hiatus from novel writing, and a reputation fast deteriorating in the States thanks to several volumes of vituperative political commentary and a number of nasty, well-publicized lawsuits that had drawn criticism from many quarters. Cooper's view of America's progress had changed from one of guarded optimism to disappointment, and his view of novel writing had changed from the art of presenting real life to creating art that generated moral uplift in its readers. If Cooper had begun to come to terms with the power of his Leatherstocking character in *Prairie*, he would make his new novel about America witnessing the growth of that character, rather than vice versa. Filled with some of Cooper's most compelling landscape descriptions and several scenes of sailing maneuvers of the kind he had reveled in while writing *The Spy*, *The Red Rover*, and *The Water-Witch*, the fourth *Tale* combined two of Cooper's signature settings—ships and forests—as the backdrop for a rewriting of the Aeneas-Dido story.

Critics have noted that Pathfinder, as Natty is known in this book, makes little happen in the plot. George Dekker has observed that *Pathfinder* represents Cooper's only foray into adapting Scott's wavering Waverley character, whose internal drama of choice is more important than the external drama of wars and adventures. The story takes place soon after that of *Mohicans*, with Pathfinder and Chingachgook both still middle-aged but with Uncas only a memory. While Pathfinder has a new protégé in Jasper Western, his most important companion is the young, beautiful Mabel Dunham, with whom both Pathfinder and Western fall in love. The only scene in the *Tales* to depict Natty Bumppo weeping freely besides Uncas's funeral occurs when Mabel rejects his proposal. Cooper clearly found this moment critical for Natty's character development, and his final renunciation of marriage after Mabel later agrees on her father's deathbed to marry the Pathfinder ensures that he will in fact go on to be the great, solitary hunter he was famous for being in the earlier books.

The question as to how Pathfinder will deal with Aeneas's choice to either stay with Dido or follow his destiny is as false as it was for Aeneas—but only because we know the story already. Virgil announces in the first page of the *Aeneid* that his hero will go on to found a nation in Italy, and the impossibility of doing so in Carthage requires him by sheer narrative logic to give up the girl. Similarly, readers of *Pioneers* and *Prairie* would already know that Natty Bumppo spends his life alone. Thus, if the suspense of the actual choice is removed, something else must generate the interest. And here is where I see *Pathfinder*'s greatest claim as a turning point in the series: by narrating a story with a known outcome, Cooper practices what Goethe and other German writers of his day called "epic deferral," the technique of slowing down an already known story in order to tease out the meaning, the importance, the poetic possibilities of that story.[19] Natty had become a new kind of epic hero for Cooper in *Pathfinder*, one in whom he found "an interest . . . that falls little short of reality," yet could be larger than life even in a supporting role. As the great empires of Europe rage across a vast American wilderness, Natty Bumppo wonders whether to join them. Only a character already well known and invested with power by his readers could pull that off.

Cooper doubted that his new book would be received as well as the first three, and he complained in the 1850 preface that his fears had been confirmed, yet *Pathfinder* was perhaps the most celebrated of all the *Tales* in European countries. It prompted Balzac to call Bumppo "a statue, a magnificent moral hermaphrodite," and the Russian critic V. G. Belinsky found the novel to be "Shakespearian drama in the form of a novel—the only creation in this genre, entirely without equal, a triumph of modern art in the sphere of epic poetry."[20] While Balzac incisively highlighted Cooper's elevation of Natty Bumppo to mythic status, Belinsky made the complex connection between epic, novel, and drama that I have argued was implicit in the prefaces to *Deerslayer*; the power of the work is the coexistence of multiple genres operating together, creating not only a romance narrative but also a larger story about the emergence of a nation among several empires. Significantly, in *Mohicans*, *Prairie*, and *Pathfinder* the Manichean drama of the good Indian / bad Indian is always complicated by the fact that multiple empires are involved in each stage of the drama: France, England, the Iroquois, the Delawares, the Sioux, the Pawnees, and even the lawless pioneers must all work by stratagem and alliance to stay viable in contested territory, and nature as an actor in the story of America is readily apparent even in the seeming interethnic harmony of *Pioneers*. To enhance the Leatherstocking's

mythic status, a sharper dualism would be needed—and that was exactly what Cooper provided in the fifth and last novel, *The Deerslayer.*

The Deerslayer (1841)

Written immediately after *Pathfinder,* the final *Tale* moved even further into the colonial past, at the dawn of both King George's War (the American avatar of the War of Austrian Succession) and Natty Bumppo's manhood. It is in the original preface to this work that Cooper deploys his metaphors of the five-act drama and the study for the finished pictures; his thinking about the series has progressed from Natty-as-witness to the character's own development as a witness to the growth of America. If the series up through *Prairie* was about the landscape and its struggle with the incursions of white settlers, the later books bring matters of white moral choice—the parlor or the forest, the love of a woman or the glory of a warrior—to the fore. The first three books are passages in Natty Bumppo's life; the last two are rites of passage. The title of the last book indicates as much. The name Deerslayer, in honor of his hunting exploits, also implies that he has little experience as a warrior. His quest for a new name parallels Chingachgook's quest for his first scalps. Again out of reach of the law, Deerslayer must take leadership as his companions, each with their own goals and methods, are often absent, incapacitated, or unhelpful. Never has he been so much in charge of the story, yet never has he been so inexperienced: ever the unschooled poet, he must learn by doing.

As Natty coolly performs his duty—to rescue Chingachgook's beloved, to protect the sisters Judith and Hetty Hutter from the Hurons—he learns that his fame is already growing. His name as a hunter is already known in the area, and his fame grows among the Hurons even in the course of the story. As he steps off onto the shore that will be the site of his first battle, the narrator prepares the reader for a key threshold moment: "Such was the commencement of a career in forest exploits, that afterwards rendered this man, in his way, and under the limits of his habits and opportunities, as renowned as many a hero whose name has adorned the pages of works more celebrated than legends simple as ours can ever become" (2:593). The comparison drawn here is a more subdued version of a classic device in epic writing: to claim the superiority of the hero over previous heroes is typical, but to claim the simplicity of the form relative to that of "more celebrated" works argues both for the recognized belatedness of Cooper's text and its status as somehow more classical, more heroic, because of its sheer simplicity. This is a return to the oral tradition, the engine that propels Natty Bumppo's fame in the denouement of the novel: "[H]e made his fame spread far and

near, until the crack of his rifle became as terrible to the ears of the Mingos, as the thunders of the Manitou" (2:1027–28). By contrast, Judith Hutter's name diminishes in proportion. As a beauty of "fame," Judith is sought out by men and in danger of both their physical aggression and the rumors that they spread of her character. After she discovers that Thomas Hutter is not her real father, she happens on a cache of family papers. The only other witness to this cache is Deerslayer, who, being illiterate, can only read the pain of Judith's reaction in her expressions. The girl's education is "far superior to her situation in life," which allows her to scan "page after page of the letters, with a readiness that her schooling supplied" (2:892). Judith lives in a literate world, but her search for her true name in her mother's letters meets with frustration as she finds every name and address erased or cut out from the pages. In the absence of oral tradition—both Thomas Hutter and Judith's unnamed mother have died, leaving no spoken hints of the truth—Judith Hutter is reduced to Judith, the woman with no name, and hence no good name. Her fate is not positively known, but years later Deerslayer (now Hawk-eye) hears a rumor that a former British officer known to have compromised Judith's character in New York "lived on his paternal estates" with "a lady of rare beauty . . . who had great influence over him, though she did not bear his name" (2:1030). The virtuous life that Deerslayer leads becomes the stuff of legend, but so does the degraded life of one possessed of advantages of beauty and literacy. Deerslayer's inadequacies become safeguards of his greatness.

These safeguards help to protect his solitude as well. Deerslayer receives a wedding proposal from Judith, the continually pursued woman who falls in love with the only man who abstains from pursuing her. While Pathfinder had found difficulty in choosing between the freedom of the woods and the charms of Mabel Dunham, Deerslayer stays true to his first love in the final novel. Earlier, when Judith asks Deerslayer where his sweetheart is, his response turns to natural poetry, and the reason is obvious: "She's in the forest, Judith—hanging from the boughs of the trees, in a soft rain—in the dew on the open grass—the clouds that float about in the blue heavens—the birds that sing in the woods—the sweet springs where I slake my thirst—and in all the other glorious gifts that come from God's Providence" (2:617). If the outcome of Pathfinder's romance with Mabel is predetermined, that between Deerslayer and Judith is even more so. This both consolidates Natty's quality as a man of nature and adds poignancy to the conflict he feels in *Pathfinder*. Here *Deerslayer* becomes an extended gloss on the prior *Tales*, and all of Natty's wanderings find their object: the search for home, in God's country. The wilderness is the home of the American hero.

The Leatherstocking Tradition: A Synoptic Reading

Let us now return to Lawrence's ecstatic declaration that the *Tales* are the American Odyssey, and that Bumppo is Odysseus. Bumppo's wanderings certainly invite the association; his love for "sarcumventions," whether using his rifle to make a fire break in *Prairie* or dressing as a bear to infiltrate a Huron village in *Mohicans*, also puts him in company with Homer's tactician. Bumppo is "skilled in all ways of contending"; in *Deerslayer* alone, he negotiates, taunts, argues, races, wrestles, navigates several watercraft, wins a shooting match, avoids marriage twice, and fells opponents with two different weapons. And he is also No Man. With a birth name so homely as to have little meaning for him (except when he wants to be remembered at the end of his life), he takes on names to suit both his talents and the various stages of his palimpsest life: Deerslayer, Hawk-Eye, La Longue Carabine, Pathfinder, Leatherstocking, the hunter, the scout, the trapper, the wise chief. Yet this tension between constancy of character and fluidity of "*sobriquet*," as Cooper often called Natty's names, makes his witness to the changing of America especially poignant: how much did things change when New York went from being a British colony to being a state? Has America always been America, or is America only the latest name for something more fundamental in the land, or the people, or the story? To think of Natty Bumppo, a figure so universally accepted as a feature of American mythology, as an Odysseus figure seems to me accurate, but it raises questions of what this kind of figure means to our understanding of America. If Bumppo's life is a search for his beloved wilderness—the Penelope of his story—can the story truly end in redemption? Judith, as the false Penelope, finds herself inundated with suitors and assailants, but despite her talents she is not faithful or crafty enough to ward off all of their advances. Will the wilderness fare any better? By returning to Lake Otsego before the days of Templeton, Cooper seems to be reaching back to a homeland that, like Ithaca, does not exist for its Odysseus anymore. The almost painful love for the woods and water of the Glimmerglass, the mythic name given Otsego by white hunters in the absence of a "Colony name" (2:524), gives *Deerslayer* the elegiac tone of a legend of the Golden Age, a time that even Bumppo cannot reclaim when he returns to find the Hutter's "castle" in ruins and a sole ribbon the only reminder of Judith's existence—and then a growing town to at last erase that memory along with the pristine landscape.

Natty's first fight with an enemy also suggests the fleeting achievement of an ideal that will never again be realized. After Deerslayer spots a Huron who has

just shot at him, he finds a clear sightline but calls to the Huron to parlay rather than take advantage of his unseen maneuvers. As the two seem to part amicably, Deerslayer looks back just in time to see the Huron drawing a bead on him, and his response is instantaneous: "To cock and poise his rifle were the acts of a single moment, and a single motion; then, aiming almost without sighting, he fired into the bushes where he knew a body ought to be, in order to sustain the appalling countenance which alone was visible. . . . So rapid were his movements that both parties discharged their pieces at the same instant, the concussions mingling in one report" (2:598). The Indian rushes out of the bushes but only to fall mortally wounded on the shore. Deerslayer's response is to bring his foe water, resting his head in his lap and assuring him he will not take his scalp. The exchange between the two shifts from martial excitement to tender respect, almost affection, and when Deerslayer tells the fallen Huron his name, the brave replies: "'That good name for boy—poor name for warrior. Get better quick. No fear *there*—' the savage had strength sufficient, under the strong excitement he felt, to raise a hand and tap the young man on his breast—'eye, sartain—finger, lightening—aim, death. Great warrior, soon—No Deerslayer—Hawkeye—Hawkeye—Hawkeye—Shake hand'" (2:602). The warrior's name that Deerslayer earns is given not by his friends but by his first enemy, and it is the name he uses with the Hurons throughout the rest of the book. No other single combat is so satisfying or so moving throughout the other books, certainly not Natty's other great kill, Magua. Never again will a single combat have so much meaning, or matter so much to Natty. After reading his first battle, the earlier (or later) fights pale in comparison, even if they exceed it in scale.

And it is precisely this type of back-and-forth reading that the *Tales* invite that makes them work as a group. Though conceived only one book at a time, Cooper's *Tales* continue to weave back and forth into each other, changing the meaning of tears, for example, whether one first reads Hawkeye mourning for Uncas or Pathfinder weeping in the face of Mabel's rejection. The morality of shooting across the novels might be the best example of this. Deerslayer refuses to take a covert shot at his first enemy, but when he finally receives Kill-deer as a gift from Judith, Cooper compares him to a boy wishing to try out a toy trumpet. He proposes a shooting match with Chingachgook, in which various of the birds that teem on the Glimmerglass serve as unsuspecting targets. The two hunters give little thought to the birds' welfare, at least until the time comes for Deerslayer to try Kill-deer for the first time. An eagle soars high over the lake, out of range of Chingachgook's rifle, as it looks for food for its chicks, which are also in visual

range (though unseen by all but the narrator). Deerslayer laughs when he takes aim at the eagle, but once it falls on the deck of the Hutters' boat, he exclaims, "We've done an unthoughtful thing, Sarpent—yes, Judith, we've done an un-thoughtful thing in taking life with an object no better than vanity!" (2:928). His thoughts lead him to reflect on the larger lesson of his vanity: "What a thing is power! . . . and what a thing it is, to have it, and not know how to use it. It's no wonder, Judith, that the great so often fail of their duties, when even the little and the humble find it so hard to do what's right, and not to do what's wrong" (2:929). He wishes to find the eagle's nest and put the chicks out of their misery, but he is on furlough from captivity, and he accepts his promised return as punishment, knowing that torture and death inevitably wait for him.

A previously unnoticed intertext shows the importance of this moment to Natty's moral development. A very similar scene occurs at the start of the Quaker John Woolman's journal, a text that was almost certainly known to the Cooper household while the novelist was growing up. Woolman recalls killing a bird by throwing stones at it as a young boy and triumphing over his deed until he real-izes that the bird will no longer feed its babies, whom he could see in their nest from the spot where the bird fell. He then wrings the necks of the baby birds, and the verse comes to his mind that "the mercies of the wicked are cruel."[21] The fa-mous integrity of Woolman's morality is forged partly from the pain of this memory, and so it seems to be for Natty, who willingly submits to the promise of painful death as a response to his misdeed—which no one else in his party sees as a sin. Of course, Natty is rescued, but his willingness to face death somehow redeems his action, even as the redemption comes at the price of the Hurons' decimation by a bayonet attack from British troops, drawn to the spot by the sound of Killdeer's report. The gruesome violence that frees Natty causes him less pain than the shooting of the eagle, and the notion of being "wasty" domi-nates his ideas about other games in the book.

The Christmas turkey shoot in *Pioneers* carries no such moral burden, be-coming almost ridiculous when Natty's rifle misfires (it is Kill-deer, but Cooper did not name the rifle until *Mohicans*) and Brom, the owner of the birds in the contest, heckles the shooters in turn. Natty can also shoot the head off a pheasant for his dinner as a way of showing his skill and laugh at his victory. Yet a deadlier sport, the slaughter of the migrating pigeons, is one of the first moments where the noble indignation of Leatherstocking emerges in its fullness. Though he had earlier lamented the downfall of the Delawares and the damaging of the forest for syrup and firewood, his "tall, gaunt form" paces across the field as dead and

dying birds cover the ground. Dozens of sportsmen fire into a flock of thousands of pigeons, and the terminally hyperbolic Richard Jones even fills a small cannon with shot to bring down as many pigeons as possible, for no other reason than to bring them down. As both a show of skill and an admonition to the others' profligate shooting, Leatherstocking brings down a lone pigeon with a single shot, all the while decrying the townspeople's "wasty ways." Judge Temple agrees with Leatherstocking, understanding him as condemning the hunting practices, which Temple wishes to regulate for the sake of conservation. Leatherstocking's response is unexpectedly pointed: "Put an ind, Judge, to your clearings. An't the woods [God's] work as well as the pigeons? Use, but don't waste. Wasn't the woods made for the beasts and birds to harbour in? and when man wanted their flesh, their skins, or their feathers, there's the place to seek them. But I'll go to the hut with my own game, for I wouldn't touch one of the harmless things that kiver the ground here, looking up with their eyes on me, as if they only wanted tongues to say their thoughts" (1:250). Stricken, Temple watches Leatherstocking walk away, carefully avoiding the fallen pigeons as he goes, and announces that the hunt is over. Though the pigeons have been slaughtered, Natty has gained a moral victory, if a belated and temporary one in passing on the lesson the eagle had taught him as Deerslayer.

Given the distinction that Natty tends to make between killing for need and killing for sport, the aftermath of the shooting match in *Pathfinder* now takes on a disturbing tinge. During a shooting contest at Fort Oswego, Pathfinder deliberately misses a shot after he learns of Western's frantic desire to win the prize of a silk shawl as a gift for Mabel. After Western wins the shawl and gives it to Mabel, Pathfinder walks along the lake with her. When Mabel expresses her surprise that such a famous marksman could miss a shot, Pathfinder seeks to set the record straight:

"[N]o one did as much [as Jasper] there, but you shall know what *can* be done here. Do you observe the gulls that are flying over our heads?"

"Certainly, Pathfinder—there are too many to escape notice."

"Here, where they cross each other, in sailing about—" he added, cocking and rasing his rifle—"the two—the two—now look!"

The piece was presented as quick as thought, as two of the birds came in a line, though distant from each other many yards, the report followed, and the bullet passed through the bodies of both the victims. No sooner had the gulls fallen into the lake, than Pathfinder dropped the breach of the rifle, and

laughed in his own peculiar manner, every shade of dissatisfaction and morti-
fied pride having left his honest face. (2:175)

Although Pathfinder's exploit soothes his pride and impresses Mabel, his other
experiences with such "wasty" shooting suggest not only that he is mentally dis-
tracted from his usual life by affection for Mabel; he is morally distracted as well,
and only when he disappears back into the forest with Chingachgook at the end
of the novel is he wholly himself again.

This reading across books scattered across both the Cooper and the Bumppo
chronologies is decentered and multidirectional, lending to layered rereadings of
the same passage and the same device over and over. This is the true narrative
power of the *Tales*, which ultimately behave not so much as a retelling of the
course of American empire as an invitation to continually reassess and revisit
the American experience, mythically and ideally as rendered in the stories. The
game is a device running through the epic tradition that celebrates the dead (in
the *Iliad* and *Aeneid*), allows for the winning of glory and wealth (in the same
works), and occasions the revelation of true identity (in the *Odyssey*). Cooper's
recycling of devices such as this, as Leatherstocking shoots to win turkeys but
also to prove his mettle—and, in a shooting match with Heyward in *Mohicans*,
his identity—allows him to continually reinvent his character, the story he in-
habits, and the tradition from which they are all drawn.

Lukács was right to call the *Tales* a cycle, for no chronology emerges as *the*
chronology. The books work in a kind of Troy Cycle, a series of connected stories
that have the potential to proliferate endlessly (as Cooper had contemplated
adding another tale soon before his death, the fifth such time the idea had struck
him). Like the trove of narrative material that provided a common source for the
Iliad, the *Odyssey*, Aeschylus's *Agamemnon*, Sophocles's *Electra*, and a number of
other classical works, Cooper had turned his novels into both a source and a
product of a tradition made of a balance of fictive imagination and American
history, one that would even inform his other writings, as Uncas (an ancestor of
Chingachgook's) battles in *The Wept of Wish-Ton-Wish* and in *Home as Found*
later descendants of Oliver Effingham discuss Leatherstocking with an Ameri-
can commodore, who avers, "They may talk of their Jeffersons and Jacksons, but I
set down Washington and Natty Bumppo as the two only really great men of my
time."[22] Donald Pease writes that for Cooper's contemporaries, "Natty Bumppo
seemed less a character in his own right than the progenitor of a tradition that
he demanded be continued," and that the character's "life took possession of

Cooper's imagination in the way a tradition takes possession of a country's."[23] That tradition takes epic form at times, but like the Troy Cycle, it is somehow prior to epic, operating inside and outside the bounds of Aristotelian chronology at the same time. And in the books, Natty lives on in the stories people tell of him, in the young soldier in *Prairie* and the young sailor-turned-merchant in *Pathfinder*, in the rifle that becomes an heirloom in upstate New York and the dog that hunts with an army officer. If America cannot sustain the Leatherstocking ideal of innocence, honesty, and love for the land, it can at least always find a way to connect to and inherit it. Cooper had found new ways of integrating epic and novel and different ideas for what the novel itself could say and do. In the same vein as Sarah Wentworth Morton's *Beacon Hill* fragments, Cooper took apart the novel and assembled all that he thought worthy of inclusion, including epic, drama, painting, and new notions of tradition that would shape the serial epics of twentieth-century film and fantasy writing.

Lydia Sigourney and the Indian Epic's Work of Mourning

In his quest for the all-inclusive poem of America and democracy, Whitman naturally included Native Americans. But amid celebrations of the city and the wild, of sex and the dignity of slaves, this inclusion was strangely oblique: the "red girl" that marries the trapper, the "squaw rapt in her yellow-hemmed cloth," the "friendly and flowing savage," the "moccasin print."[1] Only late in his career, after encountering Native Americans during his tenure at the Indian Affairs Bureau in Washington after the Civil War, did Whitman conclude that he needed to give more focused attention to this element of the America he sought to speak into being. One late effort to do this was his poem "Yonnondio," which appeared in the *Critic* in 1887, before inclusion in *November Boughs* and the 1891 *Leaves*. The poem opens as a commentary on its one-word title: "A song, a poem of itself—the word itself a dirge," which evokes wild scenes and "strange tableaux" through sheer syllabic resonance (440). The sounds of the word *Yonnondio* evoke western landscapes, which become populated by faceless, spectral crowds, "swarms of stalwart chieftains, medicine-men, and warriors, / . . . flitting by like clouds of ghosts" (440). In a contemplative aside the poet mourns the passing not

only of the Indians but of their representations and the memory those missing representations would have held:

> (Race of the woods, the landscapes free, and the falls!
> No picture, poem, statement, passing them to the future:)
> Yonnondio! Yonnondio!—unlimn'd they disappear . . . (440)

The irony of Whitman's lament here is that depictions of Indians in wilderness, and particularly near sights such as Niagara, were standard subjects for Cole and other landscape artists of his generation; to say that the Indians are thus "unlimn'd" suggests that some deeper, even if less polished, representation is lacking. Having nearly taken the Indian for granted in his poetry for the first three decades of his career as a poet, Whitman seemed to be content with lamenting the Vanishing Indian, that most ideologically fraught trope of the nineteenth century. Yet the turning point after mourning the "unlimn'd" shows Whitman's refusal to leave the Vanishing Indian by himself:

> To-day gives place, and fades—the cities, farms, factories fade;
> A muffled sonorous sound, a wailing word is borne through the air for a
> moment,
> Then blank and gone and still, and utterly lost. (440)

The fading of the native now overtakes the very mechanisms that destroyed the Indians: westward expansion, agriculture, urbanization, industrialization. The lament comes to encompass everything, red or white, so that the loss of the Indian portends the loss of the new country itself.

But where does this lament come from? Whitman included a note with every printing of "Yonnondio" explaining that "the sense of the word is *lament for the aborigines*. It is an Iroquois term; and has been used for a personal name" (440). This gloss seems to be unique to Whitman; only three weeks after the poem first appeared in the *Critic*, a correspondent signing his name as "ETYMOLOGIST" explained that the word "Yonnondio" had never meant any such thing as Whitman ascribed to it, but was rather a mistranslated Iroquois name for Montmagny, an early French governor of Canada. The name became a form of address for later Canadian governors, often appearing in treaty proceedings.[2] Whitman mentioned this correction to Horace Traubel but asserted, "I am sure of my correctness. There never yet was an Indian name that did not mean so much, then more, and more, and more—then more beyond that," citing one of his favorite native words, "Mannahatta," as his example.[3] Whitman claimed an almost mystic

connection to the word's deepest meanings ("Oh! I have felt it all!"), understanding "more than all attempted explanation." But from Whitman's own words, it is unclear how much of the meaning of Yonnondio was discovered and how much was created in the feeling of it. The poem "Yonnondio," with its inexorably expanding lament, was virtually the only published result of a plan that Whitman began formulating in the 1880s to research and write a poem about the entirety of Native American history and culture,[4] a late iteration of his attempt to write the nation that he had announced in the preface to *As a Strong Bird on Pinions Free*. Whitman's own failure to limn the Indian, in no small part a symptom of his own fading in health and poetic stamina, was both represented and regretted in a powerful but consciously inadequate twelve-line poem that made its own meaning for a word that would remain forever foreign to Whitman. Tillie Olsen would remove the word "Yonnondio" even further from its origins when she appropriated it as the title for her sprawling account of the western poor in *Yonnondio: From the Thirties*, which included the note and the closing lines from Whitman's poem. Proper sources mattered little for Whitman or Olsen, who both found in a word of appropriate sound the sign for emotions that they found difficult to express.

Whitman's lament, based as it is on a single word and the work that the word does in the poem, offers insight into the afterlife of a subgenre recognized by mid-nineteenth-century critics but already forgotten by the end of Whitman's career: the "Indian epic." While McWilliams sees the epic treatment of Native Americans as largely a prose enterprise in the wake of *Last of the Mohicans*, and Gordon Sayre has claimed that there is no tradition of verse epic in English on native subjects, the fact is that American poets repeatedly, earnestly, and creatively kept writing long narrative poems about Indians, continually looking back to earlier examples and culminating in the most popular book-length poem of the century, Longfellow's *Song of Hiawatha* (1855).[5] Beginning with Morton's *Ouâbi* (1790) and inflected by British works such as Thomas Campbell's *Gertrude of Wyoming* (1809) and Robert Southey's *Madoc* (1805), the Indian epic as a poetic subgenre developed prior to and alongside the novelization of the Native American in works such as *Hope Leslie*, *Hobomok*, and *Mohicans*. Whitman's most likely source for the word "Yonnondio" was William C. H. Hosmer's popular 1844 poem *Yonnondio; or, Warriors of the Genesee*, once recognized as one of the most accomplished of the Indian epics. Yet to celebrate Hosmer's poem as one of the greatest of the genre was itself an act of forgetting; the foremost writer of long-form poems on Native American topics in the first half of the nineteenth century

was Lydia Sigourney, a woman known at the time not for her depictions of natives but for sentimental portrayals of domesticity and death, a member of what was dubbed the "graveyard school" of poets for their focus on scenes of mourning.[6] Despite her four long-form poems about Native Americans during her career—one a book-length poem, and two others the title poems of collections—critics refused to class Sigourney's works alongside those of Hosmer and other male practitioners of the Indian epic. I will argue in this chapter that the reasons for ignoring Sigourney as an epicist during her career were closely related to the reasons for Indian epic's disappearance by the time Whitman wrote "Yonnondio." Perhaps more than any other epic subject, Native American subjects led poets to the elegiac, to mourning and the focus on what has disappeared or been lost, rather than on the glory or fame that remains. Following the chronology of Sigourney's Indian epics, this chapter reconstructs the Indian epic as a subgenre that evolved alongside the female poet's own career and that helped create the massive audience for Longfellow's *Song of Hiawatha* (discussed at length in chap. 7). As we will see in this chapter, the importance of mourning in American epics only increased over the course of Sigourney's career, and the importance of verse form for those choosing to write epic poems also increased, taking on new importance as the rhetoric of meter became more nuanced in transatlantic poetry.

Milton and Missions: Sigourney's *Traits*

Sigourney had originally risen to public notice through the very kind of act she would become famous for: mourning. The child of a tradesman, Sigourney had been taken into the care of Jerusha Lathrop, a wealthy matron of Norwich, Connecticut; when Mrs. Lathrop died in 1805, Sigourney (then Lydia Huntley) wept publicly and without restraint. The sincerity of her grief caught the attention of Daniel Wadsworth (later a patron of Thomas Cole), who became her first literary patron, assisting the publication of her first work, a prose collection titled *Moral Pieces*, in 1815.[7] By the time of her marriage to Charles Sigourney in 1819, the young Lydia Huntley already enjoyed considerable local fame and hoped to support her impoverished parents with her royalties. Her husband, however, insisted that his wife was not to write under her own name or for profit—literary pursuits to him were at best a hobby, at worst a threat to accepted standards of wifely submission. According to her autobiography, Sigourney had already composed *Traits of the Aborigines* by 1817, having been inspired by hearing stories of the Mohegans from an acquaintance in Norwich.[8] It finally appeared in print (anonymously) in 1822.

Traits was a massive undertaking, even for as rapid a writer as Sigourney. Running more than four thousand lines with another hundred pages of explanatory notes, it represented a dual achievement, as the *Christian Spectator*'s reviewer pointed out: it was both "one of the first American poems in blank verse, of sufficient length and importance to demand the attention of criticism," and a work that "collect[s] almost all that is known" about the history of Native Americans and their contact with Europeans.[9] Over a decade before the works of ethnologists such as Henry Rowe Schoolcraft and George Catlin brought Native culture to middle-class, eastern Americans, Sigourney presented information gathered not only from scholarly sources but from accounts by missionaries and their supporters, ranging from Moravian reports to works by prominent politician and philanthropist Elias Boudinot.

Yet more than the range of material, the tone and structure of *Traits* represented a new potential tradition in American poetry. The other key contemporary text that *Traits* connects with is William Cullen Bryant's *Thanatopsis*, often considered the first internationally acclaimed poem by an American, which used a Wordsworthian blank verse to meditate on the relationship between nature, death, and virtue; the poem was an instant success upon its publication in the *North American Review* in 1817, and it was reprinted in Bryant's first volume, *Poems*, the year before Sigourney published *Traits*. Though the two poets shape the blank verse form to very different modes—Bryant's is philosophical, while Sigourney's is both highly descriptive and fiercely admonitory—they both ultimately pursue didactic purposes, a fairly recent use of blank verse popularized by poets such as William Cowper. Sigourney's approach is decidedly more Miltonic, at least in the sense of invoking Milton via the romantics as a voice of prophetic power. The opening passage of the poem takes in huge, hemispheric vistas in presenting a prelapsarian life for Native Americans before European contact:

> O'er the vast regions of that Western world,
> Whose lofty mountains hiding in the clouds
> Conceal'd their grandeur and their wealth so long
> From European eyes, the Indian rov'd,
> Free and unconquered.[10]

The occlusion of European sight in this description echoes Adam's subjunctive vision in *Paradise Lost* XI, where Milton questions whether he would actually have been able to see the new world from the Mount of Vision.[11] This concealment calls for analogy in Sigourney's work, and in the first pages she compares

Indian war chiefs to "some Pictish King," and later more specifically to Regulus; native religion she relates to both Carthage and Israel (5, 7–9). The diffusion of the description reaches its extreme in an apostrophe to Boudinot, from which the poem's speaker recalls herself:

—But whither art thou fled,
Adventurous strain? Resume thy opening theme.
Paint the bold Indian ranging o'er his vales,
Unaw'd, and unsubdued. (9)

The verb "paint" here is fitting, for Sigourney's long poems emphasize scene and tone rather than narrative drive, and *Traits*'s first canto provides a vivid tableau of precontact images to prepare the reader for the change wrought by Columbus and the conquistadors who would follow him.

This is not to say that *Traits* is devoid of narrative. Canto I concludes with a paean to Christian piety and to the power of the Holy Spirit to speak truth to humanity, figured in the trope of the "sacred" or "mysterious harp" that sung through the lives of the Patriarchs, of David, and ultimately to the shepherds by angels announcing Christ's birth (26–30). Against this universal history, Canto II introduces waves of European explorers and immigrants, both a continuation of and a threat to the song of the divine harp. This canto is the most recognizably epic section of the poem, partly because it alone focuses on a single hero, John Smith, described as one "on whose daring soul / Breath'd the high spirit of heroic deeds" (34). Smith comes to represent not only Christian England but a much more global type of the virtuous adventurer whose tumultuous life leads him circuitously to America. Smith's military endeavors in the Mediterranean, in the Holy Land, and at sea are related in breathless succession, although Sigourney's commitment to domestic sentimentality leads her to temporarily rebel against the ethos of epic battle that the canto seems to celebrate. In the middle of a naval battle in which Smith participates in brutal hand-to-hand combat, the speaker interjects:

How can I paint
The features of that scene? My pencil shrinks
From dies so deep! Oh! 'twas a fearful sight
To souls who love not carnage, to behold
God's image in the human form so marr'd,
And his blest work defac'd. (52)

Sigourney here returns to the language of painting in a critique of epic violence that differs from that articulated by writers such as Barlow and Goethe. Rather than object to bloodshed on secular grounds of civilization and superior morality, Sigourney follows the line of Snowden and Branagan in fusing sentiment with evangelical fervor; Branagan also uses the language of painting and, like Sigourney, both shows the carnage and decries it. Sigourney here changes the moral calculus of her poem, rejecting the celebration of violence in order to support other kinds of heroism, ones built both on national imaginaries and on social contracts of sentimental expression.

In the pages following the speaker's outburst, Smith journeys to Italy, where he is likened to Aeneas arriving to found a new nation, and he even has a romantic interlude with a Dido figure during his time in Austria later on. Both Virgilian echoes prefigure the nature of his heroism in helping to found Jamestown, as well as his ambiguous relationship with Pocahontas, who Sigourney endows with a heroism superior even to that of Smith. As Powhatan prepares to order the deathblow for his English captive, his daughter behaves as an exemplary reader of the scene:

> Soft tears of Pity wound
> Their copious course, and her imploring hands
> Unconsciously she rais'd tow'rd him who seem'd
> Her sire . . .
> At length the trance of Fear
> Vanish'd, and from those dove-like eyes shone forth
> A dazzling spirit. That meek child, who seem'd
> To shrink as the Mimosa, now evinc'd
> More than a warrior's daring. Like the winds,
> Rushing in wildness tow'rd th' imprison'd foe,
> His head she clasp'd.
> "Now let the death-stroke fall!"
> Boldly she cried, "for ere it reach that head
> This shall be crush'd." (77–78)

Pocahontas is here not only a saving heroine but also an admonition both to Smith and to the reader. Rather than preserving her own safety, she "boldly" submits herself to danger for the captive's sake; at the same time, she begins as a sentimental reader, crying "tears of Pity" at the prospect of Smith's death, but rather than watch helplessly—or secretly enjoy the pathos—she thrusts herself

into the scene, as Sigourney will later urge her readers to do in protecting and converting the remaining Native Americans before their seemingly inevitable demise. The nature of this heroism has a double edge to it, however; after Smith is freed, the narrator compares Pocahontas's actions to "the royal maid / Of swarthy Egypt," whose "pitying heart" led her to save the infant Moses in the Exodus story. The irony of this seemingly innocuous act becomes clear in a comparison of Pharoah and Powhatan, who "little thought . . . that his child's weak arm / Fostered that colony, whose rising light / Should quench his own forever" (78). The compassionate choice to rescue an enemy, both in the Exodus story and in the Powhatan-Smith saga, seals the doom of the rescuer's nation. The irony of this rescue seems also to force the rescuer into a subordinate narrative role, since the action is done not through tragic character flaws but through compassion and "Piety," virtues related to Virgil's *pius Aeneas* but much more in line with Longfellow's Evangeline than the version of Aeneas that Smith represents in *Traits*. After a brief celebration of Pocahontas's humanity and virtue, Sigourney's speaker interrupts herself: "The unbidden tear / Rushing, Oh! Indian Princess, o'er thy grave / Effac'd my theme a moment" (79). Pocahontas may be a better hero than John Smith by Sigourney's standards, but the demands of narrative unity bind the poem to a course ultimately at odds with Sigourney's moral purpose, her own call for compassion and rescue addressed to the United States as a Christian community. The Indian must die and be mourned.

The last three cantos of *Traits* present a narrative arc of unstoppable decline and eradication of Native Americans by European settlers, but the end of Canto V offers an alternative: missionary activity focused not on enculturation so much as indoctrination, a missionary effort designed to return the United States to the principles of Jesus as much as to spread those principles to the unconverted native population. The concluding vision of futurity revisits the huge vistas of the opening lines, this time extending all around the globe, mimicking Smith's own travels, as world Christianity ushers in the millennial kingdom, the fruits of a new use of national "might." This vision, for all its didacticism, recasts the prospects of universal democracy presented by the epics of Dwight and Barlow some thirty years earlier; it offers an alternative morality in the face of increasing strain on democratic ideology brought about, Sigourney argues, through inhumane policies toward natives. Sigourney positions herself between the self-consciously marginal stances of Snowden and Branagan and the self-consciously national personae of Dwight and Barlow, a position that both led her lone reviewer to "assign to him [*sic*] an elevated station, among the most distinguished

writers of the age,"[12] and led the public to ignore a work calculated to provoke a nation unconcerned with minority abuses on the western frontier. The figure of the Vanishing Indian that would help to make Cooper so popular later in the 1820s condemned Sigourney's *Traits* to vanish as well, in its appeal to keep the figure from becoming fact. It was virtually the only one of her poetic volumes not to appear in a second edition.

Part of the work's being "singularly unpopular," as Sigourney herself put it,[13] probably also had to do with the circumstances of its publication. Submitting to her husband's wishes, Sigourney published *Traits* anonymously and chose Harvard's university press rather than a commercial press for the printing. She gave all the proceeds to charity and gave the printers the copyright (though the latter was her usual practice throughout her career). Sigourney's biographer, Gordon Haight, stated that Charles Sigourney wrote the notes and arranged for the publication of the work, though Sigourney herself credits Charles only with helping her to revise the notes.[14] In any case, the anonymity and scholarly apparatus of *Traits* may have seemed odd to readers who would have seen Bryant's *Poems* on the same bookstore shelves. Sigourney's later practice of annotating her long poems suggests that Haight exaggerated Charles's involvement,[15] but the strictures placed on Sigourney as she published her ambitious poem made her ambition hard to notice and harder still to understand. Her only review assumed that the anonymous writer was male and remained silent on the more sentimental aspects of the speaker's commentary. Sigourney also at times made it difficult to understand what she was trying to claim in her poem. The opening sentence of Canto III, which I quote in its entirety, exhibits this ambiguity:

Say! who again will listen to the call
Of the returning Muse? who rove with her,
Not in the pomp of Homer, to the fields
Of victor Greece, the conflagrated domes
Of ruin'd Ilion; not by tuneful reed
Of mighty Maro summon'd to the march
Of his majestic hero, nor allur'd
O'er the wide wave in wandering course to roam
With sage Ulysses, nor with joy upborne
On Fancy's silvery plume, what time she steers
'Tween Truth's fair region, and the varying clouds
Of wild Romance, tinting with rainbow hue

Roderick, or haughty Marmion, or the throng
Of Caledonia's monarchs, but with voice
Untun'd by art, climbing with rustic step
Undisciplin'd, the lone and misty cliff
Where mourns the forest Chieftain o'er his race
Banish'd and lost, of whom not one remains
To pour their tears for him. (89)

Here Sigourney recapitulates the epic canon, from Homer and Virgil to the epic/romance hybrids of Ossian and Scott's poetry, and places her own work in the bardic tradition of Beattie's *The Minstrel* (possibly inflected by Morton) and further turns it away from the classical center by exchanging valor for mourning. She positions *Traits* as both an antagonist to the epic tradition and its latest iteration, prefigured by the generic instability that writers such as Macpherson, Scott, and Beattie had recently introduced. As in poems such as Dwight's *Conquest*, mourning continually threatens to co-opt the epic tradition, since epos itself must begin in loss and mourning before remembered heroism can take its proper form. The subject of Native American heroism seems overshadowed by this will-to-mourn, whether in the fellowship of tears in Cooper's *Mohicans* or in Columbus's tears in Barlow's *Vision*. But rather than being a problem for the epic in Sigourney's eyes, this haunting allows her to use her own preferred strategies for redirecting a tradition that not only excludes her as a woman but excludes the subject matter that she chooses to take up. At the same time, her insistence on difference is not coded as female; her speaker never genders herself,[16] and the "forest Chieftain," seemingly patterned on the popular figure of Logan, is an occasion for mourning precisely because no woman mourns for him. At any rate, Sigourney as an author chose not to take Logan's stance as her own, at least not for long; she needed people to mourn with her and for her characters. Though the fire of what Paula Bernat Bennett has termed the "epic jeremiad"[17] of *Traits* would reappear in later writings about Native Americans, nature conservation, and immigrant rights, she seems never to have returned to the ambitious register of her early, longest poem. By 1827, her latest collection of *Select Poems* included many poems based on the persona that had first attracted Daniel Wadsworth, the consummate mourner. Among them was one that would become her most popular poem, "On the Death of an Infant": sentimental, spontaneous, short, but also focused on mourning, also defiant, and—perhaps most significantly—also in blank verse.

The Crowded Field of Indian Epic

If we except Morton, whose *Ouâbi* is a mixture of rhymed pentameter quatrains and rhymed tetrameter songs, Sigourney was the only American poet to write an Indian epic with a pentameter line, and she was definitely the only one to use blank verse instead of rhyme. This fact might have been part of the reason for *Traits*'s lack of reception, as by 1820 Americans had begun to associate the Indian subject matter with a different kind of verse form. The popular American poem *Yamoyden*, published in 1820 by James Eastburn (posthumously) and Robert Sands (anonymously), used Spenserian stanzas to introduce the poem as well as each canto; the main narrative was in rhymed tetrameter couplets, likely following on Campbell's use of the intricate, nine-line stanzas of the *Faerie Queene* for *Gertrude*. Set during King Philip's War, *Yamoyden* focuses on the romance between Yamoyden, one of Philip's warriors, and Nora, a European woman. The epic/romance tension, more from Scott than from Spenser, takes on a more ambitious quality by the use of the Spenserian—yet, strangely, Sands claims in the preface to the poem that his contributions, including the Spenserians in the "Proem," "were hastily added in the course of transcription, and printed as soon as written."[18] Besides the fact that probably no poet ever wrote Spenserians "hastily," Sands's curious self-deprecation seems to have added to his image as a young genius only beginning to discover his powers. Samuel Kettell included the "Proem" in his influential *Specimens of American Poetry*, commenting that "[t]hose parts of Yamoyden which can be identified as his, leave us no room to doubt that his powers are equal to an undertaking in the very highest walk of poetry."[19] Sands was, in other words, ready to write an epic, even if he hadn't quite done so yet. His colleague Gulian Verplanck, in writing of Sands's life after his death in 1832, declared that the "Proem as a whole is beautiful; and our language has, I think, few passages of more genuine and exquisite poetry than [several of the stanzas]. . . . They have a sobered and subdued intensity of feeling, carrying with it the conviction of truth and reality, while at the same time they glow with an opulent splendour of language and allusion, not unworthy of the learned imagination of Milton himself."[20] The last comparison again leads Sands out of the elegiac (which his Proem was, in content) and the epic-romantic (which the Spenserian is, in form) into the high epic of *Paradise Lost*, suggesting that anyone who can so command the Spenserian form could be capable of anything in poetry.

While white-authored Indian epic became increasingly self-conscious about its literary status in the 1820s, ethnographic research in the wake of westward expansion began to make "native" texts available to American readers and writers as never before. Henry Rowe Schoolcraft, whose *Algic Researches* would serve as the main source for *Hiawatha*, undertook some of his first publication projects in the 1820s with his wife, Jane Johnston Schoolcraft. Jane was a bilingual member of the Ojibwe community at Sault Ste. Marie in upper Michigan, daughter of a Scotch-Irish settler and an Ojibwe woman from one of the area's prominent families. Jane used her strong literary education to write poetry and stories, in both English and Ojibwe, often based on oral tales from her family and her tribe. Several of these writings appeared in the *Muzzeniegun, or Literary Voyager,* a manuscript periodical that Henry produced in the winter of 1826–27. Many of the entries in the journal would be collected again in Henry Schoolcraft's best-known works, such as the *Algic Researches*, and they are often signed under different pseudonyms, many of them traceable back to the Johnston family. Jane Schoolcraft, for example, used the name "Rosa," among others, in her contributions, but one of the poems anthologized under her name in recent years, "The Otagamiad," has no name attached in the *Muzzeniegun.*

Recent anthologists have usually followed the main modern source for the poem, Philip P. Mason's 1962 edition of the *Literary Voyager*, in attributing the poem to Jane Schoolcraft.[21] However, Robert Dale Parker's recent edition of Jane Schoolcraft's poems, the first ever published, demonstrates that the poem is almost certainly by Henry Schoolcraft.[22] The Ossianic element that A. LaVonne Brown Ruoff has noted in "The Otagamiad" turns out to be Henry's account of a historic Ojibwe war council, the title's "-iad" ending signifying his effort to humanize Native cultures as well as his tendency to heroicize those cultures.[23] Critical interest in the poem tends to stem from Mason's assertion that the poem is about Jane's grandfather, a famous warrior named Waub Ojeeg, and thus is part of Johnston family lore.[24] Mason's misattribution seems to come partly from this family connection and partly from the relative lack of a break before the next poem in the *Muzzeniegun*, "Invocation: To My Maternal Grandfather: On Hearing His Descent from Chippewa Ancestors Misrepresented," which is signed "Rosa."[25] This poem does not merely celebrate Jane Schoolcraft's heritage but defends it against competing accounts and rumors designed to disparage the family. Whereas "The Otagamiad" presents courage through oratory within the predictable confines of heroic couplets, "Invocation" displays unusual variety of meter and rhyme scheme while asking continually how lasting fame is for her

family: "Can the sports of thy youth, or thy deeds ever fade? . . . Can the warrior forget how sublimely you rose?"[26] The accusation that Jane Schoolcraft counters in "Invocation" is that Waub Ojeeg was born a Sioux, though raised an Ojibwe. If engaging epic in the United States is a matter of choosing one's ancestors, in Ojibwe territory it seems that keeping other people from choosing (or renaming) those ancestors is of greater concern. "The Otagamiad" in this situation appears as a luxury that an actual Ojibwe woman cannot afford to indulge in, but this case also points to the irresistibility of locating epic in the Indian voice—and Jane Schoolcraft's nickname, "the Northern Pocahontas," should remind us that the introduction of Native American literature into Anglo-American print culture involved such deification of the Natives whose names appeared on that literature that Native concepts of heroism require as much defense as those heroes' borders did in previous generations.

If the misrepresentation of living tradition, such as that of the Sault Ste. Marie Ojibwes, was a temptation for American authors, the misrepresentation of what were perceived as dead or ancient traditions was all but inevitable. One of the most bizarre texts in all of American literature, the *Walam Olum*, or "red record" of the Lenni Lenape or Delaware nation, has inspired more controversy than almost any other "native" text. C. S. Rafinesque, a French-American botanist, ethnologist, and philologist (to name just a few of his areas of publication), published a "translation" of the *Walam Olum* in 1836 in his *American Nations*, which was to be a complete compendium of knowledge concerning the peoples of the Western Hemisphere. According to Rafinesque, the poem had been handed down orally and in pictograph form; he had acquired a set of the pictographs and a "transcription" of related Lenape songs that he used in his translation. The poem begins with a creation story and then recounts the Lenapes' journey from Asia to the Midwest of North America, as well as a history of wars and kings down to the arrival of white explorers around 1600. Rafinesque also included a set of verses with no Lenape original, which continued the story up to around 1800. The poem was largely ignored for most of the nineteenth century, but through the twentieth century it enjoyed increasing acceptance, despite doubts expressed from the 1830s onward as to the authenticity of the poem.[27] Only as recently as 1994 did David M. Oestreicher publish the first definitive case against the authenticity of the *Walam Olum*, in which he demonstrated that the work was translated not from Lenape to English but vice versa.[28] Oestreicher's work has received so little attention that six years later, the *Walam Olum* appeared in *The Multilingual Anthology of American Literature*, without any mention of

doubt, much less proof against the poem's authenticity. Dennis Tedlock, in his foreword to the anthology's edition of the poem, remarks, "What makes the *Walam Olum* unique is the reach of its narrative, stretching from the beginning of the world to the arrival of the Europeans."[29] The narrative scope was certainly unique; Leonard Warren has called the poem "an unbelievable story" spanning over three thousand years.[30] Rather than reducing the Lenapes' story to an Aristotelian unity, Rafinesque used the comprehensiveness of the annals and the encyclopedia as his organizing principles. The *Walam Olum* provided evidence that Rafinesque desperately wanted to vindicate his theories concerning the Asiatic migration of the Indians (in sharp disagreement with the frequent missionary identification of the Indians with the lost tribes of Israel), his Herderian theories of language (he named Herder as a main source for his methods in *American Nations*),[31] and his insistence that the Indians held the key to an all-encompassing theory of the world's peoples. The same year in which he published *American Nations*, Rafinesque also published another lengthy epic poem, first anonymously and then under the pseudonym "Constantine Jobson," entitled *The World; or, Instability*; this poem was to be a literary expression of his Ovidian cosmology by which the entire universe operates by a principle of mutability. Two years later, Rafinesque published a treatise on translating the Hebrew Bible. His was an epic impulse, if ever there was one.

Yet the *Walam Olum* was also written out of frustration over failure and threat of utter obscurity. Rafinesque was nearing the end of his career, and publishers had by 1836 refused to consider any more of his works. He had taken to publishing his works himself, at the cheapest rates available, and many, perhaps most, copies of those works have since been destroyed. Even in the opening lines of *The World*, the speaker expresses not the usual speech act—"I sing"—but only the desire for such an act: "I wish to sing the changeful ample world."[32] The fragments that make the "sequel" to the *Walam Olum* also echo frustration and defeat, this time projected onto the dwindling Lenapes in the face of white imperialism. The *Walam Olum* ends with the verse, "At this time north and south the *Wapayachik* came, the white or eastern moving souls./They were friendly, and came in big bird-ships, who are they?" (*Nations*, 140). The sequel begins with an answer to this question: "Alas, alas! we know now who they are, these *Wapsinis* (white people) who then came out of the sea, to rob us of our country. Starving wretches! with smiles they came; but soon became snaking foes./The *Wallamolum* was written by *Lekhibit* (the writer) to record our glory. Shall I write another to record our fall? No! our foes have taken care to do it; but I speak to thee

what they know not or conceal" (141). The bitterness of exile results in a turn back to origins, as the chiefs decide to "exchange our lands, and return at last beyond the *Masispek* (muddy water, Mississippi) near to our old country. . . . Shall we be free and happy there?" (144). This closing question signals the failure of the mount of vision, the final obscurity of the future in the face of an apocalyptic present, a strained mind's attempt to cope with the prospect of perpetual misunderstanding and rejection.

As Rafinesque's Lenapes moved (under the guise of ethnographic science) toward the stance of epic curse that Gordon Sayre has identified as a key feature of Indian representation in epics of the Spanish empire,[33] Sigourney would seek to counter that curse with a call to sentimental benevolence in her next Indian poem, "Zinzendorff," the eponymous poem of her 1835 collection. This collection appeared only a year after Sigourney had begun signing her name to her works; her husband's collapsed finances had finally convinced him that a wife who could write for a living was a boon instead of an aberration. The poem took its title from Count Nicolaus Ludwig von Zinzendorf, the benefactor of the United Brethren, or the Moravians. As Sigourney had related in her memoirs that *Traits* had been inspired by hearing stories of travel, "Zinzendorff" was inspired by her own travels through the Moravian settlements of Bethlehem and Nazareth in eastern Pennsylvania.[34] The poem has rarely been commented on, and even Sigourney herself said very little about it; yet it repeats several of *Traits*'s distinctive moves (including the use of blank verse), albeit in a mode much closer to the sentimental verse on which she built her periodical reputation.

The poem opens with a description of the Wyoming valley in Pennsylvania, followed by a reference to the "legend" of the Battle of Wyoming, a Revolutionary War engagement also known as the Wyoming Massacre. Right away, Sigourney distances herself from the battle as a poet, even as she shows personal knowledge of the scene:

> 'Tis not mine to choose
> A theme so bold,—though I have trod the turf
> Whose greenness told what moisture nourish'd it,
> And ponder'd pensive o'er that monument,
> Where the last relics of the fallen brave
> Were gathered by their sons.[35]

Sigourney here refers to the Wyoming Monument, a stone obelisk built in Wilkes-Barre; she may have attended the dedication ceremony—she quotes a

speech from the 1833 occasion—but she likely saw little more than the base of the monument by the time she wrote her poem, as the monument would not be completed until 1843. The essential element for Sigourney is not the completed monument but the fact that there is such a site and such an object that would allow her to "ponder pensive," in the mode of her elegiac writing. Her disclaimer signals both that she has enough deep personal knowledge to write a memorial poem and that she will refuse the modes of both war poetry and death poetry in her new work. She continues to specify exactly what kind of poetry she will *not* write:

> 'tis not meet
> That I should tell of war, or woo the tones
> Of that high harp, which, struck in England's halls,
> Hath made the name of Gertrude, and the lore
> Of sad Wyoming's chivalry, a part
> Of classic song. (14)

Known throughout her career as "the American Hemans," Sigourney was acutely conscious of her relationship to other writers, both American and British. In a miniature version of the epic-to-romance canon she traces in *Traits*, she follows her refusal of war poetry by pointing to Campbell's *Gertrude of Wyoming* as both her formidable predecessor and her anti-model for her own presentation of the Wyoming Valley's history. Sigourney then "goes native" in her pursuit of original poetic territory: "A wilder scene I seek, / Ancient and barren, where the red man reign'd / Sole lord," before agriculture and mining changed the landscape irrevocably (14). The poem's speaker fashions herself as a kind of Indian, moving into the past to parallel the westward migration of the Senecas and Lenni Lenape that would find their land rights disputed by the time of the Revolution. The reference to mining as a chief cause of the Native Americans' downfall adds an additional hint of racial irony, as the highly lucrative anthracite coal deposits of the Wyoming area "draw / Exploring thousands to its ebon throne, / Like a swarth king of Afric" (14). Sigourney finds wealth discovered by Western capitalists to mean inevitable appropriation and colonization; her "king of Afric" is doomed to lose his throne, which shares both his color and his fate as a potential commodity.

Most of the poem's remainder relates the story of Zinzendorf's missionary journey to Pennsylvania in the early 1740s. Described as the first white man to enter the Wyoming Valley, Zinzendorf appears like the missionary Augustine to the Druids, received with wonder and suspicion by the natives. While he slowly builds a church of converts despite stern opposition by the nations' leaders, the

count becomes the target of an assassination attempt that reads as an anti–single combat. A necromancer obsessed with destroying Zinzendorf—he repeatedly dreams of "mimick warfare" with the count (24), failing to kill him every time—sends three warriors to the missionary's tent, where they see him praying for their salvation. Just before they make the fatal attack, they notice a rattlesnake enter the tent, prepare to strike, and then back down and leave the tent without violence. Reporting back to their commander, the warriors declare, "Doubtless he is a god" (27). The humor in the situation arises from Zinzendorf actually representing Christ to the natives, so that superstition, not grace, leads them to make the centurion's confession in St. Mark's Passion, "Truly this man was the Son of God."[36]

Zinzendorf escapes unscathed, seemingly unaware of the attempt on his life; he sails back for Europe, and many natives accompany him to Philadelphia to say farewell. The Philadelphia scene leads Sigourney to reflect on the numerous Christian sects whose squabbles served as a detriment to teaching the gospel to the Indians. The Moravians are held up as a nonsectarian paragon who minister to slaves and the poor rather than spend energy on doctrinal issues; the poem closes urging others to follow the Moravians' example "Till from each region of the darken'd globe, / The everlasting Gospel's glorious wing / Shall wake the nations to Jehovah's praise" (32). While Sigourney has relinquished traditional epic material and tone in her poem, her blank verse trumps Campbell's *Gertrude* and the classical war poetry tradition: she begins further back in history, claiming to be more "wild" but also more pure in her subject matter, and she concludes with a grand, global millennial vision similar to that in *Traits*. "Zinzendorff" might be seen as Sigourney's declaration of her own independence as a poet, choosing her own traditions, making her own claims to both originality and moral leadership, and (at last) signing her own name to her work. Yet for all its symbolic importance to a newly self-declaring stage in her career, the collection *Zinzendorff* went through only a couple of editions, a rather low count for Sigourney's poetry volumes. Much more successful, both critically and popularly, was her 1841 *Pocahontas and Other Poems*.

Sentimentalizing the Indian Epic

Sigourney had already told the Pocahontas story in *Traits*, but she seems to have begun contemplating a new version of that story in 1839 and wrote the new poem in 1840. Sigourney corresponded in late 1839 with Alexander Everett, editor of the *North American Review*, over whether her return to the story of Pocahontas

should be in verse or prose. Everett understood that Sigourney's intention was to write something of epic scale, and he advised her to choose prose, not only because the novel was "the true Epic of modern times," but because the best poetic models, Scott and Byron, were "dangerous" to "follow closely."[37] Whether she composed the poem solely in the United States or at least partly during her only trip overseas during most of 1840 is unknown, but what is clear is that she not only chose verse but used a particularly distinctive and difficult form: the Spenserian stanza, two rhymed quatrains joined by a couplet and ending in a hexameter line, which completes another couplet. Sigourney modified the rhyme scheme slightly, to one reviewer's dissatisfaction in his otherwise effusive review of the poem,[38] but by using Spenserians she placed herself in what had already become an accepted metrical tradition in writing poetry about Native Americans. Spenser's connection to Indian themes began with the epigraph to Morton's 1790 *Ouâbi*, from the *Faerie Queene*,[39] bringing both the fantastic and the didactic elements of Spenser's poetry to bear on a subject that, like the Elizabethan epic, was steeped in contemporary politics even as it continually gestured toward a world outside of history. Spenserians had been further associated with Indian epic, as shown earlier, through Cambell's *Gertrude* and Sands's *Yamoyden*. Yet Sigourney, already the only American poet to treat Native Americans in blank verse, became in her new "Pocahontas" the only poet to write an entire Indian epic in Spenserians. The Spenserian was not as valuable a narrative form as Scott's iambic tetrameters, but it was a linguistic showpiece, and the lyric, painterly effects of such a form led to a comparison between Hosmer's *Yannondio* and Thomas Cole's landscapes.[40] For Sigourney, a writer who continually "paints" in her works, the Spenserian would have been an attractive choice, particularly for a Native American topic, which had already been treated so extensively in the form.

But why would so many poets choose such a difficult, self-consciously poetic form to write about humans seemingly living in a state of nature? Part of the answer has to do with the prevalence of Spenserian stanzas in British poetry of the early nineteenth century; Wordsworth, Coleridge, Shelley, Keats, Byron, Southey, and Campbell were only some of the most well-known poets using the form, and often in prominent poems: "Salisbury Plain," *Adonais*, "The Eve of St. Agnes," *Childe Harold's Pilgrimage*. Apart from Campbell, however, there seems to be little written by British writers in Spenserians that bears directly on Native American subjects. Another part of the answer, then, involves the perception of the stanza in American criticism. As Virginia Jackson has stated, "Curiously, . . . in the nineteenth century, on this side of the Atlantic, Spenserians seem to have

been regarded as one of the most natural of English stanzas." Both Oliver Wendell Holmes (in 1836) and James Russell Lowell (in 1875) used the same image of waves on the shore to describe the momentum of the Spenserian as it builds to the closing hexameter line.[41] Legitimated by the greatest British authors of the era and naturalized by some of the most influential American critics at the same time, Spenserians exhibited an artless artfulness, the romantic expression of genius recast as a linguistic imitation of natural cadence. The natural eloquence and poetry of Native Americans, a concept that was already established by the time Jefferson commented on it in his *Notes on the State of Virginia*, merged aesthetically with the natural genius of the Spenserian, a form actually so difficult to use well that Bryant commented that the challenge of writing "The Ages," a poem of thirty-five Spenserians commissioned for a Harvard commencement, "had come near to making me sick."[42] For all the difficulty of the form, the fact that more than one critic called Sigourney's "Pocahontas" the most beautiful treatment of the subject ever written testifies not only to her poetic ability but to her talent for shaping narratives to meet the ideological and emotional needs of her readers.[43]

Sigourney's opening invocation, "Clime of the West! that, slumbering long and deep . . . Heard not the cry when mighty empires died," establishes the Western Hemisphere as being in a kind of stasis, both childlike ("in cradled rest") and sleeplike, until "Europe . . . [e]xtends the sceptred hand, and bids thee sleep no more."[44] The inventors of Western history here use their imperial power to pull other nations into Western history, much as the Red-Crosse Knight finds himself inexplicably in "Faerie-londe" in Spenser's work. Yet this stasis also seems to describe the life cycle that Cole had portrayed in his 1840 *The Voyage of Life*, depicting "Childhood," "Youth," "Manhood," and "Old Age." The imagery of "misty mountain's . . . shade," the "untrodden glade," and the "sounding streams" all participate in the same mode as that of Cole's *Childhood*, which Sigourney probably would have known by description, even if she had had no opportunity to see the New York exhibition or any of the prints based on the series. A more important visual cue for Sigourney's "Pocahontas" is John Gadsby Chapman's *The Baptism of Pocahontas*, nearly the last commission for the Capitol in Washington. Recalling the origin of the poem in her memoirs, Sigourney painted a picture of pious tourism similar to that of her Pennsylvania travels in "Zinzendorff": "I had great pleasure in searching out materials for ['Pocahontas']. . . . It was heightened from having once visited the ruins of the church at Jamestown, where the Princess Pocahontas, the first convert from the heathen tribes, received the rite of baptism in the first temple consecrated to God in the Western wilderness. This

event gave a worthy subject to the spirited pencil of Chapman, among the great national paintings in the rotunda of the Capitol at Washington."[45] This is a strange recollection. As Robert Tilton has pointed out, while the story of Pocahontas was very popular with the public of the Jacksonian era, virtually all of the many images of Pocahontas then circulating were either traditional portraits or portrayals of her rescuing John Smith. Chapman's painting, which also went on exhibit for the first time in 1840, was the first to depict Pocahontas's baptism and was as much a surprise choice to American art critics as Chapman's receiving a commission had been.[46] Sigourney almost certainly did not see Chapman's painting before she wrote "Pocahontas," but her later memory of the source of the poem reiterates the creative history her visit to the Wyoming Monument evinced in "Zinzendorff." If Sigourney had indeed visited the church at Jamestown before writing the poem, she may have been aware that Pocahontas's baptism had occurred there, but it would not have been the emphasized narrative among tourists of the time. However, Sigourney seems in hindsight to consider Chapman's *Baptism* painting as an important intertext for her poem, pointing again to her preferred analogy to painting, but also allowing her to improve on what was a government-sanctioned picture of Pocahontas's translation into English Christian life.

Sigourney goes on in her memoirs to describe the English settlers' practice of decorating the Jamestown church with wildflowers and relates the scene of Pocahontas's wedding to John Rolfe: "A world of early vernal flowers enwreathed the rough pine columns, and strewed the floor, loading the air with fragrance. The white and red-browed people, mingling, rejoiced together."[47] In the poem, Sigourney spends an entire stanza giving a catalog of the flowers (a patently Spenserian device) used in the church, and she includes among her copious notes a quotation from George Bancroft's *History of the United States of America* citing the practice of using flowers in the church. Yet Sigourney is not merely showing her historical veracity; as we have seen, any historical record she cites, whether accurate or not, carries an argument with it. After describing the flowers as "incense" as pleasing to God as the simple faith of seeing him in nature, Sigourney introduces Pocahontas (in the seventeenth stanza) as a "forest-child, amid the flowers at play!" (19). In this first stanza to mention Pocahontas and to introduce feminine rhymes, the poet describes the princess as a "sweet, wild girl, with eye of earnest ray, / And olive cheek, at each emotion glowing," whose "spirit-glance bespoke the daughter of a king" (19). Pocahontas is both a child of nature and a

child of nobility, balancing the best in nature and culture, even as her phenotype balances the luxurious tone of the "olive cheek" with the blush that represented both moral propriety and whiteness in antebellum discourse.

In the baptism scene, the "forest-child" becomes the "forest-flower," as natural piety and Christian missionary piety merge in "the deathless vow of Christian fealty" (23). Here the intertextual connection with Chapman's *Baptism* (fig. 17) revolves around the blending of military-political power and Christian obedience. In the painting, the pikeman who presides over the congregation, the swords on Smith's and Rolfe's waists during the ceremony, and Pocahontas's own kneeling form all combine into an image at once devotional and imperial. Even the use of the colors of red and white confuses the nature of the event; while the Native Americans wear and are red, often in poses derived from West's historical paintings, Pocahontas wears a white dress draped with a light red sash, as if her phenotypic redness is symbolically washing away in the baptism. On the other side, Rev. Hunt's white robe contrasts with the dark armor and red cloth of Smith's and Rolfe's attire. As Chapman's pamphlet accompanying the exhibition of the *Baptism* explains, the mixture of Indian and English in the picture is to be understood as positive, particularly since it amounts to a purification of the red rather than an adulteration of the white;[48] however, the soldiers' white faces and red garments suggest that other admixtures are already in play before the baptism even occurs. Sigourney chooses to address this problem of color mixing in the wedding scene with Rolfe, in which Powhatan, who is described not as red-skinned but "white-hair'd," gives away his daughter in an echo of the York-Tudor marriage that ended England's Wars of the Roses: "[N]o more the ray / Of white or red, the fires of hate illumed, / But from their blended roots the rose of Sharon bloom'd" (26). The final image, which Sigourney cites as a name given what is now commonly called the Tudor Rose, blending the white rose of York and the red rose of Lancaster together, was also seen as a prophetic description of Christ, "the Rose of Sharon and the lily of the valleys."[49] Pocahontas as an Anglicized Indian becomes a saint for American missions, and her marriage strangely becomes a kind of Christ figure, a figure of redemption through cultural and genetic absorption. The stanza following the wedding, which depicts Pocahontas as the ideal bourgeois housewife, emphasizes the "sacrifice of self" on which the political conquest in the Wars of the Roses analogy is predicated. An apostrophe to the James River in Sigourney's poem highlights the politics of absorption involved in baptism: the river's

pale-faced sponsors glide
To keep the pageant of thy christening day:
They bless thy wave, they bid thee leave unsung
The uncouth baptism of a barbarous tongue. (14)

As Pocahontas was renamed Rebecca following her baptism, the James River loses its former identity altogether—though Sigourney never explains that it had shared the name of Pocahontas's father, Powhatan. Rather than haunting the location, as other native names do in Sigourney's earlier poem "Indian Names," the James shares Pocahontas's fate: complete appropriation by the imperial voice.

This appropriation plays out more fully in one of the most telling changes in "Pocahontas" from Sigourney's earlier version of the story in *Traits*, the dynamic economy of tears that drives the action. Whereas Pocahontas had cried, begged, and then heroically intervened in the *Traits* account, here the rescue conflates tears and heroism in a single couplet: "Forth springs the child, in tearful pity bold, / Her head on his declines, her arms his neck enfold" (19). The intimacy of the embrace seems not so much to protect Smith but to prefigure her marriage to Rolfe, as if the embrace serves to protect both parties. Powhatan's attempts to remove her are thwarted not by a powerful "spirit-glance" but by her "convulsive grasp" and "pleading tones" (19). Pocahontas has evolved from the greatest of (pre-)Christian heroes to the most historically important of sentimental lovers. The irony of the rescue is again figured in terms of the Moses story, but the implications are left tacit in the flat questions: "Know'st thou what thou hast done, thou dark-hair'd child? / What great events on thy compassion hung?" While she "rescued" Smith "with a tear," Sigourney declares that "history's scroll" will "embalm thine [Pocahontas's] image with a grateful tear," one inspired both by Smith's rescue and by her later assistance through famine and conspiracy (20). The grateful tear of posterity may be the most important ironic moment in the rescue account, as the tear suggests not only how much the princess did for the English settlers but also how much it cost her and her people to do so—she must be thanked through mourning and rendered a sentimental figure of loss to be remembered and recuperated by the nation that destroyed her.

As a result of her heroic tears, Pocahontas gains full acceptance into the world of the English, and when she sails to Rolfe's home country, she marvels at the sights and sounds of England, but only for a time. After viewing "proud mementoes of a buried race" in the monuments of the island, she succumbs to "the scenery of her solitude," imaginary visions of her ailing father that had first appeared

Figure 17. John Gadsby Chapman, *The Baptism of Pocahontas* (1840). Oil on canvas. 12 × 18 ft. Architect of the Capitol.

on the voyage from Virginia and that now "[m]ix'd with her dreams a melancholy moan" (27–28). Rather than the righteous expression of silent grief through the eyes, she now voices her mourning as she prepares for death—but for her own or her father's? Her final illness and death are introduced in stark, matter-of-fact terms:

> [A]nd, as the time drew near
> To fold him [Powhatan] to her heart with filial tear . . .
> That time—it came not! For a viewless hand
> Was stretch'd to bar her foot from her green childhood's land. (28)

Pocahontas cannot cry for her father because while she is separated from him in his last hours by an ocean, his death is also hers. As she expires, the reader's tears are directed not at her but at her widower: "Ah, who can mark with cold and tearless eyes / The grief of stricken man when his sole idol dies!" (30). Pocahontas's status as an "idol" in Rolfe's life suggests that the absorption in the Rose of Sharon image might not have been as one-sided or innocuous as Sigourney had led her readers to believe; the mourning here emerges out of improper (yet generally understandable) desire, which is quickly and coldly balanced after a highly emotionally charged leave-taking between Pocahontas and her young son. From a poet whose career was supposedly based on the need to weep for the dead, the following lines are astonishing:

> The dead! the sainted dead! why should we weep
> At the last change their settled features take? . . .
> Approach we not the same sepulchral bourne
> Swift as the shadow fleets? What time have we to mourn? (30–31)

But while the Anglicized Pocahontas may rest among "the sainted dead," her father is addressed in the next stanza in a chilling return to earlier imagery: "[T]o thy scorn'd and perish'd people go, / From whose long-trampled dust our flowers and herbage grow!" (31). The people of nature have suddenly been obliterated, as Powhatan's death recedes into the history of his empire's destruction, and all that remains is the fertilizing soil for the plants on which American agriculture is based.

The spectral existence of the Vanishing Indian takes over the rest of the poem. Sigourney describes the Indians as being pushed all the way to the Pacific, like "fallen leaves"; while she offers regret—"I would ye were not, from your father's soil, / Track'd like the dun wolf"—her appeal to continue the Moravians'

missionary work in "Zinzendorff" has given way, in a matter of six years, to a subjunctive wish that such had been the case earlier (31). Echoing "Indian Names," she announces to the "[f]orgotten race" that "[o]ur mighty rivers speak your words of yore," supposedly with the exception of the James mentioned fifty stanzas earlier; the landscape starts to resemble the primeval "Clime of the West" at this point, and the waking into history comes full circle as the Indians, "like troubled shadows, sink to rest / In unremember'd tombs, unpitied and unbless'd" (32).

Sigourney's sudden desire to erase the Indian from the landscape, which she had resisted through her earlier works, is revealed in the final stanza as the necessary fiction that allows the story of Pocahontas to take on national importance. Since the rest of her people were not absorbed as she was, she must be seen as exceptional rather than representative of her race, so for her to be "shrined" in "children's loving hearts," it must be as a "[p]ure, lonely star, o'er dark oblivion's wave." While "[k]ing, stately chief, and warrior host are dead, / Nor remnant nor memorial left behind," it is "not meet" that Pocahontas's "name should moulder in the grave" (32). Pocahontas becomes the justification for the erasure of the entire race, even as she becomes the occasion for Sigourney to make her own move for immortality by adopting what in the nineteenth century was the new poetic prestige form—and that, fittingly enough, straddled the divide between pastoral elegy and epic.

Yet Sigourney's exclusion from the critical canon of "Indian epics" raises anew questions about the politics of the term "epic." "Pocahontas" appeared at the head of a wave of Indian epics, including George H. Colton's *Tecumseh; or, The West Thirty Years Since: A Poem* (1842), Charles Fenno Hoffman's "The Vigil of Faith" (1842), Hosmer's *Yonnondio* (1844), and "Genundewah" (1846), also by Hoffman. All of these poems were critically well received, and some were reprinted more than once; both Colton and Hoffman leveraged the attention their Indian epics gave them to edit major periodicals, Colton at the *American Review* (which he helped to found in 1845) and Hoffman first at the *American Monthly Magazine* and later at the *Literary World*. While Sayre has called Colton's *Tecumseh* "a late . . . contribution to the genre" of epic and stated that the verse epic "had by 1840 become too grandiloquent and too formulaic to maintain the respect of U.S. readers,"[50] the reception of these 1840s poems demonstrates that Indian epic had a ready market, critical cachet, and even a narrative of its own literary canon. Both Colton's *Tecumseh* and Hosmer's *Yonnondio*, another poem dealing with King Philip's War, used both Spenserians and Scott-style rhymed tetrameters,

the same mixture as *Yamoyden* (*Yonnondio* covered some of the same historical material as well). A reviewer in *Graham's* found Hosmer's poem "wanting in the *constructive* faculty" that appears in Scott, who was attributed as a model, but declared that "we know of but two Indian epics—the 'Yamoyden' of Sands, and Hoffman's 'Vigil of Faith'—which can be compared with 'Yonnondio' for elegance of diction or dramatic interest."[51] The company into which the *Graham's* reviewer placed *Yonnondio* described both a tradition exemplified by the near-classic *Yamoyden* and a living genre represented by Hoffman's 1842 poem. But the absence of Sigourney's even more popular "Pocahontas" from this narrative, in *Graham's* and elsewhere, is difficult to explain. Charles Fenno Hoffman's "The Vigil of Faith" ran to just over thirty pages of verse, mostly in irregular tetrameter stanzas, compared with the twenty pages that Sigourney's fifty-six stanzas filled in the 1841 edition of *Pocahontas*. Did ten pages make the difference between Hoffman's inclusion and Sigourney's exclusion? Hosmer was acknowledged in the review as a *Graham's* contributor, but Sigourney not only contributed to the same journal but was by then receiving an annual stipend to be listed in *Godey's* as a contributing editor.[52] Was rivalry between journals a factor? Perhaps the exclusive use of Spenserians put the poem into a different class; Hosmer's "Genundewah," the only other extended treatment of Native Americans in Spenserians throughout, failed to garner the attention that *Yonnondio* had.

The divergence of literary taste certainly played a role in the reception of "Pocahontas." Sigourney's correspondent Everett, who favored the novel as an epic form, damned the female poet with faint praise: "[T]he substance of her poetry is of the very highest order. If her powers of expression were equal to the purity and elevation of her habits of thought and feeling, she would be a female Milton, or a Christian Pindar."[53] Sigourney seemed doomed to be a comparative author, always named with other authors, and often (as in the above case) to argue for her inferiority as a poet. Everett's "Pocahontas" review alone connects her to Felicia Hemans, Scott, Cooper, Homer, Petrarch, Thomas Moore, Byron, and Wordsworth, in addition to Milton and Pindar; the reviewer in the *New York Evangelist* related her use of Spenserians to Beattie, Campbell, and Bryant. Such a crowd of fellow writers tended to reinforce Sigourney's own self-image as a writer of pastiche, a poetically inspired recycler of familiar work.

Most of all, however, her reputation for writing miniature lyric pieces also seems to have miniaturized her longer poems in the eyes of her reviewers. Commenting on the relative length of "Pocahontas," "only thirty-seven, out of nearly three hundred pages," compared with the "series of short" poems that made up

the bulk of the volume, Everett commented that "whatever merit there may be in some two or three very long poems—the Iliad, for example, or the Paradise Lost—we much prefer, in general, for our own private reading, the shorter compositions even of the greatest masters to their long ones." Everett seems to be saying both that Sigourney's shorter works are better than "Pocahontas" and that even "Pocahontas" is a short poem and therefore more delightful than the prestigious, though painstaking, epic. He later says that "Mrs. Sigourney's compositions belong exclusively to the class of short poems," and he explicitly includes "Pocahontas," since it does not "exceed thirty or forty pages."[54] Perhaps most damning, and most revealing, of Everett's comments is his mention of "private reading," suggesting that even the grand political subjects—Indian removal, national remembrance, natural vistas—that Sigourney treats are only suitable for individual or domestic enjoyment. There is no sufficiently public forum for Sigourney, both as a woman and as a writer of short forms, to find her place as an epic poet. Even with her grasp of the two most prestigious meters, blank verse and Spenserians, she will only be seen as a producer of miniatures, not suitable for either the college classroom, where literature was beginning to make inroads into the curriculum, or the pantheon of criticism, where long, difficult works were favored. If she ultimately consigned the Native Americans to a silent death, her works had tuned themselves to historical conditions so well that they were simultaneously economically (and critically) successful and yet somehow historically removed from the extrahistorical canon that was taking shape in the first half of the nineteenth century—a canon of "deathless" classics that, as we have seen, both overshadowed and nourished a vernacular epic tradition that included women writing epics.

Sigourney's final extended Indian poem, "Oriska," first appeared as the first poem in her *Illustrated Poems* (1849), a gift-book collection that combined new material with the poet's most popular works. Running to only twelve pages in an edition that increased the length of "Pocahontas" from about twenty-three to thirty pages, "Oriska" is a much more compact poem than her earlier narrative verse, but that she would choose the work as the first poem in a collection that announced her standing as a major poet—and that included an engraved illustration, no less—speaks to the importance that Sigourney continued to place on her writings on Native Americans. The story of "Oriska" centers on the beautiful daughter of a Sioux chief who is wooed and married by a French Canadian who, as a classic seducer, loses interest and leaves after Oriska gives birth to their son. She tracks him to a town where he has just remarried, in order to beg that he may care for her and the child after her dying father has passed away. As she kneels at

the chief's deathbed, the husband appears but tells her he will not take her back, even as a servant. The dying chief suddenly rouses and says to the wayward Canadian, "*His* curse be on thee! He, who knoweth where / The lightnings hide!"[55] When the daughter begs her father not to curse, he softens his statement, telling her,

> The cold black gall-drop in a traitor's soul
> Doth make a curse. And though I curse him not,
> The sun shall hate him, and the waters turn
> To poison in his veins. (25)

After the father dies, his people return to their homeland to bury him. As soon as the turf is smoothed, the scene changes to one of confusion:

> Who is yon woman, in her dark canoe,
> Who strangely towards Niagara's fearful gulf
> Floats on unmoved? (26)

The answer, of course, is that it is Oriska, dressed in her bridal regalia and committing ritual suicide with her small son by going over Niagara in a small canoe with a weirdly oral "epitaph" that the "eternal surge / Sound[s]" (28)—the image of the shattered but defiant woman, inexorably heading toward the oblivion of the steaming landscape behind her, might be read as Sigourney's own resigning of the form of the Indian epic, a form to which she had been committed for over thirty years but that had, like the French Canadian in the town, refused her entry into a space she had labored for: the title of an epic poet. That Oriska would die singing of death fits preconceptions of Native Americans, but it seems oddly prescient of Sigourney's posthumous reception as well. After making a career of mourning, she found her serious engagements with both epic poetics and the politically charged topic of Native Americans in national history receiving as ephemeral an epitaph as Oriska had.

Coda: Dramas of Indian Authenticity from *The Walam Olum* to *Hiawatha*

The most successful of all the Indian epics, Longfellow's *The Song of Hiawatha* (1855), has long been faulted for its inauthentic portrayal of Ojibwe legends. Yet the initial accusations focused not on how much Longfellow romanticized the Indian, but how much he humanized the native. Emerson commented to

Longfellow after reading the poem, "The dangers of the Indians are, that they are really savage, have poor small sterile heads,—no thoughts, & you must deal very roundly with them, & find them in brains; and I blamed your tenderness now & then, as I read, in accepting a legend or a song, when they had so little to give."[56] For Emerson, as for many Americans on the east coast in his day, seeing Native Americans in epic dress was a shock to his expectations, a violation of authenticity as formed in Emerson's preconceptions of the native real. Indeed, as this chapter has shown, writers of Indian epic rarely troubled themselves with questions of authenticity, and even the pursuit of authenticity could lead to controversy and confusion.

George Squier, the foremost of the archaeologists drawn to the mounds of the Ohio valley in the 1840s, gained access to Rafinesque's notes by 1848, when he began writing articles on Indian legends.[57] Squier had taken to studying narratives as part of his scholarly project to demonstrate that Indians were not culturally deficient. When he saw Rafinesque's notes on the *Walam Olum* translation, Squier thought he had found the evidence he needed to make his case for a sophisticated body of oral legends transforming into a written literature via the pictographs that Rafinesque had recorded. However, his method of verifying the *Walam Olum*'s authenticity showed both his lack of cultural understanding of living Native Americans and the mutual relationship between the fluidity of native identity and its abstraction as a universal idea of "the Indian." In his article on the Rafinesque manuscript in the *American Review*, Squier described the manuscript as "a series of Indian traditional songs . . . written out from the recitations of the Indians, by some person conversant in the Indian tongue." Elsewhere in his essay, Squier almost always uses words such as "Algonquin" and "Chippeway" rather than "Indian"; even his title identifies his subject as the "Algonquins," and the manuscript derived from the "Lenni-Lenape." That he should use "Indian" so infrequently through the rest of the essay and so much within the single paragraph describing the manuscript is odd, but his explanation of the manuscript's authenticity reveals the utility of his sudden vagueness: "As already observed, it has strong internal evidence of being what it purports to be,—evidence sufficiently strong, in my estimation, to settle its authenticity. I may however add, that, with a view of leaving no means unemployed to ascertain its true value, I submitted it, without explanation, to an educated Indian chief, (Kah-ge-ga-gah-bowh,) George Copway, who unhesitatingly pronounced it authentic, in respect not only to the original signs and accompanying explanations in the Delaware

dialect, but also in the general ideas and conceptions which it embodies. He also bore testimony to the fidelity of the translation."[58]

At the time of Squier's publication, his "educated Indian chief," George Copway, had recently become a celebrity on the Eastern Seaboard, having published his autobiography in 1846, which quickly went through several editions. Copway, a Methodist Ojibwe from the Canadian side of Lake Superior, had been educated in missionary schools and was particularly adept at conforming his Indian-ness to Euro-American expectations.[59] Copway had left behind a reputation for shady money deals and self-promotion when he headed east, and his ability to take on the role of the "educated Indian" in exchange for celebrity (and the royalties and lecture fees that followed it) won Squier both supporters and critics for his article. Henry Rowe Schoolcraft, whose *Algic Researches* would be the central source for the stories in Longfellow's *Hiawatha*, doubted the *Walam Olum*'s authenticity, and while he did not directly question Copway's involvement, Schoolcraft's own knowledge of Ojibwe life (not least through his wife, Jane Johnston Schoolcraft) would certainly have led him to doubt Copway's claimed expertise.[60] Squier's story of verifying the *Walam Olum* sounds as if he had tricked Copway into spontaneously and artlessly revealing the document's authenticity; that very lack of narrative allowed Copway in turn to generalize a narrative that he calculated would meet Squier's expectations. As an Ojibwe, Copway would not likely have known "the Delaware dialect," but such cultural distinctions seemed to have been lost on the well-intentioned Squier. Cultural difference here results not in unintelligibility but in a performance of authentic understanding that defers the question of literal fluency in an actual language. The verification of the translation only serves to intensify the permeability of cultural signifiers in Copway's performance.

Copway's ambition as an "educated Indian chief" led him to poetry as well, including his own Indian epic, *The Ojibway Conquest, a Tale of the Northwest* (1850). The publication of *The Ojibway Conquest* was his announcement of his intention to establish himself as a poet as well as a man of letters, along the lines of his literary admirers such as Bryant and Longfellow—the publisher was George Putnam, one of the era's leading promoters of American literature. *The Ojibway Conquest* presents in rhymed tetrameter couplets a legendary episode from the many story cycles connected with the long wars between the Sioux and the Ojibwe. The main character, Me-gi-si, is a young, handsome warrior who leads his Ojibwe compatriots to victory, and he captures the opposing band's aging though formidable chief. The chief turns out to be an avatar of the "WEN DI

GO OF ICY HEART," a legendary character in Ojibwe stories whose grim tenacity, cruel deeds, and seeming indestructibility place him between the human and spirit worlds.[61] The chief breaks his bonds at night and leads Me-gi-si away to reveal to him that the mysterious tattoo on his chest, which no Ojibwe had ever been able to decipher, meant that he had been born a Sioux, and that he must help his father, the Wen di go, avenge his mother, who had been killed in an Ojibwe raid.[62] Me-gi-si goes along and prepares for a battle to the death against his home clan on their island in Lake Superior, an island formerly held by the Sioux. The dramatic tension lies in the love between Me-gi-si and the beautiful, virtuous Me-Me, who waits for her beloved to return with the other warriors. She is heart-broken when she does not find him, but when he appears at night to tell her what he must do—not only leave her but attack their village in the morning—she becomes stony with grief. The next day, the assault on the island fails, as Me-gi-si falls on the beach in a crowd of new enemies, the Wen di go escapes certain death as he leaps through a crowd and disappears into the water, and Me-Me is found after the battle, dead of a broken heart in her lodge.

The *Romeo and Juliet* overtone is only one of several marks of *Conquest*'s westernized poetics. Me-gi-si "look[s] like Mars himself" as he joins a war dance; Me-Me's virtue is celebrated in Christianized language, as "[n]o passion angels might not own / Had ever in her dark eyes shone." Even her name, which translates as "dove" in the text, speaks to both the use of Indian names as signifiers (Me-gi-si is, appropriately, the "eagle") and the tendency in Anglo-American poetics to read innocence into female love interests. As in Sigourney's Indian epics, the initial emphasis is not on the natives but on their landscape; curiously enough, the first canto is titled "The St. Louis," using the French name for the river that empties into Lake Superior from present-day Minnesota.[63] In the midst of majestic scenery, magic, and war, the love story of *The Ojibway Conquest* and the loss that ends it overwhelm the politics of the themes of invasion, betrayal, and uncertain ancestry.

The poem itself proved to be of dubious origins. Copway had put his own name as the author both on the title page and on the copyright for the book, and no one thought to contest it, as none of his other works had been of doubtful authorship. Almost fifty years later, however, a former Indian agent named Julius Taylor Clark published *The Ojibue Conquest* in Topeka, Kansas. In the preface to the volume, which included "Other Waifs of Leisure Hours," Clark explained that he had written the poem around 1845 and had met "a native Indian Convert"

in Madison, Wisconsin, who had asked to publish the poem as a fundraiser in the east.[64] Later correspondence from the unnamed Indian (certainly Copway) informed Clark that the only way to publish the poem was for the Indian to put his name on it. Clark gave him permission to do so but never heard from him again, mentioning that he had still never seen a copy of the poem and did not know whether it had been published. His own decision to publish the poem came after discovering a copy of the manuscript while going through old papers. Clark's account partially exonerates Copway from what some critics have characterized as out-and-out plagiarism, but one scholar shrewdly observes, "Copway's appropriation of Clark's manuscript does have the touch of first-rate prankishness about it if one just considers who was actually 'copping' from whom in the marketing of Indian legendary material in the first place."[65] Clark's status as an Indian agent places him on shaky middle ground somewhere between the Ojibwe-cum-Methodist Copway and the desperate ethnologist Rafinesque. Clark held the copyright on *The Ojibwe Conquest*, but who owned the poem? Its amalgamation of Ojibwe storytelling and Anglo-American poetics renders it in some ways unownable, the way that any translation is unownable, continually crossing between authors that cooperate and compete with each other across cultures.

Copway's uninhibited self-fashioning ultimately absorbed him into yet another poem, building on other translations. Copway inscribed a presentation copy of *Ojibway Conquest* to Longfellow with an epithet for the senior poet as "Nature's Poet," arguing for the common discourses of the native and the natural as mutually composing the project of American literature.[66] Copway could recognize Longfellow as a poet of nature, despite Longfellow's fame for characters like Evangeline and the village blacksmith, because he too could move from landscapes to "natural" humanity, both as an Ojibwe and as an American. Copway's great talent was for presenting his otherness to white Americans as a way for his audience to unexpectedly recognize themselves. Following the publication of Longfellow's *Hiawatha*, Copway undertook a tour of the Atlantic cities giving public readings of *Hiawatha* "in full costume."[67] For his later European tour, he secured from Longfellow a letter of recommendation to his friend and translator, Ferdinand Freiligrath, but the Ojibwe soon became increasingly unstable, borrowing money and disappearing for long periods of time; alcohol abuse was suspected. In 1858, Longfellow wrote to Freiligrath, "[Copway] is still extant. But I fear he is developing the Pau-Puk-Keewis element rather strongly."[68] Copway had become for Longfellow the Ojibwe trickster figure that he had translated into

a reckless troublemaker in *Hiawatha*; he had changed himself into so many different characters that literary existence and corporeal identity were beginning to merge. Copway would be dead a decade later, impoverished and forgotten, and his writings that had served to fuel his celebrity were all but vanished. Yet his involvement in three dramas of Indian authenticity made him the embodiment of the often lethal politics of the Indian epic.

Longfellow's Pantheon

When Lydia Sigourney died in 1865, she was one of the best-selling American poets of the century. One of the few who outdid her in sales was Henry Wadsworth Longfellow, a lawyer's son from Maine who by 1865 had published over 100,000 copies of his volumes of poetry, from his early collection *Voices of the Night* to the book-length poems *Evangeline* and *The Song of Hiawatha*—and that only accounts for the US market; he outsold Tennyson in Britain. He had brought Paul Revere from an obscure local legend to a Founding Father with his 1860 "Paul Revere's Ride"; crafted blacksmiths, ships, clocks, arrows, and legend-bearing banners into national icons; and coined phrases including "ships that pass in the night," "the patter of little feet," "footprints on the sands of time," and "a boy's will is the wind's will," the last providing Robert Frost with the title for his first book of poetry, *A Boy's Will*. Yet that tells only one side of Longfellow's accomplishments. By 1865 he had also been a professor of modern languages at Bowdoin and Harvard; given the first lectures on Goethe in the States (among those attending the first series in 1837 was a Harvard senior named David Henry Thoreau); edited a mammoth anthology of non-Anglophone European literature, in which he did many of the translations himself; written articles for the

North American Review on Anglo-Saxon, French, Spanish, Italian, Swedish, and German literature; started a renaissance in English hexameter poetry by daring to use the classical meter in *Evangeline*; built up a readership that stretched to South America and across Europe to India and China; and corresponded with scholars and illuminati in no fewer than five different languages. By the end of the decade, he would have an audience with Queen Victoria, receive honorary degrees from Oxford and Cambridge, and be gorgeously photographed by Julia Margaret Cameron. In 1865, he was completing the first American translation of Dante's entire *Divine Comedy*, a specially bound edition of which would be sent by the US government to Florence in that year to honor Dante's six hundredth birthday, helping to seal Longfellow's reputation as the nation's greatest literary ambassador of his age.

The internationality of Longfellow's work, in both what and who influenced him and what and whom he influenced, is easy to miss, because few expect to find it in his poetry. Longfellow, like Sigourney, was a much-beloved poet for a mass reading audience who identified with the figure of goodness and decency that spoke to the themes of hope, loss, home, and faith that mattered to them but were so difficult to put into words. This version of Longfellow was easy to love, but also easy to deride among critics who preferred "serious" or "challenging" literature; in a letter thanking Longfellow for a copy of *Hiawatha*, Emerson commented on how much his 11-year-old son, Edward, enjoyed the poem, and he gave his own appreciation of reading the poet's work: "I have always one foremost satisfaction in reading your books that I am safe—I am in variously skilful hands but first of all they are safe hands."[1] This was an almost viciously backhanded compliment from the man who wrote his famous letter to Whitman about *Leaves of Grass* in the same year. Yet if Emerson was cloyed by what he saw as the sentiment and conventionality of *Hiawatha*, his lame criticism (later in the same letter) that Longfellow had falsely made a degenerate race seem cultured shows that the Concord sage had little idea what the Cambridge poet was doing in his "Indian Edda," as Longfellow liked to call it. Longfellow had selected a meter from a German translation of an obscure Karelian poem and borrowed plot elements from that poem—which was currently celebrated as a triumph of Finnish nationalism and a monument of what Goethe called *Weltliteratur,* or world literature, in Europe—in order to show both the nation and the world that Native Americans were just as worthy of cultural recognition as any Northern European people might be. Americans in search of a "native" literature that would use national material in a national way, as Emerson declared that Whitman was doing, would

little suspect how large a world Longfellow was writing in when he wrote his tales of the chief at Gitche Gumee.

Longfellow's fall from the canon of American literature is a well-known story by now and is wrapped up with the nationalism and New Critical poetics advocated by early twentieth-century poets and critics. While the growing body of scholarship that has emerged on Longfellow since Lawrence Buell's 1988 Penguin edition of his poems has freshly opened up discursive worlds of sentimentalism, world literature, translation, tourism, and children's poetry (among other areas), Longfellow is still treated more often as an interesting writer than as a great one. This chapter can be read as an apology for Longfellow's greatness, but only insofar as it is the first sustained treatment of Longfellow as a practitioner of long-form poetry. Being fluent in classical Greek and Latin, as well as most of the languages of western and central Europe, Longfellow was probably more widely read in Western epic tradition than any other American of his century, and the bold formal experiments and transnational perspectives that Longfellow brought to bear on that epic tradition would not only help create American literature in his day but offer readers in our day new ways of considering American literature's place in the world. And *contra* Ezra Pound's "Pact" with Whitman, this new look at Longfellow reveals that the *Cantos*, that sprawling project that begins in the middle of Homer's *Odyssey* and plows straight through Dante via a host of other European literary landmarks, might have more to do with the man that Pound claimed as a great-uncle than the one he claimed as a "pig-headed father."

Evangeline as *Weltliteratur*: Longfellow's Transnational Poetics

The conception and composition of *Evangeline: A Tale of Acadie* is well documented, largely thanks to the scholarship of Manning Hawthorne and Henry W. L. Dana.[2] Longfellow first conceived of the story after hearing a tale recounted in a conversation with Rev. Horace Lorenzo Conolly, an Episcopalian rector who had heard the story in turn from an old Acadian woman. According to Conolly, a legend in Nova Scotia told of a pair of lovers who were separated on their wedding day by the British expulsion of Acadian peasants from Nova Scotia during the Seven Years' War—an event named by Acadians *le grand dérangement*—and who spent the rest of their lives searching for each other, only to find each other at the moment of death. Conolly and others had initially encouraged Nathaniel Hawthorne to write a story based on the legend, but Hawthorne found the story

too dark for him to feel confident in expressing appropriate pathos. Instead, he "offered" the story to Longfellow by introducing him to Conolly, and even when Hawthorne published a story on *le grand dérangement* in his 1841 collection *Famous Old People*, he carefully excluded any mention of the legend of the separated lovers. In fact, he even included in his story the statement, "Methinks, if I were an American poet, I would choose Acadia for the subject of my song." To drive his point home, Hawthorne sent Longfellow a presentation copy of his book, and after the publication of *Evangeline*, he added a line to subsequent editions of his own Acadian story acknowledging that the "most famous of American poets" had indeed written the wished-for poem and had thus "drawn sweet tears from all of us."[3]

Hawthorne's commentary on *Evangeline* brings out the tension that helped to make the poem such an international success, both at its first appearance and throughout the next century: the grandeur of epic and the tenderness of elegy. This tension has also served to obscure the poem's claims to high literature, as Robert Kendrick has argued that the centrality of mourning in Phillis Wheatley's epyllia and "To Maecenas" both defined and disguised her own epic ambition.[4] In the case of *Evangeline*, the semantic halo[5] of unrhymed hexameters and the Odyssean scope of the heroine's travels in Part 2 constantly run up against the quiet, passive pathos of the lovers' devotion and the emphasis on the woman rather than the man as the most heroic lover. In his review of *Evangeline* for the *Salem Advertiser*, Hawthorne declared early on that the story was "as poetical as the fable of the Odyssey," and that in Longfellow's hands the story is told "with the simplicity of high and exquisite art," so that the "pathos [is] all illuminated with beauty." While the simplicity of Homer's art might be said to be characteristic of the original *Odyssey*, pathos illuminated by beauty is not one of Homer's most renowned qualities. Echoing Schlegel's use of "epic" as a term of comparative rather than positive identification, Hawthorne describes *Evangeline* as a simile for the *Odyssey*, not a successor to it. The review concludes with a discussion of Longfellow's hexameter lines, the most controversial aspect of the poem for early reviewers; Hawthorne admits that the choice of meter "may be considered an experiment," one to which "the first impressions of many of his readers will be adverse." Even as the hexameter formed the gold standard among classical poetic forms, the use of such a meter in English was seen as either woefully imitative or bewilderingly avant-garde. However, Hawthorne argues that Longfellow's particular talent with the hexameter line would eventually win the reader over, and that "we cannot conceive of the poem existing in any other measure."[6] Newton

Arvin notes that in a mood of self-parody, Longfellow recomposed the description of the mocking-bird in Part 2, Canto 2 in heroic couplets—perhaps as a way of reassuring himself that his choice of unrhymed hexameters was preferable to alternative traditional forms.[7] Together with the Odyssean narrative and what Arvin calls the "quasi-epical announcement of the theme" in the prologue,[8] hexameters gave *Evangeline* an unusual place in the epic tradition, balancing classical poetics and modern discourses of sentiment. As James Russell Lowell put it, *Evangeline* struck contemporary readers as a poem "not ancient nor modern, its place is apart / Where time has no sway, in the realm of pure Art."[9]

Yet even for Longfellow hexameters were not solely an epic form, nor even an extended narrative form. In his 1845 *The Belfry of Bruges and Other Poems*, published the same year as his mammoth anthology *The Poets and Poetry of Europe*, Longfellow included the poem "To the Driving Cloud," a lament in hexameters in the voice of an exiled "chief of the mighty Omahas," neither at home in the white man's city nor secure on the prairies quickly filling with "the breath of these Saxons, and Celts, like the blast of the east-wind." By the time the poet-professor had completed *Poets and Poetry*, he had almost twenty years of experience as a professional translator, and "To the Driving Cloud" highlights Longfellow's interest in translating not only words and poems but also forms. The overall success of the Omaha lament encouraged Longfellow to continue writing in hexameters, and he began work on *Evangeline* just before the publication of *The Belfry*.

While Homer and Virgil (and to a lesser extent Ovid) were still the most illustrious poets to use hexameters by Longfellow's time, German poets had begun to embrace the meter in the late eighteenth century, most notably Goethe in his "domestic epic" *Hermann und Dorothea*. The meter may have served what Goethe considered one of the prime functions of epic poetry, that of slowing down or deferring the action of the poem.[10] The meter had also been used in the German translation of the *Iliad* that Carlyle used in his study of Homer (see chap. 4), as well as in the Swedish author Esaias Tegnér's *Frithiofs Saga*, which Longfellow had reviewed at length for the *North American Review* in 1837, and from which he translated, at times in hexameters. Critics have often noted the similarities between the plots and the heroines of Goethe's poem and Longfellow's, and they have shown that the source for the "forest primeval" and the rest of the Acadian landscape came not from Nova Scotia but from Tegnér's descriptions of Sweden.[11] The importance of noting the similarity between the forms as well is that the form signified the work's participation in a tradition both venerably old and radically new, and the hexameter in this new tradition became the

meter not only of the *Iliad* but of stories of loss and attempted recovery of a national ideal, wrapped up in the pastoral imaginary at least as much as in an ideology of heroism. What may be called the *pastoral heroics* of romantic hexameters presents a hero, such as Evangeline, whose literary purpose is not so much to astonish her readers by her exploits as to inspire admiration and imitation through her quiet though remarkable strength and virtue.

The intense visuality of Tegnér's and especially Longfellow's hexameter works suggests J. M. W. Turner's Epic Pastoral.[12] This new hybrid genre drew on the canons of academic history painting while situating the grand architecture of European history in picturesque scenes of farmland, rolling hills, and anonymous peasants—as history painting became a ruin of itself in Britain, painters of elevated pastoral placed the literal ruins of that history into the larger narrative of ecological change and continuity, thus giving the landscape painter (and his subject) a rhetorical edge over the humanism of history painting. Not only was the subject bigger than ever before; now it could contain what before constituted the greatest subjects of art. Longfellow's *Evangeline* starts with a similar move. Rather than singing of arms or the man, the first sentence reads like a bardic caption for a Thomas Cole canvas: "This is the forest primeval." From these initial lines, the "pines and the hemlocks" are personified, "murmuring," "bearded with moss" and wearing "garments green," standing like "Druids of eld" and "harpers hoar, with beards that rest on their bosoms." And the next set of lines makes clear that while this wilderness was once inhabited, the farms are "waste," and those who lived on them "scattered like dust and leaves," leaving behind only "tradition"—a "mournful tradition, still sung by the pines of the forest," which, as it were, have taken the role of bardic rememberers in the absence of more articulate singers.

This Epic Pastoral, with its timeless tone of lament, stands in tension with the rustically ordered time of the georgic life of Grand-Pré. In a poem whose meter already foregrounds the idea of duration, the Acadians live a life marked by the civil order of the clock as well as the natural order of the seasons. The first appearance of a clock in the poem coincides with a scene in which Evangeline and her father Benedict Bellefontaine sit quietly in their house; as the father sings fragments of songs from Normandy, the daughter works at her spinning wheel. All is domestic tranquility, almost to the point of a religious hush, as the text intimates: "As in a church, when the chant of the choir at intervals ceases, / Footfalls are heard in the aisles, or words of the priest at the altar, / So, in each pause of the song, with measured motion the clock clicked."[13] The tick of the clock is a sound always present but only accidentally heard in the absence of other sounds.

The clock provides ambient noise, like the footsteps in the aisle, but it is also somehow the center of the action, as the priest's words, which in the Catholic liturgy of the eighteenth and nineteenth centuries are not heard by the congregation but rather overheard in the occasional silences of the choir. This not heard but overheard click would have likely called to the minds of Longfellow's readers another clock the poet had famously described two years earlier, in "The Old Clock on the Stairs," which presides over the lives of a family across the generations, always saying "Forever—never! / Never—forever!" as its pendulum swings (51). This poem, which appeared in *The Belfry of Bruges* with "To the Driving Cloud," grew out of Longfellow's fascination with the French divine Jaques Bridaine's description of a clock's pendulum perpetually repeating "*Toujours, jamais! Jamais, toujours!*" in "*le silence des tombeaux*"—the silence of the tombs (828).[14] If, like the priest in church, the clock holds the secret to the real story of *Evangeline*, Longfellow's readers have been prepared to expect that the real story will soon descend into death. The first simile of the scene also casts an ominous gloom over an ostensibly cheery fireside: "In-doors, warm by the wide-mouthed fireplace, idly the farmer / Sat in his elbow-chair and watched how the flames and smoke-wreaths / Struggled together like foes in a burning city" (65). The contented Bellefontaine seems undisturbed by such a likeness, likely because, unlike the poem's reader, he does not see it, or rather he cannot read it. The poem's visuality slips into literacy, a consciousness more available to *Evangeline*'s readers than to the characters it portrays.

Literacy vies with orality in the next mention of the clock. As the scene of the farmer and his daughter unfolds, we learn that they are waiting for the blacksmith and his son, Evangeline's beloved; once they arrive, everyone waits for the notary Leblanc's arrival. The clock's less direct association with waiting in the poem establishes the act of not acting alongside the terrible fatalism of "The Old Clock on the Stairs," coupling the two elements that will most profoundly define Evangeline's life. Once the notary arrives, the second mention of a clock appears, as the description of the new visitor moves from his hair to his glasses that bespeak "wisdom supernal" to his family: "Father of twenty children was he, and more than a hundred / Children's children rode on his knee, and heard his great watch tick" (69). Here the ominous detachment of the clock in the hall gives way to the intimate heartbeat of the watch in the waistcoat, which grandchildren hear as they lean against their grandfather. Yet even this moment is not all tenderness. The lines immediately following explain how Leblanc gained his wisdom at a great cost: four years' detainment as a prisoner of war—and by the French, on

accusation of the notary's sympathies toward the English. Leblanc has already lived the tragedy of accusation, exile, and captivity that now awaits the entire village of Grand-Pré. And while he himself eschews "all guile or suspicion," he forgets nothing: the notary is also the keeper of both official town records and traditional town legends. He is a master storyteller who entertains with ghost stories and anecdotes of folk medicine, "whatever was writ in the lore of the village" (69). Separation between notarized writing and oral "lore" disappears in the person of the notary, who, instead of offering reasoned conjecture on the sudden appearance of British warships in the harbor, tells a fable that he had learned while in prison—a story to answer the new events of the day that "was the old man's favorite tale," which "he loved to repeat . . . When his neighbors complained that any injustice was done them" (70). The story, instead of surprising its audience into quiet philosophy, is as mechanical a response to others' grumbling as the tick of Leblanc's watch, and the blacksmith whose grumbling induced the story sits "Silenced, but not convinced" (71).

The official business of the notary's visit soon commences, and the evening concludes when "the bell from the belfry," ringing "the hour of nine, the village curfew" (72), summons the visitors to their homes. If the earlier click and tick of the clock suggested a universal finality, a much more local finality appears here as the role of time in the policing of Grand-Pré jars the reader out of bucolic domesticity and into civil society. This jarring, though the function of the order of local law, foreshadows the awful "summons sonorous" of the bell's toll the next day, this time accompanied by a drum sounding "over the meadows" as the British officers summon the Acadian men to the church for an announcement. Inside the church, the drum echoes "with loud and dissonant clangor"; the sound is quickly engulfed by the "silence of the crowd," while the women wait outside in the churchyard, *dans le silence des tombeaux*. The British commander announces that the Acadians, as a result of alleged hostility toward Britain, are to be removed from Novia Scotia and all their lands are to be seized by the Crown. Shock runs through the audience and then their collective rage sparks a near-riot, until the appearance of the priest, Father Felician, who seems the clock on the stairs come to life:

> Raising his reverend hand, with a gesture he awed into silence
> All that clamourous throng; and thus he spake to his people;
> Deep were his tones and solemn; in accents measured and mournful
> Spake he, as, after the tocsin's alarum, distinctly the clock strikes. (77)

The tocsin, an old French word for an alarm bell, seizes attention here not through ringing but by "a gesture," a "reverend" but violent movement that creates a space of silence for the "deep . . . tones and solemn" that follow. And in a rare moment in American epopee, Father Felician pushes the power of visuality even further by using an *ekphrasis* to admonish his congregation—an *ekphrasis* that seems to come to life as he describes the image. Pointing to the crucifix behind the altar, he cries,

> Lo! where the crucified Christ from his cross is gazing upon you!
> See! in those sorrowful eyes what meekness and compassion!
> Hark! how those lips still repeat the prayer, "O Father, forgive them!"
> Let us repeat that prayer in the hour when the wicked assail us,
> Let us repeat it now, and say, "O Father, forgive them!" (77)

The *ekphrasis* accomplishes its work; the congregation acts as an extension of the description by repeating "O Father, forgive them!" in response.

Now prisoners in their own church, the men of Grand-Pré join their priest in prayer, and the bell that announced the curfew and the military summons now rings a call to prayer, the "Angelus" at sunset. The time of day is finally trumping the o'clock, preparing the Acadians for their journey from georgic paradise to Epic Pastoral. Yet the clock has not yet been destroyed; the heartbeat of Evangeline's home will finally die only with her father, who emerges from the church on the day of deportation looking "Haggard and hollow and wan, and without either thought or emotion, / E'en as the face of a clock from which the hands have been taken" (83). Grand-Pré's time is now over; the bustle of the village falls silent on this day, and "from the church no Angelus sounded" (82); the only sound is the cows lowing while they wait for milkmaids that will never return for them. The physical death of the village, which gives Benedict Bellefontaine the shock that finally kills him, comes in fire as British soldiers torch the buildings while their former tenants watch from the shore. In this apocalyptic scene, nature threatens to destroy itself:

> Loud on a sudden the cocks began to crow in the farm-yards,
> Thinking the day had dawned; and anon the lowing of cattle
> Came on the evening breeze, by the barking of dogs interrupted.
> Then rose a sound of dread, such as startles the sleeping encampments
> Far in the western prairies or forests that skirt the Nebraska,
> When the wild horses affrighted sweep by with the speed of the whirlwind,

Or the loud bellowing herds of buffaloes rush to the river.
Such was the sound that arose on the night, as the herds and the horses
Broke through their folds and fences, and madly rushed o'er the meadows.

(84)

In a striking simile anticipating the frontier landscape of the second half of the poem, Grand-Pré's animals leave their own domestic spaces for the wildness of exile, a fate awaiting their former owners—a fate commenced with the burial of Bellefontaine on the shore and the departure that leaves behind "the dead on the shore, and the village in ruins." The clock in Evangeline's house has been silenced by the fulfillment of its own fatal prophecy.

Evangeline's first half may be described as an idyl, a georgic-pastoral poem depicting "the home of the happy." Yet even as these words close the invocation at the poem's outset, the happiness of Grand-Pré has quickly vanished into an epic of exile reminiscent of the *Odyssey* and the *Aeneid*. The second half of the poem opens *in medias res*, with language borrowed directly from Virgil:

Many a weary year had passed since the burning of Grand-Pré,
When on the falling tide the freighted vessels departed,
Bearing a nation, with all its household gods, into exile,
Exile without an end, and without an example in story. (86)

Right away, the epic language sounds a dissonant chord with the narrative of the Acadians. They may have carried images of saints, as good Catholics might, but did they carry "household gods"? Is this exile without an example, even as allusions by this point in the poem have included not just Aeneas's Trojans but also Ishmael and Hagar (with other biblical parallels clearly in the background)? What critics such as McWilliams have labeled as the problems of imitation in modern epic poetry actually involve the most interesting creative tensions in works including *Evangeline* as well as more canonical texts such as *Paradise Lost* and Camões's *Lusiads*, which use the language of epic to univeralize their stories while simultaneously claiming to supersede those stories that came before. This move borders on cliché, as almost every major epic convention does,[15] and this border helps ensure for writers as popularly successful as Longfellow that their works will relate to the largest possible audience through internationally recognized generic signposts. The idea of ships bearing a nation, while already bound up in the American mythologies of Columbus and the Mayflower Pilgrims, extended over the Atlantic to stories of Aeneas in Italy, Brutus in Britain, Madoc in Wales,

and Beowulf in Denmark, just to name a few. Longfellow's poem tapped a vein that was at once most universal and most national, even as it narrated the particulars of a people before virtually unknown even to Americans, much less Europeans. A few lines after this Virgilian opening, Longfellow stops the narration of Evangeline's search for Gabriel with a new invocation, complete with an epic simile:

> Let me essay, O Muse! to follow the wanderer's footsteps;—
> Not through each devious path, each changeful year of existence,
> But as a traveler follows a streamlet's course through the valley:
> Far from its margin at times, and seeing the gleam of its water
> Here and there, in some open space, and at intervals only;
> Then drawing nearer its banks, through sylvan glooms that conceal it,
> Though he behold it not, he can hear its continuous murmur;
> Happy, at length, if he find the spot where it reaches an outlet. (89)

Longfellow here prepares the reader for the long view of Evangeline's narrative, a view heightened by the increased focus on American scenery in the second half—from the Mississippi to Louisiana bayous to Texas and Nebraska prairies, and eventually into the poem's first and last city, Philadelphia.[16] *Evangeline* has once and for all made the transition (if there ever was one to begin with) from idyl to epic.

The clock is eerily absent from the second half of *Evangeline*, replaced instead by the calendar (seasons and months) and times of day (morning, afternoon, evening). Even when the heroine reaches Philadelphia, the bells of the church steeples have no meaning beyond worship—and worship in forms foreign to the maiden-turned-nun. She hears on a Sunday morning "the chimes from the belfry of Christ Church" and "Sounds of psalms, that were sung by the Swedes in their church at Wicaco" (112). Evangeline hears these sounds, but they barely register as she walks not to church but to a hospice where she cares for the sick and dying. It is here that she discovers Gabriel, forty years later, on his deathbed, and the reunion that brought tears to so many Victorian readers' eyes closes the poem—almost. After Evangeline murmurs, "Father, I thank thee!" the narrator leaves the tender scene with a sudden bardic turn: "Still stands the forest primeval," presented in contradistinction to the now-dead lovers who lie together in a Philadelphia cemetery. In the closing lines of the poem, the narrator reveals that the ruined village at the beginning still does in fact shelter settlers, new settlers unfamiliar with the Acadians or their stories—all except for a few stragglers who

managed to return after *le grand dérangement*, in whose houses the young women

> repeat Evangeline's story,
> While from its rocky caverns the deep voiced, neighboring ocean
> Speaks, and in accents disconsolate answers the wail of the forest. (115)

In the end, the oral presence of the ocean and the forest contains and silences the Acadians, giving voice to what they can barely remember and what they cannot relate to the foreigners outside. If Grand-Pré has been decisively conquered by the poem's conclusion, the landscape of Acadia stands unvanquished against the literate, military tyranny of the British empire.

The chronology of *Evangeline*'s setting is crucial to this nature-versus-empire narrative and will conclude our discussion of the poem. The expulsion of the Acadians takes place in 1753, just before the commencement of the Seven Years' War. Evangeline, Gabriel, and Father Felician wander through the country throughout the war, then the American Revolution, and finally the yellow fever epidemic of 1793 in Philadelphia, in which Gabriel and Evangeline die at the end of the poem. The epidemic, which shut down what was then the nation's capital for most of the summer, and which Charles Brockden Brown described in gothic detail in works such as *Arthur Mervyn*, barely registers in the narrative; Evangeline seems unaffected by the cataclysms of history that occur around her. Much of her western journey anticipates the imagery of nineteenth-century expansion, from Gabriel's coonskin hat to Basil Lajeunesse's Texarkana rancho. While the heroine's own quiet story seems strangely untouched by her world—her greatest virtues of patience and fortitude serve to detach her from her circumstances, even as her grief is apparent throughout the story—she becomes a vehicle for the portrayal of not only forty but a hundred years of American history, right up to Longfellow's own time. Like Cole's versions of Turnerian Epic Pastoral, Longfellow's poem not only provides a picture of what has been lost—Grand-Pré, the frontier, national innocence—but also establishes an index whereby an audience may "measure" how far the present situation has strayed from the ideal. The independent farmer, the self-made man, and the willful yet remarkably self-controlled heroine all emerge out of a rhetoric of an epic past, somehow realizable in the present but clearly not yet realized. How could America come to itself before the bittersweet moment of recognition emblematized by Evangeline and the dying Gabriel? Longfellow attempted an answer to this question eight years later with his most successful and controversial poem,

based, like *Evangeline*, on American narratives and international epic conventions: *The Song of Hiawatha*.

Into the Pantheon of World Poetry: My Hiawatha's Journey

In his journal Longfellow recorded on April 19, 1854: "At eleven o'clock, in No. 6 University Hall, I delivered my last lecture,—the last I shall ever deliver here or anywhere." The lecture concluded Longfellow's final course on Dante at Harvard and marked a difficult turning point in his career; after over twenty years of teaching, the scholar would turn to his poetry full-time, and at a period in his life during which he had written virtually no poetry since 1851. Just a few months before the end of the Dante course, the beleaguered professor had closed his journal for 1853 with an unusually frank lament: "How barren of all poetic production, and even prose production, this last year has been! For 1853 I have absolutely nothing to show. Really, there has been nothing but the college work." However, two months after his retirement, Longfellow recorded that his muse had returned: "I have at length hit upon a plan for a poem on the American Indians, which seems to me the right one, and the only. It is to weave together their beautiful traditions into a whole. I have hit upon a measure, too, which I think the right and only one for such a theme."[17] Both the measure and the plan to "weave" a collection of stories into a "whole" were inspired by the Finnish epic *Kalevala*, which Longfellow reread at the beginning of June 1854, probably in a German translation. The American poet's choice of sources would be a point of fascination and controversy among his readers throughout his lifetime, as well as a site of contestation for scholars reading his work through the other side of the Civil Rights Movement. *The Song of Hiawatha* appeared in late 1855, at a moment of escalating sectional tensions and political uncertainty fueled by debates over slavery and territorial expansion. While the poem was to speak to the current political crisis, the message conveyed by Longfellow's intertextual strategy to his international audience was that the United States was ready to declare its own cultural legitimacy in European terms, and *Hiawatha* would seal Longfellow's fame abroad as the preeminent American poet of his day.

Even during the "silent period" of his last years at Harvard, Longfellow returned to his earlier ambitions to combine the universal and the national. In the fall of 1853, Longfellow's last lecture on Goethe benefited from his recent careful rereading of Johann Peter Eckermann's *Conversations with Goethe*. Eckermann,

a disciple of Goethe who had carefully recorded years of table talk and published his transcripts in 1835 as a posthumous tribute to his hero, had created an international sensation with his *Conversations*, or *Gespräche*, and Longfellow had likely already read the book in the original German. The occasion for his rereading was the republication of the recently deceased Margaret Fuller's English translation in 1852. While Longfellow seldom wrote marginalia in his books, and indeed rarely annotated them at all, his copy of Fuller's *Conversations* is underlined and annotated throughout as he traced Goethe's theories of originality, authorship, and canonicity. Among the many passages Longfellow marked was one of Goethe's most famous comments on literature: "National literature is now rather an unmeaning term; the epoch of World literature is at hand, and each one must strive to hasten its approach."[18] In one of the few instances of retaining German nominal capitalization, Fuller here translates *Weltliteratur* as "World literature," pointing to the seminal importance of the concept not only for Goethe but for his international readers, and specifically for Fuller's Concord- and Boston-based cohorts who had turned to German thought for guidance in fashioning an American intellectual culture.

Angela Sorby's recent work on Longfellow's vicissitudes as a "schoolroom poet" sheds light on how the poet's reception after his death has obscured the more sophisticated elements of his writing, sometimes by outright deletions from the text. One of the most influential redactions is that of the beginning of *Hiawatha*; most American schoolchildren between 1880 and the 1970s who memorized the supposed opening of the poem learned the following lines:

> By the shores of Gitche Gumee,
> By the shining Big-Sea-Water,
> Stood the wigwam of Nokomis,
> Daughter of the Moon, Nokomis.
> Dark behind it rose the forest,
> Rose the black and gloomy pine-trees,
> Rose the firs with cones upon them;
> Bright before it beat the water,
> Beat the clear and sunny water,
> Beat the shining Big-Sea-Water. (157)

These lines launch the reader (or reciter) into mythic space, a far-off wilderness whose landscape echoes the "forest primeval" and "deep-voiced neighboring ocean" that open *Evangeline*, thus drawing a close connection between the tone

and imagery of the two poems. But these are not the lines with which Longfellow originally opened his poem; the "shores of Gitche Gumee" actually appear only some sixty lines into the third canto of the poem, entitled "Hiawatha's Childhood." Much has been elided in this redaction, not least of which is Mudjekeewis's highly sensual seduction of Hiawatha's mother, as well as his immediate abandonment of his pregnant lover and Nokomis's lament over her daughter who had "in her anguish died deserted" (157). Hiawatha's mythic importance as the ultimate noble savage, the universal hero of cultivated mind and gentle though strong spirit, stands in sharp contrast to his scandalous origins, and much of the sexuality of the poem—including a later canto that describes Minnehaha's fertility ritual in which she walks nude around a corn field—has been expunged from the version of *Hiawatha* that remains in public memory. And it is in these moments that some of Longfellow's most subtle intertextual echoes appear. In "Hiawatha's Childhood," the account of the hero's birth introduces a peculiar epithet: "Thus was born my Hiawatha, / Thus was born the child of wonder." The second line translates the German concept of *Wunderkind*, the child prodigy, but the first line contains a more obscure allusion in the phrase "my Hiawatha." As professor of modern languages at Harvard, Longfellow wrote and lectured on monuments of Spanish literature, including a work he usually referred to as the *Poema del Cid*. As Longfellow knew, however, the original title of the twelfth-century Castilian poem was the *Cantar del Mio Cid*, or "The Song of My Cid." The convention of using the possessive is at least as old as Homer[19] and belongs almost exclusively to oral (or previously oral) poetic traditions as a way of drawing the poet and a character together; Longfellow uses the phrase "my Hiawatha" twelve times in his poem, emphasizing the intimate interpersonal connection between the hero and his poet-advocate, who himself tells a story that he learned through another relationship:

> I repeat them [the tales] as I heard them
> From the lips of Nawadaha,
> The musician, the sweet singer. (141)

This explanation of the poet's source appears in the opening lines of *Hiawatha*'s "Introduction," one of the most unusual opening sections of any epic in Western literature. The poem opens as one side of a hypothetical conversation that immediately places the reader as both a listener and a potential interlocutor—potential because the speaker begins in the subjunctive:

Should you ask me, whence these stories?
Whence these legends and traditions[?]

.

I should answer, I should tell you,
"From the forests and the prairies . . . ["] (141)

Here Longfellow's speaker establishes a rather pedagogical stance: he waits for
questions, anticipates their wording, and suggests his answers, all while the in-
teraction between listener/reader and speaker/poet exists only in possibility. Yet
the choice of "should" rather than the Kiplingian "if" signals the expectant atti-
tude of the poet, who not only waits for questions but proleptically hastens their
appearance. Questions of origins ("whence these stories?") and questions of
identity ("who was Nawadaha?") go unasked, yet they must be asked, and the
poet prepares a historical and civic education for the time when the reader is
ready to ask those questions.

That a poet would write for the purposes of civic education was something of
a commonplace in the generations preceding Longfellow, but that commonplace
had received serious challenges from authors such as Byron, Poe, and Heine, who
insisted that the individual author's genius overrode considerations of art's con-
tribution to the common good. Longfellow sought to overcome what he called
"spirit of the age, [which] is clamorous for utility, for visible, tangible utility,—
for bare, brawny, muscular utility";[20] however, he did so from the attitude of a
reformer rather than an iconoclast.[21] Resisting what he saw as the antisocial, the
morbid, the destructive tendencies of writers such as Byron and Poe, Longfellow
believed that a writer's greatest duties are to himself or herself, and next of all to
furthering the moral development of his or her readership. But of course, Long-
fellow's own model for public life was the statesman who had previously occu-
pied his house on Cambridge's Brattle Street: General George Washington.

Longfellow was a lifelong student of Washington's life, and his residence in
what had become known as the Craigie House, combined with his friendship with
Jared Sparks and his enthusiasm for Washington Irving—both men wrote major
biographies of Washington—kept "the Father of his Country" continually in Long-
fellow's mind. The poet wrote most famously of Washington in the poem "To a
Child," addressed to Charles Longfellow, the already famous poet's young son:

Once, ah, once, within these walls,
One whom memory oft recalls,

The Father of his Country, dwelt. . . .
Up and down these echoing stairs,
Heavy with the weight of cares,
Sounded his majestic tread;
Yes, within this very room
Sat he in those hours of gloom,
Weary both in heart and head. (39)

Longfellow's own identification with Washington as a father leads him to follow his hero's ghost through the house, from the entryway to the stairs (where a copy of Houdon's bust of Washington looked down on visitors to the house from the landing on the main staircase), and into Charley's nursery, where Longfellow believed Washington had slept during the siege of Boston. However, the visitation is only to Longfellow, not to his energetic and oblivious son, the hallowed confines of whose nursery "[a]re now like prison walls to thee":

But what are these grave thoughts to thee?
Out, out! into the open air!
Thy only dream is liberty,
Thou carest little how or where. (39–40)

Longfellow as poet must protect Washington's memory against the forgetfulness of the rising generation, and poems such as "Paul Revere's Ride" served to do just that for generations in American schoolrooms. However, celebration is not Longfellow's only intent as a public poet; "To a Child" was published in *The Belfry of Bruges*, along with "The Occultation of Orion," which critics in recent decades have read as a provocative meditation on the tension between war and peace in history, and "To the Driving Cloud," Longfellow's early hexameter experiment that reflected on the disappearance of the Native American from the continental landscape. As Robert Ferguson has argued, Longfellow was deeply invested in the pressing political questions of his day, such as the abolition of slavery, sectionalist tensions in Congress, and the ethics behind westward expansion.[22] Yet Longfellow's unwillingness to participate in politicking extended to his refusal to write occasional poetry, either before or after he became famous; after declining an offer from George Curtis to write a patriotic poem after the eruption of the Civil War, Longfellow noted in his journal, "I am afraid the 'Go to, let us make a national song,' will not succeed." The next sentence in the journal entry, however, shows that the poet's skepticism came not from personal taste

but from a belief that truly national works cannot be manufactured, but are organic expressions of culture: "It will be likely to spring up in some other way."[23]

Longfellow's version of Washington's grand inaction helped to maintain his image as a nationally representative figure, but it caused problems for his writing analogous to those that had faced Washington's hero-worshipers: if he would not write the great national poem on demand, how could he write such a poem without giving in to the pressure of the moment? *Hiawatha*, with its organic, preliterate past and its emphasis on remembrance as the path to salvation, was Longfellow's answer to this problem amid the turmoil of the mid-1850s. The first canto, entitled "The Peace-Pipe," describes a meeting of hostile nations called by Gitche Manito, the chief god. The god makes a pipe from "the red stone of the quarry," "fashion[s] it with figures," and smokes it as "a signal to the nations" (144). As the nations gather, feuds revive and violence breaks out, but Gitche Manito speaks "with voice majestic" as he raises his right hand to compel their silence. The god declares to his children that "All your strength is in your union, / All your danger is in discord" (146), wearing the veil of political allegory very thin indeed. He then announces that he will send "a Prophet . . . A Deliverer of the nations" (146–47) who will teach the reconciled tribes how to improve their lives. But this deliverer's role is not solely that of a pedagogue but also that of a messianic suffering servant who "shall toil and suffer with you" (147). This deliverer is, of course, "my Hiawatha," a savior of the people in the tradition of not only the Cid—a freedom fighter who expels enemies from his homeland—but also Christ, who sacrifices his life for those he loves. Following on the ideal of heroic patience that permeated *Evangeline*, Longfellow depicts Hiawatha as a hero of human proportions. Numerous critics even in the 1850s observed that the magical deeds of young Hiawatha somehow fail to magnify the warrior into an Achilles, but it is reasonable to think that Longfellow never intended such a magnification. As Virginia Jackson has shown, Canto 14, "Picture-Writing," is the heart of the entire poem;[24] Longfellow shows Hiawatha's greatest moment as a moment of bringing his people from orality to literacy as a better means of remembering the past, a means that did not rely on individual people but could belong to the entire culture. However, from this moment the narrative also declines quickly. Even in the "Picture-Writing" canto, the first use that the Iroquois make of writing is to mark graves with totems "inverted as a token / That the owner was departed" (230). And telling the story of Gitche Manito and the other gods leads seamlessly to phantasmagoric "Headless men, that walk the heavens," and from there to the carnage of an Iroquois *Iliad*:

> Bodies lying pierced with arrows,
> Bloody hands of death uplifted,
> Flags on graves, and great war-captains
> Grasping both the earth and heaven! (230)

This final image of the larger-than-life warrior is precisely the image that Hiawatha rejects for himself, but in rejecting it he ensures his own peaceful, all too peaceful demise.

The next canto, "Hiawatha's Lamentation," narrates the murder of Hiawatha's close friend Chibiabos, the greatest of all poets. Hiawatha's initial response is tantamount to a nervous breakdown, but out of his trauma comes his own poetry in lamenting his loss, and revenge on the murderer soon follows. However, the downward slope is now inexorable. Kwasind, Hiawatha's other closest friend, dies apart from the hero, ambushed by wood-spirits; the cantos following Kwasind's death, "The Ghosts" and "The Famine," literally bring death home to Hiawatha, as his wigwam is haunted by ghosts of refugees (possibly echoing the victims of the Indian Removal?), and a food shortage that even his abilities as a farmer and hunter cannot amend claims the life of his wife, Minnehaha, who, despite her own fertility rites for the land earlier in the poem, leaves her husband without an heir. Hiawatha has now lost everything but his authority, and the time is ripe for "The White Man's Foot," the penultimate canto, which is named for a plant said to move west ahead of white settlers. In this canto, Hiawatha has a vision of the white man's arrival in Iroquois territory, in which the thrilling prospect of Euro-American migration gives way to "a darker, drearier vision":

> I beheld our nation scattered,
> All forgetful of my counsels,
> Weakened, warring with each other[.]

And here the imagery from "To a Driving Cloud" returns with a vengeance:

> [I] Saw the remnants of our people
> Sweeping westward, wild and woful,
> Like the cloud-rack of a tempest,
> Like the withered leaves of Autumn!" (272–73)

Just as certain as the triumph of the Euro-American settler is the eradication of the Native American peoples. The westward course of (white) empire is inexorable in the poem, and the fault seems to lie with the natives themselves—their

dispersal is punishment for their failure to keep Gitche Manito's covenant concerning his "Deliverer of the nations":

> If you listen to his counsels,
> You will multiply and prosper;
> If his warnings pass unheeded,
> You will fade away and perish! (147)

Hiawatha's time is all but spent, and his mission to deliver his people seems a great failure. All he can do now is greet the first white men to his lands and then depart without a struggle.

Critics have long wrung their hands at the ending of *Hiawatha*, usually along the lines of either Newton Arvin's aesthetic critique that "there is no painful complexity, no rich contradictoriness" in the ending, or Cecilia Tichi's account of what she perceives as the poem's ideology: "Longfellow is able at the last to suggest a continuity of cultures in America from the primitive yet dignified indigenous to the sophisticated migratory transplanted from the old world."[25] In a poem that seems to celebrate the cultural richness of the Iroquois and Algonkin nations, the figure of the epitaph in the introduction comes full circle as the slow death of the Indian nations begins with the coming of the whites. As Gordon Brotherston has argued, what could have been an admirable poem descends into a devastating justification for race death as Manifest Destiny: "[A]ll [Longfellow's] loving attention to native text has its categorical price: Manabozho/Hiawatha is celebrated only on condition that he disappear. Terminally epic, the hero follows the solar walk not through its circuit but just westward to annihilation in the 'fiery sunset'; and upon leaving, he orders his people to concede all to the new representatives of the 'Master of Life.' Hence, they simply self-destruct, ensuring that all territory is vacated in principle even before the whites invade."[26] Yet this interpretation, in its rush to condemn Longfellow's willingness to let the red man die, ignores the political urgency of the opening cantos concerning the threat of disunion. Hiawatha's role as bringer of culture was meant to unify warring nations and exchange peace and prosperity for distrust and violence; politics fueled by envy and blind force destroyed his friends, and then his wife, and the hero who had mustered his greatest strength through coalition (as in his marriage to the Dacota woman Minnehaha, meant to reconcile rival nations through the union) finds himself friendless in his last hours. Disunion has undone Hiawatha, and he now must stand by and watch destiny fulfill itself.

So how do we make sense of Hiawatha's "exultation" in meeting the white men? Is this meeting of the races truly meant to be a solution to the Indians' fatal flaws? If so, it is a strange solution indeed. For the white men that Hiawatha meets are not farmers, ranchers, or industrialists, but French Jesuits, "the Black-Robe chief . . . With his guides and his companions" (274). Longfellow's fascination with Catholicism had made itself known in *Evangeline*, as we have already seen, and his reworking of a minnesinger's saint's legend in his 1851 *The Golden Legend* elicited the comment from the poet's wife that the work was "almost too Catholic, and rather dangerous to publish in these excited times!"[27] Portraying Hiawatha's encounter with the Jesuits in the mid-1850s was also potentially dangerous, as rumors flew of Jesuits infiltrating the United States on a mission from the Vatican to dissolve the country. In any case, the fact that Catholic missionaries, rather than Puritans or other Protestant settlers, should be the potential saviors of the Algonkins may well have served to criticize Protestant America's self-righteousness rather than to praise the supremacy of the whites.[28] The "Priest of Prayer" comes not to seize land but to win souls, and he delivers his message of salvation to all the elders of Hiawatha's people, who respond rationally and cordially:

> We have listened to your message,
> We have heard your words of wisdom,
> We will think on what you tell us.
> It is well for us, O brothers,
> That you come so far to see us! (276)

As at the start of the poem, hope lies in union, but union fostered by dialogue rather than by fiat. The Algonkins' tendency to stop talking is what leads Gitche Manito to call his great council, and it is also what leads Hiawatha to invent picture writing so that knowledge will not be lost. It is not the inadequacy of orality that necessitates the rise of literacy, but the failure to use orality effectively. Longfellow may well have been thinking of Daniel Webster's infamous 1850 "Constitution and Union" speech, in which the senator supported the passage of the Fugitive Slave Act (see chap. 2); shortly after *Hiawatha*'s publication, dialogue in Congress over the slavery question broke down traumatically when Preston Brooks, a representative from South Carolina, caned Longfellow's closest friend Charles Sumner while the latter was on the floor of the Senate in 1856—the caning was in response to Sumner's increasingly ad hominem attacks on Southern politicians in his speeches.

In Longfellow's mind, the specter of civil war in the United States and the destruction of the Indian nations were ominously related. Like Cole in his painting cycle *The Course of Empire*, Longfellow largely adhered to Herder's philosophy of history: nations rose and fell in a cyclical pattern, such that one nation conquering or displacing another nation is no guarantee of the victor's greater virtue or longevity. The importance of preserving lost cultures, whether that of the ancient Hebrews or of the fading American nations, was partly to remind later generations of the parts of humanity that have been lost in the name of progress and superiority. The abruptness of the poem's ending suggests both the cataclysmic nature of the Herderian cycle, as someone like Cole might interpret it, and the cultural tensions inherent in *Hiawatha*'s most famous literary source, the *Kalevala*.

In the preface to his "authorized" German translation of Longfellow's "Indian Edda," *Der Sang von Hiawatha*, Ferdinand Freiligrath argued that instead of "Edda" the poem should "more rightly be called an Indian Kalewala [*sic*]."[29] Freiligrath expresses his admiration for Longfellow's ability to weave his various literary and anthropological sources organically together into the poem, but he also objects to the ending: "In this respect only the conclusion of the poem may appear doubtful, insofar as the tale and poem make almost all too abrupt and sudden an impression. Hiawatha, the son of the West-Wind, the grandson of Nokomis who fell from the moon, suddenly shakes the hand of seventeenth-century French missionaries! As unmatched in spirit is the tale told of the same cultural-historical [*culturhistorische*] moment, the coming of Christendom, in the Kalewala!"[30] Despite the numerous articles that appeared in the wake of *Hiawatha*'s publication pointing out parallels between Longfellow's poem and the *Kalevala*, no mention of the relationship between the two epics' endings has been made in modern criticism, even in a monograph dedicated to comparing the works.[31] Much of the early debate revolved around the question of plagiarism—did Longfellow take too much from the poem, or at least too much without acknowledgment?—but the strange similarity between the closing cantos of each poem highlights the complexity of Longfellow's intertextual strategies, as well as the nature of his ideas concerning the relationship between epic and the nation.

The *Kalevala* did not exist as a single narrative until Elias Lönnrot synthesized dozens of transcriptions from oral performances of Karelian epic cycles. This synthesis, arranged in fifty cantos and including several hundred lines added by Lönnrot to aid narrative coherence, was Longfellow's source not only

for meter but also for organizing principles. Longfellow himself worked with transcriptions of oral tales, via ethnologists such as Henry Rowe Schoolcraft, and the introduction balances the speaker on the very edge between orality and literacy that Lönnrot approaches in his reworking of the Karelian songs. By referring to the poem as his "Indian Edda," Longfellow further identified himself with the previous work of compilers of epic material, in this case the thirteenth-century Icelandic poet Snorri Sturluson, whose *Prose Edda* was not only to serve as a guide for later poets and historians in the Icelandic tradition but also to give its name to an earlier collection of heroic poems now known as the *Poetic* or *Elder Edda*. The blurring between earlier poet and later compiler that characterizes the composition of the *Eddas* and the *Kalevala* is part of Longfellow's own temporal slippage in his work. While most of *Hiawatha* takes place in an inaccessible mythic past, the final canto, as Freiligrath noted, unexpectedly thrusts the story into history, such that a mythic hero and an anonymous but historical Catholic missionary can meet in the same poem. The arrival of European Christianity, despite Hiawatha's hopes for the future, seems to drive the hero off. This parallels the final canto of the *Kalevala*, where some of Lönnrot's most telling editorial work occurs.[32]

Most of the Finnish epic up to this point recounts the deeds of Väinämöinen, a bard with magical, almost Promethean powers; through his strength and cunning, the Karelian people find their unity even while losing their greatest treasure, the mysterious Sampo, in a civil war. With the destruction of the Sampo Väinämöinen's power wanes, and the last canto begins abruptly with Lönnrot's refashioning of Orthodox legends of the Virgin Mary, now a Karelian maiden named Marjatta, those legends themselves local folk versions adapted from Russian saints' legends. When the time for the infant Christ's baptism and naming arrives, Väinämöinen is called on to judge whether the child, who has no identified father, should live. The old bard, envious of the child's obvious power, decides the baby must be killed, and in response the two-week-old Christ rebukes and banishes his unjust judge. Väinämöinen then sails into—and possibly over—the sunset, and the poem concludes in a modern Orthodox Finland. Christianity's capacity to both disrupt old cultures and consolidate new ones in their place is a dominant feature of both the *Kalevala* and *Hiawatha*, and the hero's departure in the face of the gospel (presented in the older idioms of Catholicism and Orthodoxy rather than Protestant ones) makes for a disturbingly easy resolution in both poems. Lönnrot constructed his poem in the name of promoting Finnish national culture, in a country that had suffered foreign occupation for centuries,

with Russia finally displacing Sweden about a century before the *Kalevala*'s com-
pilation. Longfellow also had clear nationalistic purposes in writing *Hiawatha*,
although his nationalism sought to balance a kind of cultural universalism with
national belonging figured through the union of native and European cultures.

This patently romantic approach to culture, in the spirit of Goethe's *Weltlit-
eratur*, was not lost on Longfellow's German translator, who asserted, "Thus is
the poem a humanist and yet also a specifically American one. . . . Longfellow,
one can indeed say, has among Americans first discovered America in poetry."
As Longfellow is the greatest among American poets, so he is also one of the
greatest among all poets: "In the pantheon of World Poetry [*Weltpoesie*]," which
Freiligrath credits Herder with devising, "the 'Song of Hiawatha' is not lack-
ing."[33] To create a truly American epic, in Freiligrath's as well as in Longfellow's
mind, is to create an epic that reaches across nations and even oceans. The poetic
source for *Hiawatha* lies not so much in the Old World, as critics such as Tichi
would argue, but in the "old country," the marginalized Karelian culture that
stood in the mid-nineteenth century for Finnish national pride, just as the fading
memory of American nations destroyed by waves of European settlers served as
both a warning and a shared history, in the tradition of Sacvan Bercovitch's
"American Jeremiad." As in Whitman's case, Longfellow saw himself as an epic
poet whose duty it was to bring the nation to a sense of itself, but also to alert the
nation to the dangers threatening it from within. At the same time, this warning
could translate to European readers as a celebration of what makes America
distinctive—its distant past, now all but reduced to an epitaph. The only way to
epic *kleos* or glory, for Hiawatha as for Achilles, is through loss and mourning.

Private Poetry and the Loss of a Public: Dante and *Christus*

Mourning would become a new motive in writing for Longfellow in the years
following *Hiawatha*'s publication. Or rather, it would return as a motive; the poet
had lost his first wife, Mary, following complications from a miscarriage while
traveling in Europe in 1835. A few years later, Longfellow alluded to his loss (he
had been Mary's nurse in her last days, and almost never spoke of her death) as
"a care that almost killed" in his sonnet "Mezzo Cammin," a meditation on his
lack of poetic production by the age of thirty-five (671).[34] He had published several
of his most popular poems by then, including "A Psalm of Life" and "The Village
Blacksmith," many of them clearly motivated by his grief over losing Mary. When

Longfellow's second wife, Fanny, the mother of their five children, died of burns when a candle flame caught her dress in 1861, he was left physically and emotionally incapacitated for weeks. Fanny had run in a panic into her husband's study as the flames enveloped her dress, and Henry's efforts to smother the flames with a blanket had left her alive but burned beyond recovery. Henry himself had sustained burns to his hands and face so severe he could not leave his bed the day Fanny was buried, and he found shaving almost impossible even after he healed; the trademark white beard that appears in most pictures of Longfellow dates only from this time, a cover for scars that would continually remind him of his loss.

By early 1862, the poet had determined to translate the *Divina Commedia* into English. He had already translated all or most of the *Purgatorio* in the 1850s, and he turned next to the *Paradiso* before translating the *Inferno*. Following the printing of *Inferno* for the Dante celebration in Florence in early 1865, Longfellow gathered a group of friends to assist in revising the translation in what became known as the Dante Club, a circle recently depicted in Matthew Pearl's novel *The Dante Club*. As he prepared the final translation, Longfellow included extensive annotations and "illustrations," or literary and critical extracts that shed light on the respective canticles of Dante's work. Yet while the scholar of Italian literature was clearly at work in Longfellow's Dante, the poet also found his own ways of making himself heard. Longfellow chose blank verse for his translation in order to allow the greatest freedom for rendering the Italian idiom. He wanted the translation readable, but not without the American reader feeling the otherness of the Florentine Dante, as well as the strangeness of a narrative where characters include Homer, Virgil, and Ulysses, in addition to a range of people Dante had known on the streets of Florence.

The line between the translator-as-guide and the translator-as-poet blurred in a series of six sonnets that Longfellow wrote about his process in translating the *Divine Comedy*. The sonnets were first published as "Divina Commedia" in the poet's 1866 collection *Flower-de-Luce*, and a pair of the sonnets appeared before each of the three canticles when the full *Divine Comedy* translation was published in 1867. The poems read within the translated work as glosses on Longfellow's experience of the poem, but in the absence of a prose preface, they necessarily become guides to the poem as well. The first sonnet develops the image of a "laborer" who enters a cathedral to lay down his "burden" and pray, while the "noises of the world retreat." At the volta in line 9 (Longfellow used the Petrarchan form almost exclusively in his sonnets), Longfellow envisions himself as the laborer, with his translation work as his cathedral. The simile portrays him as a laborer, but

one whose work breaks off for translation—this is an act of devotion, not one meant for the market, and as he prays in his translating, the "tumult of the time disconsolate" gives way to transcendence, where "the eternal ages watch and wait" (480). The waiting at the end suggests not the full transcendence of heaven, but rather the respite of a brief glance beyond the rush of time; Longfellow asks his readers to share the act of worship that translating Dante was for him.

Many of the subsequent sonnets follow the narrative of exploring a cathedral, inspecting the faces in sculpture, walking the aisles, gazing at sunlit windows; the great surprise in the midst of this architectural survey, however, is that Longfellow himself becomes a character in the *Divine Comedy*, as he sees the "poet saturnine" in the "gloom / Of the long aisles," and "strive[s] to make my steps keep pace with thine" (480). Longfellow here casts himself as the Dante figure following Dante-as-Virgil, extending the genealogy of master and apprentice poets. The Cambridge poet's interest in such genealogical projection is clear from his choice of epigraph for the full translation, a couplet from Spenser's *Faerie Queene*, Book IV, Canto 2: "I follow here the footing of thy feete / That with thy meaning so I may the rather meete."[35] Spenser is here speaking of Chaucer, and the pun on "feet" points to metric imitation as well as striving for following in the line of the master. Longfellow, working as he was in a metrical form very different from Dante's *terza rima*, faced a difficult dance in "keeping pace" with Dante, and by foregrounding his struggle in the prefatory sonnets, he presents himself much more as a fellow poet than as a mere translator. This was certainly an appropriate stance for the publication context of the poem; Longfellow's *Divine Comedy* appeared as the first in a series of translations of world classics that Ticknor & Fields (and later Fields & Osgood) used to celebrate both the firm's reputation for elegant editions and the accomplishments of American poets who could harness the greatest poetry of all time. The series was devoted to works of the epic tradition, including William Cullen Bryant's translations of the *Iliad* and *Odyssey* (1870, 1871), Bayard Taylor's version of Goethe's *Faust* (1871), and C. P. Cranch's *Aeneid* (1872); the list of titles indicated that what Americans thought constituted the epic canon had changed over the previous fifty years or so, but starting the series with Longfellow also consolidated that poet's status as America's premier translator-poet. This point became further emphasized in the 1885 Riverside edition of Longfellow's works, when in the *Inferno* volume Houghton Mifflin included as the frontispiece a photograph of a marble bust of Longfellow, rather than an image of Dante. I have yet to find another translated work that places the translator's portrait rather than the author's on the frontispiece, but Longfellow's

status as an author who "discovered" poetic matter for Americans gave him pride of place even over the master he claimed to be following in his sonnets.

Of course, Longfellow continued producing a substantial amount of original work after his Dante project, but the line between translating and authoring continued to blur as he became increasingly devoted to the sonnet and dramatic poem forms. After building a career based on a reputation for simplicity and accessibility (whether that fairly represented his work or not), Longfellow finally found the time, vision, and energy to complete an ambitious project that he had been considering since 1841, a history of the life of Christ and his influence on the world since: a pointed return to the closing books of *Paradise Lost*, but with the intention of exploring that history rather than merely deploying it for the sake of the *telos*. *The Golden Legend*, the first piece of what Longfellow envisioned as his crowning work, was not written until 1851. From the start *Legend* was intended to be the second part of a trilogy of dramatic poems that would treat "the various aspects of Christendom in the Apostolic, Middle, and Modern Ages."[36] The poet would go on to write a prose drama on John Endicott's persecution of the Quakers (while he was writing his hexameter *Courtship of Miles Standish* in the late 1850s), then turning that play into verse after the Civil War and pairing it with a drama about the Salem Witch Trials to form *The New England Tragedies*. Though Longfellow envisioned writing a drama about the Bethlehem Moravians—the same topic that Sigourney had taken up in "Zinzendorff"—he used his New England pair as the third, "Modern" part of his larger poem. *The Divine Tragedy*, a retelling of the life, death, and resurrection of Christ intended as the first part of the poem's chronology, was finally completed in 1871. Around these three (or four) previously published pieces, Longfellow then composed a dialogue between an angel and the prophet Habakkuk as an "Introitus"; interludes of the Abbot Joachim (after *The Divine Tragedy*) and Martin Luther (after *The Golden Legend*); and a "Finale" monologue by St. John the Divine to complete *Christus: A Mystery*, which appeared in three volumes in 1872.

This poem, if it was to be taken as a single poem, was clearly complicated and difficult to take in. Longfellow had long planned *Christus* to be an intricate work. On finishing work on his popular collection *The Seaside and the Fireside* (1850), Longfellow wrote in his journal, "And now I long to try a loftier strain, the sublimer Song whose broken melodies have for so many years breathed through my soul in the better hours of life, and which I trust and believe will ere long unite themselves into a symphony not all unworthy the sublime theme, but furnishing 'some equivalent expression for the trouble and wrath of life, for its sorrow and

its mystery.'" *The Golden Legend* followed soon after Longfellow wrote this entry, and nearly all of Longfellow's biographers and critics who have written on *Christus* have quoted this passage as the poet's declaration of his intent (he never provided a preface or other substantial gloss on the project). The sheer scale of Longfellow's ambition has largely escaped critical attention, however. He speaks of the poem as a "Song" conveyed by "broken melodies," but he desires this to grow into a "symphony." A lifelong lover of music and opera and an accomplished pianist, Longfellow chose music rather than painting for his metaphor in describing his most ambitious work, and while critics have noted the darkness of intent in the quoted lines about "trouble" and "sorrow," no scholar has previously identified the source, despite the poet's reference to that source in the next paragraph of the journal entry. Fanny Longfellow had just been reading John Ruskin's *Seven Lamps of Architecture* aloud to her husband, who was taken with Ruskin's "magnificent breadth and sweep of style."[37] *Christus* was to share in the aesthetics not only of music but of architecture as well.

The lines Longfellow quoted from Ruskin come from the chapter on the "Lamp of Power," in which Ruskin explains the challenges and possibility of conveying sublimity in architecture. Observing that painters had recourse to color and shading in creating sublime effects while architects had only the shadows thrown by direct sunlight, Ruskin argued that any piece of art must reflect the shadows of lived experience in order to be true, and thus sublimity could not be ignored in architecture—some "equivalent expression" must be adapted from other aesthetic vocabularies in order to make "this magnificently human art of architecture" ring true.[38] That Longfellow would range so widely in his aesthetic conception of *Christus* suggests the sweeping, unprecedented nature of what he was attempting to do. While Longfellow was treating a grand subject in a way to accent its sublimity, he was choosing not to do so within any generic framework that would be recognized as epic—only the aesthetic effect would be tied to that tradition. What he was doing was like *Paradise Lost*, but it was just as much like a Beethoven symphony or the San Marco cathedral in Venice. Using the relatively obscure form of the closet drama, Longfellow planned to open up the power and the tragedy of Christ's life and influence across almost two millennia. This would be not merely a poem, but an aesthetic and religious experience, as indicated by its subtitle, *A Mystery*. While clearly alluding to the medieval mystery plays, the single word "mystery" carries senses of religious scenes of meditation (as in the mysteries of the Catholic Rosary), as well as of the bewildering fact of life, "its sorrow and its mystery," as Longfellow had quoted from Ruskin. As with Melville's *Clarel*,

which was subtitled "A Poem and Pilgrimage in the Holy Land," critics have not fully acknowledged the spiritual nature of the claims made for the difficult, often uninviting but impressive poetry of *Christus*.

The web of aesthetic and religious analogies became even more complicated when Longfellow named his opening dialogue an "Introitus." The predominance of the Latin of Catholicism runs throughout the poem—the title *Christus* is also the name of Christ's character in *The Divine Tragedy*—and Longfellow uses the older term for the introductory rite of the Mass. The sense of movement and procession is key to the effect of the Introitus; Habakkuk, the prophet of mercy, has been interrupted from bringing food to poor farmers so that an angel could transport him with food to Daniel, who is keeping vigil in the lions' den. This piece ushers the reader into the most sacred part of the work, as *The Divine Tragedy* moves between scenes adapted from tradition or invented by the poet and scenes that are rendered, in a surprising reprisal of the Dissenting epic tradition described in chapter 1, in a very close (for most critics, too close) paraphrase of the Authorized Bible into blank verse. The curious mixture continues throughout the drama, with Christus sounding the most biblical of all the characters, and the epilogue returns to the multivalent mystery of the whole work: headed "Symbolum Apostolorum," it is simply an antiphonal recitation of the Apostles' Creed, with each of the Twelve (with Matthias, not Judas, of course) taking lines in turn. The use of the ancient name of the Creed as the "Symbol of the Apostles" emphasizes its proximity to Christ's life, but the distinctly antidramatic presentation of it suggests both the antiphonal liturgy of the Introitus-as-form and the rapid movement from life to doctrine that the development of the church brought about. Christ's call to Peter to feed his lambs in the closing scene of the drama might be the high point of the influence of love in *Christus*, but the response of belief is, as the rest of the work demonstrates, shot through with light and dark possibilities. The epilogue of *The Divine Tragedy* recasts the "mystery" as a meditation on the meaning of belief itself, a theme that will continue through the dangerous (though ultimately contained) excesses of veneration in *The Golden Legend* and the lethal excesses of orthodoxy in *The New England Tragedies*.

Indeed, the place of belief in world history seems to hang in the balance by the time St. John enters in the "Finale." The apostle is "wandering over the face of the Earth," not on a mission from God as Habakkuk was but lost both geographically and existentially. He muses on the fall of empires and nations that leave no trace, while

evil doth not cease;
There is war instead of peace,
Instead of Love there is hate;
And still I must wander and wait[.][39]

Though on the brink of despair, John still anticipates some final resolution, yet he sees little hope for it in the wake of the mystery. As he asks the big questions ("doth Charity fail? / Is Faith of no avail?"), he insistently takes the long view (472). His answer to the seeming failure of love in *The New England Tragedies* comes as an extended simile:

The clashing of creeds, and the strife
Of the many beliefs, that in vain
Perplex man's heart and brain,
Are naught but the rustle of leaves,
When the breath of God upheaves
The boughs of the Tree of Life,
And they subside again!

The violence of religious conflict is terrible, but in the face of eternity it means little compared to Christ's call to follow God's will. The teacher's words bring images of the living Christ to John's mind, and he moves from the simplicity of the Galilean's ministry to a vision of the cyclical fall and return of the Church:

Poor, sad Humanity
Through all the dust and heat
Turns back with bleeding feet,
By the weary road it came,
Unto the simple thought
By the great Master taught.
And that remaineth still:
Not he that repeateth the name,
But he that doeth the will! (473)

The difference between belief as confession (the "Symbolum Apostolum") and belief as the motive for love (Habakkuk's mission of mercy) is the ultimate distinction, left for the reader to judge whether the right kind of belief will prevail—in the reader, before anyone else.

For the closet drama form necessitates the fiction of a reader personally and actively engaged with the text, using imagination to bring the scenes to their fullest expression and meditating on the meanings of those scenes. In no other work, not even in *Hiawatha*, does Longfellow foreground the act of writing so consistently and with such profound reflection. Habakkuk's angel informs him that he has been honored by God because "thou art / the Struggler" who has served others "with deed and word and pen" (3): a reflection of Longfellow himself, who had repeatedly lamented in his journals that he had not been able to say all that he wanted to, or to work as much on *Christus* as he desired. Nor has Habakkuk's work ended in the Introitus. The Angel gives him a new task, one that, as it closes the section, seems to take in the entire balance of the work:

> Awake from thy sleep, O dreamer!
> The hour is near, though late;
> Awake! write the vision sublime[.] (4)

The Habakkuk scene is one of the few moments in his works where Longfellow figures the struggle of writing, though he himself had experienced it so frequently in his life. Remarkably, that figure appears again in the Joachim interlude, as the abbot thinks of himself as reliving St. John's exile on Patmos (where the Apocalypse unfolds before the apostle), and he remembers his pilgrimage to the Holy Land where "first I heard the great command, / The voice behind me saying: Write! . . . And I have written" (130). Joachim exults in the triumph of Love and the goodness of God as a new age, the "coming of the Holy Ghost," at the turn of the second millennium (132), and his rest comes in large part because he has fully obeyed his "great command":

> My work is finished; I am strong
> In faith and hope and charity;
> For I have written the things I see,
> The things that have been and shall be[.] (133)

Following the "Symbolum Apostolorum," Joachim finds wholeness even in isolation, but the isolated writer would not find peace at the dawn of modernity.

Martin Luther begins his soliloquy by writing his famous hymn, *Ein' feste Burg ist unser Gott*, and reflecting on his ability to enjoy "a heart of ease . . . Safe in this Wartburg tower" (303). Longfellow intersperses the stanzas of Luther's hymn throughout the monologue, giving the text in his own translation rather than the now-standard version by his fellow Unitarian and Harvard professor

Frederic Henry Hedge, "A Mighty Fortress Is Our God"; while critics have noted that Hedge's text scans better, Longfellow uses his gloss of the German to bring out key hints that Luther's mind is not all peace and piety.[40] Hedge opens his version thus: "A mighty fortress is our God, / A bulwark never failing."[41] Longfellow's version echoes the tower that Luther cites as his physical source of safety: "Our God, a Tower of Strength is he, / A goodly wall and weapon" (303). But in celebrating the Almighty's defense, he also signals the potential for aggression. As Luther continues, he calls down curses on the Pope, on Catholic heretics, and especially on "Erasmus the Insincere!" (307). After this latest execration, however, he turns to his distant friend, Philip Melancthon, who, it turns out, is the true recipient of the hymn, as he alone can read both for the praise of God and for the personality of Luther in the sympathetic way that the writer craves:

> My Philip, unto thee I write.
> My Philip! thou who knowest best
> All that is passing in this breast . . .
> My Philip, in the night-time sing
> This song of the Lord I send to thee;
> And I will sing it for thy sake,
> Until our answering voices make
> A glorious antiphony,
> And choral chant of victory! (308)

The antiphon of the Introitus and the "Symbolum Apostolorum" is now remediated into writing, and the hymn becomes a form of epistolary exchange before it can even be sung—and as Luther sings it for the sake of his friend, it seems that the hymn is just as much about the cohesion of the community as anything else, the very bond that the atrocities of *The New England Tragedies* were meant to protect. And yet, the intimacy of the gift between Luther and Philip mirrors the intimacy that the closet drama posits between author and reader, the only two performers of the scene, together in mind though distant in space and time. *Christus* is as much about the dynamics of writing as it is about the nature of belief, and the two indeed hinge in the poem on similar virtues of faith, hope, and love.

Longfellow had in fact designed his opus with a tripartite structure not only in terms of historical ages but also in connection with the three theological virtues; later editions of *Christus* would indicate in the table of contents that the first part was about hope, the second about faith, and the third about love. This element

of the structure has caused frustration among critics, because the reality of *The New England Tragedies* is that love does not win out: John Endicott is left to mourn his son, crying "Absalom!" as his final scene ends, and Giles Corey lies dead in the last page of his play. Arvin has objected to this as a failure of consistency, a key contributing factor to his final takeaway that "one is forced to wonder what Longfellow is really saying at the end of it all."[42] Buell finds *Christus* to be "stitched together," following William Dean Howell's assessment that "the parts are *welded*, not *fused*, together."[43] Yet some of this perceived inconsistency derives from the fact that Longfellow is not only addressing what Buell calls "the failure of the ideal of charity to realize and sustain itself" but also what such huge ideals as Faith, Hope, and Charity look like in individual lives and in decidedly local places.[44] For all the sweep of *Christus*, almost everything in it happens at a pedestrian's-eye view. After Habakkuk enjoys his vista of Babylon's illuminated skyline, the central plays stay on the hills of Galilee and Odenwald, the streets of Jerusalem, Salzburg, Salerno, and Salem; the lives of individual people are the main objects of dramatic interest.

This is what creates the shock of St. John's long view while "wandering" the globe at the end—this is a perspective unavailable through eighteen hundred years of history, and it is the only one out of chronological order (unless this is a vision of spiritual haunting, but that is for another study). As John looks for the end of struggle, and along with it the end of writing, we find Longfellow consigning himself to the ages, having created a work that asks for a kind of reading that almost no one could be ready to bring to it: from the liturgy of the Introitus to the plays and interludes, ending with the symphonic "Finale," *Christus* is indeed a mystery, but one meant to be contemplated rather than merely consumed and explained. On the other side of the Civil War, of his second wife's death, and of his journey through Dante, Longfellow seems to no longer want to be understood, at least not in the facile ways that many of his readers approached him. The layers of translation, of scholarship, of writerly craft, and of spiritual longing had finally come together, and if no one sang its praises, he at least had made his "equivalent expression." In that way, Longfellow's postwar career paralleled that of Herman Melville, whose own thinking about the nature of career in the epic tradition is the focus of the final chapter.

Melville's Epic Career

> For God ordain'd not huge Empire as proportionable to the Bodies, but
> to the Mindes of Men; and the Mindes of Men are more monstrous,
> and require more space for agitation and the hunting of others, then
> the Bodies of Whales.
>
> —Annotated in Melville's copy of WILLIAM D'AVENANT'S
> *Gondibert: An Heroick Poem*[1]

Did Herman Melville have a career? The question sounds facetious, since many
critics have gone to great lengths to articulate and contextualize that career. In
almost every case, however, that career has been one of a fiction writer, and espe-
cially of a novelist, whose turn to poetry on the eve of the Civil War has fre-
quently been seen as beginning what Willard Thorp called in the 1930s "Mel-
ville's Silent Years."[2] This, despite the fact that Melville wrote poetry for over
twice as many years as he did prose, has been a difficult paradigm to break from,
even as scholars have paid increasing attention to Melville's poetry. Sheila Post-
Lauria has deftly shown that Melville was already easing into poetic types of lin-
guistic experimentation in *The Confidence-Man*, and that his experience with
magazine writing prepared him to think of himself as an author who could ef-
fectively execute poetry. Edgar Dryden has seen Melville's poetry as charting the
development of a second, more intentional career after his first career as a fiction
writer failed. More recently, Hershel Parker has persuasively argued that Melville
was in fact steeped in poetry even before he was an author, and that his engage-
ment with poetry not only marked key developments in his fiction-writing years
but also led him to begin thinking of himself as a poet even before the ink was

dry on the pages of his last published novel, *The Confidence-Man* (1857).[3] So then: did Melville have one career, or two, or one with a twist?

These varying answers to my opening question tend to conflate what Jonathan Arac calls "a public relationship to readers" and the "narrative overview" that partially determines that relationship.[4] The narrative overview, an author's sense of explaining what they do by temporalizing it into a story—often as an element in a larger work, such as a novel or a long poem—is my focus in this chapter. Rather than focusing on Melville's relationship to his audience, though that certainly affects my reading in ways that will become clear in the following pages, I intend to read Melville's relationship to himself as an author, in company with other authors, and particularly through his engagements with epic poetry. These engagements were nearly constant, especially between 1848 and about 1876. In 1848, the year that Melville completed his third novel, *Mardi*, and made a drastic break from the travelogue style of his earlier works, Melville first read Dante; he was reading Tegner's *Frithiofs Saga* and Ossian in the same year. In 1849, the year he discovered Shakespeare, he also read intensively in Milton and purchased the Harper Family Classical Library, whose volumes of Virgil and Homer he would peruse for years. By the time he wrote *Moby-Dick*, he had spent considerable time with Spenser, Davenant, and Byron. By 1860, he was well versed in Ariosto, Tasso, Wordsworth, Tennyson, and multiple translations of Homer; he also had branched out into more recent American experiments in epic, such as John Quincy Adams's *Dermot Mac Morrogh* (1832), the only epic poem ever written by a US president.[5] *Clarel* indicates Melville's familiarity with the *Ramayana* and other non-Western epics, and his deep engagement with the sea adventure of Camões's *Lusiads* seems to have lasted from his sailing days until the end of his life. To reconstruct Melville's self-conception as an author among epics, I look not very much to his letters, which are usually considered the preeminent evidence of Melville's understanding of himself as a writer, but in his relentlessly active reading (markings, annotations) and in his published works. Though not comprehensive, this survey of Melville's encounters with epic offers insight into Melville's craft, his chosen "ancestors" (in Ralph Ellison's sense), and his use of narrative as a mode of thinking.

Epic Overtures: Lombardo's *Koztanza*

Melville first revealed his struggle with form in *Mardi and a Voyage Thither* (1849), his longest work in prose and his first explicitly fictional work. *Mardi* was also

Melville's first attempt at expanding his literary technique to digest his reading—which by 1848 was extensive. As "the man who lived among the cannibals" absorbed volumes of Ossian, Dante, and other classic authors, he reenvisioned himself as an ambitious young author whose South Sea adventures were mere gateways into the intellectual and spiritual oceans that he was now discovering. The structure of *Mardi* is complicated and uneven: the narrator, an unnamed sailor who later adopts the name Taji, deserts his whaling ship and wanders into a fanciful archipelago called Mardi, which turns out to be a microcosm of the Western world in cannibal dress. The main Mardian characters, King Media, the philosopher Babbalanja, the poet Yoomy, and the historian Mohi, travel with Taji and his fellow deserter Jarl on a circuitous voyage through Mardi, part rescue quest, part pleasure cruise. In chapter 180, the characters discuss the ancient Mardian poet Lombardo with King Abrazza in the form of a Platonic dialogue; as Elizabeth S. Foster has pointed out, critics have often read this chapter as a kind of allegorical defense that Melville makes for his choice in writing *Mardi*,[6] and it seems strangely prophetic of the book's outraged reception by critics who had previously called Melville "the American Crusoe."

Taji describes the conversation as concerning "old Homeric bards:—those who, ages back, harped, and begged, and groped their blinded way through all this charitable Mardi; receiving coppers then, and immortal glory now."[7] The characterization brings to mind Homer's self-reflexive depictions of blind bards in the *Odyssey*, such as Demodokos, who sings inspired songs on command in the land of Phaeacians. Here even Homer and his kind are working, as Carlyle would say, "under conditions," forced to their work by economic necessity and market demand rather than by disinterested inspiration that desires only "immortal glory" and not "coppers." Babbalanja, serving as Lombardo's biographer, explains why such poets perform for money and not for pure art: "[T]he greatest fullnesses overflow not spontaneously; and, even when decanted, like rich syrups, slowly ooze; whereas, poor fluids glibly flow, wide-spreading. Hence, when great fullness weds great indolence;—that man, to others, too often proves a cipher; though, to himself, his thoughts form an Infinite Series, indefinite, from its vastness; and incommunicable;—not for lack of power, but for lack of an omnipotent volition, to move his strength. His own world is full before him; the fulcrum set; but lever there is none" (593).[8] The mechanistic metaphors of the passage—viscous fluids, fulcrums and levers—highlight not only the imposition of movement upon the poet but the ultimate lack of volition on the part of Lombardo and his kind. The necessity of material resources for artistic production

also becomes apparent as Babbalanja explains that the first step in Lombardo's composition process was to acquire "a ream of vellum" and a bunch of quills, which he declares to be "indispensable preliminaries . . . to the writing of the sublimest epics" (594). Even the most inspired poet is powerless without access to enough materials to communicate his ideas. And the need to share his poetry strangely coincides with a prodigious appetite for raw materials, as Lombardo fills fifty folios in ten days and then throws them all away; Babbalanja wryly comments that the poet "loved huge acres of vellum whereon to expatiate" (595), not unlike the "sea-room" that Melville declared was necessary for the American writer to achieve his potential.[9] The vast appetite for territory and material, which Wai Chee Dimock has discussed in her *Empire for Liberty*, is a hallmark of Melville's epic impulse, even as his denouncements of American expansionism and the excesses of the wealthy reach at times jeremiadic pitches elsewhere in his writings (including much of both *Mardi* and *Moby-Dick*).[10]

But even barring ideological difficulties, Melville's epic appetite caused artistic problems for him, just as it did for Lombardo. After King Abrazza objects that Lombardo's *Koztanza* violates all of "the unities" of form, Babbalanja counters by insisting that while the work's beauty "is restricted to its form . . . its expanding soul" continues not only beyond form but even beyond the world of Mardi, as "there are things infinite in the finite; and dualities in unities" (597). In the footsteps of Shelley and Byron, Lombardo "abandoned all monitors from without" while "retain[ing] one autocrat within—his crowned and sceptred instinct" (597). Or did he? The incompatibility of the romantic author who writes the truth and the writer who can succeed by giving the public what it wants defined for Melville the tragic struggle of his own career. In a famous letter to Hawthorne, written near the end of *Moby-Dick*'s composition, Melville confessed to his fellow author, "My dear Sir, a presentiment is on me,—I shall at last be worn out and perish, like an old nutmeg-grater, grated to pieces by the constant attrition of the wood, that is, the nutmeg. What I feel most moved to write, that is banned,—it will not pay. Yet, altogether, write the *other* way I cannot. So the product is a final hash, and all my books are botches." And in the next few lines, it seems that Melville was losing not only the artistic battle with the market, but the economic one as well, as his own labors were now split (painfully) between writing and maintaining his farm in Pittsfield: "I'm rather sore, perhaps, in this letter; but see my hand!—four blisters on this palm, made by hoes and hammers within the last few days."[11]

Like Melville, Lombardo saw his own work as a botch. As Babbalanja relates, "[I]t ever seemed to him but a poor scrawled copy of something within, which, do

what he would, he could not completely transfer. 'My canvas was small,' said he; 'crowded out were hosts of things that came last. But Fate is in it.' And Fate it was . . . which forced Lombardo, ere his work was well done, to take it off his easel, and send it to be multiplied" (601–2). The analogy to painting emphasizes the artistic intentions of Lombardo, but his work is not only imcomplete but "a copy"— though of something internal to him, rather than based on some previous model. The small canvas, as the denial of Lombardo's appetite for "huge acres of vellum," prefigures the failure of the work once "off his easel." Yet how far off was the *Koztanza* from what its author had intended? When Abrazza objects that the poem "lacks cohesion," that "it is wild, unconnected, all episode," Babbalanja responds by redefining mimesis: "And so is Mardi itself:—nothing but episodes; valleys and hills; rivers, digressing from plains; vines, roving all over; boulders and diamonds; flowers and thistles; forests and thickets; and, here and there, fens and moors. And so, the world in the Koztanza" (597). Here the age-old "don't blame me, blame my source" argument moves from literary source to mimetic source: the work is unmanageable and asymmetrical because its subject matter is as well. Melville here pushes the classical arguments of the interdependence of form and content almost to the annihilation, or at least the subjugation, of form. But if the *Koztanza* is a flawed, incomplete work, is its formal makeup the result of artistic intention, or of the inability to fulfill that intention? Is formal incoherence an aesthetic triumph of "barbaric vertù,"[12] or simply a mistake—or even tragic fate? Much of Melville's career after *Mardi* revolved around these questions, and in *Moby-Dick* some of his most explicit thoughts on intention and form dovetail with a magnificent yet flawed narrative.

How to Draught an Epic

Ishmael declares an ambition to write "a mighty book" with "a mighty theme," not unlike Lombardo. However, the narrative of *Moby-Dick* might not have been the book he had planned to write, either. In chapter 102, "A Bower in the Arsacides," Ishmael mentions that he had the dimensions of a sperm whale skeleton tattooed on his right arm while in the South Seas, as "at that period, there was no other secure way of preserving such valuable statistics." However, he continues, "I was crowded for space, and wished the other parts of my body to remain a blank page for a poem I was then composing—at least, what untattooed parts might remain" (451). No longer the uninitiated Ishmael that shudders at the sight of Queequeg's tattoos, the narrator here declares that he has conceived of tattooing as

the proper vehicle not only for recording important data but also for preserving poetry, making the monument of the poet's achievement coextensive with the body of the poet himself—and thus tying the poetry to his life, such that the poetry will survive as long as (and no longer than) he does. The quest for poetic immortality is transposed into a further example of Melville/Lombardo/Ishmael's appetite for poetic materiality, a now self-consuming and self-inscribing appetite that bears a strange resemblance to the image of the ill-fated "nutmeg-grater" in Melville's letter to Hawthorne. But again, the work is incomplete; the tattoo poem is not written, or at least is not revealed to the reader. The body itself has become implicated in what Emerson in his essay "The Poet" called the "necessity to be published," but by both casting the (white) body as a tabula rasa and leaving it blank (at least to the reader), Ishmael-as-poet merely echoes Emerson's sum of human nature: "For all men live by truth, and stand in need of expression. . . . The man is only half himself, the other half is his expression."[13] Like Emerson, Ishmael still awaits his other half.

Yet even as Ishmael loudly yearns for greatness, his projected poem is unwritten, or at least uncompleted, or at the very least unpublished. The "un" world of *Moby-Dick* thematizes the incompletion that haunts not only Ishmael but the army of critics that have tried to explain his book. As Harrison Hayford remarks on the opening question of his essay, "Is *Moby-Dick* a Botch?"

> The biographical evidence says "Yes."
> The critical consensus says "No."
> The textual evidence says "Maybe."
> And the aesthetic implications need further study.[14]

However we understand the integrity of the book as a whole, the thematics of incompletion are overwhelming at times. At the beginning of the famous "Cetology" chapter, Ishmael offers his version of a "comprehensive classification" of the various kinds of whales, with a qualification worthy of the Connecticut Wits: "As no better man advances to take this matter in hand, I hereupon offer my own poor endeavors. I promise nothing complete; because any human thing supposed to be complete, must for that very reason infallibly be faulty" (136). But Ishmael's reason for his incompleteness is not merely his own lack of merit; he rejects outright the idea of completion in a "human thing." His failure to be definitive is his fault only insofar as he shares humanity's inherent limitations for objective and comprehensive expression. In fact, Ishmael's inability to perfect his classification system bespeaks its greatness, as he insists at the conclusion of the chapter:

It was stated at the outset, that this system would not be here, and at once, per-
fected. You cannot but plainly see that I have kept my word. But I now leave my
cetological System standing thus unfinished, even as the great Cathedral of
Cologne was left, with the crane still standing upon the top of the uncom-
pleted tower. For small erections may be finished by their first architects; grand
ones, true ones, ever leave the copestone to posterity. God keep me from ever
completing anything. This whole book is but a draught—nay, but a draught of
a draught. Oh, Time, Strength, Cash, and Patience! (145)

Here incompletion becomes not a failure but a (questionable) fulfillment of au-
thorial intent, and the sublimity of the grand and true supplants the economy of
symmetry that had dominated poetics in the eighteenth century.

The asymmetry of form is part of the ambiguity that has fueled critical debate
over whether *Moby-Dick* is better understood as a novel, a tragedy, or an epic.
However, as the discussion of Jones Very in chapter 4 has shown, some of the
most interesting and productive analysis in epic and tragedy comes not through
identifying the hero so much as through identifying the other key characters. In
Paradise Lost, for example, Very favors Satan as the hero of the poem, following
the German romantics in their reading of Milton as a rebellious prophet. Very's
most original contribution to his summary of romantic criticism is his identifi-
cation of Adam with Troy, the doomed city around whom the action revolves. To
the extent, then, that the *Iliad* is about Troy—and the title of the poem indicates
that Troy (i.e., Ilium) is centrally important—*Paradise Lost* is about not Satanic
rebellion but the Fall of humanity, "Of man's first disobedience, and the fruit."
Following this line of reasoning, Moby Dick might seem to be the center of his
story, but of all characters he possesses the most effective will—he can destroy
without (immediately) succumbing to others' wrath. Likewise, Ishmael is in too
much control of his own story to become the passive subject of a modern epic. In
my view, Starbuck holds the vital place in the story, as the brave, virtuous man
who can face deadly whales but "cannot withstand those more terrific, because
more spiritual terrors, which sometimes menace you from the concentrating
brow of an enraged and mighty man" (117). In this passage from the first "Knights
and Squires" chapter, Ishmael likens Ahab to Achilles, the first "enraged and
mighty man." Starbuck is more like the first man, Adam, at peace with the world
until the soul-wrenching contradictions of his life—pacifism and slaughter, order
and tyranny, duty and justice—paralyze him into his grave. Ishmael suggests that
the power behind Starbuck's portrayal is "the undraped spectacle of a valor-ruined

man" (117), the man who keeps his virtue even as it abandons him. The poignancy of this moment brings Ishmael into what amounts to his epic invocation, which I quote at length:

> But this august dignity I treat of, is not the dignity of kings and robes, but that abounding dignity which has no robed investiture. Thou shalt see it shining in the arm that wields a pick or drives a spike; that democratic dignity which, on all hands, radiates without end from God; Himself! The great God absolute! The centre and circumference of all democracy! His omnipresence, our divine equality!
>
> If, then, to meanest mariners, and renegades and castaways, I shall hereafter ascribe high qualities, though dark; weave round them tragic graces, if even the most mournful, perchance the most abased, among them all, shall at times lift himself to the exalted mounts; . . . then against all mortal critics bear me out in it, thou just Spirit of Equality, which hast spread one royal mantle of humanity over all my kind! Bear me out in it, thou great democratic God! . . . Thou who, in all Thy mighty, earthly, marchings, ever cullest Thy selectest champions from the kingly commons; bear me out in it, O God! (117)

Ishmael's "I treat of" signals at the beginning of the invocation that his borrowing of epic is a complicated one. Not only is his subject matter "not the dignity of kings and robes," but he does not sing that dignity but, as an epic essayist—perhaps in Emerson's vein—treats of it.[15] The hyperbole of this passage seeks its parallel in the tremendous fame of John Bunyan, Miguel de Cervantes, and President Jackson, even as it dwells on their grotesque shortcomings (the "swart convict," the "stumped and paupered arm") and Ishmael's misgivings concerning the virtue of their successes ("the pale, poetic pearl," "higher than a throne"). The invocation threatens to ring false, even as Ishmael makes his triple appeal "bear me out in it" rather than "sing in me" or "tell me." Ishmael has bypassed the Muses and gone straight to the top of Parnassus (or Sinai), but not so that he can hear inspiration directly from God, but so that he might have the strength to say what is already in him to say.

Uniting will and strength is Ahab's dream, and it is Starbuck's conflicted wish. Ahab recognizes that Starbuck alone possesses the virtue to stand against him, and so the captain must continually remind Starbuck of his authority, his charisma, his will to power, in order to keep the first mate silent. While Ahab sounds like Lear or Macbeth, his goal is not to be Lear or Macbeth, but to be Achilles, the charismatic warrior whose wrath can change the fate not just of his

people but of the cosmos. His rival for the role of Achilles is Starbuck, whose righteous anger could overthrow Ahab's supremacy and thus bring his war with the whale to an ignominious end. Thus, Ahab must be not only Achilles but Agamemnon, the seat of legal and political authority who can manipulate others by virtue of his position and cunning, but who can also overstep his bounds and suffer consequences for it. Repeatedly through the book, Ishmael calls attention to the prudential reasons that Ahab might have for various actions—not that such are necessarily his motives, but that his action indicates a political strategy for keeping the romantic monomania on an uninterrupted course. Following Milton's legacy (as Very described it), Melville blends his stock characters until the epic types of the classical tradition are only at first glance recognizable.

Even more fundamentally, Melville imitates Milton's penchant for similes. The extended simile, a rhetorical figure so commonly associated with epic and so basic to the poetics of the form that it has become known as the epic simile, traces its origin to the *Iliad*. However, as later epicists borrowed the device, it became increasingly sophisticated until in *Paradise Lost* the simile could do not only the positive work of layering associations onto a certain object or action but also the negative work of accentuating an object's sublimity by extended comparison in the object's favor. One of the most famous similes in *Moby-Dick* is of this second, negative kind and introduces the white whale himself near the end of the book: "Not the white bull Jupiter swimming away with ravished Europa clinging to his graceful horns; his lovely, leering eyes sideways intent upon the maid; with smooth bewitching fleetness, rippling straight for the nuptial bower in Crete; not Jove, not that great majesty Supreme! did surpass the glorified White Whale as he so divinely swam" (548). H. Bruce Franklin has called this passage "one of the great moments of revelation in literature," but Lawrence Buell rightly qualifies Franklin's statement by pointing out the highly stylized nature of the simile as an allusive literary device, thus calling into question how pure the moment of noumenal encounter actually is.[16] Buell connects Melville's technique with that of Milton in, for example, the negative simile comparing Eden to its classical counterparts in *Paradise Lost* IV; both Melville and Milton, he says, use negation as a method of deploying the rhetorical capital of extended comparison while finally denying the possibility of commensurability.[17]

While Buell's attention to the form of the simile is important, he elides the paradoxical nature of the whale that exhibits a "gentle joyousness—a mighty mildness of repose in swiftness," while his history as told throughout the book emphasizes the awful violence, even malice, of his encounters with whalemen. Indeed,

such is ultimately the encounter of the *Pequod* as Moby Dick's "predestinating head" (571) sends the ship and crew to their doom on the last day of the chase. Leslie E. Sheldon has pointed out this paradox, reading it as a parallel to Melville's reading of the Son in *Paradise Lost*, a character who appears meek before his Father and phantasmagorically awful before his enemies.[18] And this is precisely the kind of paradox Melville works into his simile through his reading of Ovid. The story of Jove's rapine of Europa in *Metamorphoses* II.834–81 emphasizes the woman's emotions, especially her attraction to and fear of the bull, which is really Jupiter in disguise, and her terror when the bull suddenly swims for the open ocean as she rides on his back.[19] In Melville's retelling of the story, Europa almost disappears except as an object of the god's gaze, an element unmentioned in Ovid's version. Recalling Ishmael's discussion of the whale's sideways, twofold vision in "The Sperm Whale's Head" (330–31), the god-bull's "lovely, leering eyes sideways" are "intent upon the maid." Simultaneously, Jupiter keeps his lateral gaze on Europa while swimming swiftly and straight ahead for "the nuptial bower in Crete," the site of the rape. In this simile, the *Pequod*'s crew is already doomed, following spellbound in the wake of a sublime creature that leads them into its own terrible violence. Even if the negative simile elevates Moby Dick beyond comparison, the form still does the powerfully subtle work of describing, but describing periphrastically—*around* the whale, not *into* the whale, as Ishmael so often attempts to do in the book. Ishmael's quest, it seems, has also failed at this point, insofar as his mission to understand and communicate the whale, a la Emerson's Poet, has been pulled down into the vortex of negation and periphrasis.

This example of the negative simile shows its usefulness to Melville as an enactment of the epistemological defeat that both Ishmael and Ahab fear, as well as a strategy for transforming that failure into literary apotheosis. It also suggests, in the figure of the "leering" god, the tremendous appetite for acquiring— "harpooning," as the sexual pun in "Fast-Fish and Loose-Fish" puts it—more and more of the literary universe that is a hallmark of Melville's project, particularly in *Moby-Dick*. June W. Allison has remarked that "Melville has employed elements of epic technique to the fullest and, one might hazard, even to excess as in the case of the similes and the huge epic digressions on cetology"; she counts over eight hundred similes in *Moby-Dick*, compared with 740 in the *Iliad* and the *Odyssey* combined.[20] Even more illustrative of Melville's epic appetite is illustration, or rather visuality, in the panoramic views and spectacular descriptions of the *Pequod*'s voyage and the whale's world. And Melville's emphasis on visuality—another

inheritance from Milton—announces a new turn in American epic literature: the return to *ekphrasis*. As a rhetorical device dating back to ancient Greece, *ekphrasis* is a verbal description of a work of visual art. Let us explore Melville's reintroduction of this strategy into epic writing, as well as his redefinitions of ekphrastic subject matter and the implications for his developing notion of authorial career.

Romancing *Ekphrasis*

As with similes, *Moby-Dick* is filled with *ekphrasis*.[21] From the first chapter, "Loomings," when Ishmael describes a hypothetical landscape painting, verbal representations of artwork appear in "endless processions," so that, as Bryan Wolf has commented, a painting becomes "most like a whale" (4–5, 7).[22] Melville had taken a keen interest in art even before his seagoing days, but his visits to art galleries in Europe, together with the purchase of several illustrated editions of classic works while in London in 1849–50, transformed his visual imagination almost at the same time that he encountered "the Divine William" and Carlyle. His first serious forays into *ekphrasis* appeared in *Redburn*, in which the title character reveals his desire for the wealth that has abandoned his downwardly mobile family by describing the glass model ship that his father had brought from France.[23]

When the wondrous Homeric shield appears in Ishmael's narration, it comes almost at the very end of the series of pictorial chapters, 55–57, which are arranged in order from the "monstrous" distortions of whales by landlocked artists to more and more mimetic—meaning based on firsthand observation, in this case—pictures, concluding with an array of art made from the actual bodies of whales and other sea creatures. A particular focus during the latter part of the sequence is skrimshander, carved teeth or bones from whales. Using an "almost omnipotent tool," the jackknife, sailors produce works of art that bespeak their restoration to "that condition in which God placed him, *i.e.* what is called savagery." Yet even as Ishmael gleefully identifies himself and his sailing brethren as "as much a savage as an Iroquois," he associates a surprising quality with savagery: "Now, one of the peculiar characteristics of the savage in his domestic hours, is his wonderful patience of industry" (270). By connecting the savage to domesticity and industry, patent hallmarks of Western civilization in Melville's day, Ishmael democratizes the value of patient craftsmanship. He declares a richly carved "ancient Hawaiian war-club or spear-paddle" to be "as great a trophy of human perseverance as a Latin lexicon," noting that both works have "cost

steady years of steady application" (270). With this allusion back to the pale ush-
er's lexicons at the beginning of the book, Melville hints at an ambition of his to
write slowly and thoughtfully, a luxury that he regretted doing without. In the
same letter in which Melville told Hawthorne he wrote only "botches" of books,
he lamented that he had to rush to finish *Moby-Dick* in the frenetic maze of New
York rather than the repose of his Pittsfield farm: "The calm, the coolness, the
silent grass-growing mood in which a man *ought* always to compose,—that, I fear,
can seldom be mine. Dollars damn me; and the malicious Devil is forever grin-
ning in upon me, with the door ajar."[24] The demands of the market and the ac-
count book, the forces which had driven *Mardi*'s Lombardo to fill "fifty folios" in
ten days, and that had driven Melville to write *Redburn* in less than ten weeks
and *White-Jacket* in just over six, denied Melville the savage artistry achieved by
"steady years of steady application."[25] Yet the level of artistry of which Melville
believed himself capable led him to recognize in the savage art of sailors the
makings of an epic creation, such that he himself might produce to rival Homer,
in the historical economy of savagery: "As with the Hawaiian savage, so with the
white sailor-savage. With the same marvellous patience, and with the same sin-
gle shark's tooth, of his one poor jack-knife, he will carve you a bit of bone sculp-
ture, not quite as workmanlike, but as close packed in its maziness of design, as
the Greek savage, Achilles' shield; and full of barbaric spirit and suggestiveness,
as the prints of that fine old Dutch savage, Albert Durer" (270). Melville's re-
peated experimentation with *ekphrasis* in *Moby-Dick* is both a rebellion from the
iconoclastic refinement of Milton and a challenge to the example of Homer—the
vital center of Melville's epic is in its visuality.

The problematic nature of this visuality emerges early in the book, when Ish-
mael encounters a picture in the Spouter-Inn that would undoubtedly illuminate
his thoughts, if he could only tell what it literally shows. In contrast to the signs
of "The Crossed Harpoons" and of the "tall straight jet of misty spray" (8, 10),
where interpretation could occur after relatively easy identification of the repre-
sented objects, the Spouter-Inn's painting is "thoroughly besmoked, and every
way defaced," and hung in "unequal cross-lights" (12). The ambiguity of the pic-
ture immediately foregrounds interpretation: "[I]t was only by diligent study and
a series of systematic visits to it, and careful inquiry of the neighbors, that you
could any way arrive at an understanding of its purpose" (12). The simple art of the
signpost, rather than finding its counterpart inside a cheap inn, gives way to the
sustained, repeated, and collective attention demanded of the most sophisticated
gallery paintings. Also unlike the emblems in the streets of New Bedford is the

attention to "purpose" that appears immediately in Ishmael's encounter with the painting, as he speculates that "at first you almost thought some ambitious young artist, in time of the New England hags, had endeavored to delineate chaos bewitched" (12). Yet as much as the painting frustrates interpretation, it provokes the hermeneutic act: "A boggy, soggy, squitchy picture truly, enough to drive a nervous man distracted. Yet was there a sort of indefinite, half-attained, unimaginable sublimity about it that fairly froze you to it, till you involuntarily took an oath with yourself to find out what that marvellous painting meant" (12–13). After speculating further on wild, cosmically allegorical readings such as "a blasted heath," the "combat of the four primal elements," and "Time," Ishmael identifies the key problem for interpretation: "[A]t last all these fancies yielded to that one portentous something in the picture's midst. *That* once found out, and all the rest were plain" (13). Here the *ekphrasis* takes on the symbolic importance traditionally associated with the form in epic poetry; the inscrutability that drives Ishmael to understand the painting enacts the reader's proper response to the book, which seems to hold a sublime mystery at its center, possibly "the great leviathan himself." Robert K. Wallace has rightly characterized this passage as "arguably the most significant of Ishmael's many attempts to 'paint the whale in words,'"[26] as it provides both a symbol for the overall narrative and a poetics with which to approach the book. Ultimately, Ishmael's interpretation can make no greater claim than "theory," and it is not his reading alone but that of several more experienced readers in composite that gives him his understanding: "[T]he artist's design seemed this: a final theory of my own, partly based upon the aggregated opinions of many aged persons with whom I conversed upon the subject" (13). The picture comes into focus just in time to collect all of Ishmael's previous guesses into one cataclysmic, highly figurative depiction of one of the most destructive moments possible in a whaleman's experience—storm, shipwreck, and whale attack simultaneously. Yet as much as Ishmael has read into the painting before deciphering it, he now leaves the description to stand on its own, without further indication of its symbolic importance or its prophetic relationship to the rest of the book. This further reading is left for *Moby-Dick*'s reader to perform.

By making his *ekphrasis* so performative, Melville introduces one of his major reinterpretations of Homer's poetics. As complex as the *ekphrasis* of Achilles's shield is,[27] Homer bases his description on a mimesis that is epistemologically untenable for Melville. No character reads the shield in the *Iliad*; only the narrator, in omniscient third person, describes the scenes as they unfold on Haephestus's workbench. The act of perception is rendered transparent as the pictures confront

the reader in narrative language. In *Moby-Dick*, however, the language of description and narration gives way to a narrating of the act of perception—an act that, as Melville demonstrates, rarely occurs spontaneously or instantly. Working from his engagements with Kant and Coleridge, Melville highlights the moment of perception as the center of the ekphrastic project, and thus whether or not a viewer "reads into" an object is no longer a neutral question, since even Ishmael's refusal to read into the Spouter-Inn picture once he has "seen" it emphasizes how much he actually does bring his own agenda to what he sees, as the blasted heath and the elements hover in the conceptual background.

Melville's *ekphrases* thus highlight a slippage between art and nature, between the world of human thought and physical reality. Ahab's monomaniacal drive toward solipsism is an extreme version of this slippage, representing as an epic hero both the reality of the interplay between world and mind and the dangers of exploiting that interplay through the will to dominance. The metaphysical violence of Ahab's gaze first shows itself in chapter 37, "Sunset," which immediately follows his declared vow to kill Moby Dick and which introduces a series of the most self-consciously theatrical chapters in the book. The entire chapter is a dramatic monologue by Ahab, with stage directions occasionally added to indicate his bodily movements. As he watches the ship's wake through the windows, the captain remarks, "I leave a white and turbid wake; pale waters, paler cheeks. The envious billows sidelong swell to whelm my track; let them; but first I pass" (167). Watching the ship's impact on the ocean and the ocean's natural reaction becomes a high drama in which ship and captain merge, even as the view from a cabin window morphs into the proscenium arch of a romantic dramatic poem. The next three sentences further transform the view from the window into the lyrical stasis of a landscape painting: "Yonder, by the ever-brimming goblet's rim, the warm waves blush like wine. The gold brow plumbs the blue. The diver sun—slow dived from noon,—goes down; my soul mounts up! she wearies with her endless hill" (167). Bryan Wolf has connected this passage with the erasure of nature in Bartleby's view out of his Wall Street office window; he argues that in both Ahab and corporate America "nature is not only converted into a painting and held in abeyance by a frame, it literally disappears." As the sun sets and Ahab's soul rises, the murder proposed in the captain's quarterdeck speech has already been perpetrated: "Nature died the moment it was framed. It was murdered by a sublime and monomaniacal imagination."[28]

Yet as Wolf points out, Ishmael himself is not immune from such imaginative tyranny over nature. Even as Ishmael describes the experience of direct visual

contact with the ocean from the panoptic masthead, in contrast to the framed window of Ahab's gaze, he does not notice so much the ocean (or the whales he is under orders to watch for) but what the ocean suggests to him about his own soul. He slips into a reverie he describes as pantheistic, in which the barriers between ocean, ship, and self dissolve—just as they do for Ahab as he watches the ship's wake two chapters later. And this reverie is not only detrimental to the economic task of the ship ("Whales are scarce as hen's teeth whenever thou art up there [in the masthead]") but also potentially deadly to the sensitive gazer: "But while this sleep, this dream is on ye, move your foot or hand an inch, slip your hold at all; and your identity comes back in horror. . . . And perhaps, at midday, in the fairest weather, with one half-throttled shriek you drop through that transparent air into the summer sea, no more to rise for ever. Heed it well, ye Pantheists!" (159). Ishmael's and Ahab's gazes derive at least in part from Emerson's transmutation of land into landscape at the beginning of *Nature*: "There is a property in the horizon which no man has but he whose eye can integrate all the parts, that is, the poet. This is the best part of these men's farms, yet to this their warranty-deeds give no title."[29] But in *Moby-Dick* to acquire a property in the landscape, as both Ishmael and Ahab do, is to risk losing one's soul. What Emerson proposes is the transformation of description into *ekphrasis* through subsuming nature into art, but the cosmic appetite for art that such a practice introduces—and one to which Ishmael is susceptible—threatens spiritual annihilation for the poet, as Ahab eventually realizes. Yet Ahab's mark remains on Ishmael, as Robillard has argued; when Ishmael first sees Ahab, his description of the captain becomes an ekphrastic rendering of a portrait rather than the account of a man. In order to see Ahab as heroic, Ishmael must see him through the predetermined categories of heroism in art, such as "Cellini's cast Perseus" (123).[30] To portray a "grand, ungodly, god-like man," Ishmael must think a little like him as well—and at his own peril.

The most complicated and extended *ekphrasis* in *Moby-Dick*, the nine readings of the eponymous coin in "The Doubloon," redramatizes the dangers of ekphrastic reading even as it reveals the necessity of *ekphrasis* for interpretation.[31] As each successive reader—Ahab, Starbuck, Stubb, Flask, the Manxman, Queequeg, Fedallah, and Pip—gives his own response to the images on the doubloon, that reading is at least doubly mediated. Each reader is witnessed by Stubb (and many are narrated by him rather than by Ishmael), and each speaks and acts against the backdrop of the seemingly neutral description that Ishmael gives of the coin before the interpretations begin:

On its [the coin's] round border it bore the letters, REPUBLICA DEL
ECUADOR: QUITO. So this bright coin came from a country planted in the
middle of the world, and beneath the great equator, and named after it; and it
had been cast midway up the Andes, in the unwaning clime that knows no au-
tumn. Zoned by those letters you saw the likeness of three Andes' summits; from
one a flame; a tower on another; on the third a crowing cock; while arching over
all was a segment of the partitioned zodiac, the signs all marked with their usual
cabalistics, and the keystone sun entering the equinoctial point at Libra. (431)

As with Ishmael's other *ekphrases*, this description is far from neutral. The inscrip-
tion on the border invites an emphasis on the equatorial origin, even the climate
and the topography that Ishmael associates with Ecuador. But the exact location
is pure speculation, as is the classification of the bird on one of the hills, because
official government records identify the bird as a condor; one of the strangest
aspects of the doubloon Ishmael describes is that the coin actually existed (fig.
18).[32] While Parker and Hayford used an image of the eight-escudo piece on the
cover of their anthology, Moby-Dick *as Doubloon*, no scholar has ever com-
mented on the significance of the coin's existence, much less how Melville knew
of it or what the coin's attributes might lend to an understanding of Ishmael's
description. Unlike the famous *ekphrases* of the epic tradition—Achilles's and Ae-
neas's shields, the temple of Juno in Virgil, the gates of Dis in Dante and of Jerusa-
lem in Tasso, the various arms of fictional warriors in Ariosto and Spenser—
Ahab's coin is not the product of the writer's imagination. "The Doubloon,"
while the most Homeric of the *ekphrases* in *Moby-Dick*, is a crucial point of de-
parture in the development of epic literature. The chapter, as a metonym for the
book as a whole, is the moment when the epic and the encyclopedic meet. The ency-
clopedic narrative that Mendelson has described and read back through the canon
as far as the *Divine Comedy* actually begins, with its emphasis on scientific knowl-
edge and corresponding empiricist epistemology, in *Moby-Dick*, and locating the
ekphrasis among the stuff of the living world so that the reading itself is the imagi-
nation's domain marks a gestalt shift in the use of *ekphrasis* in epic literature.

But how did Melville know of the coin? A common seaman would have had
little occasion to acquire a sixteen-dollar piece, as Ahab sets the value of the coin;
what we know of Melville's reading indicates that he had little specific interest in
numismatics, and prints of coins outside of books were extremely rare. Melville
may have found the coin either at a shop in New York or during visits with fellow

sailors. One other possibility is that Melville saw engravings of both sides of a very similar 4-escudo gold piece in Jacob Eckfeldt and William Du Bois's *A Manual of Gold and Silver Coins of All Nations* (1842); though some of the details would have been somewhat small for someone with Melville's chronic eye strain to see, there is enough visible to make the book a possible source for the doubloon.[33] In any case, the description of the coin is remarkably detailed, and remarkably like its original. However, there are important departures from the coin itself.

Besides the speculative work that Ishmael had to have done as noted above, three other aspects of the coin's face show further the narrator's slant in giving a supposedly objective reading of the image. First of all, the order of the hills is completely arbitrary; on the actual coin, the left-to-right order is tower-bird-flame, while Ishmael's order is flame-tower-bird, bringing the "crowing cock" in as the third in a curious echo of Christ's prophecy to Peter on the night of Judas Iscariot's betrayal: "Verily I say unto thee, That this night, before the cock crow, thou shalt deny me thrice."[34] Denial is a major theme in this chapter. Stubb refuses to see the truth in his reading but watches all the other readings (except Ishmael's); Starbuck abruptly stops his reading, "lest Truth shake me falsely" (432), lacking the resolve to recognize the ship's doom. Pip recognizes the danger, but his insanity precludes anyone taking him seriously. Ishmael's reordering of the hills signals the treachery involved in reading—and not reading—the doubloon. Another aspect of the coin, the chasm between the tower's hill and the bird's hill, does not appear in Ishmael's reading, but it does finally surface in Starbuck's noting of a "dark valley between [the] peaks" (432). Starbuck is a sensitive reader of the doubloon, perhaps an overly sensitive one, but Ishmael's omission in the "objective" reading creates the impression that Starbuck really is imagining things. The presence of the valley on the coin implicates Ishmael with Ahab in the silencing of Starbuck by making the first mate not the finder but the creator of a vital element in the picture.

The third aspect of the coin is that the condor (or crowing cock, as Ishmael has it) actually has a twin, which appears on top of the tower on one of the other hills; this second bird does not appear anywhere in "The Doubloon." The missing bird in Ishmael's account doubles a much more drastic omission, for as Pip states in his *ekphrasis*, "[W]hen aught's nailed to the mast, it's a sign that things grow desperate" (435). Garrison insightfully points out that the doubloon's being nailed to the mast establishes a crucial difference between the *ekphrases* in

Figure 18. Reverse of 1839 eight-escudo coin, Ecuador.
Accession no. 1960.6.43.
American Numismatic Society, New York.

the *Iliad* and those in *Moby-Dick*: while the shield of Achilles shows a symmetrical world (including war and peace, country and city, love and hate), the doubloon shows only one side, keeping the reverse face hidden, possibly forever. This difference symbolizes for Garrison the contrast between the finally balanced heroism of Achilles, who expresses pity and remorse at the end of the *Iliad*, and the monomaniacal heroism of Ahab, who sees no other side—or, if Ahab's mournful speech in "The Symphony" is a move toward balance, it is a move that Ahab retracts by the end of the chapter.[35] And what the other side of that balance would have been is crucial to understanding Ahab as Achilles-turned-Agamemnon. Since Melville knew the reverse of the doubloon so well, he most likely knew at least the high points of the much simpler obverse, particularly the bust portrait of the goddess Liberty and the inscription "El Poder en la Constitucion [The Power in the Constitution]" (fig. 19). The restraint of constitutional law, as Starbuck lamented earlier in the book, is two oceans and a continent away during the doubloon's reading, and Ahab's monomaniacal denial of both procedural

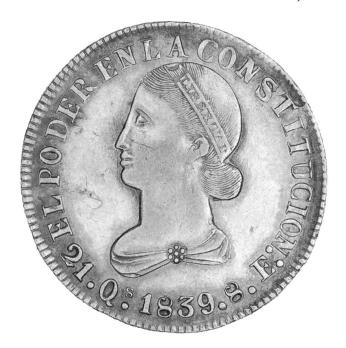

Figure 19. Obverse of 1839 eight-escudo coin, Ecuador.
Accession no. 1960.6.43.
American Numismatic Society, New York.

justice and liberty in favor of his own form of justice drives itself home in the act of the captain nailing the doubloon to the mast, hiding the reverse from view. Oddly, the power of the Constitution also surrounds the only explicitly female presence on the ship, one not detected before by Melville critics, and certainly not detected by the crew—the portrait of Liberty, rendered as an Ecuadorian *senora*, literalizes the female imagery in the book noted by critics from Joyce Sparer Adler to Juniper Ellis.[36] The Constitution's power, it seems, has a female cast that Ahab both shouts down in his Achilles-Agamemnon violence and perverts in his "queenly personality" in "The Candles" (507). Only by such a bizarre ontological elision of gender can Ahab maintain control of his ship, and he glares, shouts, or argues down every mention of contracts, rights, and justice by Starbuck, the constitutional conscience of the *Pequod*. When Ahab makes the doubloon a "Loose-Fish," and thus a piece of property alone, he obliterates part of the meaning of the object, and thus any *ekphrasis* will be a failed reading, an exercise in not-seeing.

And that is the joke of *ekphrasis* in *Moby-Dick*. As Bryan Wolf has argued about the genre in general, *ekphrasis* is in Ishmael's mighty book an act of not reading *at least* as much as it is an act of reading. Nowhere is this more obvious than in the case of Queequeg's tattoos, which Ishmael says were "the work of a departed prophet and seer," and that the designs contained "a complete theory of the heavens and the earth, and a mystical treatise on the art of attaining truth" (480). Yet no Rosetta stone is available; only the departed prophet knew what he had written, and his secret died with him, so that not even Queequeg could read his own body. Composed as an intelligible text, the tattoos have become unintelligible and thus can only exist now in the realm of *ekphrasis*—a text to be described aesthetically, not to be read articulately. In his characteristic manner, Ishmael suggests that this might have been the reason for Ahab's outburst one day while looking at Queequeg: "Oh, devilish tantalization of the gods!" (481). Queequeg's secret would die with him, as would the secret of the doubloon, and the meaning of the *Pequod* would be entrusted to one sole orphan, self-named Ishmael, who admits to have suffered abandonment on the sea similar to that which drove Pip to his insanity—tantalization of the gods, indeed.

Mechanizing Milton in *Battle-Pieces*

An investigation of *Battle-Pieces* and *Clarel* also can show us how Melville's thinking about and use of epic develops beyond *Moby-Dick* and later stories such as *The Encantadas*, which included several epigraphs from Spenser's *The Faerie Queene* and thematic material from Dante. Melville had a lifelong fascination with Spenser and Dante, as he did with Shakespeare and Milton, and these heroic presences in Melville's library remained central even as he expanded his reading into many poets of his century, including Matthew Arnold, both Brownings, Robert Southey, and Henry Kirke White, to mention a few of those more popular in their own century. As Hershel Parker has argued, Melville's career as a poet began in 1859–60 with the intention of becoming a major epic poet.[37] In an ongoing effort to improve his flagging health, Melville accompanied his brother Thomas on a voyage around Cape Horn, leaving the manuscript of his first volume of poems in the care of his other brother Allan and his editor Evert Duyckinck. The fledgling poet expected to arrive in San Francisco with his poems published and waiting for him in his mail, and in anticipation he had packed not

only several volumes of literary periodicals to read during the voyage but also a library of classic epic poetry, beginning with Chapman's Homer (and probably Pope's as well) and continuing to Virgil, Milton, Ariosto, Tasso, and Dante, plus additional titles. According to Parker, Melville's reading during his voyage was meant to launch him into the next stage of a poetic career, fashioned after Milton's, viewing the first volume as an apprenticeship on the way to the masterwork of the epic poem. If Melville could not write truth in a saleable genre such as fiction, he would retreat to the much less lucrative but more historically important genre of the epic. Such aspirations, however, were dashed when Melville found no package awaiting him in San Francisco, but instead a letter from his wife Lizzie informing him that Duyckinck could not secure a publisher. Dejected, Melville decided to return home rather than continue his voyage, and no other mention of the manuscript of his first poems has ever been found; the manuscript itself was probably destroyed.

Melville returned home from his disappointing voyage in late 1860, just as unrest surrounding the presidential election and the threat of secession was rising dangerously. Through the four years of the Civil War, Melville remained financially unstable, despite receiving an inheritance from his father-in-law Lemuel Shaw. Although he showed little interest in the war in its early years, sometime in 1863 he began writing poems about various events and reflections based on newspaper accounts, and in 1864 he and Allan visited their cousin Henry Gansevoort while the latter served at the front with the Union cavalry in Virginia. The visit gave Melville considerable material for description and reflection, and several poems in *Battle-Pieces*, including the longest poem in the book, "The Scout toward Aldie," are based on his time in camp and in the field. Melville rode with the dashing young colonel Charles Russell Lowell—the poet-professor James Russell Lowell's nephew—in a scouting party whose mission was to locate and capture John Singleton Mosby, a Confederate cavalry officer whose guerilla campaigns against Union forces required cavalry units such as Gansevoort's and Lowell's to remain stationed within sight of the newly completed dome of the United States Capitol in Washington.

Melville continued working on his Civil War lyrics into 1866 and published them as *Battle-Pieces and Aspects of the War* in that same year. The presence of prose in Melville's first volume of poetry is remarkably strong; besides the essay, a characteristically ambiguous prefatory note appears before the table of contents, and extensive notes in the back contextualized and identified events and artistic

choices, sometimes to the length of several paragraphs. If *Battle-Pieces* consti-
tuted Melville's declaration of his new choice of career, it also evidenced his con-
tinued understanding of the power and cultural importance of prose, both in his
own prose and in the poetry.

Despite the hyper-realism of the journalistic details and the narration of te-
legraphy, posting, and reading in poems such as "Donelson," Melville's goal in
Battle-Pieces was not merely to depict faithfully the reality of the war, but also to
make the war a reality by its incarnation into printed poetry. This approach, in-
formed by his reading of Wordsworth's "Supplementary Essay" to the preface of
Lyrical Ballads, arose from the belief that poetry should show not things as they
are but things as they are felt and perceived—human interaction with the world
around the self. Melville's approach ran the risk of alienating his audience by
creating too much distance between the clearly artificial poetry and the reader;
William Dean Howells criticized the poetry's vulnerability to that danger in his
review of the book, in which he described Melville's poetic consciousness as be-
ing filled with "tortured humanity shedding, not words and blood, but words
alone"[38]—an ironic criticism, or perhaps a displacement of guilt, since Howells
had spent the war years as a diplomat in Venice. The terrible sublimity of the war,
particularly for Northern noncombatants, often seemed so self-evident that the
poet's role in celebrating the war was to keep their poetry as transparent as pos-
sible, for the poetry was already in the events and actions themselves. In Septem-
ber 1864, Emerson wrote to Thomas Carlyle his impressions of the military sub-
lime of the Civil War: "I shall always respect War hereafter. The cost of life, the
dreary havoc of comfort & time are overpaid by the Vistas it opens of Eternal
Life, Eternal Law, reconstructing & uplifting Society,—breaks up the old hori-
zon, & we see through the rifts a wider. . . . Our Census of 1860, and the War, are
poems, which will, in the next age, inspire a genius like your own."[39] This aes-
thetic account of the sacrifice of the war seems shocking today, but his insistence
that the Civil War is itself a poem, along with the 1860 Census (the document or
the counting itself?), suggests that Emerson's earlier epic impulse was in 1864
searching for its object in the horror of the nation's crisis and the expanse of the
nation's accomplishments.

Emerson faced a problem in the Civil War similar to Whitman's problem of
the nation-as-poem: how can you represent something that seems already so
grandly to speak for itself? Melville's solution to this dilemma was to deny
Emerson's premise that the war itself was a poem; in the pages of *Battle-Pieces*,
Melville would literally reconstruct the Civil War, and with it the nation, as his

preface to the book suggests an analogy to the problem of federalism: "[The poems] were composed without reference to collective arrangement, but being brought together in review, naturally fall into the order assumed."[40] This claim for natural order, or else a happy accident of arrangement, takes a decidedly romantic turn in the rest of the preface, as Melville describes the poems as treating "a few themes" that "for any cause chanced to imprint themselves upon the mind," concluding with an almost ridiculously shopworn allusion to Coleridge's "Aeolian Harp": "Yielding instinctively, one after another, to feelings not inspired from any one source exclusively, and unmindful, without purposing to be, of consistency, I seem, in most of these verses, to have but placed a harp in a window, and noted the contrasted airs which wayward winds have played upon the strings" (3).

Yet even as Melville declares his allegiance to the British romantic poets, he also alerts the reader to an epic unity that stands behind, and thus haunts, the seeming lyric serendipity of the book. The "few themes," he says, have been taken from "the events and incidents of the conflict—making up a whole, in varied amplitude, corresponding with the geographical area covered by the war" (3), a totality defined by time, space, and action that, if not exactly Aristotelian, stands far from the extravagant formlessness of *Mardi*. Just before the preface, Melville's dedication is "TO THE MEMORY OF THE THREE HUNDRED THOUSAND" Union dead (2). If the *Iliad*'s true subject is not the Trojan War but the anger of Achilles, and that of *Paradise Lost* is not the expulsion from Eden but "man's first disobedience, and the fruit," the true subject of *Battle-Pieces* is not the war's fallen heroes, as Howells would have wished, but the act of memorializing those heroes as an aesthetic and social endeavor of epic proportions. *Battle-Pieces*, as a collection of lyric poems, is, like Lombardo's *Koztanza*, "all episode"; yet the collection is also a coherent book, Melville's "American *Iliad*," as Laurie Robertson-Lorant has dubbed it,[41] and thus the episodes orbit around a still small point— the hollow center of a nation's unfathomable loss. The mimicry of manuscript in the italics of "The Portent" also signals, consciously or not, Melville's departure from public letters; he would never purposely write a public work again in his lifetime. With the country's future hanging in the balance, and John Brown's body "*Hanging from the beam, / Slowly swaying (such the law)*" (5), Melville has just published his suicide note as a public author. Whether "*the law*" stands for the market or the merciless demands of artistic integrity (the two forces that Melville said made his books "botches"), it has hanged the poet—or the poet has hanged himself with it.

The need to escape the horror of the war resonates throughout *Battle-Pieces*. Two early poems, "Dupont's Round Fight" and "The Stone Fleet," suggest a retreat from engagement with history. Critics have often read "Dupont's Round Fight," a poem describing the formal beauty of the Union gunboats' elliptical formation in the Battle of Port Royal, as Melville's rejection of political prophecy for the detached pleasure of aesthetic appreciation. "The Stone Fleet" nostalgically mourns the end of the age of sailing and of whaling—a lengthy note to the poem includes the list of old whaling ships sunk by Union forces in an unsuccessful attempt to blockade the port of Charleston, South Carolina. This poem, subtitled "An Old Sailor's Lament," ventriloquizes a former whaleman bemoaning the futile fate of his former ship and its contemporaries. If "Dupont's Round Fight" celebrates human accomplishment (and several critics have questioned whether it actually does), "The Stone Fleet" shows the insignificance of human action, even as the ships themselves serve as permanent, stony memorials of the end of action.

Following the long poem of a land-and-sea siege are four more naval poems. The second poem, "In the Turret," continues the theme of mechanical warfare, with the suitably named "Worden" enjoying fame as the first sailor to man a turret in a battle. Describing the tomblike enclosure of the turret, the poet comments,

> Alcides, groping into haunted hell
> To bring forth King Admetus' bride,
> Braved naught more vaguely direful and untried. (39)

The allusion to Euripides's play *Alcestis* recalls a battle between Death and Hercules (son of Alcmene), the latter armed with a newly made weapon, an olive-wood club. The figured battle with death overwhelms the narration of the battle, and the glory of poetry resides in Worden's ability to "live, twice live in life and story" (40), so that the fact of whether he survived or not becomes irrelevant—although the *Monitor*, according to the poem's last lines, has certainly perished.[42] As an aspiring tragedian, or so it seems, the poet mock-heroically takes on Euripides himself in asking Worden,

> What poet shall uplift his charm,
> Bold Sailor, to your height of daring,
> And interblend therewith the calm,
> And build a goodly style upon your bearing. (39)

The irony of Worden's heroism is that he was unprecedentedly well protected, but that very lack of precedent left him uncertain as to whether the armor would

actually work—the heroism was mental more than physical, taking on unknown security rather than the known danger of the *Cumberland*, the doomed sailing ship celebrated in the poem preceding "In the Turret." Similarly, the poet's triumph is not so much in praising Worden as in seeking to outdo his own mental deed in constructing "a goodly style" never seen before. As many critics have noticed, Melville's style in *Battle-Pieces* is provocative, innovative, tense, but almost never "goodly." The supposed celebrations of the war's great deeds are becoming fainter and fainter echoes of history, as Howells had noted, and grow more self-reflexive with each poem.

A new level of reflexivity appears in the next piece, the first *ekphrasis* in the book: "The Temeraire." Inspired by Turner's iconic painting *The Fighting Temeraire*, the poem is "supposed to have been suggested to an Englishman of the old order by the fight of the Monitor and Merrimac" (41). As Hsuan Hsu has argued, the sense of *ekphrasis* as its etymology *ek-phrazein*, to "say away" or to "say outside," comes across powerfully in this poem; watching the war from an outsider's perspective, this Englishman from the age of sail observes the first battle between ironclad ships and moves from observation of history to perusal of art.[43] If Worden faced absorption into his ship, "sealed as in a diving bell" (39), one of the great ships-of-the-line from Trafalgar is now succumbing to, even merging with, an ignoble steamboat: "A pigmy steam-tug tows you [the ship], / Gigantic, to the shore" (42). The adjective "gigantic" can apply to either ship, and as Turner's picture suggests, size is rendered neutral by engineering.[44] Even as the *Temeraire* is described as a "Titan," the Englishman laments that its "bulwarks to the years must yield, / And heart-of-oak decay" (87). Size, grandeur, and strength almost become reasons for decay, such that even the central might of "heart-of-oak" comes apart in the end. This reflection is particularly ominous, as in the earlier poem "Lyon," the eponymous Union general's courage is described as "wizard-heart and heart-of-oak" (16). Even the courage of brave leaders cannot survive the relentless approach of the steam engine.

And approach the engine does in the next poem, "A Utilitarian View of the Monitor's Fight." After the near-blind view of the *Monitor* in "The Turret" and the willful blindness of "The Temeraire," this poem reduces the ship to evidence of a global theory: the modern world's drive for progress and utility has rendered war as commercial and mechanical as peacetime life. At the end of this chain of poems about not-seeing, Melville turns again to aesthetic theory. Many critics have pointed out that Melville's austere poetics receives its most direct expression in the opening lines of "A Utilitarian View":

Plain be the phrase, yet apt the verse,
More ponderous than nimble;
For since grimed War here laid aside
His Orient pomp, 'twould ill befit
 Overmuch to ply
The rhyme's barbaric cymbal. (44)

The allusion to Milton's prefatory comment on the blank verse of *Paradise Lost* is clear; however, the verse's ponderousness coupled with the denial of "pomp" serves also to reject Whitman's "barbaric yawp."[45] A measured dissonance traces its way between the smooth regularity of heroic couplets and the sprawling grandeur of the Whitmanian line. The burial of the story of "the Monitor's Fight" amid all this theorizing is one of the book's most extreme examples of what Helen Vendler identifies as Melville's greatest formal innovation. Melville starts lyric poems with philosophical reflection rather than building to it through description and emotion, a strategy that allows him to "fold the epic matter of history into lyric," maintaining a god's-eye view in the most personal and fragmentary of forms.[46]

Such casting of a cold eye on war allows Melville to leave traditional heroes aside for the "renegades and castaways" of the lower classes: war now "belongs— / Among the trades and artisans." However, this return of the "ruthless democracy" that Melville had claimed while writing *Moby-Dick* gives those artisans neither dignity nor agency. "[W]arriors / Are now but operatives," and epic finally deflates into unredeemed cliché: "Needless to dwell; the story's known" (44). The phrasing of this line suggests that more has been lost than the nostalgia of epic storytelling; since the story is "known," and thus bears no more repeating, not only is it not worth thinking about, but it is not even worth continuing life—"Needless to dwell." The question as to whether the country had ultimately survived the war, a question that recurs throughout the book and throughout the literature of the time, is rendered moot. As long as war can now be fought by "operatives," by "crank, / Pivot, and screw," whether the divinely directed soul of the nation still lives is irrelevant. The bitterly ironic tone of "A Utilitarian View" thus concludes this sequence in a jeremiad, prophesying that the nation's trust in technology, economics, progress, and the will to power has destroyed its promise more fundamentally than the violence of civil war.

In "The House-Top," one of the most anthologized of Melville's poems and, not incidentally, the only poem in *Battle-Pieces* written entirely in blank verse,

the idealistic narrator voices his shock as the relentless violence of labor riots in New York forces the redeployment of the victors of Gettysburg in order to put down the city's unrest. As the narrator watches from his roof,

> Wise Draco comes . . .
> In code corroborating Calvin's creed
> . . . and the Town, redeemed,
> Give thanks devout; nor, being thankful, heed
> The grimy slur on the Republic's faith implied,
> Which holds that Man is naturally good,
> And—more—is Nature's Roman, never to be scourged. (64)

The need for the army to restore order is bad enough, bearing witness to humanity's "total depravity," as American Calvinists had long put it, but the citizens' reaction belies the very foundation of democratic faith, that humans' ability to self-regulate waives the need for government intervention. Even further, such self-regulation actually forms the basis for a right against government intervention; as Union troops arrive in New York, Melville finds that even the creedal foundations of the nation cannot rest secure. "The House-Top" bears the same enigmatic date, "July, 1863," as the poem before it, "Gettysburg," for the two events are inextricably linked for Melville. After the battle's cacophony, an Arcadian hush descends over the battlefield-turned-cemetery at the end of "Gettysburg":

> Soldier and priest with hymn and prayer
> Have laid the stone, and every bone
> Shall rest in honor there. (63)

The riots in New York cannot leave even this distant field in peace, however, as the opening words of "The House-Top" attest: "No sleep." The glorious battle of what Daniel Aaron calls the "Federal Epic" of the war sinks into the restless ignominy of David staying home from the war to seduce Bathsheba.[47]

Yet Melville's bleak foray into pentameters in "The House-Top" would find a new use in his far bleaker poem, *Clarel*. Published in 1876, that poem represented the height of Melville's realized ambition as a poet, and its date thus serves as the end of this study's scope, because one of the few clear messages from the labyrinthine text of *Clarel*—nearly twice the length of *Paradise Lost*—is that epic, along with the world that it is used to represent, has changed.

Redeeming Pentameters in *Clarel*

Clarel was something of a family effort, requiring the assistance of Lizzie and several other female members of the family to copy and proofread, as well as a gift from Melville's Albany uncle Peter Gansevoort to finance the printing. And the metaphor of the pilgrimage that Melville made so central to his poem would emphasize not only the loneliness of the work but also the streams of tradition in which *Clarel* made its way.

The most extensive critical assessments have tended to interpret *Clarel* as a poem about comparative religion,[48] and indeed, questions of the truth of Christianity and its relation to the other faiths of the world drive much of the conversation and reflection in the poem. Yet the threads of those religions weave through the literary tapestry with which Melville constructed his poem. In the first section, "Jerusalem," two cantos amount to reflections on the disconnect, and possibly the reconnection, between the American tourists of Melville's generation in the Holy Land and the worlds of two epics far removed geographically, temporally, and materially: Tasso's *Jerusalem Delivered* was rapidly falling into obscurity by the publication of *Clarel*, and the *Ramayana* had only become available to English-speaking audiences in the thirty years prior.[49] Canto 4, "Of the Crusaders," follows Clarel's doubt-ridden visit to the Holy Sepulchre, where his questions as to the veracity of the Resurrection are deflected by musings on the return of "Godfrey and Baldwin," two of Tasso's main characters, to the area as ghosts. The canto, a brief thirty-three lines, opens with a series of questions concerning the character of those Crusaders: were they mere brigands, as Voltaire asserted, or were they on a mission of piety? The narrator, whose reflection the canto relates, has it both ways by remarking that "man is heir / To complex moods,"[50] and that service to God and searching for gain could be twin motives. The statement "man is heir" suggests also that this complexity is not merely a matter of psychology but one of history; if Tasso's knights could receive their mismatched intentions from earlier patrimonies, perhaps Clarel might find belief amidst his doubt. Indeed, embedded in the *Odyssey* narrative of the poem, in which the hero quests for the home of belief through a waste wilderness of commercialism and rationalism, is a spiritualized *Iliad* in which doubt and faith vie for the battleground of Clarel's mind—Jones Very's *Paradise Lost* even more abstracted. But the associations that resonate from this canto are at last thematized by the closing lines, a kind of manifesto for the poem as a whole:

But wherefore this? such theme why start?
Because if here in many a place
The rhyme—much like the knight indeed—
Abjure brave ornament, 'twill plead
Just reason, and appeal for grace. (17)

Just before these lines, the narrator had asserted that whatever the truth behind the Crusades, Godfrey and Tancred were about more important business in Palestine than tourists like Clarel, and this disparity between the power of old stories and the aridity of modern experience serves as a symbol for the poetics of *Clarel*: Melville's terse, jagged, often barely readable tetrameters are to deliver not beauty but earnest striving in which the reader must participate to continue. *Clarel* is, after all, both a poem *and* a pilgrimage.

Canto 32, "Of Rama," offers a meditation on the possibility of bridging the distance articulated in Canto 4. The dramatic appearance of Rolfe, a character generally associated with Melville's image of his younger, more confident self, leads the narrator to ask whether a human could actually parallel the life of Rama, the incarnate god who lived ignorant of his deity before fulfilling his true destiny. The question becomes a larger one of representation: "May life and fable so agree?" (104). Myth is another central theme of the poem, and this question raises the possibility that myths, so important both to the East and to the (earlier) West of Clarel's world, might be closer to real experience than rationalists like Vine would be willing to admit. At the heart of the question also lies a longing to find the person that can unlock, for himself and for others, the secret of human existence, such as Rama managed to do in eventually realizing his deity. The canto concludes with the tantalizing couplet, "Was ever earth-born wight like this? / Ay—in the verse, may be, he is" (105). Such a person might exist in real life, if real life is confined to the world of imaginative expression, and then only "may be," as possibility is the only realm in which such a being could survive.

The rich fantasy of a real-life Rama quickly withers into the journey into the wilderness of Part 2, and the promise of ecstatic revelation at the monastery of Mar Saba in Part 3 collapses into a collective reading of the monastery's palm tree reminiscent of the doubloon chapter in *Moby-Dick*; the bloody-minded Mortmain destroys himself by gazing on the divine, Vine and Rolfe face the consternation of the *Deus absconditus*, and Clarel watches all the while, hoping to find new faith through aesthetic experience. But the eroticism that Clarel hopes will lead

him to God collapses again at the end of the poem, as his return to Jerusalem and the discovery that his beloved, Ruth, has died during his sojourn abroad leave him more desolate than the dystopian Palestine that he has experienced ad nauseam.

And then a curious thing happens: the final canto of the poem, the "Epilogue," moves from an edgy tetrameter line to a flowing rhymed pentameter. The canto's thirty-four lines set themselves up roughly as two fifteen-line sonnets, each preceded by a couplet. The rhyme scheme refuses to settle at any point through the canto, even as the hope of salvation mocks the reader who has been led on an episodic trek into despair. Bryan C. Short has offered a reading of the change in meter as a dramatic convention in which the player announces what the story he has just seen really amounts to—or better yet, how to walk away from it.[51] The answer given to the canto's opening question, "If Luther's day expand to Darwin's year, / Shall that exclude the hope—foreclose the fear?" is simply that science cannot say whether humanity has any hope of finding God, and the only thing that will end humanity's quest is God's self-manifestation, leaving open the possibility that "Even death may prove unreal at the last, / And stoics be astounded into heaven" (498–99). After all, *Clarel* is ultimately a poem about death, and its monumental arc carries its reader on Odysseus's pilgrimage into the underworld and stops, as if the *Odyssey* went no further than the middle of Book XI, but *Clarel*'s narrator cannot help suspecting (or wishing) that the story, of its own organic accord, must somehow open up into something more glorious than the inglorious dead. Melville ends his epic with a bizarre sonnetesque volta, containing a quatrain between two couplets addressed not to the reader but to the main character:

> Then keep thy heart, though yet but ill-resigned—
> Clarel, thy heart, the issues there but mind;
> That like the crocus budding through the snow—
> That like a swimmer rising from the deep—
> That like a burning secret which doth go
> Even from the bosom that would hoard and keep;
> Emerge thou mayst from the last whelming sea,
> And prove that death but routs life into victory. (499)

The stirring rhetoric of these lines, driven by cadences resembling those of Longfellow in his apostrophe to the Union in "The Building of the Ship," also points back to the sonnets that Longfellow had composed to accompany his translation

of Dante's *Divine Comedy*. The will to believe, the juxtaposition of the sublime and the skeptical (the sonnet cycle ends, "And many are amazed and many doubt"),[52] rings throughout Longfellow's Dante and Melville's *Clarel*—the latter formed on Mathew Arnold's theory of translated poetics, according to one critic.[53] As in the epilogue to *Moby-Dick*, the hope of finding life in the midst of death leaves the reader off balance, just as the narrator finally knows himself to be; yet hope of finding that revelation in the afterlife of a character is at the end a continuing quest for the real-life Rama. Epic has become about searching the entire world—its creeds, its forms, its people, its literature—for the Word.

Melville never returned to such a hopeful note after *Clarel*. The man who had begun his forays into the epic tradition with the panache of the Carlylean prophet, continuing with the "savagery" of Homer and the private ambition of Milton, self-identified at last with one of his youth's favorite poets, Luis de Camões, or Camoens, as Melville wrote the name. In an unpublished poem, titled "Camoens," Melville presents a diptych marked "(BEFORE)" and "(AFTER)/camoens in the hospital." The first part, reflecting on the unquenchable drive of epic ambition, depicts the poet, like the Melville of *Moby-Dick*, destroying himself for the sake of his art:

> And ever must I fan this fire?
> Thus ever in flame on flame aspire?
> Ever restless, restless, craving rest—
> The Imperfect toward Perfection pressed!
> Yea for the God demands thy best.[54]

The unnamed God that "demands" the ultimate in artistic production, "the height of epic song" (296), gives no reason for the demand and ultimately abandons the poet in the second half of the diptych to the "wile and guile ill understood," practiced on the innocent poet by hypocrites who,

> fair in face,
> Still keep their strength in prudent place,
> And claim they worthier run life's race,
> Serving high God with useful good. (297)

The epic that inspired a career has sunk below the surface of a society driven by false piety and a worship of "useful good," which literature was increasingly divorced from in the late nineteenth century. Melville no doubt saw his own

career in such a light, but his epics would, like Camoens's, resurface after his death. Epic seemed to have descended to what Ralph Ellison in *Invisible Man* would call "the lower frequencies," but, as my epilogue will argue, that is precisely where the greatest diffusion is possible. Epic had not disappeared from American culture; it had simply been absorbed to the point of invisibility.

Invisible Epic

Epic did not end with Melville's *Clarel* in the United States, but it changed quickly and drastically.[1] As epic merged more completely with what Edward Mendelson calls "encyclopedic narrative," the representation of an entire cultural moment through the lens of science, writers who engaged epic were faced with the choice of becoming more staunchly "literary," reaching back to a heritage of earlier authors to substantiate their work, or of engaging a wider public through exploiting the rising popular interest in technology, new media, and the complex social patterns of an urbanizing nation. The visuality that had been so crucial to the prospects of early American epics evolved through epic painting into increasingly visual (instead of, or as well as, linguistic) manifestations of epic storytelling through the panorama, the cyclorama, big-budget Broadway productions, and eventually film. The revolutionarily wide interpretations of epic in the generation of Emerson and Longfellow had opened the possibility that epic might not be only a matter of literature after all—epic belonged, at least potentially, to virtually all forms of cultural expression, as Ernest Bloch's symphonic piece *America: An Epic Rhapsody* (1928) would suggest. To get a sense of when this change

happened and what that change actually amounted to, let us return briefly to Melville and the early posthumous reception of *Moby-Dick* as a case in point.

The Melville Revival as Antinarrative Turn

Melville's experiments with epic went largely unrecognized, or at least unremarked on, for most of his life. A few contemporary reviews of *Moby-Dick* did identify Melville's authorial ambitions, but either in the half-mocking of George Ripley's scare quotes ("The present volume is a 'Whaliad,' or the Epic of that veritable old leviathan") or with William A. Butler's approximation of Ishmael's casting about for adequate terms to describe his observations: "[W]e do not know how we can better express our conception of his general drift and style in the work under consideration than by entitling it a prose Epic on Whaling."[2] After Melville's death, however, critical declarations of *Moby-Dick*'s epic status proliferated on both sides of the Atlantic. An anonymous reviewer in the New York *Critic* in 1893 rhapsodized on the book's "witching power" and what it meant for its subject: "The undreamt poesy lying in the lives of Nantucket whalers in the fifties has for once received epical treatment, and the result is a marvellous Odyssey of adventure." J. St. Leo Strachey echoed Butler in the London *Spectator* in calling *Moby-Dick* an "epic of whaling," while Canadian critic Archibald Mac-Mechan shrewdly described the book's blended genres in 1899: "This book is at once the epic and the encyclopaedia of whaling."[3] These reviews as a group showed the slippage of the word "epic" as it moved from a mock meaning to a mere element within a mixture of forms—but the nascent Melville Revival would show that the word could be taken to even greater lengths. In the pages of the 17 November 1900 issue of the London magazine *Literature*, an anonymous reviewer critiqued the choices made in Sampson Low's *Famous Novels of the Sea* series, first by attacking the literary merits of William Clark Russell and James Fenimore Cooper and then by elevating one choice to its own shelf: "But of all these six books the one, the only one, which is supremely great and undoubtedly a work of genius is Herman Melville's 'Moby Dick.' And it just as surely has no claim to be in the collection at all. It is not a novel. It is hardly a story. It is an epic, and a most astounding epic too. The human hero is nothing to the great white whale which dominates the intense and imaginative narrative. . . . And the book is an encyclopaedia."[4] Epic without story? The evolution of the term had at this point opened the semantics of epic to an almost limitless extent, and critics commenting on epic's fate in the twentieth century waver between denying the epic

label altogether, as with Mendelson's theory of encyclopedic narrative, and sug-
gesting that the word has become meaningless. Yet McWilliams also comments
on the sense in which the modernist masterworks of Pound, Williams, and Crane
work as epics: "Not only are they an outgrowth of the epic as Wordsworth and
Whitman had redefined it; they often create in us the awe, literary as well as the-
matic, associated with the genre."[5] The "astounding epic" that the *Literature* critic
saw in *Moby-Dick* indicates how epic had changed to accommodate the *Cantos*,
Paterson, and *The Bridge*: the word had changed from having a primarily literary
valence to having a primarily aesthetic one. A new psychological category in the
experience of art was emerging in the late nineteenth century, a kind of extended
or narrativized sublime, that would render epic both invisible and hegemonic in
the reception and consumption of artistic work in the twentieth century.

The growth of epic as an aesthetic concept had in fact been occurring for over
a century, dating back to art theorists such as Jonathan Richardson and Joshua
Reynolds, who compared history painting and the Grand Manner to epic poetry.
Benjamin West's concept of "epic painting" as the telescoping of several narra-
tives into a single canvas opened up the possibilities of the tightly structured
genre of the history painting. By the height of Melville's career in the 1850s, the
moving panorama allowed viewers to experience their own odyssey without the
fatigue of travel, and the cyclorama provided a virtual reality experience in
which the viewer had no direct connection with the outside world: the special
exhibit halls built to display cycloramas (the word originally applied to the build-
ings, not the canvases) were circular, admitting outside light for viewing the can-
vas through skylights invisible to the viewers in the center of the building. Epic
in the visual realm could effectively remove viewing subjects from material real-
ity through the illusion of perfect mimesis on a colossal scale.

The technology required to provide such visual marvels as the moving pan-
orama and the cyclorama should prompt a comment at this point on the role of
technology in American culture following the Civil War. As Joel Dinerstein has
recently argued, not only is the idea of technology itself "a *white mythology*," but
the very cultural practices by which technology is employed in modern America
link technology and whiteness into a future-oriented narrative designed to forget
the multiracial present—or worse, the racist past.[6] The tendency of aesthetic epic
to draw attention to the technology that created it, particularly in film, made the
wonder of the experience the real story, such that the lack of context for the story,
such as the disappearance of the Civil War from *Gone with the Wind*, was not
only excusable but almost expected. As I will show later in my discussion of John

Huston's adaptation of *The Red Badge of Courage*, the story behind the film, not behind the story it portrayed, often became the most important context for the audience's reception. The encyclopedic narrative tradition articulated by Mendelson might be said to do similar work for literary epic in the twentieth century, as the research required for a book such as *Gravity's Rainbow* became a key expression of the author's ambition to meet the challenge of earlier epic writers, as well as an important element of the audience's reception of such a text.

Following the Civil War, two publishing phenomena placed literary and visual epic side by side in the national consciousness through appeals to encyclopedic completeness. The first, a series of translations of European masterworks, began appearing from Fields and Co. in 1867, with Longfellow's translation of Dante's *Divine Comedy*; translations of Homer (by Bryant), Goethe (by Bayard Taylor), and Virgil (by C. P. Cranch) followed, the last seeing print in 1874. While Boston's elite literary publishing house sought to reestablish American ties to the Western canon, the Appleton brothers of New York produced a project, first through the *Appleton Journal* and later through a subscription book in parts, that would draw on European ideals of the picturesque to celebrate the territory and the accomplishments of the once again United States.[7] *Picturesque America* eventually filled two heavy volumes with over nine hundred illustrations, both woodcuts and fine steel engravings, displaying the wonders of American scenery both natural and urban. William Cullen Bryant, as the ostensible editor of the collection, lent prestige to the project; one of the most respected poets of his day, his translations of Homer came out in the Fields series in 1871–72, just before the publication of the first half of *Picturesque America* in 1872. In his preface to the collection, Bryant emphasized the variety of the American landscape and the opportunity for American artists to explore and "conquer" the many views still unknown to the majority of Americans.

The book amounted to a guide for tourists of the picturesque, a more leisurely, contemplative type of tourist compared with those of the rising middle class that had little time to devote to sitting for hours staring at a single vista. While focusing on this more privileged form of tourism, the book emphasized the tourism industry's greatest ally following the Civil War: the railroad. Descriptions of Northern California included plans for a railroad linking the Sacramento and Columbia rivers; the cross-country rail trip was hailed as the ideal approach to Yosemite, a site still inaccessible by train; and the skyline of Washington, D.C., was framed by the view from rail cars arriving from Baltimore. The assumed audience is from the Northeast, where the New York–based Appletons tended to

focus their marketing, but the nationalism of the work is unmistakable. The collection ends with Washington, D.C., remarking on the "liberal expenditures" and "newly born pride in the government" that had only recently made Washington a prestigious and picturesque city. After touring the great public buildings between the White House and the Capitol, the text concludes with a journey south of the city down the Potomac to Mount Vernon and the series of forts "familiar to the history of the war of rebellion."[8] The closing sentence emphasizes the "Southern clime" that Washington inhabits, revealing both the scars of the war and the insistence that had appeared throughout the text that the nation had embraced each of its regions—the capital can even be Southern. Virtually all of the images, whether of cities or of remote locations, include humans, a convention of picturesque art designed to give variety to the composition, but also emphasizing alongside the text the work that the human presence infuses into the territory: America is great because Americans live in it, view it, and improve it.

Picturesque America is a remarkable Reconstruction text in that it dramatizes Reconstruction as an imaginative and aesthetic undertaking more than a physical and economic one. The *Iliad* that the Civil War represented for Emerson became in *Picturesque America* an episode in a larger *Aeneid* of national progress. However, the spectacle and the scars of the war could not be put away easily. One of the most popular of the circular panoramas, or cycloramas, of the postwar period was French-born Paul Philippoteaux's *The Battle of Gettysburg*, which depicted Pickett's Charge in a 360-degree round. Displayed in Boston starting in 1883 and toured around major eastern US cities for years following, *Gettysburg* brought to mass audiences the wonder and the carnage of the war.[9] One of the most profound meditations on the spectacle of the war also appeared from the Appletons' presses ten years after the cyclorama's heyday: Stephen Crane's *The Red Badge of Courage.*

All Episode (Again), from Crane to Huston

Immediately recognized on its publication in 1895 as a formal and mythic tour de force, Crane's brief novel would help make up the core of the American novel tradition described by myth-and-symbol critics such as Richard Chase and Leslie Fiedler. Yet Crane's attraction-repulsion attitude toward the grand story of the war manifests itself in the book's subtitle: "An Episode of the Civil War." By calling his work an "episode," Crane highlights both the miniature and the fragment in his work by invoking a popular late nineteenth-century periodical genre, the

fictional episode, a genre marked by its small scale and its ephemeral existence as text. And this generic marker has great implications for reading *Red Badge*'s engagement with the epic tradition: while Homer's *Iliad* might itself be regarded as an episode, as it narrates only a brief slice of the Trojan War's chronology, Aristotle's principles of epic unity emphasized the completeness of epic works. Hector visiting Andromache is an episode because it draws the reader away from the main action; the *Iliad* is not an episode in this sense, because it draws the reader's attention to a central moment in a larger narrative. *Red Badge*'s subtitle suggests two competing conclusions: either this new sort of war story is not an epic but fundamentally a fragment of one, or this sort of story is in fact representative of the epic tradition and thus we must reconsider that tradition as a series of episodes, digressions—that, like Babbalanja's "Koztanza" in *Mardi*, it is "all episode."

Crane's *Red Badge* is certainly all episode, for despite its remarkable narrative economy, the entire story revolves around not so much the actions as the thoughts of Private Henry Fleming of the New York 304th Infantry. One way of understanding the novel is a meditation on mood, as versions of the Homeric *menos* (battle-rage), sympathy, and hate interact with the stress and trauma of modern warfare; in other words, while the text's marking as "episode" tracks with Susan Stewart's notion of the miniature as a metaphor for interiority, the battle in *Red Badge* is not between blues and grays at Chancellorsville but between the tiny interiority of Fleming and the gigantic monstrosity, the appalling extravagance of the modern war machine, where cannons become dragons and smoke-shrouded troops become ghouls.[10] This is *Paradise Lost*'s conflict pushed to its most extreme. Jones Very had argued that Adam was the battleground, not the hero, of Milton's poem, but in Crane the hero and the battleground collapse into the same character, even after the battle is over.

The aftermath reflections at the end of *Red Badge* have sparked perennial controversy among critics; the strangely optimistic resolution to Henry Fleming's traumatic experience does not seem to fit the psychological realism that Crane so famously sustains throughout his narrative, and the ideology at the end seems eerily similar to that which Fleming expounds at the start of the story. I quote from the last page at length in order to situate Fleming's thoughts in the final narrative frame:

> So it came to pass that as he trudged from the place of blood and wrath his soul changed. He came from hot plowshares to prospects of clover tranquility, and it was as if hot plowshares were not. Scars faded like flowers.

It rained. The procession of weary soldiers became a bedraggled train, de-spondent and muttering, marching with churning effort in a trough of liquid brown mud under a low, wretched sky. Yet the youth smiled, for he saw that the world was a world for him, though many discovered it to be made of oaths and walking sticks. He had rid himself of the red sickness of battle. The sultry nightmare was in the past. He had been an animal blistered and sweating in the heat and pain of war. He turned now with a lover's thirst to images of tran-quil skies, fresh meadows, cool brooks—an existence of soft and eternal peace.

Over the river a golden ray of sun came through the hosts of leaden rain clouds. (98)

The central question that has troubled critics in this passage is whether Crane is being ironic. As previous discussions in this study have shown, the dichotomy between sincerity (epic) and irony (mock-epic) had broken down decades before Crane's career, as in *Walden*'s "battle of the ants" episode and Melville's use of heroism and satire in *Moby-Dick*. The biblical opening of the passage quoted above ("So it came to pass") connects with the moralistic, summational tendency of modern epic while signaling the transient nature of this type of narration—the Youth's resolution comes to pass, not to stay. In the Heraklitean universe of *Red Badge*, where no one can cross the same Rappahannock twice, that Fleming can return to his earlier idealism means not that he has learned nothing, but that he has learned too much. The Civil War marked the beginning of American medical research into the impact of battle on soldiers; "soldier's heart" was just one name for a variety of conditions that would later be labeled "battle fatigue," "shell shock," and "post-traumatic stress disorder." Another common diagnosis for Civil War veterans was a condition known as "nostalgia," the acute longing for familiar surroundings that did not carry a sentimental connotation until the early twentieth century.[11] The image of the smiling Fleming in the midst of a grum-bling, miserable regiment as the landscape dissolves back into the fluid oblivion that opened the novel is not so much an image of unearned optimism as it is a symptom of nostalgia, a first step toward the madness exhibited by the wounded man who sings an improvised nursery rhyme, "Sing a song 'a vic'try, / A pocketful 'a bullets" (38), as an attempt to fuse together the coherence of his early memories with the traumatic disruption of his recent experience. The "prospects of clover tranquility" that make "scars fade like flowers" do not actually make the scars disappear—those prospects merely screen the scars from Fleming's consciousness. Those prospects, which inspire "a lover's thirst," reenact the vision of futurity

that dominates so many of the post–American Revolution epics, most of all Dwight's *Conquest* and Snowden's *Columbiad*, two texts haunted by violence between neighbors and the terrible loss of family to the national cause. *Red Badge* is completely devoid of cause; at no point does either narrator or character reflect on the reasons for the war, the context that surrounds the violence. All that remains is the trauma of loss, and the prospect that from the nation's beginnings had been grafted into the epic has been exposed for what it undoubtedly is by the end of the Civil War: a coping mechanism. The language of the American prospect-epic finally overrides the alternative (naturalistic, impressionistic, photographic) ways in which Fleming tries to understand his experience in *Red Badge*, but only as a way of compensating for the loss of the self. Connecting his thoughts to the imagined community of the prospect-viewing nation is Henry's one means of continuing, but he no longer connects either with his own memory or with his comrades' experience. Epic has won narrative primacy at the end, and it is dragging Henry Fleming Hector-style in its wake, almost as if the turn into an epic prospect mode was an inevitable outcome of the story.

The problem of epic's inexorable presence in war stories haunted Crane's *Red Badge*, but even more so John Huston's 1951 film adaptation of the book. Coming off a wave of successes both as a war documentary director for the Army Signal Corps and as a Western film director for Hollywood, Huston proposed to MGM an adaptation of *Red Badge* in the midst of the Korean War and the Red Scare— the difficult politics of the story, which Huston's original screenplay preserved, split the studio, ultimately leading to the forced retirement of Louis B. Mayer, the film's most vocal opponent.[12] Huston planned his film as both a meditation on the nation's attitude toward war and a departure from the larger-than-life epideictic formulas of the Hollywood epic, especially the myriad World War II films that had appeared in the years since Pearl Harbor. Rejecting the star system that had driven MGM's production philosophy for twenty years, Huston cast the new actor Audie Murphy, the boy-faced son of a Texas sharecropper who had played roles such as Billy the Kid and Jesse James on film, but who was nationally famous as the most decorated Army soldier in World War II. The role of Wilson, or the Loud Soldier, went to Bill Mauldin, who had never acted before but had also gained fame as one of the lead cartoonists for *Stars and Stripes* during the late war. Huston's further directing choices were also unconventional; he shot the film in black and white in order to evoke Matthew Brady's photography, and the original cut of the film opened with an unidentified sentry (Murphy) having a moonlit conversation across a river with an unseen enemy picket. After Huston left for

Africa to begin production on *The African Queen*, Dore Schary, the producer who had originally fought for *Red Badge*'s life, radically overhauled Huston's first cut in an effort to make the film more marketable.

Most drastic among Schary's alterations was editing out half of the footage in Huston's version of the film, about an hour's worth of material, in effect reminiaturizing *Red Badge* to the point where it hardly worked as a feature film: the final running time was sixty-nine minutes. The night sentry scene moved to the night before the battle, when Murphy's character could be readily identified and contextualized, and the new opening for the film involved a voice-over and a book whose pages showed both the credits and a portrait of Stephen Crane. The voice in fact conflated the book and the film to such an extent that the very writing of the book by "a boy of twenty-two . . . made [Crane] a man," in a process seemingly identical to the process by which Fleming became not just a man but an everyman, one whose story merely echoes those of "many frightened boys who went into a great Civil War and came out as a nation of united, strong, and free men," a claim underscored by the brass arrangement of "The Battle Hymn of the Republic" and the close-up shots of soldiers' faces accompanying the narration. Various bits of narration, added by Schary to make the narrative easier to follow, are explained at the end of the prologue as being "quotes from the text itself."[13] Schary's original hope had been that a film based on Crane's novel, already a canonical favorite of the academy, would be a prestige piece for the studio, and the voice-over's main purpose seems to be building and pointing to the canonicity of the book in order to lend the film as much cultural capital as possible—with perhaps a bit of Lincolnian glory mixed into a depiction of a "great Civil War."

Much of what Schary cut from Huston's version dealt, predictably, with the dark side of war. Several minutes of close-ups showing Murphy's frightened face, for instance, were cut, as Schary believed that audiences would reject seeing a decorated war hero playing a frightened boy. Portraying Murphy as a virile warrior was, as Huston intended, next to impossible, however; lacking the towering presence of the John Wayne of *The Sands of Iwo Jima* (1949) or *Fort Apache* (1948), Murphy comes across as an unlikely hero—somewhat like Fleming, but nothing like what MGM hoped to sell to the American public. The bitter final speech and death of the Tattered Soldier, which had shocked preview audiences, also disappeared from the final version. One sequence that does remain, however, introduces a moment of strident mock-epic into a film whose producers desperately tried to render an epic: the train of wounded, in which a nostalgic soldier sings a manic rendition of "John Brown's Body" in place of "Sing a song 'a vic'try." The

orchestral score was not in Huston's version of the film, and its heavy reliance on "Battle Hymn" as a motif places the soundtrack under the ominous shadow of a mad soldier screaming, "John Brown's body lies a-molderin' in the grave."

The most climactic use of the "Battle Hymn" motif appears at the end of the final charge, when Fleming's regiment overruns a Confederate unit and captures their battle flag. The flag in the book is a prize ferociously sought by Fleming and Wilson, who race for it, but in the film the soaring brass grinds to a halt as Fleming wistfully, even sadly walks alongside the Confederate color-bearer in his tortured last steps. While the Union flag that Fleming now carries had to be pried earlier from the dead color-bearer's hands, in this case the youth gently takes the flag just as his enemy dies, as if receiving a passed baton. In perhaps the strangest moment in the film, Fleming holds the Confederate flag sideways, so that its shadow provides shelter to its dead former bearer as the cloth fills with the breeze. Wilson, who seized the flag in the book, gently takes the flag from Fleming and furls it slowly as the orchestra strings play "Taps." As the two flagpoles—the upright Union and the horizontal Confederate—intersect each other, they form a cross on the field to Murphy's right, in a scene that finally unites North and South through the cost of death. The scene might be interpreted as a filmic version of Lincoln's Gettysburg and Second Inaugural Addresses, but Huston's interest in the psychology of war continues in the next scene to show that North and South have not yet united. A series of shots depicts Confederate prisoners seated on the ground, surrounded by calm, concerned Union soldiers. Immediately after this sequence, we see Fleming and Wilson also sitting on the ground, surrounded by a ring of their comrades, one of whom relates what he heard the colonel saying about the two young heroes. Though triumphant in his leadership during the charge, Fleming has become so detached from his regiment that he occupies space reserved for outsiders, and he shows that he is not a prisoner only by getting up and walking out of the ring without a word. After confessing his desertion to Wilson, he learns that many of his fellow soldiers behaved in the same way, and he finds redemption as the final narration reads from the conclusion of the novel. Epic takes over Huston's film as the organizing principle, against the director's wishes; the Hollywood epic was in fact on the way to gaining primacy over the documentary as newsreels disappeared from American film-watching experience over the next decade. Huston's *Red Badge* has long been famous for what it could have been, but of particular interest to this study is what it is: standing in the middle ground between wartime documentary and large-scale epic, mimicking Matthew Brady's photography while invoking the primacy of the

book over the picture, *Red Badge* is a prime example of the permeability between high art and popular entertainment. Yet the story of *Red Badge*, both as literature and as film, represents only one major strain in the new directions epic took in the post-Reconstruction United States, the prevalence of the fragment or episode. The next section explores an opposing but related strand, that of the populist work that prepared the aesthetics of epic for mass consumption.

Ben-Hur and Beyond: The Epic and Postmodern Populism

By the time Crane's *Red Badge* appeared, another work of historical fiction had already reconceptualized the popular possibilities of epic in a very different vein. When Lew Wallace published *Ben-Hur: A Tale of the Christ* in 1880, he had lived through the horrors that Crane would later describe, having served as a Union officer at such gruesome engagements as Fort Donelson and Shiloh. Through painstaking yet highly romanticized researches, Wallace composed *Ben-Hur* with an immense historical and geographical backdrop, synthesizing the epic of the Roman *imperium* with the biblical epic of the Messiah. Wallace casts the Christ story as a world event; the opening chapter of *Ben-Hur*, "The Desert," cinematically pans from an immense mountain on the edge of the ancient territory of Ammon to the journey of the three wise men, first from their respective countries to a desert rendezvous, and then to the manger at Bethlehem. Using the character of Judah Ben-Hur as the lens for these near-global events, Wallace works firmly within the tradition of the historical novel, but the spectacle of encyclopedic detail often threatens to overwhelm *Ben-Hur*'s moralistic focus. The message of the work—Wallace had initially undertaken the project in answer to an acquaintance's expressed doubts regarding Christ's divinity—disappeared into its medium, as copies sold by the hundreds of thousands and the New York firm Klaw and Erlanger spent nearly as many dollars backing a Broadway adaptation, complete with an on-stage chariot race with actual horses. *Ben-Hur* became an industry unto itself, so much so that when the Kelem Company produced a thirteen-minute film adaptation of the novel, Wallace's heirs and Klaw and Erlanger successfully sued for damages in a case that went all the way to the United States Supreme Court and established the precedent that guaranteed authors film adaptation rights to their works.

What seemed to set *Ben-Hur* apart was not so much its story as its scale; the encyclopedic research that stood behind the highly descriptive writing attracted readers familiar enough with Roman history and the Bible to appreciate the

story, but whose entertainment dollars went increasingly toward panoramas, cycloramas, and other large-scale visual media. And scale was a major element of both the production values and the marketing for MGM's two film versions of *Ben-Hur*, Fred Niblo's 1925 silent version and William Wyler's 1959 widescreen adaptation—the latter a cinematic myth unto itself. The combination of over-whelming materiality, as in the 1925 picture's touted "Cast of 125,000!" and the association of that materiality with a spiritualized backstory made *Ben-Hur* even more an epic on screen than on the page, just as epic became more and more aestheticized—and more material—during the rise of film. By the zenith of the Hollywood historical epic in the late 1950s, extending a sense of wonder across an expansive narrative had become the primary defining characteristic of "epic." While *The Red Badge of Courage* served to miniaturize that wonder into extreme interiority, the phenomenon of *Ben-Hur* helped to diffuse epic into a site for ex-treme projection into the world, overwhelming the individual out of self-awareness as the multisensory power of the film carried its audience along. The latter is ex-emplified today through the seemingly endless spatial and temporal sweep of *Gettysburg,* or of the *Lord of the Rings* trilogy, a project often compared to Wag-ner's *Ring of the Nibelungs* and assailed by critics not least for its violation of Al-fred Hitchcock's maxim that length of a film should be limited by the endurance of the human bladder. Film epics, by pushing such biological limits as Hitchcock wryly cited, have ironically come closer to the experience of reading an epic, an experience not usually confinable to a single sitting or recitation. Contrary to critical consensus, epic has not died; it has diffused so far and so successfully that it is no longer visible as a purely literary concept. And as this study has shown, it has hardly been purely literary at any point in its American history.

Ralph Ellison's Other Ancestor

Yet the literary remained important in the development of epic through this period, and perhaps the most successful integration of epic techniques into an American novel in the twentieth century is Ralph Ellison's *Invisible Man.* Pub-lished in 1952 (between the release of Huston's *Red Badge* and Wyler's *Ben-Hur*), *Invisible Man* has long stood in the uneasy critical territory between white mod-ernist aesthetics and African-American vernacular, and the tense racial politics of the 1940s and 1950s have continued to play themselves out in assessments by critics as diverse as Kenneth Burke, Houston Baker, Alan Nadel, and Arnold Rampersad.[14] And as Ellison himself argues in his essay "The Shadow and the

Act," those politics are themselves the result of the unresolved trauma of the Reconstruction that played itself out most explicitly in American film culture. However, though an accomplished cultural critic, Ellison strongly self-identified as a novelist, and in that context he continually engaged, both in *Invisible Man* and in his later essays, with those he called his "ancestors."[15] The list of those ancestors echoes the canon of novelists of Chase and Fiedler, along with several transatlantic names: Melville, Twain, Crane, Hemingway, Faulkner, Joyce, Eliot, Malraux, and Dostoevsky are among the most cited names both by Ellison and by his critics, but as I have shown in my study of Melville, an older, more complex web of intertexts lies behind Ellison's ancestors. The genealogy of *Invisible Man* traces all the way back to Homer, and critics, though aware of the many references to Homer that appear in Ellison's novel, have made little of Greek epic's presence in a modern African American work of prose fiction. While Keith Cartwright has pointed out that many of the motifs in *Invisible Man* are traceable, through the Creole culture that shaped the Oklahoma of Ellison's youth, to the Islam-inflected Sunjata epic tradition of Senegal and its environs,[16] I focus here on Homer to show how Ellison creatively addresses the problem of inheriting a literary tradition tainted with moral stains that troubled American writers as early as Joel Barlow.

The novel's opening statement, "I am an invisible man," resonates with Odysseus's self-identification as "Nobody" in his encounter with the Cyclops Polyphemus, yet this refusal to share one's name—a refusal that leads Cartwright to declare that Ellison's work "is no epic"[17]—is also a refusal of genre and technology. In explaining his invisibility, the invisible man says that he is "not a spook like those who haunted Edgar Allan Poe," or "one of your Hollywood-movie ectoplasms."[18] The double entendre of Poe's "spook," both the ghost in the story and the Southern slave culture outside, rejects the Gothic with its pathologization of the racial Other, but the other alternative, an "ectoplasm," is an odd one. The word "ectoplasm" refers more to the special effects used to make ghosts glow on film rather than the ghosts thus depicted, already calling into question the role that film technology plays in hiding the Other, as he will critique the role of technology in erasing identity at the Liberty paint factory and in the lobotomy scene. But this sequence of denials is also in response to the invisible man's suffering of rejection at his Tuskegee-like college. In chapter 5, after the invisible man has unintentionally introduced the white trustee Mr. Norton to the incestuous Trueblood and the too-frank Negro veterans of the Golden Day, he attends what he knows will be his last chapel service before his inevitable expulsion from

the college. The trustees and other officials attend the service as well, and an opening hymn precedes the keynote speaker, as yet unknown to the invisible man, a "man of striking ugliness" who wears "black-lensed glasses" (117–18). The speaker spins a tale, set to the cadences of black preaching that the invisible man assumes as an authoritative form, about the history of the school's unnamed Founder, of his decline, and of his legacy through the school. Though the speech is clearly designed to inspire, that inspiration must come through catharsis. The invisible man notices the copious tears of his neighbors, even while he wrestles with his own emotions, a blend of the proper catharsis with a nauseating nostalgia for what he is about to lose: "For the first time the evocation of the Founder saddened me, and the campus seemed to rush past me, fast retreating, like the fading of a dream at the sundering of slumber. . . . And I watched with a sick fascination, knowing part of the story, yet a part of me fighting against its sad inevitable conclusion" (123, 125). The story of the Founder is familiar to the speaker's audience to the point of cliché, yet the very inevitability of the end creates a tension intensified for the invisible man through knowing that his own demise in the college's eyes is mere hours away. The full import of the story's performance and reception emerges only after the speaker's name is known, a name that a fellow student implies with a look that the invisible man should have known already: "Reverend Homer A. Barbee, Chicago" (123). The obvious connection with Homer's traditional description—the excessive ugliness, the blindness, the theatricalized inspiration—reveals why this story matters. The invisible man hears the story of a heroic past no longer accessible to its audience, any of its audience, but he is the hearer most painfully aware of the gulf between heroic story and present failure. Homer stands at the beginning of the invisible man's story, but only as an ancestor so far removed that he can only be pushed away, as Davenant shoved off from his sea-marke to seek for new territory. Lighting out for the territory was one of Ellison's favorite tropes from Twain (he referred throughout his life to his home state of Oklahoma as "the territory"), and light out the invisible man must if he is to make his own story.

Throughout *Invisible Man*, modernist and surrealist techniques bump up against folk vernacular and jazz idioms, and one of the most jarring instances of this collision occurs late in the novel during the riot spurred by Ras the Destroyer. The Afro-Caribbean Ras, having dropped his earlier moniker of "the Exhorter," has moved from fighting words to a fighting stance in a progression connected to single combat scenes in the *Iliad*. Yet this single combat borders on the absurd, as Ras appears on horseback, "dressed in the costume of an Abyssinian

chieftain; a fur cap on his head, his arm bearing a shield, a cape made of the skin of some wild animal around his shoulders" (556). And Ras has set out to fight only an abstract "white man," rather than an actual rival—until he comes across the invisible man, his previous rhetorical opponent in the neighborhoods of Harlem. The invisible man, now on the run after being betrayed by the Communist Party that had made him a spokesman, exchanges words with Ras and the crowd before the Creole orders his followers to kill the invisible man and launches a spear at him as a warning shot. The invisible man, when he sees that he has run out of rhetoric, throws the spear back and thereby throws the scene into utter chaos: "I let fly the spear and it was as though for a moment I had surrendered my life and begun to live again, watching it catch him as he turned his head to shout, ripping through both cheeks, and saw the surprised pause of the crowd as Ras wrestled with the spear that locked his jaws" (559–60). The spear thrust through the cheek is a standard death wound in the *Iliad*, and here it elevates the fight between the invisible man and Ras to mythic proportions echoing back to both Greece and Africa. Yet the juxtaposition of a Homeric trope in the midst of surreal horror "more out of a dream than out of Harlem" (556) also renders the heroic absurd; the invisible man's throw is a lucky shot, not the determined blow of a warrior, and no one gains any ground through the conflict.

In fact, the scene precipitates the invisible man's descent underground, a descent that would involve a pantheon of ghosts in Homer's world but in the invisible man's Harlem involves walks in dank sewers, stolen electricity in abandoned basements, and protests of his difference from "ectoplasms." Ellison's twin accomplishments of reintroducing Homeric devices into a workable contemporary poetics and repudiating Homeric authority as useless in the world of the postmodern novel typify the epic impulse in postwar America. Barlow's and Snowden's love-hate relationships with epic find a kind of redemption in *Invisible Man*, as epic finally settles into a larger tapestry of literary traditions, aesthetic effects, and above all experiences of racial and social identity. And one of the strange phenomena in the history of the epic impulse appears in Ellison's own *Nachleben*. Myriad African American writers since Ellison have had to wrestle with *Invisible Man*, and many have done so openly. Yet I am not aware of a single instance of a writer engaging Ellison as a way of getting to the epics, either Sunjata or Homeric, that stand behind his achievement. The epic impulse throughout this study has been shown to lead authors to take on Homer and his successors in a range of ways, but from World War II on that same impulse continues while the classical or canonical figures that stood behind earlier uses have now faded into a

kind of intertextual background noise: Thomas Pynchon takes on not Homer and Virgil but Melville and Madison. And this tendency appears outside literature as well, as the next section shows.

From Lower Frequencies to Higher Bandwidth: Epic Technology

Two last examples highlight both the prevalence of epic in contemporary media culture and the possibilities for engaging epic from a postmodern standpoint. Significantly, both take their inspiration from Thomas Cole, who by the late twentieth century had moved from a transnational experimenter in combining pictorial genres and defying the conventions of the Grand Manner into an exemplar of an American Grand Manner just as formidable—and to postmodern artists just as suspect—as the aesthetics of Diderot's *grand machines*. The first of these examples stands in the space of modern epic, an internationally presented work designed to speak for a nation: Ed Ruscha's *Course of Empire* (2005). Ruscha, like Cole, has become an icon in American art, but like Cole, his work's resistance to easy classification has frequently made his work a flashpoint of aesthetic and cultural politics in the post-1950 American art world. Trained as a commercial artist in the 1950s, Ruscha "has been characterized as doing Pop art . . . conceptual art . . . Abstract Expressionism . . . surrealism . . . [and] social realism."[19] Whatever Ruscha's school or lack thereof, his work became nationally representative when he was selected to present a new work for the 51st Venice Biennale in 2005, a recurring exhibition intended to present the state of art in (mainly Western) nations at an international venue. While Ruscha did not choose the title for his work, *Course of Empire*, until after he had started working on it, numerous critics commented on the appropriateness of such a subject for the Venice Biennale: "Under the conditions of globalization, the founding contradictions of the Biennale—on the one hand, the propagandistic interests of the nation-state; on the other, the critical projects of the avant-garde—have clearly shifted from latency to manifest urgency."[20] Considering not only that the US Pavilion followed a neoclassical architectural scheme that was almost universally described as Jeffersonian, but also that two lead sponsors of the Pavilion were the US State Department and Lehman Brothers, Ruscha as a leading American artist could hardly have avoided either critique of or implication in the imperial politics that several commentators believed automatically disqualified any American artist from winning first prize at the Biennale.[21]

But while Ruscha had taken his title from Cole, little in the visuality of his (what else?) five-canvas series suggested the dramatic sweep of Cole's 1836 series. Ruscha based his five color air-brushed pictures on a five-canvas black-and-white series that he had done in 1992 titled *Blue Collar*. That earlier series had presented mottled Los Angeles sky hovering over the tops of five fictional structures (including a telephone booth) in various states of use and disuse in industrial LA. *Blue Collar* had been typified by a kind of documentary nostalgia, as it mimicked monochrome photography while highlighting the painterly material of the air-brushed canvas. In *Course of Empire*, Ruscha returned to each of the *Blue Collar* structures, showing changed signs (one of them in ersatz Chinese), boarded windows, raised barbed-wire fences around condemned property, and a blank power pole and a tree branch that had replaced the frame that the telephone booth had occupied before the rise of cell phones. The series was a record of the passing of (fictional) time, emphasizing the "social realism" that Joan Didion praised in his work in the catalog's foreword while also idealizing the industrial landscape even at the level of fake brand names and made-up Asian characters. This series was about history, about the international, about the local, about the state of art as social commentary—but it was also about the tradition of the "Two Coles" still trying to coexist in an art world that had never been ready to view "pure" landscape and "fanciful" imagery as congruent or even compatible.

Why Cole? Ruscha had resonated with the emotional tone of the older *Course of Empire* series, but the serial structure and the unique capacity of the visual series to develop and articulate ideas seem to have been most valuable to him; in the catalog, Ruscha commented, "I think the nickel dropped when I realized these [Cole's] pictures were actually this artist's vision of his concept. I was looking at them individually at first and, well, they're far greater as a group of works than they are individually." The "grand epic upon canvass" that James Fenimore Cooper had seen in 1853 had been rediscovered as a way to present big ideas in a high-stakes venue. Conceiving of his own *Course of Empire* as a series also moved Ruscha to reconceive his earlier, disjointed group as having a certain kind of aesthetic and historical unity, sustained retrospectively by his new work. This unity became clearest in the installation scheme. Leaving the central rotunda of the C-shaped US Pavilion empty, Ruscha installed *Course of Empire* on one side and *Blue Collar* on the other, such that viewers had to walk between the two series without being able to keep visual contact with the series they were leaving behind, thus requiring the viewer to "file an image in memory in order to compare it with its 'look-alike.'"[22] In other words, forgetting and remembering become

Figure 20. Elliot Anderson, *Prometheus Bound*, 2007.
Courtesy of the artist.

mutually constitutive functions, and the sustained narrative of the series is immediately reorganized by the individual viewers' associations, reflections, and forgettings. Looking at the passage of time also means looking again at Cole and his original audiences, too; the anxiety of postmodern uncertainty and guilt over multinational capitalism and imperialism finds expression through the tradition of an early transnational critic of the Industrial Revolution and the economies of art that it set into place. Ruscha's *Course of Empire* has rarely been exhibited in the United States,[23] and the fate of this series raises another question about the complications involved in creating a national tradition (like that of Longfellow's *Evangeline*) that will connect with international audiences and then trying to sustain that tradition among the nation's own audiences.

One way of approaching this last problem is to focus further into the local, which our second example does through a surprising application of digital technology. In a 2007 exhibit at the de Young Museum in San Francisco, new media artist Elliot Anderson presented what amounts to a meditation on the relationship between the ideology of Hudson River School landscape painting and contemporary tourist photography. The pieces composing the exhibit, titled "Average Landscapes," were constructed from a computer program that searched the Internet for tourists' posted photographs using keywords from the titles of the de Young's nineteenth-century landscape paintings. The collected photographs were then overlaid and averaged by a computer graphics program and projected onto lightboxes, revealing multilayered but surprisingly close approximations of the de Young's nineteenth-century images of Yosemite, Lake George, and Yellowstone. Included in Anderson's exhibit was a piece based on Cole's *Prometheus Bound*. The main composition of the painting consists of a mountain range, with a few trees in the foreground rhyming with a sole male nude figure fastened to the most prominent peak; a lone vulture soars upward from the trees as the dawn glows behind it, and a single star signifying Jupiter's vigilance over the rebellious Titan hangs in a dark blue sky. Anderson used keyword searches for "Prometheus" to produce four separate images to mimic Cole's composition (fig. 20): a compilation of images from the Hubble Space Telescope in place of Jupiter, a juxtaposition of images of raptors and jet fighters in place of the vulture, a blend of mountain images strikingly similar to Cole's mountains, and an array of male nudes taken largely from images on the website for a gay male erotica publishing house called Prometheus Books.[24] The fragmenting and reiterating of Cole's *Prometheus* splits the epic into an ever-repeating series of Kodak moments, incoherent and yet all-encompassing—mythmaking through encyclopedic inclusion

rather than narrative exclusion. We have seen this tendency increase throughout this study, as epic has become more a way of seeing the world than a form for describing that world. Such may well be the future of epic in the American experience; whether such a future ultimately renders epic bound or unbound remains to be seen.

Notes

INTRODUCTION: Epic Travels

1. Moulton, ed., *Lewis and Clark Journals*, 284.
2. Bergon, "Wilderness Aesthetics," 129.
3. Furtwangler, *Acts of Discovery*, 192, 201.
4. Coues, "Preface to the New Edition," v–vi.
5. Quaife, "Some New-Found Records," 106.
6. Furtwangler, *Acts of Discovery*, 204.
7. Tucker, *Epic*, 1–2.
8. "Our New States," 185, 192.
9. D. Jackson, ed., *Letters*, 1.13.
10. Bergon, "Wilderness Aesthetics," 129. Though he does not comment on his choice, Gary Moulton, the editor of the most recent complete edition of the *Journals*, follows the same structure in his University of Nebraska abridged edition (cited above), tellingly subtitled "An American Epic of Discovery."
11. Bergon's preface to his edition emphasizes the importance of pluralism as a theme in the story of the expedition; Furtwangler argues cogently against the centrality of pluralism in the journey. See Bergon, ed., *Journals of Lewis and Clark*, x; Furtwangler, *Acts of Discovery*, 194.
12. Whitley, *American Bards*, 189.
13. Silva-Gruesz, *Ambassadors of Culture*; Frank and Mueller-Vollmer, *Internationality of National Literatures*.
14. This is a corollary to David Quint's argument in *Epic and Empire* that the losers' perspective actually rewrites the form of epic from Virgil on down to Milton. In making that argument, Quint is one of the first comparative scholars of what is often called "secondary epic"—epic that originates in writing rather than in oral tradition—to analyze American works such as Joel Barlow's *Columbiad* alongside European works.
15. John 18:38 (AV); Augustine, *Confessions*, 239.
16. Moretti, "Conjectures," 57–58.
17. Davis and Joyce, comps., *Poetry by Women to 1900*.
18. Kazin, *American Procession*.
19. See Kaul, *Poems of Nation*; Bennett, *Poets in the Public Sphere*; Loeffelholz, *From School to Salon*; V. Jackson, *Dickinson's Misery*; Sorby, *Schoolroom Poets*; Cavitch, *American Elegy*; McGill, ed., *Traffic in Poems*; M. Cohen, "Whittier, Ballad Reading"; Whitley, *American Bards*.
20. V. Jackson, *Dickinson's Misery*, 98.
21. Harrington, "Why American Poetry."

22. Mendelson, "Encyclopedic Narrative"; Dimock, *Through Other Continents*. On the history of the conflation of epic and novel, see Burrow, *Epic Romance*.

23. On the history of the concept of the Great American Novel, see Buell, "Unkillable Dream."

24. Murnaghan, "Poetics of Loss in Greek Epic," 203.

25. McWilliams, *American Epic*, 2.

26. Woloch, *One vs. the Many*, 3.

27. See Moretti, *Modern Epic*.

28. Dimock, "Genre as World System." Both Moretti and Dimock take Immanuel Wallerstein's work as their point of departure in their concepts of the world-system.

29. After the rise in interest in Asian literature in late eighteenth-century Europe, epicists numbered among the authors who included Asian texts in their own traditions; one example of this is Melville's canto on *The Ramayana* in *Clarel*.

30. Eliot, *Selected Prose*, 38.

31. R. Ellison, *Collected Essays*, 185.

32. Davenant, *Sir William Davenant's* Gondibert, 3.

33. C. Lewis, *Preface to Paradise Lost*, 129.

34. For example, see P. DuBois, *Rhetorical Description*.

35. See Wells, *Devil & Dr. Dwight*; Wells, "Aristocracy"; D. Shields, *Oracles of Empire*; D. Shields, *Civil Tongues*; and Dowling, *Poetry and Ideology*.

36. Moretti, "Conjectures on World Literature," 57.

37. Damrosch, *What Is World Literature?* 25–26.

38. Dimock, "Genre as World System."

39. Benjamin, *Illuminations*, 88–89.

40. Moulton, *Lewis and Clark Journals*, 284n, 461.

PROLOGUE: Reading Epic

1. On the controversy surrounding Sandys's translation as "the first utterance of the conscious literary spirit articulated in America," see Davis, "George Sandys' 'Ovid,'" 297–98.

2. Sandys, *Ovids Metamorphosis* (1632), 1.

3. For an excellent discussion of the history of this debate, as well as a modern case for the classification of Ovid as an epicist, see Otis, *Ovid as Epic Poet*.

4. J. Ellison, *George Sandys*, 158, 101–8, 107–8.

5. Sandys, *Ovids Metamorphosis* (1626), "Dedication" (n.p.).

6. Sandys, *Ovids Metamorphosis* (1632), 418, 389, 454. For a more extensive discussion of Sandys's references to America, see Davis.

7. Sandys, *Ovids Metamorphosis* (1626), "Dedication."

8. Graeme, *Poemata Juvenilia*, l. 345; further citations will be given parenthetically.

9. Stabile, Introduction to *The Most Learned Woman*, 26–27.

10. Graeme's friend and agent Elias Boudinot reported that the printers were unable to read her handwriting, a surprising statement if the fair copy now in the Library Company of Philadelphia was the copy they saw in 1793, when she finished her last revisions. For the publication history of *Telemachus*, see Ousterhout, *Most Learned Woman*, 320–30.

11. The two odes have never been published in print and are in the commonplace book made for the Willing sisters, presumably in the 1790s; the book is currently at Graeme Park.

12. Stabile, Introduction to *The Most Learned Woman*, 1.

13. Blecki and Wulf, eds., *Milcah Martha Moore's Book*, 201.

14. The commonplace books for Penn, Williams, and Dickinson are all held at the Historical Society of Pennsylvania.

15. The Dickinson gift copy, which is now held by the Library Company of Philadelphia, was the 1791 Philadelphia imprint by Henry Taylor; Robert Bell, the initial publisher of Paine's *Common Sense*, had issued the first American edition of *Paradise Lost* in 1777. On the historiography of reading epic in the eighteenth century, see Reinhold, *Classica Americana*. For a recent study of the female reception of epic and other classical literature in early America, see Winterer, *Mirror of Antiquity*.

16. Brown, *Power of Sympathy*, 57.

17. Julian Mason has suggested John Wheatley, while John C. Shields has argued convincingly that Mather Byles is the likeliest candidate for Maecenas—though the patron in Wheatley's poem seems to bear a resemblance to Alexander Pope as well. See J. Mason, ed., *Poems of Phillis Wheatley*, 3; J. Shields, "Phillis Wheatley"; Wheatley, *Collected Works*, 276–77.

18. Thoreau, *Walden*, 106.

19. Wheatley, *Collected Works*, 9; hereafter cited parenthetically.

20. John C. Shields, in his notes on "To Maecenas," points out the considerable variance of speed through the Homer section of the poem; see Wheatley, *Collected Works*, 277n. For the Byles poem, see Byles, *Poems on Several Occasions*, 25–34.

21. Cuningham, *Timothy Dwight*, 26–27. One of George Sensabaugh's most mystifying comments concerning Timothy Dwight is his statement that the future Yale president had read Virgil in Latin, but Homer only in Pope's translation; see Sensabaugh, *Milton in Early America*, 166. Dwight's study of Homer in Greek had been noted earlier and had been well documented long before Sensabaugh's 1964 study. Perhaps Sensabaugh's meaning is that Dwight used Homer through Pope in his poetry rather than through his own translations of Homeric ideas.

22. Howard, *Connecticut Wits*, 86.

23. Cuningham, *Timothy Dwight*, 237–39, 241–42.

24. Alexander Anderson, "Sketch of the Life of Dr. Alexander Anderson written by himself in his Seventy Third year, 1848," in Papers. New York Public Library MssColl 98, 4.

25. Jenkyns, *Victorians and Ancient Greece*, 194.

26. Homer, *Iliad of Homer* (1808), title page. Jane R. Pomeroy has found that Anderson's apprentice, Garret Lansing, did the engravings for the second volume of the Odyssey; See Pomeroy, *Alexander Anderson*, 1:323. Anderson had copied British designs for his work on an edition of Macpherson's Ossian (1810) and Thomson's Seasons (1810); see Pomeroy, 1.xliii.

27. Tasso, *Jerusalem Delivered*, 327.

28. See, for example, G., "Barlow's Columbiad." As recently as 1990, Michael Warner has misidentified Columbian type, made by the same foundry, with that used in the Columbiad; see Warner, *Letters of the Republic*, 121. John Bidwell has demonstrated that, while no evidence exists that Barlow commissioned a typeface for his

poem, the poet did have a hand in selecting and purchasing the type; see Bidwell, "Joel Barlow's Columbiad," 356–59.

29. Bidwell, "Joel Barlow's Columbiad," 352, 379.

30. Howard, *Connecticut Wits*, 322; Bidwell, "Joel Barlow's Columbiad," 378–79; Barlow, *Columbiad*, iii–iv.

31. Bidwell, "Joel Barlow's Columbiad," 373–74.

32. Ibid., 377–78.

33. This copy is now in the Library Company of Philadelphia's collection.

34. Jeffrey, "Columbiad," 40. On Jeffrey's authorship of this essay, see Griggs, Kern, and Schneider, "Early 'Edinburgh' Reviewers," 206.

35. E. Lewis, "Ambiguous Columbiads," 111, 114–17.

36. "A Ten-Inch Columbiad."

CHAPTER 1. Diffusions of Epic Form in Early America

1. The first instance of a content-based definition of epic that I have found appears in Dyche's *New English Dictionary* (1702). For the first half of the eighteenth century, lexicographers followed the approach of Phillips and others, but even before Johnson's 1755 *Dictionary*, definitions based on Dyche's appeared in Wesley's *Complete English Dictionary* (1753) and Martin's *Lingua Britannica Reformata* (1754).

2. Kames, *Elements of Criticism*, 2:365n.

3. Cavitch, *American Elegy*, 80–107.

4. Blair, *Lectures on Rhetoric*, 508.

5. Kames, *Elements of Criticism*, 2:365n, 2:366n.

6. See Herder, *Spirit of Hebrew Poetry*, in which Homer and Ossian often appear together as the exemplary pair of oral poets.

7. Blair, "Critical Dissertation," 354, 346, 358.

8. Seelye, "Flashing Eyes."

9. Berkeley, "Verses," 346. The poem was originally published in Berkeley's *Miscellany* in 1752.

10. The text most familiar to students of the period is the 1772 composite text cowritten by Brackenridge and his classmate Philip Freneau. For the history of the text, see Smeall, "Respective Roles"; for critical analysis of the textual history of *Rising Glory*, see Wertheimer, *Imagined Empires*, 17–51.

11. Brackenridge and Freneau, *Rising Glory of America*, 24.

12. Trumbull, *Fine Arts*, 9.

13. Sensabaugh, *Milton in Early America*, 166.

14. Dwight, "Proposals for Printing."

15. Dwight, *Major Poems*, 18.

16. McWilliams, *American Epic*, 16.

17. J. Shields, *American Aeneas*, 218.

18. On the composition history of *Conquest* and its related poems, see Howard, *Connecticut Wits*, 83–85, 93–96.

19. It was also the basis for Dwight's "Columbia," which was included in Elihu Hubbard Smith's 1793 anthology *American Poems*.

20. Dwight, *Major Poems*, 11–12. The full title of the poem is *America: Or, a Poem on the Settlement of the British Colonies; Addressed to the Friends of Freedom, and Their Country.*

21. For a typical reading of Joshua as Washington, see Silverman, *Timothy Dwight*, 33–34.

22. See Wertheimer, *Imagined Empires*, 52–90.

23. Snowden, *Columbiad*, 46; further citations will be given parenthetically.

24. McWilliams, *American Epic*, 37.

25. Ousterhout, *State Divided*, 117–20.

26. The first source mentioned is Palmer, *Biographical Sketches of Loyalists*, 811. The second source is an anonymous obituary for Snowden in the *Saturday Evening Post*.

27. Snowden, *American Revolution*, 1:43–47.

28. The best account of Dwight's family's experience during the war and its influence on his poetry is Kafer, "Making of Timothy Dwight."

29. Dwight, *Major Poems*, 255, 324.

30. For a full treatment of the publication and revision history of Branagan's antislavery poetry, see Phillips, "Epic, Anti-Eloquence."

31. Branagan, *Tyrant*, 71. Hereafter cited parenthetically as *Tyrant*.

32. Branagan, *Avenia*, 171. Hereafter cited parenthetically as *Avenia*.

33. See, for example, Branagan, *Serious Remonstrances*, v–vii.

34. J. Dryden, *Virgil's Aeneid*, 377.

35. Pope, Preface to *The Iliad of Homer*, 1.n.p.

36. J. Shields, *American Aeneas*, 216–51; R. Kendrick, "Re-Membering America."

37. Morton, *Beacon Hill*, 13. Hereafter cited parenthetically as *Beacon*.

38. Beattie, *Minstrel*, v.

39. See King, *Romantic Autobiography*.

40. For the publication history of *Beacon Hill*, see Phillips, "Fragmenting the Bard."

41. Jung, *Fragmentary Poetic*.

42. Morton, *Virtues*, iv. Hereafter cited parenthetically as *Virtues*.

43. N. Webster, *Grammatical Institute*, 4, 5.

44. Barlow, *Columbiad*, vii–ix.

45. Lewalski, *Life of John Milton*, 410; Ellwood, *History of the Life*, 314. Lewalski doubts that Ellwood actually inspired *Paradise Regained*, though she does accept Ellwood's account of Milton telling Ellwood (ironically or otherwise) that he had in fact inspired it; see 450–51.

46. Ellwood, *Davideis*, 13. Hereafter cited parenthetically.

47. Timothy Dykstal has argued that Cowley developed his poem while in exile in France, where he was probably influenced by Catholic works such as Sannazaro's *De Partu Virginis* (1526), Du Bartas's *Judit* (1574), and Marino's *La Strage de gli Innocenti* (1610). See Dykstal, "Epic Reticence," 96.

48. In addition to the five London editions and one Dublin edition identified by Walther Paul Fischer in his study of Ellwood, I have identified the following American imprints: 1751 & 1760, printed by Franklin & Hall (Philadelphia); 1754 by James Chattin (Philadelphia); 1764 by James Adams (Wilmington, DE); 1785 by Joseph

Crukshank (Philadelphia); 1792 by Eliphalet Ladd (Dover, DE); 1797 by Joseph Johnson and Samuel Preston (Wilmington, DE). See Fischer, Introduction to *Thomas Ellwood's Davideis*.

49. Whittier, *Poetical Works*, 2:422.

50. The first attribution of *The Gospel Tragedy* to Brockway is apparently Dexter, *Graduates of Yale College*, 3:271.

51. According to federal records, Hutchins held the copyright to Brockway's poem. See Gilreath, ed., *Federal Copyright Records*, 85.

52. Hutchins, "Proposal."

53. Dexter, *Graduates of Yale College*, 3:270.

54. Brockway, *Gospel Tragedy*, iii. Hereafter cited parenthetically.

55. Buell, *New England Literary Culture*, 166–93.

56. Dwight, *Major Poems*, 545–46.

57. In 1795, Dwight's *Dissertation* was reprinted in New York as an appendix to Samuel Jackson Spratt's *The Sublime and the Beautiful of Scripture*.

CHAPTER 2. Constitutional Epic

1. Burke, *Grammar of Motives*, 362.

2. Quoted in Slauter, *Origins of the Constitution*, 33–34.

3. J. Adams, *Defence*, 365, 366.

4. Quoted in Schulman, *American Republic*, 128.

5. Ibid., 128–29.

6. Richard, *Founders and the Classics*, 10.

7. Adams, Adams, and Jefferson, *Adams-Jefferson Letters*, 538.

8. See Burke's essay "Literature as Equipment for Living" in Burke, *Philosophy of Literary Form*, 293–304.

9. Carl J. Richard's discussion of the Founders' knowledge of the classics is the best available; see Richard, *Founders and the Classics*, esp. 12–38. For a broader narrative of the place of classics in early American education, see Winterer, *Culture of Classicism*, 10–43.

10. Slauter, *Origins of the Constitution*.

11. Jefferson, *Writings*, 1501.

12. Slauter, *Origins of the Constitution*, 104–6.

13. For Burke's "calculus of motives," see his discussion of constitutional dialectics in Burke, *Grammar of Motives*, 323–401, esp. 377–78.

14. Ketcham, *James Madison*, 46.

15. G. Kennedy, "Classical Influences," 138.

16. See ibid., 119–38; Gummere, *American Colonial Mind*, 173–90; Reinhold, *Classica Americana*, 102–5.

17. Hamilton, Madison, and Jay, *Federalist*, 323. All subsequent citations of this work will be given parenthetically.

18. Ferguson, *Reading the Early Republic*, 151–71; Slauter, *Origins of the Constitution*, 63–85.

19. My reading of Montesquieu is based in part on Ferguson, *Law and Letters*, 42–49.

20. Pope, *Poetry and Prose*, 46.

21. In describing this critique of Montesquieu, my reading of *Federalist* 47 is closer to Jack Rakove's, who sees Madison as arguing that "Montesquieu could not have meant what his popular interpreters claimed he meant" regarding separation of powers, than to either Gary Rosen's reading of the review of state constitutions at the end of the essay as "a corrective" to Montesquieu or Slauter's assertion that Madison saw Montesquieu as making "a mistaken assumption that the British Constitution was a 'perfect model' rather than simply one example." In fact, I read Madison as pushing forward precisely the idea that Montesquieu used the British Constitution as a gold standard, in order to make a larger point about the practice of political criticism. Rakove, "Madisonian Moment," 490; Rosen, "Problem of Founding," 574; Slauter, *Origins of the Constitution*, 121.

22. Quoted in Fliegelman, *Declaring Independence*, 96; for the list of Jefferson's epics in his library, see Gilreath and Wilson, eds., *Thomas Jefferson's Library*, 111–12.

23. Jefferson, *Writings*, 618, 619.

24. Fliegelman, *Declaring Independence*, 63–64.

25. The range of possible referents for "Publius" is considerable, as well as unusual for one of Hamilton's Plutarchian choices, which tended to be figures such as Pericles. Besides Virgil, Ovid and Terence both shared the first name "Publius."

26. Blair, *Lectures on Rhetoric*, 478.

27. For bibliographic information, see Brunet, *Manuel du libraire*, 2:130. The Madison copy of *L'Iliade d'Homère* (Paris, 1809), formerly part of Jay Fliegelman's collection, is now in Skillman Library at Lafayette College. Based on my examination of the Madison copy, as well as copies held at the Grolier Club and the Morgan Library, it seems likely that each copy was customized for the owner, either before or soon after the presentation of each book, further indicating the importance of the book as a personal gift object.

28. Quoted in C. Smith, *James Wilson*, 308.

29. McCloskey, Introduction to *Works of James Wilson*, 1:37.

30. Wilson, *Works*, 1:412.

31. Ibid., 1:400.

32. *Chisholm v. Georgia*, 1793 U.S. LEXIS 249, at *462–63.

33. D. Webster, *Speeches, Volume 2*, 515. All subsequent references to Webster's speech will appear parenthetically.

34. For the "liberty and union" passage in Webster's "Reply to Hayne," see D. Webster, *Speeches, Volume 1*, 347–48. Note the difference in the reported version, 393, from the official published version.

35. My definition of *ekphrasis* derives mainly from the eighteenth-century sense of the term: it is a rhetorical device whereby an object of visual art is represented in language. My definition differs slightly in that, following James A. W. Heffernan, I view the work of language as representative and not merely descriptive. As I show in my discussion of *Iliad* XVIII in this section, Homer represents Achilles's shield, but his representation is not only descriptive but also narrational. See Heffernan, *Museum of Words*, 3, 14.

36. Among the more famous attempts are the one by Henry Flaxman in designing a cast model that now resides in the Royal Collection in London and the various versions

of Benjamin West's *Thetis Bringing the Armor to Achilles*, which West had initially intended for sale to the Pennsylvania Academy of Fine Arts around 1807 (the academy declined to purchase it). West's engagement with epic as an artistic concept is addressed at length in chap. 3.

37. Alexander Pope, *The Iliad of Homer*, Add. MS 4808, ff.81v. British Library. For an online image of Pope's manuscript drawing, see "Image from Alexander Pope's 'Iliad,'" *British Library Online Gallery*, last accessed February 21, 2011, www.bl.uk /onlinegallery/onlineex/englit/pope/large17438.html.

38. Homer, *Iliad* (1974), 453.

39. Andrew Sprague Becker has argued convincingly that lines 417–20 (Homer, *Iliad* [1974], 448), describing Haephestus's appearance with statues that moved like virgins, foreground all of the major representative possibilities for the rest of *Iliad* XVIII. See Becker, *Shield of Achilles*, 79.

40. Office of the Curator, Supreme Court of the United States, "The Bronze Doors: Information Sheet," *United States Supreme Court*, last updated May 4, 2010, www .supremecourtus.gov/about/bronzedoors.pdf.

41. James, *William Wetmore Story*, 2:268.

42. Marshall, *Major Opinions*, 174.

43. Ibid., 174–75.

44. Reynolds, *Discourses*, 112.

45. LaRue, *Constitutional Law as Fiction*, 86.

CHAPTER 3. Epic on Canvas

1. For example, see Paulson, *Literary Landscape*, 75; Lindsay, *J. M. W. Turner*, 99.

2. Pye, *Notes and Memoranda*, 34–35.

3. Cole, "Letter to Critics," 230.

4. Truettner, "Two Coles," 153–55.

5. Dillenberger, *Benjamin West*, 44–45; Alberts, *Benjamin West*, 158.

6. Bromley, *Philosophical and Critical History*, 1:56, 2:xxv, xxviii, xxxiv.

7. Ibid., 2:xxxiv–xxxvi, xxxvii, xxxix–xlii.

8. For a helpful overview of history painting and its significance for early American artists, see Mitnick, "History of History Painting," *Picturing History*, 29–43.

9. Richardson, *Works*, 10–11, 17.

10. Reynolds, *Discourses*; see esp. 325–37 from the fifteenth and final lecture, which is essentially an apology for Michelangelo as the "exalted Founder and Father of modern art."

11. Richardson himself was renowned as a portrait painter, but he also pursued literary criticism; he and his son wrote an influential volume on *Paradise Lost*, a work that Richardson had encountered while apprenticing in John Riley's studio. See Gibson-Wood, *Jonathan Richardson*, 30.

12. Reynolds, *Discourses*, 123.

13. Alberts, *Benjamin West*, 274–75, 214.

14. Ibid., 54.

15. See Mitchell, "*Death of Nelson*," 265–66.

16. Quoted in ibid., 266.

17. Alberts, *Benjamin West*, 326.

18. Farington, *Diary*, 3:226.

19. Quoted in Erffa and Staley, *Paintings of Benjamin West*, 220.

20. "Fine Arts. Death of Lord Nelson," 186.

21. Farington, *Diary*, 4:151.

22. The later provenance of West's *Nelson* seems to bear some relationship to this; his original now hangs in the Liverpool Art Museum, while Devis's *Nelson* is in the National Maritime Museum at Greenwich.

23. "Mr. West's Picture," 1. The original review, as the *Herald* states, was an "English publication," though I have not been able to trace it.

24. "New Painting."

25. Alberts, *Benjamin West*, 348, 352–53. West had earned only £35,000 from his court appointment across more than thirty-five years, while his P.R.A. predecessor Reynolds had averaged above £6,000 annually from his portrait commissions. See Dillenberger, *Benjamin West*, 112.

26. Erffa and Staley, *Paintings of Benjamin West*, 350; Dillenberger, *Benjamin West*, 117.

27. Haydon, *Diary*, 1:463.

28. Dillenberger, *Benjamin West*, 118–19.

29. Mitchell, "*Death of Nelson*," 268.

30. Austen, *Jane Austen's Letters*, 273.

31. Ganwell and Tomes, *Madness in America*, 31. The manuscript of the *Notioniad*, along with an earlier fragment from a poem Nisbet called the *Cattawassiad*, is in the collection of the Historical Society of Pennsylvania.

32. I borrow the term "absorption" from Fried, *Absorption and Theatricality*, in recognition of Fried's argument that absorption was the goal of artistic experience as the *grand machine* style of painting was developed, a style to which West was particularly indebted.

33. *Christ Rejected*, 4, 8.

34. Carey, *Critical Description*, 99–100.

35. Galt, *Life, Studies, and Works*, 2:203.

36. Alberts, *Benjamin West*, 411.

37. Barry, Opie, and Fuseli, *Lectures on Painting*, 382, 383.

38. Carey, "Letter," 2.

39. The Academy would eventually mortgage its building in 1835 to purchase *Death on the Pale Horse*, and it later acquired *Christ Rejected* as a gift from Philadelphia art collector Joseph Harrison, Jr., one of the last public champions of American Grand Manner history painting, who bought the work in 1859 in order to keep it in Philadelphia. Goodyear, "History of Pennsylvania Academy," 23, 33; Nutty, "Sartain and Harrison," 52–53. *Penn's Treaty* and John Vanderlyn's *Ariadne at Naxos* were also part of the Harrison gift.

40. The best history of the Capitol rotunda commissions is Fryd, *Art and Empire*, 9–61.

41. Kloss, *Samuel F. B. Morse*, 136–39. Kloss presents several theories to explain Morse's rejection and persuasively suggests that Morse's own hard-line nativism had made him politically unsuitable by the 1830s.

42. Philadelphia's art community had faced similar struggles in earlier years. Charles Willson Peale organized the Columbianum in 1794 as an association and academy for artists, but lack of funding and membership ruined it quickly. The Pennsylvania Academy had a board of over sixty members when it began in 1805, but Peale lamented that he was only one of three artists among a board of bankers, merchants, and lawyers. The taste for history painting at the Pennsylvania Academy may be tied to its leadership of rich connoisseurs, though the preference for American artists made it more inclined to buy and exhibit new works than Trumbull's similarly populated Academy. For a brief narrative of this history, see Goodyear, "History of Pennsylvania Academy."

43. Staiti, *Samuel F. B. Morse*, 169–70.

44. Kames, *Elements of Criticism*, 2:377.

45. Morse, "Lecture Notes 1–8 (b)," Papers.

46. Morse, *Lectures*, 61.

47. Staiti, *Samuel F. B. Morse*, 171, 169.

48. For example, see "Fuseli's Lectures"; "Lectures on Painting"; "Professor Howard's Concluding Lecture."

49. Morse, "Exhibition," 5.

50. Parry, *Art of Thomas Cole*, 24–27. As Parry explains, the story of Cole's discovery had quickly become lore; for versions published shortly after Cole's death, see Bryant, *Orations and Addresses*, 8; Noble, *Life and Works*, 34–36.

51. Quoted in Parry, *Art of Thomas Cole*, 26.

52. Dunlap, *Rise and Progress*, 3:149.

53. Dunlap, "American"; quoted in Parry, *Art of Thomas Cole*, 25–26.

54. Wallach, "American Empire," 24–25.

55. One of the first examples of this narrative is Noble, *Life and Works*, 4–5.

56. Wallach, "American Empire," 26–28.

57. Truettner and Wallach, eds., *Landscape into History*, 164; Parry, *Art of Thomas Cole*, 21.

58. See Truettner, "Two Coles."

59. Quoted in Wallach, "American Empire," 42.

60. On the influence of Martin's *Paradise Lost* mezzotints and other works on Cole, see Parry, *Art of Thomas Cole*, 87–89.

61. Parry, *Art of Thomas Cole*, 73–75; Wallach, "American Empire," 79–82.

62. Noble, *Life and Works*, 7; Parry, *Art of Thomas Cole*, 76–77.

63. See Truettner, "Two Coles."

64. "Cole's Pictures"; "Course of Empire," 513.

65. Quoted in Wallach, "Course of Empire," 378.

66. Byron, *Complete Poetical Works*, 2:160.

67. For the history of moving panoramas in the United States, see Oettermann, *Panorama*, 323–40.

68. Wallach, "*Voyage of Life*," 241.

69. "Apollo Gallery."

70. Hofland, "Fine Arts," 50. For references to Salvator and Claude, see Wallach, "American Empire," 55.

71. "Art Union Pictures," 13.

72. "World of Art," 307.

73. "Our Landscape Painters," 30. For contemporary reviews of *Mercy's Dream*, see Gerdts, "Bunyanesque Imagery."

74. "Art Union Pictures," 13.

75. "Fine Arts: Obituary."

76. See, for example, Wallach, "Course of Empire"; A. Miller, *Empire of the Eye*. Patricia Junker makes a similar argument for Cole's *Prometheus Bound*.

77. Noble, *Life and Works*, 287–88.

78. "Cole Gallery."

79. Gerdts, "Bunyanesque Imagery," 174–75. The most extensive bibliographic treatment of Bunyan's popularity in America is D. E. Smith, "Bunyan's Works in America."

80. Bryant, *Orations and Addresses*, 34.

81. Lanman, "Epic Paintings," 355.

82. Ibid.

83. Cole's manuscript description of the painting includes an extended quotation from Elizabeth Barrett's poetry. Cole, *Prometheus Bound*. Curatorial files.

84. Parry, *Art of Thomas Cole*, 188–90.

85. Junker, "Cole's *Prometheus Bound*," 37–42.

86. Ibid., 37.

87. Cole Family Scrapbook II, McKinney Library, Albany Institute of History and Art. Copy in curatorial files on Cole's *Prometheus Bound*.

88. "George H. Story."

89. Patricia Junker, memo, Jul. 8, 1999, in curatorial files on Cole's *Prometheus Bound*.

90. Talbot, *Jasper F. Cropsey*, 19.

91. "Art and Artists" (December 1851), 149.

92. Sweeney, "Advantages of Genius," 123–25.

93. E. Clark, *History of National Academy*, 64–65.

94. Quoted in Inness, *Writings and Reflections*, 107.

95. H., "Noble Picture," 1i. The *North American*, a Philadelphia newspaper, had reprinted this item from an unidentified issue of the *New York Gazette and Times*. The critic quoted at length from this article in a later piece on Leutze in the 1849 *Bulletin of the American Art-Union*, 16–17. Mark Thistlethwaite has posited that the author of the article is Henry Walter Herbert, an English-born critic and sports writer; Mark Thistlethwaite, personal e-mail, Oct. 2, 2008.

96. "Art and Artists" (November 1851), 130.

97. Jarves, *Art-Idea*, 213–14.

98. "Rothermel's New National Painting," 2; quoted in Thistlethwaite, *Art of Rothermel*, 52.

99. Coddington, "Rothermel's Paintings," 8–16, 25–26.

100. "Battle of Gettysburg."

101. Hobbs, *1876*, 18; Thistlethwaite, "Sartain and Rothermel," 40–41.

102. On the reception of Rothermel's *Gettysburg*, see Hobbs, *1876*, 18; Thistlethwaite, *Art of Rothermel*, 21–22.

103. Johns, *Thomas Eakins*, 47.

104. H. Adams, *Eakins Revealed*, 216–17.

CHAPTER 4. Transcendentalism and the "New" Epic Traditions

1. Winterer, *Culture of Classicism*, 77–98.

2. For a helpful summary of the Homeric question's place in American intellectual life, see Winterer, *Culture of Classicism*, 84–92. For examples of American responses to Wolf's ideas, see "Prologomena ad Homerum"; and "Homer."

3. For a discussion of Thomas Cole's role in this culture war as an unrecognized advocate of Bunyan, see chap. 3.

4. "The Pleasures of the Pen," 108.

5. J. N. D., "John Bunyan."

6. "Notices.—Editor's Table."

7. Carlyle, *Heroes*, 94.

8. Subsequent quotations of Very's essay are taken from *Essays and Poems* and are cited parenthetically in the text.

9. Gittleman, *Jones Very*.

10. P. Miller, ed., *Transcendentalists*, 343.

11. Gittleman, *Jones Very*, 98–100.

12. Perry Miller declared Very's "Epic Poetry" to be "practically unique in American criticism" in its use of the German critical distinction between classical and modern aesthetics; see P. Miller, *Transcendentalists*, 343.

13. T. Kennedy, "Francis Lieber," esp. 31.

14. Lieber claimed to have introduced the words "nationalism," "internationalism," "interdependence," and "Pan-American" into American English through his political writings; see Heath, "American English," esp. 224.

15. Lieber, *Encyclopaedia Americana*, 4:537; further citations will be given parenthetically. The author of the "Epic" article is unknown; Lieber's authorship has only been determined for thirteen articles in the entire *Encyclopaedia*; for the titles of Lieber's known articles, see T. Kennedy, "Francis Lieber," 48n.

16. Herder, *Spirit of Hebrew Poetry*. In introducing his discussion of the meaning of "prophet" in Hebrew culture, Herder explains his method: "Let us inquire into the conception attached to the word not by tracing etymologies, which are always unsafe guides, but by observing the obvious use of the term at different periods of time"; see 2:49.

17. Emerson and Carlyle, *Correspondence*, 99; further citations will be given parenthetically.

18. John Clubbe gives a helpful account of Carlyle's study of Homer, along with its later implications for his work as a writer, in his essay "Carlyle as Epic Historian."

19. Clubbe, "Carlyle as Epic Historian," 120–21.

20. *Oxford English Dictionary*, s.v. "Epic." 3rd ed. 0-www.oed.com.libcat.lafayette.edu/.

21. Carlyle, *Heroes*, 93; final italics are Carlyle's.

22. Ibid., 85, 96, 97.

23. Emerson, *Essays and Lectures*, 58.

24. The German translates, "according to my sense."

25. R. Adams, "Thoreau's Mock-Heroics," 89.

26. McWilliams, *American Epic*, 7–9.

27. Thoreau, *Walden*, 45; further citations will be given parenthetically.

28. The Princeton edition of *Walden*, though a Modern Language Association Approved Text, omits Thoreau's epigraph, which appears in the first edition (Boston, 1854).

29. Kirby and Spence, *Introduction to Entomology*, 327.

30. O'Connell, " 'Battle of the Ants.' "

31. Melville, *Moby-Dick*, 456.

32. Whitman, *Leaves*, 616, 619.

33. Ibid., 680; Whitman, *Poetry and Prose*, 1280; further citations from both of these volumes will be given parenthetically, designated as *L* and *P*, respectively. Some of the thinking for this section has been spurred by Wai Chee Dimock's recent essay "Epic and Lyric."

34. Whitman, *Notebooks*, 1813.

CHAPTER 5. Tracking Epic through *The Leatherstocking Tales*

1. Lukács, *Historical Novel*, 64. As McWilliams points out, neither Cooper nor any other American text is featured in Lukács's main epic-to-novel study, *The Theory of the Novel*; see McWilliams, *American Epic*, 5.

2. Lawrence, *Classical American Literature*, 55.

3. McWilliams, *American Epic*, 136–44. Geoffrey Rans also sees *Mohicans* as the most epic of Cooper's works, while George Dekker has argued that *The Wept of Wish-Ton-Wish*, a novel based on King Philip's War, deserves that title. See Rans, *Cooper's Leather Stocking Novels*, 118–29; Dekker, *American Historical Romance*, 335–37.

4. Quoted in Chase, *American Novel*, 16.

5. On the history of the idea of the Great American Novel, see Buell, "Rise and 'Fall' "; Buell, "Unkillable Dream." For the "Iliad of the Blacks" reference, whose original source has never been identified, see "Uncle Tomitudes," 98.

6. Buell, "Unkillable Dream," 139–40.

7. "Aunt Tabitha Timpson," 148. The *Gazette* gives the *New York Transcript* as the source for the story.

8. "Novels," 419.

9. E. D., "Modern Fiction," 344.

10. Bryant, *Orations and Addresses*, 79.

11. Cooper, "Literary Notices," 363–64.

12. Cooper, *Lionel Lincoln*, 4.

13. Cooper, *Leatherstocking Tales*, 1:101; further citations will be given parenthetically.

14. Cooper, *Letters and Journals*, 2:99.

15. "Novel Writing," 20.

16. I adapt this catalog of Cooper's genres from Howard Mumford Jones's "Prose and Pictures," 136–37; quoted in Shulenberger, *Cooper's Theory of Fiction*, 5.

17. Dekker and McWilliams, eds., *Fenimore Cooper*, 5.

18. Noble, *Life and Works*, 169, 166.

19. For Goethe's and Schiller's discussion of the idea of "epic deferral," see Goethe and Schiller, *Correspondence*, 181–91. The translation "epic deferral" is taken from Barchiesi, "Virgilian Narrative: Ecphrasis," esp. 278.

20. Dekker and McWilliams, *Fenimore Cooper*, 196, 195.

21. Woolman, *Journal and Major Essays*, 24–25.

22. Cooper, *Home as Found*, 1:222; Cooper, *Wish-Ton-Wish*.

23. Pease, Introduction to *The Deerslayer*, vii, xii.

CHAPTER 6. Lydia Sigourney and the Indian Epic's Work of Mourning

1. Whitman, *Leaves*, 668, 672, 697, 690. All further references to this text will be given parenthetically.

2. Etymologist [pseud.], "'Yonnondio.'"

3. Traubel, *With Walt Whitman*, 5:469–70.

4. Folsom, *Whitman's Native Representations*, 79.

5. See chap. 5 of McWilliams, *American Epic*; Sayre, *Indian Chief*, 30.

6. Eighteenth-century poets such as Edward Young, Thomas Parnell, and Thomas Gray were often seen as progenitors of this mode; see Warnke, Preminger, and Metzger, "Graveyard Poetry." Sigourney was frequently mentioned in this context alongside poets such as Felicia Hemans, indicating that the sentimental mourning of the graveyard poetry was a transatlantic phenomenon well into the nineteenth century.

7. Haight, *Mrs. Sigourney*, 4–12.

8. Sigourney, *Letters of Life*, 327.

9. "Traits of the Aborigines," 260, 258.

10. Sigourney, *Traits of the Aborigines*, 3. All subsequent citations of this text will be given parenthetically.

11. "[I]n spirit perhaps he [Adam] also saw / Rich Mexico . . . Cusco . . . Atabalipa . . . Guiana . . . El Dorado." Milton, *Paradise Lost*, 270.

12. "Traits of the Aborigines," 262.

13. Sigourney, *Letters of Life*, 327.

14. Haight, *Mrs. Sigourney*, 23, 25–26; Sigourney, *Letters of Life*, 327.

15. Nina Baym notes the discrepancy between Haight's and Sigourney's account of the composition of *Traits*'s notes, but she refrains from making an argument for either one; see Baym, "Reinventing Lydia Sigourney," 396. Lauter quotes the relevant passage in Sigourney's *Letters*, but in order to take issue with Martha Bacon's characterization of Sigourney in *Puritan Promenade*; see Lauter, "Teaching Lydia Sigourney," 112.

16. I have assumed the feminine pronoun in describing Sigourney's speaker because her other writings on the subject of Indian missions and the importance of native voices in American history indicate a very close resemblance between Sigourney's prose rhetoric and that of *Traits*'s speaker.

17. Bennett, "Was Sigourney a Poetess," 276.

18. Eastburn and Sands, *Yamoyden*, vii.

19. Kettell, *Specimens of American Poetry*, 2:228.

20. Verplanck, ed., *Writings of Sands*, 1:12–13.

21. Anthologies giving the poem as Jane Johnston Schoolcraft's include Kilcup, ed., *Native American Women's Writing*, 60–63; and Watts and Rachels, eds., *First West*, 335–37. Paula Bernat Bennett anthologizes "Invocation: To My Maternal Grandfather," mentioning in a footnote that Jane Schoolcraft had also written "The Ota-

gamiad," in *American Women Poets*, 395. Maureen Konkle also mentions the "Otagamiad" as Jane Schoolcraft's poem; see Konkle, *Writing Indian Nations*, 172.

22. Schoolcraft, *Sound the Stars Make*, 258–59.

23. Ruoff, "Early Native American Women," 84. On the difference between Henry's and Jane's styles, see Schoolcraft, *Sound the Stars Make*, 258.

24. P. Mason, ed., *Literary Voyager*, 182–83.

25. Ibid., 142–43. Jane Johnston Schoolcraft is not an attributed author on the title page of Mason's edition, though he credits her in his introduction and notes with making many contributions.

26. Ibid.

27. Warren, *Constantine Samuel Rafinesque*, 149–53.

28. A summary of Oestreicher's findings can be found in Oestreicher, "Unraveling the *Walam Olum*."

29. Tedlock, Foreword to "Walam Olum," 96. The *Multilingual Anthology* dates the poem as "before 1833," apparently basing the date on Rafinesque's own claim to have translated the work in 1833. Oestreicher has established that the *Walam Olum* dates from 1834 at the earliest; See Oestreicher, "Unraveling the *Walam Olum*," 239–40.

30. Warren, *Constantine Samuel Rafinesque*, 148.

31. Rafinesque, *American Nations*, 4. All subsequent references to this text will appear parenthetically.

32. Rafinesque, *World; or, Instability*, 9.

33. Sayre, *Indian Chief*, 27–29. Sayre draws on David Quint's analysis of the epic curse and its imperial implications in Quint, *Epic and Empire*, 99–130.

34. Sigourney, *Letters of Life*, 338–39.

35. Sigourney, *Zinzendorff*, 14. All subsequent citations of this text will be given parenthetically.

36. Mark 15:39 (AV).

37. Quoted in Haight, *Mrs. Sigourney*, 123–24.

38. "The Thinker."

39. "Fierce Wars and faithful Loves shall moralize my Song." Morton, *Ouâbi*, title page.

40. "Yonnondio," 96.

41. V. Jackson, "Bryant," 196, 193.

42. Quoted in ibid., 199.

43. Ann Uhry Abrams sees Sigourney's Pocahontas as a composite of the versions put forth by John Gadsby Chapman in his painting *The Baptism of Pocahontas*, Seba Smith's *Powhatan*, and Robert Dale Owen's *Pocahontas: A Historical Drama*—a remarkable blend of forms. Abrams, *Pilgrims and Pocahontas*, 133–34.

44. Sigourney, *Pocahontas*, 13. All subsequent citations of this text will be given parenthetically.

45. Sigourney, *Letters of Life*, 347.

46. Tilton, *Pocahontas*, 92, 96. For an account of Chapman's campaign for the commission, see 102–5; for an analysis of the painting and its place in antebellum cultural politics, see 116–40.

47. Sigourney, *Letters of Life*, 347.

48. See Tilton, *Pocahontas*, 118–19.

49. Canticles 2:1 (AV).

50. Sayre, *Indian Chief*, 273, 289.

51. "Yonnondio," 96.

52. Levine, "Lydia Howard Huntley Sigourney," 1029.

53. Everett, "Mrs. Sigourney," 247.

54. Ibid., 247.

55. Sigourney, *Illustrated Poems*, 24; further citations of "Oriska" will be given parenthetically from this source.

56. Emerson, *Letters*, 8:464.

57. Bieder, *Science Encounters the Indian*, 121.

58. Squier, "Historical and Mythological Traditions," 177.

59. For a brief narrative of Copway's life, see D. B. Smith, "Life of George Copway."

60. Bieder, *Science Encounters the Indian*, 123.

61. See the note in Copway, *Ojibway Conquest*, 86–87.

62. This is similar to the accusation that Jane Johnston Schoolcraft counters concerning her grandfather's heritage in her "Invocation: To My Maternal Grandfather," suggesting that the source of *Ojibway Conquest* might have some relationship to the Johnstons' Ojibwe connections.

63. According to Warren Upham, the previous name of the St. Louis River was in fact Ojibwe, "Kitchigumi zibi," meaning "Lake Superior river." This suggests that Copway's geography overlaps considerably with Longfellow's in *Song of Hiawatha*, which centers around Lake Superior, known in the poem as "Gitche Gumee," the "shining Big-Sea-Water." Upham, *Minnesota Geographic Names*, 9; H. Longfellow, *Poems and Other Writings*, 157.

64. J. Clark, *Ojibue Conquest*, v.

65. Peyer, *Tutor'd Mind*, 269.

66. Copway's presentation copy to Longfellow is in the Longfellow collection at the Houghton Library, Harvard University.

67. "Hiawatha," 3.

68. H. Longfellow, *Letters*, 4:109.

CHAPTER 7. Longfellow's Pantheon

1. Emerson, *Letters*, 8:464.

2. Hawthorne and Dana, "Origin of Longfellow's *Evangeline*." Newton Arvin cites Hawthorne and Dana's work as a monograph, but I have not yet found a copy of such a work.

3. Quoted in Hawthorne and Dana, "Origin of Longfellow's *Evangeline*," 174.

4. R. Kendrick, "Re-Membering America." Hawthorne and Dana enumerate approximately 130 translations of *Evangeline* by 1947; see "Origin of Longfellow's *Evangeline*," 201. On the importance of *Evangeline* in South American literary circles, see Silva-Gruesz, *Ambassadors of Culture*, 87–100.

5. I take this phrase from Tarlinskaja and Oganesova, "Meter and Meaning."

6. Hoeltje, "Hawthorne's Review of *Evangeline*."

7. Arvin, *Longfellow*, 113.

8. Ibid., 101.

9. Lowell, *Poetical Works*, 142.

10. For a discussion of "epic deferral," see n. 19 in chap. 5.

11. Arvin, *Longfellow*, 105–6.

12. For a further discussion of Turner's "Epic Pastoral," see chap. 3.

13. H. Longfellow, *Poems and Other Writings*; further citations of Longfellow's poems will be given parenthetically, referring to this text unless otherwise noted.

14. The editor's note in *Poems and Other Writings* quotes and translates Longfellow's journal entry concerning the source, which is also found in S. Longfellow, ed., *Life of Longfellow*, 2:24. The translation of the French is based on the editor's note.

15. See Jameson, *Fables*, 62–80; C. Kendrick, *Milton*.

16. For an excellent reading of the mythic quality of landscape in *Evangeline*, see Seelye, "Attic Shape."

17. S. Longfellow, *Life of Longfellow*, 2:243, 238, 247–48.

18. Eckermann, *Conversations with Goethe*, 204.

19. Robert Fitzgerald translates the Homeric epithet for Odysseus's servant Eumaios as "O my swineherd!"

20. H. Longfellow, "Defence of Poetry," 59.

21. Robert Ferguson and William Charvat have both given valuable renderings of Longfellow as a public writer. See Ferguson, "Longfellow's Political Fears"; Charvat, *Profession of Authorship*.

22. See Ferguson, "Longfellow's Political Fears."

23. S. Longfellow, *Life of Longfellow*, 2:366.

24. V. Jackson, "Longfellow's Tradition."

25. Arvin, *Longfellow*, 166; Tichi, "Longfellow's Motives," 553.

26. Brotherston, *Book of the Fourth World*, 347. Alan Trachtenberg quotes Brotherston in his own reading of *Hiawatha* in *Shades of Hiawatha*, 85.

27. Wagenknecht, *Longfellow*, 295.

28. The European Catholic identity of the missionaries also works against many critics' accusation that Longfellow was arguing for Anglo-Saxon racial superiority.

29. Freiligrath, *"Vorwort des uebersetzers,"* xi. I am grateful to Steffi Dippold for her invaluable assistance in the translation from the German; all quotations from this text are my translations.

30. Ibid., xii.

31. See Moyne, *Hiawath and Kalevala*.

32. For an anthropological account of the evolution of this canto, see T. DuBois, "From Maria to Marjatta."

33. Freiligrath, *"Vorwort des uebersetzers,"* x, xii.

34. For an account of Mary Longfellow's death and its effect on Longfellow, see Calhoun, *Longfellow*, 114–18.

35. Spenser, *Faerie Queene*, 587.

36. S. Longfellow, *Life of Longfellow*, 1:388–89.

37. Ibid., 2:151–52.

38. Ruskin, *Seven Lamps of Architecture*, 85. The Longfellows would have been reading from the first edition, which had just been released in 1849.

39. H. Longfellow, *Christus: A Mystery*, 471; further citations will be given parenthetically.

40. Hedge's version was originally published in *Gems of German Verse* (1852) and in *Hymns for the Church of Christ* (1853), the latter of which he coedited and saw several reprintings of during his lifetime, though it is unclear when his translation became the "standard" American version of the hymn. On criticism of the hymn, see Arvin, *Longfellow*, 267.

41. Hedge and Huntington, eds., *Hymns*, 620.

42. Arvin, *Longfellow*, 277.

43. Buell, ed., *Selected Poems*, xxi; Howells, "Art of Longfellow," 483.

44. Buell, *New England Literary Culture*, 256.

CHAPTER 8. Melville's Epic Career

1. Quoted in Olsen-Smith and Marnon, "Melville's Marginalia," 86.

2. Thorp, "Herman Melville's Silent Years."

3. See Post-Lauria, *Correspondent Colorings*; E. Dryden, *Monumental Melville*; Parker, *Making of a Poet*.

4. Arac, *Commissioned Spirits*, 7, 2.

5. On Melville's reading of John Quincy Adams's *Dermot Mac Morrogh* (1834), see Parker, *Making of a Poet*, 148–49.

6. Foster, "Historical Note," 662.

7. Melville, *Mardi*, 591. Future references to *Mardi* will be given parenthetically.

8. Compare H. Longfellow's statement in his "Defence of Poetry," 59: "With us, the spirit of the age is clamorous for utility,—for visible, tangible utility,—for bare, brawny, muscular utility. We would be roused to action by the voice of the populace, and the sounds of the crowded mart, and not 'lulled asleep in shady idleness with poet's pastimes.'" Written almost twenty years before *Mardi*, and by a forceful young writer in his twenties, Longfellow's article addresses a literary marketplace that had not yet supported a professional poet in the United States; by the time Melville wrote his parable of Lombardo, the poet's status had changed from one of market exclusion to one of the prospect of market inclusion—at the likely expense of artistic independence. For more on Longfellow's remarkably successful engagement with the literary market of his day, see Charvat, *Profession of Authorship*, 106–54.

9. Melville, "Hawthorne and His Mosses," 525.

10. See Dimock, *Empire for Liberty*.

11. Melville, *Correspondence*, 191.

12. Melville, *Moby-Dick*, 449. Further references will be given parenthetically.

13. Emerson, *Essays and Lectures*, 448.

14. Hayford, *Melville's Prisoners*, 69.

15. Ovid makes a similarly equivocal gesture at the beginning of the *Metamorphoses* when he eschews the "I sing" of Homer and Virgil for the infinitive "to tell" or "to relate" (*dicere*), as discussed in the prologue.

16. Franklin, *Wake of the Gods*, 64.

17. Buell, "*Moby-Dick* as Sacred Text," 62.

18. Sheldon, "Milton in *Moby-Dick*," 40–46.

19. The line numbers are taken from the Oxford World Classics edition of Ovid, *Metamorphoses*, 49–51.

20. Allison, "Similies in *Moby-Dick*," 14–15, 12. As Allison has pointed out, two major functions of the Homeric simile (via Milton) are vital to Melville's technique in *Moby-Dick*: the figure creates a space for tangential or startling comparisons, and it provides a vehicle for developing unity through thematic repetition; see 13–14.

21. Douglas J. Robillard has written the most extensive analysis of *ekphrasis* in *Redburn*; see Robillard, *Ionian Form, Venetian Tint*, 47–69. See also his discussion of *Moby-Dick* at 70–98, to which this section is greatly indebted.

22. Wolf, "*Moby-Dick* and the Sublime," 141.

23. Melville, *Redburn*, 7–9.

24. Melville, *Correspondence*, 191.

25. Melville, *Mardi*, 595; Parker, "Historical Note," 315; Thorp, "Historical Note," 404.

26. Wallace, *Melville and Turner*, 324.

27. See the discussion of Achilles's shield in chap. 2.

28. Wolf, "*Moby-Dick* and the Sublime," 143, 144.

29. Emerson, *Essays and Lectures*, 9.

30. Robillard, *Ionian Form, Venetian Tint*, 80–82.

31. The best reading of "The Doubloon" as *ekphrasis* is by a classicist; see Garrison, "Melville's Doubloon."

32. The eight-escudo piece that matches Ishmael's description was minted in Ecuador from 1838 to the early 1840s. See Ortuño, *Historia Numismática del Ecuador*.

33. A book that competed with Eckfeldt and Du Bois's *Manual*, *The Coins of the World*, published by Matthew T. Miller in 1849, showed only the obverse (the missing side in *Moby-Dick*) in an engraving, and gave a description of the reverse far too short to have been useful to Melville.

34. Matt. 26:34b (AV).

35. See Garrison, "Melville's Doubloon," 179–80.

36. See Adler, *War in Melville's Imagination*, 60–61; Ellis, "Engendering Melville," 74.

37. For a detailed narrative of Melville's preparation for his post-1860 epic, see Parker, *Melville: A Biography*, 2:428–53.

38. Quoted in Higgins and Parker, eds., *Contemporary Reviews*, 527.

39. Emerson and Carlyle, *Correspondence*, 542.

40. Melville, *Published Poems*, 3; further citations will be given parenthetically.

41. Robertson-Lorant, *Melville: A Biography*, 484.

42. Worden was in fact blinded by an explosion during the battle; see the note in H. Cohen, ed., *Battle-Pieces*, 224.

43. Hsu, "War, Ekphrasis," 61.

44. Melville had seen Turner's canvas in the National Gallery in May 1857, a few days before setting sail for home after his voyage to the Holy Land that would provide the material for *Clarel*. He mentions it in his journal as "The Fighting——taken to her last birth." Melville, *Journals*, 128. In a note to his poem, Melville eulogizes the ship, "the subject of the well-known painting by Turner"; with wry irony, he declares that the loss of the *Temeraire* "is lamented by none more than by regularly educated navy officers, and of all nations" (*Published Poems*, 174)—Melville not included among them, although perhaps the aesthetically minded Dupont is.

45. Whitman, *Leaves*, 709.

46. Vendler, "Melville," 256.

47. Aaron, *Unwritten War*, xiii. The phrase "No sleep" is an allusion to the story of David's adultery with Bathsheba in 2 Sam. 11 (AV), which begins, "And it came to pass in an evening-tide, that David arose from off his bed, and walked upon the roof of the king's house" (11:2).

48. See Potter, *Melville's Clarel*; Obenzinger, *American Palestine*; Goldman, *Melville's Protest Theism*; Kenny, *Herman Melville's Clarel*.

49. Walter Bezanson has posited that Melville knew of the *Ramayana* through William Rounsville Alger's *The Poetry of the East* (1856), which included a prose synopsis of the story and a translated fragment; see Melville, *Clarel*, 750.

50. Melville, *Clarel*, 17; further citations will be given parenthetically.

51. Short, "Form as Vision."

52. H. Longfellow, *Poems and Other Writings*, 482.

53. Cannon, "On Translating Clarel."

54. Melville, *Selected Poems*, 296; further citations will be given parenthetically.

EPILOGUE. Invisible Epic

1. Hershel Parker has recently argued that

> the phrase "the great American novel" . . . pre-dates by a decade or so the time when working critics stopped looking for great American literature to come in the form of an epic poem. Throughout the 1860s and even the early 1870s (when Melville was writing *Clarel*), the status of poetry, especially epic poetry, remained high. At some yet-to-be-established point toward the end of Melville's life, perhaps before the 1870s were over, a majority of influential critics ceased looking for great new literary works to come in the form of the long poem and began looking for such a great work to come as prose fiction. (Parker, *Making of a Poet*, 103)

2. Quoted in Parker and Hayford, eds., *Moby-Dick*, 609, 617.

3. Higgins and Parker, eds., *Critical Essays*, 99, 102, 110.

4. Ibid., 113.

5. McWilliams, *American Epic*, 241–42.

6. See Dinerstein, "Technology and Its Discontents," 570.

7. On the history of the publication of *Picturesque America*, see Rainey, *Creating Picturesque America*.

8. Bryant, ed., *Picturesque America*, 2:565–66, 576.

9. The cyclorama has been restored and is now on display at Gettysburg National Military Park in Pennsylvania. On the history of the cyclorama, see Oettermann, *Panorama*, 343–44.

10. See Stewart, *On Longing*, 37–103.

11. *Oxford English Dictionary*, s.v. "Nostalgia." 3rd ed. 0-www.oed.com.libcat .lafayette.edu/.

12. On the history of the production of Huston's *Red Badge of Courage*, see Kaminsky, *John Huston*; DeBona, "Masculinity on the Front." Lillian Ross's *Picture*, based on a series of *New Yorker* pieces she wrote while covering the production, is

one of the first books published on the making of a film and is still considered a classic of film journalism, despite its bias against the studio.

13. Huston, dir., *Red Badge of Courage.*

14. See Burke, "Ralph Ellison's Trueblooded Bildungsroman"; Baker, "Failed Prophet"; Nadel, "Integrated Literary Tradition"; Rampersad, *Ralph Ellison: A Biography.*

15. Ellison, *Collected Essays*, 302–9, 185.

16. Cartwright, *Reading Africa*, 60–67.

17. Ibid., 60.

18. R. Ellison, *Invisible Man*, 3; further citations will be given parenthetically.

19. Didion, Foreword to *Course of Empire,* n.p.

20. Buchloh, "Curse of Empire," 254.

21. "Editorial."

22. Quoted in De Salvo and Norden, "Course of Empire," n.p.

23. I have only been able to find one US exhibition of the series, by the Whitney Museum of American Art in New York in November 2005–January 2006; two of the five paintings have been given to the Whitney, so it is unlikely that another full series exhibition will be offered in the near future. Critic John Haber noted that Cole's *Course of Empire* was on display at the New-York Historical Society, just across Central Park, at the same time as the Whitney exhibition. "Whitney Acquires Two Ruscha Paintings," Artinfo.com, last updated November 18, 2005, www.artinfo.com/news/story/1607/whitney-acquires-two-ruscha-paintings/; Whitney Museum, "Press Release: Whitney in Association with Harvard University Art Museums to Present Ed Ruscha's *Course of Empire*, Which Represented the United States at the 2005 Venice Biennale," last accessed June 26, 2011, www.whitney.org/file_columns/0000/2589/november_2005.pdf; John Haber, "Imperious Criteria," *Haber's Art Reviews*, last accessed February 21, 2011, www.haberarts.com/empire.htm.

24. Cornell, Average Landscapes.

Bibliography

Aaron, Daniel. *The Unwritten War: American Writers and the Civil War.* New York: Knopf, 1973.

Abrams, Anne Uhry. *The Pilgrims and Pocahontas: Rival Myths of American Origin.* Boulder, CO: Westview Press, 1999.

Adams, Abigail, John Adams, and Thomas Jefferson. *The Adams-Jefferson Letters: The Complete Correspondence between Thomas Jefferson and Abigail and John Adams.* Edited by Lester J. Cappon. Chapel Hill: Institute of Early American History and Culture / University of North Carolina Press, 1959.

Adams, Henry. *Eakins Revealed: The Secret Life of an American Artist.* New York: Oxford University Press, 2005.

Adams, John. *A Defence of the Constitutions of the United States.* Philadelphia, 1787. Early American Imprints. o-infoweb.newsbank.com.libcat.lafayette.edu.

Adams, John Quincy. *Dermot Mac Morrogh, or The Conquest of Ireland; An Historical Tale of the Twelfth Century.* Boston, 1832.

Adams, Raymond. "Thoreau's Mock-Heroics and the American Natural History Writers." *Studies in Philology* 52 (1955): 86–97.

Adler, Joyce Sparer. *War in Melville's Imagination.* New York: New York University Press, 1981.

Alberts, Robert C. *Benjamin West: A Biography.* Boston: Houghton Mifflin, 1978.

Alexander Anderson Papers. New York Public Library.

Allison, June W. "The Similes in *Moby-Dick*: Homer and Melville." *Melville Society Extracts* 47 (1981): 12–15.

"The Apollo Gallery." *New-York Mirror* 18.15 (Oct. 3, 1840): 119. American Periodical Series Online. o-search.proquest.com.libcat.lafayette.edu.

Arac, Jonathan. *Commissioned Spirits: The Shaping of Social Motion in Dickens, Carlyle, Melville, and Hawthorne.* 1979. Reprint, New York: Columbia University Press, 1989.

"Art and Artists in America." *Bulletin of the American Art-Union* 6 (Nov. 1851): 130–31.

"Art and Artists in America." *Bulletin of the American Art-Union* 6 (Dec. 1851): 149–50.

"The Art Union Pictures." *Broadway Journal* 1.1 (Jan. 4, 1845): 12–13. American Periodical Series Online. o-search.proquest.com.libcat.lafayette.edu.

Arvin, Newton. *Longfellow: His Life and Work.* Boston: Atlantic Monthly Press / Little, Brown, 1963.

Augustine. *Confessions: Books IX–XIII.* Translated by William Watts. Loeb Classical Edition. 1912. Reprint, Cambridge, MA: Harvard University Press, 1997.

"Aunt Tabitha Timpson." *Literary Gazette* 1.19 (Jan. 30, 1835): 148–49. American Periodical Series Online. 0-search.proquest.com.libcat.lafayette.edu.

Austen, Jane. *Jane Austen's Letters.* Edited by Deirdre Le Faye. 3rd ed. New York: Oxford University Press, 1995.

Bacon, Martha. *Puritan Promenade.* Boston: Houghton Mifflin, 1964.

Baker, Houston A., Jr. "Failed Prophet and Falling Stock: Why Ralph Ellison Was Never Avant-Garde." *Stanford Humanities Review* 7 (1999): 4–11. www.stanford .edu/group/SHR/.

Barchiesi, Alessandro. "Virgilian Narrative: Ecphrasis." In *The Cambridge Companion to Virgil*, edited by Charles Martindale, 271–81. New York: Cambridge University Press, 1997.

Barlow, Joel. *The Columbiad, a Poem.* Philadelphia, 1807.

———. *The Vision of Columbus, a Poem in Nine Books.* Hartford, CT, 1787.

Barry, James, John Opie, and Henry Fuseli. *Lectures on Painting, by the Royal Academicians.* Edited by Ralph N. Wornum. London, 1848.

"The Battle of Gettysburg." *Philadelphia Inquirer* (Dec. 21, 1870). America's Historical Newspapers. Microfilm.

Baym, Nina. "Reinventing Lydia Sigourney." *American Literature* 62 (1990): 385–404. JSTOR. 0-www.jstor.org.libcat.lafayette.edu.

Beattie, James. *The Minstrel; or, The Progress of Genius. A Poem.* London, 1771. Eighteenth Century Collections Online. 0-find.galegroup.com.libcat.lafayette.edu/ecco.

Becker, Andrew Sprague. *The Shield of Achilles and the Poetics of Ekphrasis.* Lanham, MD: Rowman & Littlefield, 1995.

Benjamin, Walter. *Illuminations.* Edited by Hannah Arendt. Translated by Harry Zohn. New York: Schocken, 1968.

Bennett, Paula Bernat, ed. *Nineteenth-Century American Women Poets: An Anthology.* Malden, MA: Blackwell, 1998.

———. *Poets in the Public Sphere: The Emancipatory Project of American Women's Poetry, 1800–1900.* Princeton, NJ: Princeton University Press, 2003.

———. "Was Lydia Sigourney a Poetess?: The Aesthetics of Victorian Plenitude in Lydia Sigourney's Poetry." *Comparative American Studies* 5 (2007): 265–89. Ingenta Connect. 0-www.ingentaconnect.com.libcat.lafayette.edu.

Bergon, Frank, ed. *The Journals of Lewis and Clark.* New York: Penguin, 1989.

———. "Wilderness Aesthetics." *American Literary History* 9 (1997): 128–61. JSTOR. 0-www.jstor.org.libcat.lafayette.edu.

Berkeley, George. "Verses on the Prospect of Planting Arts and Learning in America." In *American Poetry: The Seventeenth and Eighteenth Centuries*, edited by David S. Shields, 346. New York: Library of America, 2007.

Bidwell, John. "The Publication of Joel Barlow's Columbiad." *Proceedings of the American Antiquarian Society* 93 (1983): 337–80.

Bieder, Robert E. *Science Encounters the Indian, 1820–1880: The Early Years of American Ethnology.* Norman: University of Oklahoma Press, 1986.

Blair, Hugh. "A Critical Dissertation on the Poems of Ossian." In *The Poems of Ossian and Related Works* by James Macpherson, edited by Howard Gaskill, 343–408. Edinburgh: Edinburgh University Press, 1996.

———. *Lectures on Rhetoric and Belles Lettres.* Edited by Linda Ferreira-Buckley and S. Michael Halloran. Carbondale: Southern Illinois University Press, 2005.

Blecki, Catherine La Courreye, and Karin A. Wulf, eds. *Milcah Martha Moore's Book: A Commonplace Book from Revolutionary America.* University Park: Pennsylvania State University Press, 1997.

Brackenridge, Hugh Henry, and Philip Freneau. *A Poem, on the Rising Glory of America.* . . . Philadelphia, 1772. Early American Imprints. o-infoweb.newsbank.com.libcat.lafayette.edu.

Branagan, Thomas. *Avenia: or, A Tragical Poem, on the Oppression of the Human Species, and Infringement on the Rights of man*[. . .]*Written in Imitation of Homer's Iliad.* Philadelphia, 1805.

———. *The Penitential Tyrant; or, Slave Trader Reformed: A Pathetic Poem, in Four Cantos.* New York, 1807.

———. *Serious Remonstrances: Addressed to the Citizens of the Northern States, and Their Representatives; Being an Appeal to Their Natural Feelings & Common Sense: Consisting of Speculations and Adminadversions, on the Recent Revival of the Slave Trade, in the American Republic.* Philadelphia, 1805.

Brockway, Thomas. *The Gospel Tragedy: An Epic Poem. In Four Books.* Worcester, MA, 1795. Early American Imprints. o-infoweb.newsbank.com.libcat.lafayette.edu.

Bromley, Robert Anthony. *A Philosophical and Critical History of the Fine Arts, Painting, Sculpture, and Architecture.* . . . 2 vols. London, 1793–95.

Brotherston, Gordon. *Book of the Fourth World: Reading the Native Americas through Their Literature.* New York: Cambridge University Press, 1992.

Brown, William Hill. *The Power of Sympathy* in *The Power of Sympathy and the Coquette,* edited by Carla Mulford. New York: Penguin, 1996.

Brunet, Jacques-Charles. *Manuel du libraire et de l'amateur de livres.* 4 vols. Paris, 1814.

Bryant, William Cullen. *Orations and Addresses.* New York, 1873.

———, ed. *Picturesque America; or, The Land We Live In.* 2 vols. New York, 1872–74.

Buchloh, Benjamin. "The Curse of Empire." *Artforum International* 44 (Sept. 2005): 254–58, 324.

Buell, Lawrence, ed. *Henry Wadsworth Longfellow: Selected Poems.* New York: Penguin, 1988.

———. "*Moby-Dick* as Sacred Text." In *New Essays on* Moby-Dick, edited by Richard H. Brodhead, 53–72. New York: Cambridge University Press, 1986.

———. *New England Literary Culture: From Revolution through Renaissance.* Cambridge: Cambridge University Press, 1986.

———. "The Rise and 'Fall' of the Great American Novel." *Proceedings of the American Antiquarian Society* 104 (1994): 261–83.

———. "The Unkillable Dream of the Great American Novel: *Moby-Dick* as Test Case." *American Literary History* 10 (2008): 132–55. Project Muse. o-muse.jhu.edu.libcat.lafayette.edu.

Burke, Kenneth. *A Grammar of Motives.* 1945. Reprint, Berkeley: University of California Press, 1969.

———. *The Philosophy of Literary Form: Studies in Symbolic Action.* 3rd ed. 1941. Reprint, Berkeley: University of California Press, 1973.

———. "Ralph Ellison's Trueblooded Bildungsroman." In *Ralph Ellison's* Invisible Man: *A Casebook*, edited by John F. Callahan, 65–79. New York: Oxford University Press, 2004.

Burrow, Colin. *Epic Romance: Homer to Milton*. New York: Oxford University Press, 1993.

Byles, Mather. *Poems on Several Occasions*. Boston, 1744. Early American Imprints. 0-infoweb.newsbank.com.libcat.lafayette.edu.

Byron, George Gordon, Lord. *The Complete Poetical Works*. Edited by Jerome J. McGann. 6 vols. New York: Oxford University Press, 1980–93.

Calhoun, Charles C. *Longfellow: A Rediscovered Life*. Boston: Beacon Press, 2004.

Cannon, Agnes Dicken. "On Translating Clarel." *Essays in Arts and Sciences* 5 (1976): 160–80.

Carey, William. *Critical Description and Analytical Review of "Death on the Pale Horse," Painted by Benjamin West, P. R. A. . . .* London, 1817.

———. "Letter to the Academy at Philadelphia." *New-York Daily Advertiser* 2.377 (June 26, 1818). America's Historical Newspapers. 0-infoweb.newsbank.com.lib cat.lafayette.edu.

Carlyle, Thomas. *On Heroes, Hero-Worship, and the Heroic in History*. Edited by Michael K. Goldberg, Joel J. Brattin, and Mark Engel. Norman and Charlotte Strouse Edition of the Writings of Thomas Carlyle. Berkeley: University of California Press, 1993.

Cartwright, Keith. *Reading Africa into American Literature: Epics, Fables, and Gothic Tales*. Lexington: University Press of Kentucky, 2002.

Cavitch, Max. *American Elegy: The Poetry of Mourning from the Puritans to Whitman*. Minneapolis: University of Minnesota Press, 2007.

Charvat, William. *The Profession of Authorship in America, 1800–1870*. 1968. Reprint, New York: Columbia University Press, 1992.

Chase, Richard. *The American Novel and Its Tradition*. New York: Abner Doubleday, 1957.

Christ Rejected. Catalogue of the Picture Representing the Above Subject. . . . London, 1814.

Clark, Eliot. *History of the National Academy of Design: 1825–1893*. New York: Columbia University Press, 1954.

Clark, Julius Taylor. *The Ojibue Conquest: An Indian Episode: With Other Waifs of Leisure Hours*. [Topeka, KS], 1898.

Clubbe, John. "Carlyle as Epic Historian." In *Victorian Literature and Society: Essays Presented to Richard D. Altick*, edited by James R. Kincaid and Albert J. Kuhn, 119–45. Columbus: Ohio State University Press, 1984.

Coddington, Edwin B. "Rothermel's Paintings of the Battle of Gettysburg." *Pennsylvania History* 27 (1960): 1–27.

Cohen, Hennig, ed. *The Battle-Pieces of Herman Melville*. New York: Thomas Yoseloff, 1963.

Cohen, Michael. "Whittier, Ballad Reading, and the Culture of Nineteenth-Century Poetry." *Arizona Quarterly* 64.3 (Autumn 2008): 1–29. Project Muse. 0-muse.jhu .edu.libcat.lafayette.edu.

The Coins of the World. Philadelphia, 1842.

Cole, Thomas. *Prometheus Bound.* Curatorial files. American Art Study Center, Fine Arts Museums of San Francisco.

——— [as Pictor]. "A Letter to Critics on the Art of Painting." *Knickerbocker* 16 (Sept. 1840): 230–33. American Periodical Series Online. 0-search.proquest.com.libcat .lafayette.edu.

"The Cole Gallery." *New-York Journal of Commerce.* n.d. Archives of American Art, Reel D6, frame 337.

"Cole's Pictures." Archives of American Art, Reel D6, frame 328.

"Cole's Pictures of the Course of Empire." *American Monthly Magazine* 8 (Nov. 1836): 513–15. American Periodical Series Online. 0-search.proquest.com.libcat.lafayette .edu.

Cooper, James Fenimore. *Home as Found.* 2 vols. Philadelphia, 1838.

———. *The Leatherstocking Tales.* Edited by Blake Nevius. 2 vols. New York: Library of America, 1985.

———. *The Letters and Journals of James Fenimore Cooper.* Edited by James Franklin Beard. 6 vols. Cambridge, MA: Belknap / Harvard University Press, 1960–68.

———. *Lionel Lincoln; or, The Leaguer of Boston.* Edited by Donald A. Ringe and Lucy B. Ringe. Albany: State University of New York Press, 1984.

———. "Literary Notices: Memoirs of the Life of Sir Walter Scott." *Knickerbocker* 12 (Oct. 1838): 349–66. American Periodical Series Online. 0-search.proquest.com .libcat.lafayette.edu.

———. *The Wept of Wish-Ton-Wish.* 2 vols. Philadelphia, 1829.

Copway, George. *The Ojibway Conquest: A Tale of the Northwest.* New York, 1850.

Cornell, Daniel. *Collection Connections: Elliot Anderson:* Average Landscapes. San Francisco: de Young Museum, 2007.

Coues, Elliott. "Preface to the New Edition." In *History of the Expedition under the Command of Lewis and Clark . . .* , edited by Elliott Coues, 1. v–x. 4 vols. New York, 1893.

Cuningham, Charles E. *Timothy Dwight 1752–1817: A Biography.* New York: Macmillan, 1942.

Damrosch, David. *What is World Literature?* Princeton, NJ: Princeton University Press, 2003.

Davenant, William. *Sir William Davenant's* Gondibert. Edited by David F. Gladish. Oxford: Clarendon Press, 1971.

Davis, Gwenn, and Beverly A. Joyce, comps. *Poetry by Women to 1900: A Bibliography of American and British Writers.* Vol. 2 of *Bibliographies of Writings by American and British Women to 1900.* Toronto: University of Toronto Press, 1991.

Davis, Richard Beale. "America in George Sandys' 'Ovid.'" *William and Mary Quarterly,* 3rd ser., 4 (1947): 297–304. JSTOR. 0-www.jstor.org.libcat.lafayette.edu.

DeBona, Guerric. "Masculinity on the Front: John Huston's *The Red Badge of Courage* (1951) Revisited." *Cinema Journal* 42.2 (2003): 57–80. JSTOR. 0-www.jstor.org .libcat.lafayette.edu.

Dekker, George. *The American Historical Romance.* New York: Cambridge University Press, 1987.

Dekker, George, and John P. McWilliams, eds. *Fenimore Cooper: The Critical Heritage.* Boston: Routledge / Kegan Paul, 1973.

De Salvo Donna, and Linda Norden. "Course of Empire: Waste and Retrieval." In *Course of Empire: Paintings by Ed Ruscha* by Donna De Salvo et al., n.p. Ostfildern-Ruit: Hatje Cantz, 2005.

Dexter, Franklin Bowditch. *Biographical Sketches of the Graduates of Yale College with Annals of the College History.* 6 vols. New York: Holt, 1885–1912.

Didion, Joan. Foreword to *Course of Empire: Paintings by Ed Ruscha* by Donna De Salvo et al., n.p. Ostfildern-Ruit: Hatje Cantz, 2005.

Dillenberger, John. *Benjamin West: The Context of His Life's Work, with Particular Attention to Paintings with Religious Subject Matter.* . . . San Antonio, TX: Trinity University Press, 1977.

Dimock, Wai Chee. *Empire for Liberty: Melville's Poetics of Individualism.* Princeton, NJ: Princeton University Press, 1989.

———. "Epic and Lyric: The Aegean, the Nile, and Whitman." In *Walt Whitman, Where the Future Becomes Present,* edited by David Haven Blake and Michael Robertson, 17–36. Iowa City: University of Iowa Press, 2008.

———. "Genre as World System: Epic and Novel on Four Continents." *Narrative* 14 (2006): 85–101. Project Muse. o-muse.jhu.edu.libcat.lafayette.edu.

———. *Through Other Continents: American Literature across Deep Time.* Princeton, NJ: Princeton University Press, 2006.

Dinerstein, Joel. "Technology and Its Discontents: On the Verge of the Posthuman." *American Quarterly* 58 (2006): 569–95. Project Muse. o-muse.jhu.edu. libcat.lafayette.edu.

Dowling, William C. *Poetry and Ideology in Revolutionary Connecticut.* Athens: University of Georgia Press, 1990.

Dryden, Edgar. *Monumental Melville: The Formation of a Literary Career.* Palo Alto, CA: Stanford University Press, 2004.

Dryden, John, trans. *Virgil's Aeneid.* Edited by Frederick M. Keener. New York: Penguin, 1997.

DuBois, Page. *History, Rhetorical Description, and the Epic: From Homer to Spenser.* Cambridge: Brewer, 1982.

DuBois, Thomas. "From Maria to Marjatta: The Transformation of an Oral Poem in Elias Lönnrot's *Kalevala.*" *Oral Tradition* 8 (1993): 247–88.

Dunlap, William. "American." *New-York Evening Post* (Nov. 22, 1825): 2. Project Muse. o-muse.jhu.edu.libcat.lafayette.edu.

———. *History of the Rise and Progress of the Arts of Design in the United States.* Edited by Alexander Wyckoff. 3 vols. New York: Benjamin Blom, 1965.

Dwight, Timothy. *The Major Poems of Timothy Dwight, 1752–1817, with a Dissertation on the History, Eloquence, and Poetry of the Bible.* Edited by William J. McTaggart and William K. Bottorff. Gainesville, FL: Scholars' Facsimiles & Reprints, 1969.

———. "Proposals for Printing by Subscription, *The Conquest of Canaan,* a Poem in Nine Books." [New Haven, CT?], 1775. Early American Imprints. o-infoweb.news bank.com.libcat.lafayette.edu.

Dyche, Thomas. *A New English Dictionary.* London, 1702.

Dykstal, Timothy. "The Epic Reticence of Abraham Cowley." *Studies in English Literature* 31 (1991): 95–115. JSTOR. o-www.jstor.org.libcat.lafayette.edu.

Eastburn, James Wallis, and Robert Sands. *Yamoyden, a Tale of the Wars of King Philip: In Six Cantos.* New York, 1820.

Eckermann, Johann Peter. *Conversations with Goethe.* Translated by Margaret Fuller Ossoli. Rev. ed. Boston, 1852.

Eckfeldt, Jacob R., and William E. Du Bois. *A Manual of Gold and Silver Coins of All Nations, Struck within the Past Century.* Philadelphia, 1842.

E. D. "Modern Fiction." *Southern Literary Messenger* 8 (May 1842): 342–48. American Periodical Series Online. 0-search.proquest.com.libcat.lafayette.edu.

"Editorial." *Art Monthly* 288 (July/Aug. 2005): 16.

Eliot, T. S. *Selected Prose of T. S. Eliot.* Edited by Frank Kermode. New York: Harvest-Harcourt/Farrar, Straus and Giroux, 1975.

Ellis, Juniper. "Engendering Melville." *Journal of Narrative Theory* 29 (1999): 62–84. American Periodical Series Online. 0-search.proquest.com.libcat.lafayette.edu.

Ellison, James. *George Sandys: Travel, Colonialism and Tolerance in the Seventeenth Century.* Cambridge: Brewer, 2002.

Ellison, Ralph. *The Collected Essays of Ralph Ellison.* Edited by John F. Callahan. New York: Modern Library, 1995.

———. *Invisible Man.* 1952. Reprint, New York: Vintage, 1995.

Ellwood, Thomas. *The History of the Life of Thomas Ellwood.* Edited by Joseph Wyeth. London, 1714. Eighteenth Century Collections Online. 0-find.galegroup .com.libcat.lafayette.edu/ecco.

———. *Thomas Ellwood's Davideis: A Reprint of the First Edition of 1712 with Various Readings of Later Editions.* Edited by Walther Paul Fischer. Heidelberg: Carl Winter's Universitätsbuchhandlung, 1936.

Emerson, Ralph Waldo. *Essays and Lectures.* Edited by Joel Porte. New York: Library of America, 1983.

———. *The Letters of Ralph Waldo Emerson.* Edited by Ralph L. Rush and Eleanor M. Tilton. 10 vols. New York: Columbia University Press, 1939–91.

Emerson, Ralph Waldo, and Thomas Carlyle. *The Correspondence of Emerson and Carlyle.* Edited by Joseph Slater. New York: Columbia University Press, 1964.

Erffa, Helmut von, and Allen Staley. *The Paintings of Benjamin West.* New Haven, CT: Yale University Press, 1986.

Etymologist [pseud.]. "'Yonnondio.'—A Word-History." *Critic* 207 (Dec. 17, 1887): 317. American Periodical Series Online. 0-search.proquest.com.libcat.lafayette.edu.

Everett, Alexander H. "Mrs. Sigourney." *United States Magazine, and Democratic Review* 11.51 (Sept. 1842): 246–49. American Periodical Series Online. 0-search .proquest.com.libcat.lafayette.edu.

Farington, Joseph. *The Farington Diary: By Joseph Farington, R.A.* Edited by James Greig. 8 vols. London: Hutchinson, 1923–28.

Ferguson, Robert A. *Law and Letters in American Culture.* Cambridge, MA: Harvard University Press, 1984.

———. "Longfellow's Political Fears: Civic Authority and the Role of the Artist in Hiawatha and Miles Standish." *American Literature* 50 (1978): 187–215. JSTOR. 0-www.jstor.org.libcat.lafayette.edu.

———. *Reading the Early Republic.* Cambridge: Harvard University Press, 2004.

"The Fine Arts. Death of Lord Nelson." *Port-Folio* 2.38 (Sept. 27, 1806): 186. American Periodical Series Online. 0-search.proquest.com.libcat.lafayette.edu.

"The Fine Arts: Obituary." *Literary World* 3.55 (Feb. 19, 1848): 51. American Periodical Series Online. 0-search.proquest.com.libcat.lafayette.edu.

Fischer, Walther Paul. Introduction to *Thomas Ellwood's Davideis: A Reprint of the First Edition of 1712 with Various Readings of Later Editions*, edited by Walther Paul Fischer, vii–xxvii. Heidelberg: Carl Winter's Universitätsbuchhandlung, 1936.

Fliegelman, Jay. *Declaring Independence: Jefferson, Natural Language, and the Culture of Performance*. Stanford, CA: Stanford University Press, 1993.

Folsom, Ed. *Whitman's Native Representations*. New York: Cambridge University Press, 1994.

Foster, Elizabeth S. "Historical Note." In *Mardi and a Voyage Thither*, by Herman Melville, edited by Harrison Hayford, Hershel Parker, and G. Thomas Tanselle, 657–81. 1970. Reprint, Evanston, IL: Northwestern University Press, 1998.

Frank, Armin Paul, and Kurt Mueller-Vollmer. *The Internationality of National Literatures in Either America: Transfer and Transformation, Volume 1/2: British America and the United States, 1770s–1850s*. Göttingen: Wallstein Verlag, 2000.

Franklin, H. Bruce. *The Wake of the Gods: Melville's Mythology*. Stanford, CA: Stanford University Press, 1963.

Freiligrath, Ferdinand. "*Vorwort des uebersetzers.*" In *Der Sang von Hiawatha*, translated by Ferdinand Freiligrath, vii–xiii. Stuttgart, 1857.

Fried, Michael. *Absorption and Theatricality: Painting and Beholder in the Age of Diderot*. Berkeley: University of California Press, 1980.

Fryd, Vivien Green. *Art and Empire: The Politics of Ethnicity in the United States Capitol, 1815–1860*. New Haven, CT: Yale University Press, 1992.

Furtwangler, Albert. *Acts of Discovery: Visions of America in the Lewis and Clark Journals*. Urbana: University of Illinois Press, 1993.

"Fuseli's Lectures on Painting." *Athenaeum; or, Spirit of the English Magazines* 1.7 (July 1, 1817): 7–8. American Periodical Series Online. 0-search.proquest.com.lib cat.lafayette.edu.

G. "Barlow's Columbiad." *Historical Magazine* 1 (1857): 93–94. American Periodical Series Online. 0-search.proquest.com.libcat.lafayette.edu.

Galt, John. *The Life, Studies, and Works of Benjamin West, Esq.* . . . 2 vols. 1820. Reprint, Gainesville, FL: Scholars' Facsimiles & Reprints, 1960.

Ganwell, Lynn, and Nancy Tomes. *Madness in America: Cultural and Medical Perceptions of Mental Illness before 1914*. Ithaca and Binghamton, NY: Cornell University Press/Binghamton University Art Museum, 1995.

Garrison, Daniel H. "Melville's Doubloon and the Shield of Achilles." *Nineteenth-Century Fiction* 26 (1971): 171–84. JSTOR. 0-www.jstor.org.libcat.lafayette.edu.

"George H. Story, Artist, Dies at 87." *New York Times* (Nov. 25, 1922): 10. ProQuest Historical Newspapers. 0-proquest.umi.com.libcat.lafayette.edu.

Gerdts, William H. "Daniel Huntington's 'Mercy's Dream': A Pilgrimage through Bunyanesque Imagery." *Winterthur Portfolio* 14 (1979): 171–94. JSTOR. 0-www.jstor .org.libcat.lafayette.edu.

Gibson-Wood, Carol. *Jonathan Richardson: Art Theorist of the English Enlightenment*. New Haven, CT: Paul Mellon Centre/Yale University Press, 2000.

Gilreath, James, ed., and Elizabeth Carter Wills, comp. *Federal Copyright Records: 1790–1800*. Washington, DC: Library of Congress, 1987.

Gilreath, James, and Douglas L. Wilson, eds. *Thomas Jefferson's Library: A Catalog with the Entries in His Own Order*. Washington, DC: Library of Congress, 1989.

Gittleman, Edwin. *Jones Very: The Effective Years, 1833–1840*. New York: Columbia University Press, 1967.

Goethe, Johann Wolfgang von, and Friedrich Schiller. *Correspondence between Goethe and Schiller 1794–1805*. Translated and edited by Liselotte Dieckmann. Studies in Modern German Literature 60. New York: Peter Lang, 1994.

Goldman, Stan. *Melville's Protest Theism: The Hidden and Silent God in Clarel.* DeKalb: Northern Illinois University Press, 1993.

Goodyear, Frank H., Jr. "A History of the Pennsylvania Academy of the Fine Arts, 1805–1976." In *In This Academy: The Pennsylvania Academy of the Fine Arts, 1805–1976*, by the Pennsylvania Academy of the Fine Arts, 12–49. Philadelphia: Pennsylvania Academy of the Fine Arts, 1976.

Graeme, Elizabeth. *Poemata Juvenilia*. Papers. Library Company of Philadelphia.

Griggs, Irwin, John D. Kern, and Elisabeth Schneider. "Early 'Edinburgh' Reviewers: A New List." *Modern Philology* 43 (1946): 192–210. JSTOR. 0-www.jstor.org.libcat .lafayette.edu.

Gummere, Richard M. *The American Colonial Mind and the Classical Tradition: Essays in Comparative Culture*. Cambridge, MA: Harvard University Press, 1963.

H. [Article on Leutze.] *Bulletin of the American Art-Union* (1849): 16–17.

———. "A Noble Picture." *North American* 8.2373 (Nov. 12, 1846): 1i.

Haight, Gordon S. *Mrs Sigourney: The Sweet Singer of Hartford*. New Haven, CT: Yale University Press, 1930.

Hamilton, Alexander, James Madison, and John Jay. *The Federalist*. Edited by Jacob E. Cooke. Middletown, CT: Wesleyan University Press, 1961.

Harrington, Joseph. "Why American Poetry Is Not American Literature." *American Literary History* 8 (1996): 496–515. JSTOR. 0-www.jstor.org.libcat.lafayette.edu.

Hawthorne, Manning, and Henry Wadsworth Longfellow Dana. "The Origin of Longfellow's *Evangeline*." *Papers of the Bibliographical Society of America* 41 (1947): 165–203.

Haydon, Benjamin Robert. *Diary*. Edited by Willard Bissell Pope. 5 vols. Cambridge, MA: Harvard University Press, 1960–63.

Hayford, Harrison. *Melville's Prisoners*. Evanston, IL: Northwestern University Press, 2003.

Heath, Shirley Brice. "American English: Quest for a Model." In *The Other Tongue: English across Cultures*, edited by Braj B. Kachru, 220–32. 2nd ed. Urbana: University of Illinois Press, 1992.

Hedge, Frederic H., and Frederic D. Huntington, eds. *Hymns for the Church of Christ*. 1853. Reprint, Boston, 1862. Google Books. books.google.com/books?id =YowNAAAAYAAJ.

Heffernan, James A. W. *Museum of Words: The Poetics of Ekphrasis from Homer to Ashbery*. Chicago: University of Chicago Press, 1993.

Herder, Johann Gottfried. *The Spirit of Hebrew Poetry*. Translated by James Marsh. 2 vols. Burlington, VT, 1833.

"Hiawatha by a Live Indian." *Daily Bee* (Feb. 4, 1857): 3.

Higgins, Brian, and Hershel Parker, eds. *Critical Essays on Herman Melville's* Moby-Dick. New York: G. K. Hall, 1992.

———, eds. *Herman Melville: The Contemporary Reviews*. New York: Cambridge University Press, 1995.

Hobbs, Susan. *1876: American Art of the Centennial.* Washington, DC: National Collection of Fine Arts / Smithsonian Institution Press, 1976.

Hoeltje, Hubert H. "Hawthorne's Review of *Evangeline.*" *New England Quarterly* 23 (1950): 232–35. JSTOR. o-www.jstor.org.libcat.lafayette.edu.

Hofland, Thomas R. "The Fine Arts in the United States, with a Sketch of Their Present and Past History in Europe." *Knickerbocker* 14.1 (July 1839): 39–52. American Periodical Series Online. o-search.proquest.com.libcat.lafayette.edu.

Homer. *The Iliad of Homer, translated by Alexander Pope, Esq.* Illustrated by Alexander Anderson. 2 vols. New York, 1808.

———. *L'Iliade d'Homère.* Paris, 1809.

———. *The Iliad.* Translated by Robert Fitzgerald. Everyman's Library. 1974. Reprint, New York: Knopf, 1992.

———. *The Odyssey.* Translated by Robert Fitzgerald. Everyman's Library. 1961. Reprint, New York: Knopf, 1992.

"Homer." *North American Review* 37 (1833): 340–74. American Periodical Series Online. o-search.proquest.com.libcat.lafayette.edu.

Howard, Leon. *The Connecticut Wits.* Chicago: University of Chicago Press, 1943.

Howells, William Dean. "The Art of Longfellow." *North American Review* 184.610 (Mar. 1, 1907): 472–85. American Periodical Series Online. o-search.proquest.com.libcat.lafayette.edu.

Hsu, Hsuan. "War, Ekphrasis, and Elliptical Form in Melville's *Battle-Pieces.*" *Nineteenth Century Studies* 16 (2002): 51–71.

Huston, John, dir. *The Red Badge of Courage.* 1951. Burbank, CA: Warner/MGM, 2002. DVD.

Hutchins, James R. "Proposal of James R. Hutchins, for publishing by subscription, an original work, in blank verse—entitled, The Gospel Tragedy, an epic poem. . . ." *Massachusetts Spy* (Mar. 18, 1795): 3. American Periodical Series Online. o-search.proquest.com.libcat.lafayette.edu.

Inness, George. *George Inness: Writings and Reflections of Art and Philosophy.* Edited by Adrienne Baxter Bell. New York: George Braziller, 2006.

Jackson, Donald, ed. *Letters of the Lewis and Clark Expedition with Related Documents, 1783–1854.* 2nd ed. 2 vols. Urbana: University of Illinois Press, 1978.

Jackson, Virginia. "Bryant; or, American Romanticism." In *The Traffic in Poems: Nineteenth-Century Poetry and Transatlantic Exchange,* edited by Meredith L. McGill, 185–204. New Brunswick, NJ: Rutgers University Press, 2008.

———. *Dickinson's Misery: A Theory of Lyric Reading.* Princeton, NJ: Princeton University Press, 2005.

———. "Longfellow's Tradition; or, Picture-Writing a Nation." *Modern Language Quarterly* 59 (1998): 471–96. Duke University Press. o-mlq.dukejournals.org.libcat.lafayette.edu.

James, Henry. *William Wetmore Story and His Friends: From Letters, Diaries, and Recollections.* 2 vols. New York: Grove Press, 1957.

Jameson, Frederic. *Fables of Aggression: Wyndham Lewis, the Modernist as Fascist.* Berkeley: University of California Press, 1979.

Jarves, James Jackson. *The Art-Idea: Sculpture, Painting and Architecture in America.* New York, 1865.

Jefferson, Thomas. *Writings*. Edited by Merrill D. Peterson. New York: Library of America, 1984.

Jeffrey, Francis. "The Columbiad: A Poem. By Joel Barlow." *Edinburgh Review* 15 (1809): 24–40.

Jenkyns, Richard. *The Victorians and Ancient Greece*. Cambridge, MA: Harvard University Press, 1980.

J. N. D. "John Bunyan," *New York Observer and Chronicle* 25.43 (Oct. 23, 1847): 1. American Periodical Series Online. o-search.proquest.com.libcat.lafayette.edu.

Johns, Elizabeth. *Thomas Eakins: The Heroism of Everyday Life*. Princeton, NJ: Princeton University Press, 1983.

Johnson, Samuel. *A Dictionary of the English Language*. 2 vols. London, 1755.

Jones, Howard Mumford. "Prose and Pictures: James Fenimore Cooper." *Tulane Studies in English* 3 (1952): 136–37.

Jung, Sandro. *The Fragmentary Poetic: Eighteenth-Century Uses of an Experimental Mode*. Bethlehem, PA: Lehigh University Press, 2009.

Junker, Patricia. "Cole's *Prometheus Bound*: An Allegory for the 1840s." *American Art Journal* 31 (2000): 32–55. JSTOR. o-www.jstor.org.libcat.lafayette.edu.

Kafer, Peter K. "The Making of Timothy Dwight: A Connecticut Morality Tale," *William and Mary Quarterly*, 3rd ser., 47 (1990): 189–209. JSTOR. o-www.jstor.org .libcat.lafayette.edu.

Kames, Henry Home, Lord. *Elements of Criticism*. 2 vols. 3rd ed. Eighteenth Century Collections Online. o-find.galegroup.com.libcat.lafayette.edu/ecco.

Kaminsky, Stuart. *John Huston: Maker of Magic*. Boston: Houghton Mifflin, 1978.

Kaul, Suvir. *Poems of Nation, Anthems of Empire: English Verse in the Long Eighteenth Century*. Charlottesville, VA: University of Virginia Press, 2000.

Kazin, Alfred. *An American Procession*. New York: Knopf, 1984.

Kendrick, Christopher. *Milton: A Study in Ideology and Form*. New York: Methuen, 1986.

Kendrick, Robert L. "Re-Membering America: Phillis Wheatley's Intertextual Epic." *African-American Review* 30 (1996): 71–88. JSTOR. o-www.jstor.org.libcat.lafayette .edu.

Kennedy, George. "Classical Influences on *The Federalist*." In *Classical Traditions in America*, edited by John W. Eadie, 119–38. Ann Arbor: University of Michigan Press, 1976.

Kennedy, Thomas J. "Francis Lieber (1798–1872): German-American Poet and Transmitter of German Culture to America." *German-American Studies* 5 (1972): 28–50.

Kenny, Vincent. *Herman Melville's* Clarel; *A Spiritual Autobiography*. Hamden, CT: Archon, 1973.

Ketcham, Ralph. *James Madison: A Biography*. New York: Macmillan, 1971.

Kettell, Samuel. *Specimens of American Poetry, with Critical and Biographical Notices*. 3 vols. Boston, 1829.

Kilcup, Karen L., ed. *Native American Women's Writing: 1800–1924: An Anthology*. Malden, MA: Blackwell, 2000.

King, Everard H. *James Beattie's* The Minstrel *and the Origins of Romantic Autobiography*. Lewiston, NY: Edwin Mellen, 1992.

Kirby, William, and William Spence. *An Introduction to Entomology; or, Elements of the Natural History of Insects.* 7th ed. London, 1857.

Kloss, William. *Samuel F. B. Morse.* New York: Abrams/Smithsonian, 1988.

Konkle, Maureen. *Writing Indian Nations: Native Intellectuals and the Politics of Historiography, 1827–1863.* Chapel Hill: University of North Carolina Press, 2004.

Lanman, Charles. "The Epic Paintings of Thomas Cole." *Southern Literary Messenger* 15 (June 1849): 351–56. American Periodical Series Online. 0-search.proquest .com.libcat.lafayette.edu.

LaRue, L. H. *Constitutional Law as Fiction: Narrative in the Rhetoric of Authority.* University Park: Pennsylvania State University Press, 1995.

Lauter, Paul. "Teaching Lydia Sigourney." In *Teaching Nineteenth-Century American Poetry,* edited by Paul Bernat Bennett, Karen L. Kilcup, and Philipp Schweighauser, 109–24. Options for Teaching. New York: Modern Language Association, 2007.

Lawrence, D. H. *Studies in Classical American Literature.* 1923. Reprint, New York: Penguin, 1986.

"Lectures on Painting, delivered by Henry Fuseli, P. P., with additional Observations and Notes." *Boston Monthly Magazine* 1 (Nov. 1825): 331–35. American Periodical Series Online. 0-search.proquest.com.libcat.lafayette.edu.

Levine, Robert S. "Lydia Howard Huntley Sigourney: 1791–1865." In *The Norton Anthology of American Literature: Volume B: 1820–1865,* edited by Robert S. Levine and Arnold Krupat, 1028–29. 7th ed. New York: Norton, 2007.

Lewalski, Barbara K. *The Life of John Milton: A Critical Biography.* Malden, MA: Blackwell, 2000.

Lewis, C. S. *A Preface to Paradise Lost.* 1941. Reprint, New York: Oxford University Press, 1960.

Lewis, Emanuel Raymond. "The Ambiguous Columbiads." *Military Affairs* 28 (1964): 111–22. JSTOR. 0-www.jstor.org.libcat.lafayette.edu.

Lieber, Francis, ed. *Encyclopaedia Americana. A Popular Dictionary of Arts, Sciences, Literature, History, Politics and Biography, Brought Down to the Present Time; including a Copious Collection of Original Articles in American Biography; on the Basis of the Seventh Edition of the German Conversations-Lexicon.* 13 vols. Philadelphia: 1829–33.

Lindsay, Jack. *J. M. W. Turner: His Life and Work; A Critical Biography.* Greenwich, CT: New York Graphic Society, 1966.

Loeffelholz, Mary. *From School to Salon: Reading Nineteenth-Century American Women's Poetry.* Princeton, NJ: Princeton University Press, 2004.

Longfellow, Henry Wadsworth. *Christus: A Mystery.* 1872. Reprint, Boston, 1873.

———. "Defence of Poetry." *North American Review* 34 (1832): 56–78. American Periodical Series Online. 0-search.proquest.com.libcat.lafayette.edu.

———. *The Letters of Henry Wadsworth Longfellow.* Edited by Andrew Hilen. 6 vols. Cambridge, MA: Belknap/Harvard University Press, 1966–82.

———. *Poems and Other Writings.* Edited by J. D. McClatchy. New York: Library of America, 2000.

Longfellow, Samuel, ed. *The Life of Henry Wadsworth Longfellow: With Extracts from His Journals and Correspondence.* 2 vols. 2nd ed. Boston, 1886.

Lowell, James Russell. *The Poetical Works.* 1876. Reprint, Boston, 1879.

Lukács, Georg. *The Historical Novel.* Translated by Hannah and Stanley Mitchell. 1962. Reprint, Lincoln: University of Nebraska Press, 1983.

———. *The Theory of the Novel: A Historico-Philosophical Essay on the Forms of Great Epic Literature.* Translated by Anna Bostock. Cambridge, MA: MIT Press, 1971.

Marshall, John. *John Marshall: Major Opinions and Other Writings.* Edited by John P. Roche and Stanley B. Bernstein. Indianapolis: Bobbs-Merrill, 1967.

Martin, Benjamin. *Lingua Britannica Reformata.* London, 1754.

Mason, Julian D., ed. *The Poems of Phillis Wheatley.* Chapel Hill: University of North Carolina Press, 1966.

Mason, Philip P., ed. *The Literary Voyager, or Muzzegienun.* East Lansing: Michigan State University Press, 1962.

McCloskey, Robert Green. Introduction to *The Works of James Wilson,* edited by Robert Green McCloskey, 1–52. 2 vols. Cambridge, MA: Belknap / Harvard University Press, 1967.

McGill, Meredith L., ed. *The Traffic in Poems: Nineteenth-Century Poetry and Transatlantic Exchange.* New Brunswick, NJ: Rutgers University Press, 2008.

McWilliams, John P., Jr. *The American Epic: Transforming a Genre, 1770–1860.* New York: Cambridge University Press, 1989.

Melville, Herman. *Clarel: A Poem and Pilgrimage in the Holy Land.* Edited by Harrison Hayford et al., notes by Walter E. Bezanson. The Writings of Herman Melville 12. Evanston/Chicago: Northwestern University Press / Newberry Library, 1991.

———. *Correspondence.* Edited by Lynn Horth. The Writings of Herman Melville 15. Evanston/Chicago: Northwestern University Press / Newberry Library, 1993.

———. "Hawthorne and His Mosses." In *Moby-Dick,* edited by Harrison Hayford and Hershel Parker, 517–32. Norton Critical Editions, 2nd ed. New York: Norton, 2001.

———. *Journals.* Edited by Howard C. Horsford with Lynn Horth. The Writings of Herman Melville 14. Evanston/Chicago: Northwestern University Press / Newberry Library, 1989.

———. *Mardi and a Voyage Thither.* Edited by Harrison Hayford, Hershel Parker, and G. Thomas Tanselle. 1970. Reprint, Evanston, IL: Northwestern University Press, 1998.

———. *Moby-Dick, or The Whale.* Edited by Harrison Hayford, Hershel Parker, and G. Thomas Tanselle. The Writings of Herman Melville 6. Evanston/Chicago: Northwestern University Press / Newberry Library, 1988.

———. *Published Poems.* Edited by Robert C. Ryan et al. The Writings of Herman Melville 11. Evanston/Chicago: Northwestern University Press / Newberry Library, 2009.

———. *Redburn His First Voyage: Being the Sailor-boy Confessions and Reminiscences of the Son-of-a-Gentleman, in the Merchant Service.* Edited by Harrison Hayford, Hershel Parker, and G. Thomas Tanselle. The Writings of Herman Melville 4. Evanston/Chicago: Northwestern University Press / Newberry Library, 1969.

———. *Selected Poems.* Edited by Robert Faggen. New York: Penguin, 2006.

Mendelson, Edward. "Encyclopedic Narrative: From Dante to Pynchon." *MLN* 91 (1976): 1267–75. JSTOR. 0-www.jstor.org.libcat.lafayette.edu.

Miller, Angela. *The Empire of the Eye: Landscape Representation and American Cultural Politics, 1825–1875.* Ithaca, NY: Cornell University Press, 1993.

Miller, Perry, ed. *The Transcendentalists: An Anthology.* 1950. Reprint, Cambridge, MA: Harvard University Press, 1978.

Milton, John. *Paradise Lost.* Edited by Scott Elledge. Norton Critical Editions, 2nd ed. New York: Norton, 1993.

Mitchell, Charles. "Benjamin West's *Death of Nelson*." In *Essays in the History of Art Presented to Rudolf Wittkower*, edited by Douglas Fraser, Howard Hibbard, and Milton J. Lewine, 265–73. New York: Phaidon, 1967.

Mitnick, Barbara J. "The History of History Painting." In *Picturing History: American Painting 1770–1930*, edited by William Ayres, 29–43. New York: Rizzoli, 1993.

Moretti, Franco. "Conjectures on World Literature." *New Left Review* 1 (2000): 54–68.

———. *The Modern Epic: The World-System from Goethe to García Márquez.* New York: Verso, 1996.

Morse, Samuel F. B. "The Exhibition of the National Academy of Design, 1827." *United States Review and Literary Gazette* 2.4 (July 1827): 1–23.

———. *Lectures on the Affinity of Painting with the Other Fine Arts.* Edited by Nicolai Cikovsky, Jr. Columbia: University of Missouri Press, 1983.

———. Papers. National Academy of Design, New York.

Morton, Sarah Wentworth. *Beacon Hill. A Local and Historical Poem.* Boston, 1797.

———. *Ouâbi: Or the Virtues of Nature.* Boston, 1790.

———. *The Virtues of Society. A Tale, Founded on Fact.* Boston, 1799.

Moulton, Gary E., ed. *The Lewis and Clark Journals: An American Epic of Discovery.* Lincoln: University of Nebraska Press, 2003.

Moyne, Ernest J. *Hiawath and Kalevala: A Study of the Relationship between Longfellow's "Indian Edda" and the Finnish Epic.* Helsinki: Suomalainen Tiedeakatemia, 1963.

"Mr. West's Picture." *Windham Herald* 21.1079 (Aug. 11, 1811): 1. America's Historical Newspapers. 0-infoweb.newsbank.com.libcat.lafayette.edu.

Murnaghan, Sheila. "The Poetics of Loss in Greek Epic." In *Epic Traditions in the Contemporary World: The Poetics of Community*, edited by Margaret Beissinger, Jane Tylus, and Susanne Wofford, 203–21. Berkeley: University of California Press, 1999.

Nadel, Alan. "The Integrated Literary Tradition." In *A Historical Guide to Ralph Ellison*, edited by Steven C. Tracy, 143–70. New York: Oxford University Press, 2004.

"New Painting. From a British Publication." *Newport Mercury* 52.2718 (Apr. 30, 1814): 3c. America's Historical Newspapers. 0-infoweb.newsbank.com.libcat.lafayette.edu.

Noble, Louis Legrand. *The Life and Works of Thomas Cole.* Edited by Elliot S. Vesell. Cambridge, MA: Belknap/Harvard University Press, 1964.

"Notices.—Editor's Table." *Ladies' Repository, and Gatherings of the West* 8 (June 1848): 191. American Periodical Series Online. 0-search.proquest.com.libcat.lafayette.edu.

"Novels." *Western Monthly Review* 2 (Dec. 1828): 419–24. American Periodical Series Online. 0-search.proquest.com.libcat.lafayette.edu.

"Novel Writing." *Illinois Monthly Magazine* 2.13 (Oct. 1831): 18–25. American Periodical Series Online. 0-search.proquest.com.libcat.lafayette.edu.

Nutty, Sue Himelick. "John Sartain and Joseph Harrison, Jr." In *Philadelphia's Cultural Landscape: The Sartain Family Legacy*, edited by Katharine Martinez and Page Talbott, 51–61. Philadelphia: Temple University Press, 2000.

Obenzinger, Hilton. *American Palestine: Melville, Twain, and the Holy Land Mania.* Princeton: Princeton University Press, 1999.

[Obituary for Richard Snowden.] *The Saturday Evening Post* 4.39 (Sept. 24, 1825). America's Historical Newspapers. 0-infoweb.newsbank.com.libcat.lafayette.edu.

O'Connell, Patrick F. "'The Battle of the Ants': Two Notes." *Thoreau Journal Quarterly* 12.4 (1980): 9–13.

Oestreicher, David M. "Unraveling the *Walam Olum*." In *Portraits of Rafinesque*, edited by Charles Boewe, 233–40. Knoxville: University of Tennessee Press, 2003.

Oettermann, Stephan. *The Panorama: History of a Mass Medium.* Translated by Deborah Lucas Schneider. New York: Zone, 1997.

Olsen-Smith, Steven, and Dennis C. Marnon. "Melville's Marginalia in *The Works of Sir William D'Avenant*." *Leviathan* 6.1 (2004): 79–102.

Ortuño, Carlos. *Historia Numismática del Ecuador.* Quito: Banco Central del Ecuador, 1978.

Otis, Brooks. *Ovid as Epic Poet.* 2nd ed. Stanford, CA: Stanford University Press, 1970.

"Our Landscape Painters." *New-York Mirror* 18.4 (July 18, 1840): 29–30. American Periodical Series Online. 0-search.proquest.com.libcat.lafayette.edu.

"Our New States and Territories." *Beadle's Monthly* 2 (1866): 181–92. American Periodical Series Online. 0-search.proquest.com.libcat.lafayette.edu.

Ousterhout, Anne M. *The Most Learned Woman in America: A Life of Elizabeth Graeme Fergusson.* University Park: Pennsylvania State University Press, 2004.

———. *A State Divided: Opposition in Pennsylvania to the American Revolution.* New York: Greenwood Press, 1987.

Ovid. *Metamorphoses.* Translated by A. D. Melville. Oxford World Classics. New York: Oxford University Press, 1986.

Palmer, Gregory. *Biographical Sketches of Loyalists of the American Revolution.* Westport, CT: Meckler, 1984.

Parker, Hershel. *Herman Melville: A Biography.* 2 vols. Baltimore: Johns Hopkins University Press, 1996–2002.

———. "Historical Note." In *Redburn His First Voyage: Being the Sailor-Boy Confessions and Reminiscences of the Son-of-a-Gentleman, in the Merchant Service*, by Herman Melville, edited by Harrison Hayford et al., 315–52. The Writings of Herman Melville 4. Evanston/Chicago: Northwestern University Press/Newberry Library, 1969.

———. *Melville: The Making of a Poet.* Evanston, IL: Northwestern University Press, 2008.

Parker, Hershel, and Harrison Hayford, eds. *Moby-Dick*, by Herman Melville. Norton Critical Editions, 2nd ed. New York: Norton, 2001.

Parry, Ellwood, III. *The Art of Thomas Cole: Ambition and Imagination.* Newark: University of Delaware Press, 1988.

Paulson, Ronald. *Literary Landscape, Turner and Constable.* New Haven, CT: Yale University Press, 1982.

Pease, Donald. Introduction to James Fenimore Cooper, *The Deerslayer*, ed. Donald Pease, vii–xxv. New York: Penguin, 1987.

Peyer, Bernd C. *The Tutor'd Mind: Indian Missionary-Writers in Antebellum America*. Amherst: University of Massachusetts Press, 1997.

Phillips, Christopher N. "Epic, Anti-Eloquence, and Abolitionism: Thomas Branagan's *Avenia* and *The Penitential Tyrant*." *Early American Literature* 44 (2009): 605–37.

———. "Fragmenting the Bard: Sarah Wentworth Morton's Intertextual Epic." *Literature in the Early American Republic* 4 (2012): 41–65.

"The Pleasures of the Pen." *United States Magazine, and Democratic Review* 20.103 (Jan. 1847): 103–10. American Periodical Series Online. o-search.proquest.com. libcat.lafayette.edu.

Pomeroy, Jane R. *Alexander Anderson (1775–1870): Wood Engraver and Illustrator: An Annotated Bibliography*. 3 vols. New Castle, DE: Oak Knoll Press / AAS / NYPL, 2005.

Pope, Alexander. Preface to *The Iliad of Homer, translated by Mr. Pope*, vol. 1, n.p. London, 1715.

———. *Poetry and Prose of Alexander Pope*. Edited by Aubrey Williams. Riverside Editions. Boston: Houghton Mifflin, 1969.

Post-Lauria, Sheila. *Correspondent Colorings: Melville in the Marketplace*. Amherst: University of Massachusetts Press, 1996.

Potter, William. *Melville's Clarel and the Intersympathy of Creeds*. Kent, OH: Kent State University Press, 2004.

"Professor Howard's Concluding Lecture on Painting." *Anglo-American* 1.8 (June 17, 1843): 182–84. American Periodical Series Online. o-search.proquest.com.libcat. lafayette.edu.

"Prologomena ad Homerum." *American Quarterly Review* 2 (1827): 307–37. American Periodical Series Online. o-search.proquest.com.libcat.lafayette.edu.

Pye, John. *Notes and Memoranda Respecting the Liber Studiorum of J. M. W. Turner, R.A.* Edited by John Lewis Roget. London, 1879. Google Books. books.google. com/books?id=kahAAAAAYAAJ.

Quaife, Milo M. "Some New-Found Records of the Lewis and Clark Expedition." *Mississippi Valley Historical Review* 2 (1915): 106–17. JSTOR. o-www.jstor.org.libcat.lafayette.edu.

Quint, David. *Epic and Empire: Politics and Generic Form from Virgil to Milton*. Princeton, NJ: Princeton University Press, 1993.

Rafinesque, Constantine Samuel. *The American Nations; or, Outlines of Their General History, Ancient and Modern*. Vol. 1. Philadelphia, 1836.

——— [as Constantine Jobson]. *The World; or, Instability*. Edited by Charles Boewe. Gainesville, FL: Scholars' Facsimiles & Reprints, 1956.

Rainey, Sue. *Creating* Picturesque America: *Monument to the Natural and Cultural Landscape*. Nashville, TN: Vanderbilt University Press, 1994.

Rakove, Jack N. "The Madisonian Moment." *University of Chicago Law Review* 55 (1988): 473–505. JSTOR. o-www.jstor.org.libcat.lafayette.edu.

Rampersad, Arnold. *Ralph Ellison: A Biography*. New York: Knopf, 2007.

Rans, Geoffrey. *Cooper's Leather Stocking Novels: A Secular Reading*. Chapel Hill: North Carolina University Press, 1991.

Reinhold, Meyer. *Classica Americana: The Greek and Roman Heritage in the United States*. Detroit: Wayne State University Press, 1984.

Reynolds, Joshua. *Discourses*. Edited by Pat Rogers. New York: Penguin, 1992.

Richard, Carl J. *The Founders and the Classics: Greece, Rome, and the American Enlightenment*. Cambridge, MA: Harvard University Press, 1994.

Richardson, Jonathan. *The Works of Mr. Jonathan Richardson*. London, 1773. Eighteenth Century Collections Online. o-find.galegroup.com.libcat.lafayette.edu/ecco.

Robertson-Lorant, Laurie. *Melville: A Biography*. Amherst: University of Massachusetts Press, 1996.

Robillard, Douglas J. *Melville and the Visual Arts: Ionian Form, Venetian Tint*. Kent, OH: Kent State University Press, 1997.

Rosen, Gary. "James Madison and the Problem of Founding." *Review of Politics* 58 (1996): 561–95. JSTOR. o-www.jstor.org.libcat.lafayette.edu.

Ross, Lillian. *Picture*. New York: Rinehart, 1952.

"Rothermel's New National Painting." *Philadelphia Sun* (Feb. 16, 1852): 2.

Ruoff, A. LaVonne Brown. "Early Native American Women Writers: Jane Johnston Schoolcraft, Sarah Winnemucca, S. Alice Callahan, E. Pauline Johnson, and Zitkala-Sa." In *Nineteenth-Century American Women Writers: A Critical Reader*, edited by Karen L. Kilcup, 81–111. Malden, MA: Blackwell, 1998.

Ruskin, John. *The Seven Lamps of Architecture*. 2nd ed. 1880. Reprint, New York: Dover, 1989.

Sandys, George. *Ovids Metamorphosis*. London, 1626.

———. *Ovids Metamorphosis*. London, 1632.

Sayre, Gordon M. *The Indian Chief as Tragic Hero: Native Resistance and the Literatures of America, from Moctezuma to Tecumseh*. Chapel Hill: University of North Carolina Press, 2005.

Schoolcraft, Jane Johnston. *The Sound the Stars Make Rushing through the Sky: The Writings of Jane Johnston Schoolcraft*. Edited by Robert Dale Parker. Philadelphia: University of Pennsylvania Press, 2007.

Schulman, Lydia Dittler. Paradise Lost *and the Rise of the American Republic*. Boston: Northeastern University Press, 1992.

Seelye, John. "Attic Shape: Dusting Off *Evangeline*." *Virginia Quarterly Review* 60 (1984): 21–44.

———. "Flashing Eyes and Floating Hair: The Visionary Mode in Early American Poetry." *Virginia Quarterly Review* 65 (1989): 189–214. vqronline.org/issues.

Sensabaugh, George F. *Milton in Early America*. Princeton, NJ: Princeton University Press, 1964.

Sheldon, Leslie E. "Messianic Power and Satanic Decay: Milton in *Moby-Dick*." In *Melville and Milton: An Edition and Analysis of Melville's Annotations on Milton*, edited by Robin Grey, 25–46. Pittsburgh: Duquesne University Press.

Shields, David S. *Civil Tongues and Polite Letters in British America*. Chapel Hill: OIEAHC/University of North Carolina Press, 1997.

———. *Oracles of Empire: Poetry, Politics, and Commerce in British America, 1690–1750*. Chicago: University of Chicago Press, 1990.

Shields, John C. *The American Aeneas: Classical Origins of the American Self*. Knoxville: University of Tennessee Press, 2001.

———. "Phillis Wheatley and Mather Byles: A Study in Literary Relationship." *CLA* 23 (1980): 377–90.

Short, Bryan C. "Form as Vision in Melville's *Clarel.*" *American Literature* 50 (1979): 553–69. JSTOR. 0-www.jstor.org.libcat.lafayette.edu.

Shulenberger, Arvid. *Cooper's Theory of Fiction: His Prefaces and Their Relation to His Novels.* Lawrence: University of Kansas Press, 1955.

Sigourney, Lydia Huntley. *Illustrated Poems.* Philadelphia, 1849.

———. *Letters of Life.* New York, 1868. Google Books. books.google.com/books?id =D9UAAAAAYAAJ.

———. *Pocahontas and Other Poems.* New York, 1841.

———. *Traits of the Aborigines of America: A Poem.* Cambridge, MA, 1822.

———. *Zinzendorff and Other Poems.* 1835. Reprint, New York, 1837.

Silva-Gruesz, Kirsten. *Ambassadors of Culture: The Transamerican Origins of Latino Writing.* Princeton, NJ: Princeton University Press, 2002.

Silverman, Kenneth. *Timothy Dwight.* New York: Twayne, 1969.

Slauter, Eric. *The State as a Work of Art: The Cultural Origins of the Constitution.* Chicago: University of Chicago Press, 2009.

Smeall, J. F. S. "The Respective Roles of Hugh Brackenridge and Philip Freneau in Composing *The Rising Glory of America.*" *Papers of the Bibliographical Society of America* 67 (1973): 263–81.

Smith, Charles Page. *James Wilson: Founding Father 1742–1798.* Chapel Hill: Institute of Early American History and Culture / University of North Carolina Press, 1956.

Smith, David E. "Publication of John Bunyan's Works in America." *Bulletin of the New York Public Library* 66 (1962): 630–52.

Smith, Donald B. "The Life of George Copway or Kah-ge-ga-gah-bowh (1818–1869)— and a Review of His Writings." *Journal of Canadian Studies / Revue d'études canadiennes* 23.3 (1988): 5–38.

Smith, Elihu Hubbard, ed. *American Poems.* New York, 1793.

Snowden, Richard. *The American Revolution: Written in the Style of Ancient History.* 2 vols. Philadelphia, 1793–94.

———. *The Columbiad; or, A Poem on the American War.* Philadelphia, 1795.

Sorby, Angela. *Schoolroom Poets: Childhood, Performance, and the Place of American Poetry, 1865–1917.* Durham: University of New Hampshire Press, 2005.

Spenser, Edmund. *The Faerie Queene.* Edited by Thomas P. Roche, Jr., with the assistance of C. Patrick O'Donnell, Jr. New York: Penguin, 1978.

Spratt, Samuel Jackson. *The Sublime and the Beautiful of Scripture; Being Essays on Select Passages of Sacred Composition.* New York, 1795. Early American Imprints. 0-infoweb.newsbank.com.libcat.lafayette.edu.

Squier, George. "Historical and Mythological Traditions of the Algonquins; With a Translation of the 'Walam-Olum,' or Bark Record of the Linni-Lenape." *American Review* 3.2 (Feb. 1849): 173–93. American Periodical Series Online. 0-search.proquest .com.libcat.lafayette.edu.

Stabile, Susan M. Introduction to *The Most Learned Woman in America: A Life of Elizabeth Graeme Fergusson,* by Anne M. Ousterhout, 1–27. University Park: Pennsylvania State University Press, 2004.

Staiti, Paul J. *Samuel F. B. Morse.* New York: Cambridge University Press, 1989.

Stewart, Susan. *On Longing: Narratives of the Miniature, the Gigantic, the Souvenir, the Collection*. Durham, NC: Duke University Press, 1993.

Sweeney, J. Gray. "The Advantages of Genius and Virtue: Thomas Cole's Influence, 1848–58." In *Thomas Cole: Landscape into History*, edited by William H. Truettner and Alan Wallach, 113–35. New Haven, CT: Yale University Press / National Museum of Art, 1994.

Talbot, William S. *Jasper F. Cropsey: 1823–1900*. Washington, DC: Smithsonian, 1970.

Tarlinskaja, Marina, and Naira Oganesova. "Meter and Meaning: The Semantic 'Halo' of Verse Form in English Romantic Lyric Poems (Iambic and Trochaic Tetrameter)." *American Journal of Semiotics* 4.3–4 (1986): 85–106.

Tasso, Torquato. *Jerusalem Delivered: An English Prose Version*. Translated and edited by Ralph Nash. Detroit: Wayne State University Press, 1987.

Tedlock, Dennis. Foreword to "Walam Olum." In *The Multilingual Anthology of American Literature: A Reader of Original Texts with English Translations*, edited by Marc Shell and Werner Sollors, 95–96. New York: New York University Press, 2000.

"A Ten-Inch Columbiad Mounted as a Mortar at Fort Sumter." *Harper's Weekly* 5 (Feb. 16, 1861): 100. HarpWeek. 0-app.harpweek.com.libcat.lafayette.edu.

"The Thinker." *New York Evangelist* 12.45 (Nov. 6, 1841): 180.

Thistlethwaite, Mark. "John Sartain and Peter F. Rothermel." In *Philadelphia's Cultural Landscape: The Sartain Family Legacy*, edited by Katharine Martinez and Page Talbott, 39–50. Philadelphia: Temple University Press, 2000.

———. *Painting in the Grand Manner: The Art of Peter Frederick Rothermel (1812–1895)*. Chadds Ford, PA: Brandywine River Museum, 1995.

Thoreau, Henry David. *Walden*. Edited by Jay Lyndon Shanley. Princeton, NJ: Princeton University Press, 1971.

Thorp, Willard. "Herman Melville's Silent Years." *University Review* 3 (1937): 254–62.

———. "Historical Note." In *White-Jacket* by Herman Melville, edited by Harrison Hayford, Hershel Parker, and G. Thomas Tanselle, 403–40. The Writings of Herman Melville 5. Evanston/Chicago: Northwestern University Press / Newberry Library, 1970.

Tichi, Cecilia. "Longfellow's Motives for the Structure of 'Hiawatha.'" *American Literature* 42 (1971): 548–53. JSTOR. 0-www.jstor.org.libcat.lafayette.edu.

Tilton, Robert. *Pocahontas: The Evolution of an American Narrative*. New York: Cambridge University Press, 1994.

Trachtenberg, Alan. *Shades of Hiawatha: Staging Indians, Making Americans 1880–1930*. New York: Hill & Wang, 2004.

"Traits of the Aborigines of America." *Christian Spectator* 5 (May 1, 1823): 257–63. American Periodical Series Online. 0-search.proquest.com.libcat.lafayette.edu.

Traubel, Horace. *With Walt Whitman in Camden*. 9 vols. New York: Kennerley, 1914–.

Truettner, William H. "Nature and the Native Tradition: The Problem of the Two Coles." In *Thomas Cole: Landscape into History*, edited by William H. Truettner and Alan Wallach, 137–58. New Haven, CT: Yale University Press / National Museum of Art, 1994.

Truettner, William H., and Alan Wallach, eds. *Thomas Cole: Landscape into History*. New Haven, CT: Yale University Press / National Museum of Art, 1994.

Trumbull, John. *An Essay on the Use and Advantages of the Fine Arts.* New-Haven, CT: 1770. Early American Imprints. o-infoweb.newsbank.com.libcat.lafayette.edu.

Tucker, Herbert F. *Epic: Britain's Heroic Muse 1790–1910.* New York: Oxford University Press, 2008.

"Uncle Tomitudes." *Putnam's Monthly* 1 (1853): 97–102. American Periodical Series Online. o-search.proquest.com.libcat.lafayette.edu.

Upham, Warren. *Minnesota Geographic Names: Their Origin and Historic Significance.* St. Paul: Minnesota Historical Society, 1920.

Vendler, Helen. "Melville and the Lyric of History." *Southern Review* 35 (1999): 579–94.

Verplanck, Gulian, ed. *The Writings of Robert C. Sands: In Prose and Verse.* 2 vols. New York, 1834. Google Books. books.google.com/books?id=gcpIAAAAMAAJ (vol. 1), books.google.com/books?id=LiMaAAAAYAAJ (vol. 2).

Very, Jones. *Essays and Poems.* Boston, 1839.

Wagenknecht, Edward. *Longfellow: Portrait of an American Humanist.* New York: Longmans, 1955.

Wallace, Robert K. *Melville and Turner: Spheres of Love and Fright.* Athens: University of Georgia Press, 1992.

Wallach, Alan. "Cole, Byron, and the Course of Empire." *Art Bulletin* 50 (1968): 375–79. JSTOR. o-www.jstor.org.libcat.lafayette.edu.

———. "Thomas Cole: Landscape and the Course of American Empire." In *Thomas Cole: Landscape into History*, edited by William H. Truettner and Alan Wallach, 23–113. New Haven, CT: Yale University Press / National Museum of Art, 1994.

———. "The *Voyage of Life* as Popular Art." *Art Bulletin* 29 (1977): 234–41. JSTOR. o-www.jstor.org.libcat.lafayette.edu.

Walls, Laura Dassow. *The Passage to Cosmos: Alexander von Humboldt and the Shaping of America.* Chicago: University of Chicago Press, 2009.

Warner, Michael. *The Letters of the Republic: Publication and the Public Sphere in Eighteenth-Century America.* Cambridge, MA: Harvard University Press, 1990.

Warnke, Frank J., Alex Preminger, and Lore Metzger. "Graveyard Poetry." In *The New Princeton Encyclopedia of Poetry and Poetics*, edited by Alex Preminger et al. Princeton, NJ: Princeton University Press, 1993. Literature Online. o-lion.chadwyck.com.libcat.lafayette.edu.

Warren, Leonard. *Constantine Samuel Rafinesque: A Voice in the American Wilderness.* Lexington: University Press of Kentucky, 2004.

Watts, Edward, and David Rachels, eds. *The First West: Writing from the American Frontier, 1776–1860.* New York: Oxford University Press, 2002.

Webster, Daniel. *Speeches and Formal Writings, Volume 1: 1800–1833.* Edited by Charles M. Wiltse. The Papers of Daniel Webster. Hanover, NH: Dartmouth College / University Press of New England, 1986.

———. *Speeches and Formal Writings, Volume 2: 1834–1852.* Edited by Charles M. Wiltse. The Papers of Daniel Webster. Hanover, NH: Dartmouth College / University Press of New England, 1988.

Webster, Noah. *Grammatical Institute of the English Language, Part III.* Hartford, 1785.

Wells, Colin. "*Aristocracy*, Aaron Burr, and the Poetry of Conspiracy." *Early American Literature* 39 (2004): 553–76. Project Muse. o-muse.jhu.edu.libcat.lafayette.edu.

————. *The Devil & Dr. Dwight: Satire and Theology in the Early American Republic.* Chapel Hill: OIEAHC / University of North Carolina Press, 2002.

Wertheimer, Eric. *Imagined Empires: Incas, Aztecs, and the New World of American Literature, 1771–1876.* New York: Cambridge University Press, 1999.

Wesley, John. *The Complete English Dictionary.* London, 1753.

Wheatley, Phillis. *The Collected Works of Phillis Wheatley.* Edited by John C. Shields. Schomburg Library of Nineteenth-Century Black Women Writers. New York: Oxford University Press, 1988.

Whitley, Edward. *American Bards: Walt Whitman and Other Unlikely Candidates for National Poet.* Chapel Hill: University of North Carolina Press, 2010.

Whitman, Walt. *Leaves of Grass and Other Writings.* Edited by Michael Moon. Norton Critical Editions, rev. ed. New York: Norton, 2002.

————. *Notebooks and Unpublished Prose Manuscripts.* Edited by Edward F. Grier. Vol. 5. New York: New York University Press, 1984.

————. *Poetry and Prose.* Edited by Justin Kaplan. Library of America College Editions. New York: Library of America, 1996.

Whittier, John Greenleaf. *The Poetical Works.* 3 vols. 1878. Reprint, Boston, 1884.

Wilson, James. *The Works of James Wilson.* Edited by Robert Green McCloskey. 2 vols. Cambridge, MA: Belknap / Harvard University Press, 1967.

Winterer, Caroline. *The Culture of Classicism: Ancient Greece and Rome in American Intellectual Life 1780–1910.* Baltimore: Johns Hopkins University Press, 2002.

————. *The Mirror of Antiquity: American Women and the Classical Tradition, 1750–1900.* Ithaca, NY: Cornell University Press, 2007.

Wolf, Bryan. "When Is a Painting Most Like a Whale?: Ishmael, *Moby-Dick*, and the Sublime." In *New Essays on* Moby-Dick, edited by Richard H. Brodhead, 141–79. New York: Cambridge University Press, 1986.

Woloch, Alex. *The One vs. the Many: Minor Characters and the Space of the Protagonist in the Novel.* Princeton, NJ: Princeton University Press, 2003.

Woolman, John. *The Journal and Major Essays of John Woolman.* Edited by Phillips Moulton. 1971. Reprint, Richmond, IN: Friends United Press, 1989.

"The World of Art." *New World* 6.10 (Mar. 11, 1843): 307. America's Historical Newspapers. 0-infoweb.newsbank.com.libcat.lafayette.edu.

"Yonnondio, or the Warriors of the Genessee." *Grahams American Monthly Magazine* 27.2 (Feb. 1845): 96. American Periodical Series Online. 0-search.proquest.com .libcat.lafayette.edu.

Index